Simplicity or Splendour
Arts and Crafts Living:
Objects from the Cheltenham Collections

CW01019690

THE CONTRIBUTORS

Helen Brown works with the Decorative
Arts collections at Cheltenham and job-
shares the post of Keeper of Visitor
Services. She has recently organised a
major touring exhibition on Winchcombe
Pottery.

Annette Carruthers has worked as
a curator with the Arts and Crafts
collections at Leicestershire Museums
and at Cheltenham and is now a Lecturer
in Art History and Museum and Gallery
Studies at the University of St Andrews.

Mary Greensted works with the
Decorative Arts collections at
Cheltenham and job-shares the post
of Keeper of Visitor Services. She has
written books and organised exhibitions
on the Arts and Crafts Movement.

Sophia Wilson works with the Decorative
Arts collections at Cheltenham. As
Exhibitions Officer, she researched and
organised a major touring exhibition on
Pre-Raphaelite dress.

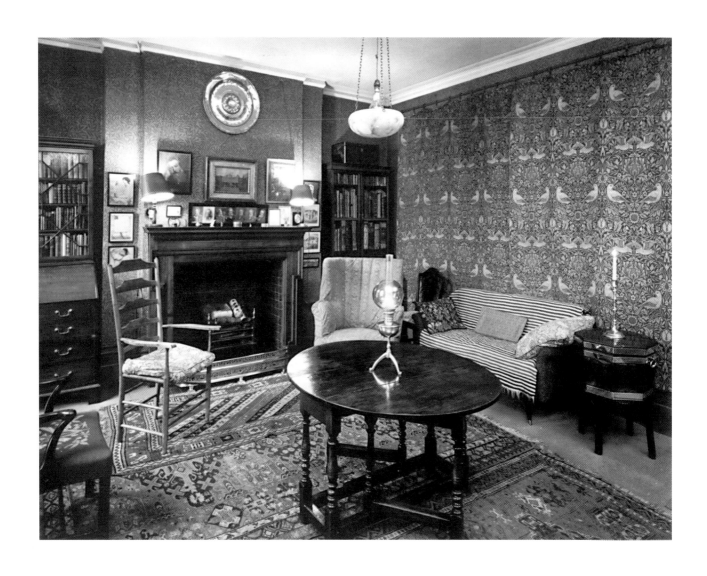

'The great advantage and charm of the Morrisian method is
that it lends itself to either simplicity or splendour.'
Walter Crane, 'The English Revival in Decorative Art', 1911

Edited by Annette Carruthers and Mary Greensted

Simplicity or Splendour

Arts and Crafts Living: Objects from the Cheltenham Collections

Cheltenham Art Gallery and Museum
in association with
Lund Humphries

First published in Great Britain in 1999 by
Cheltenham Art Gallery and Museum
Clarence Street, Cheltenham GL50 3JT
in association with
Lund Humphries
Gower House, Croft Road
Aldershot
Hampshire GU11 3HR

Reprinted in 2003

British Library Cataloguing-in-Publication Data
A catalogue record for this book is available from
the British Library

ISBN 0 85331 779 8

Designed by Alan Bartram
Typeset in Palatino by Tom Knott
Printed in China by Midas Printing International Ltd for Compass Press Ltd

FRONTISPIECE
The dining room in Emery Walker's house at 7 Hammersmith Terrace,
London, largely unaltered since the early years of the century.

Contents

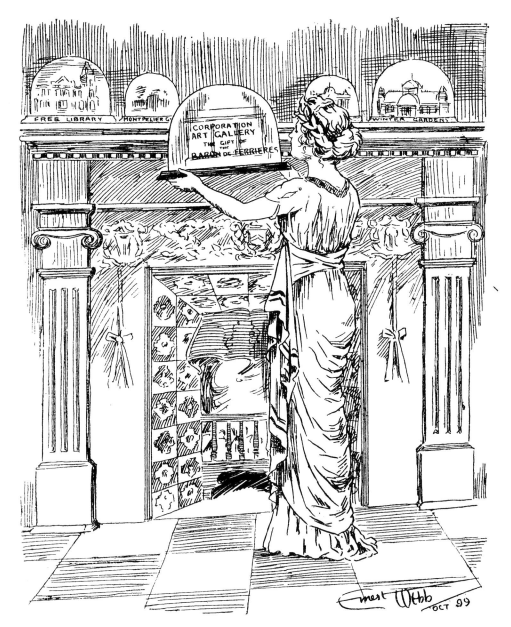

Text within the illustration:

FREE LIBRARY

MONTPELIER G

WINTER GARDENS

CORPORATION
ART GALLERY
THE GIFT OF
THE
BARON DE FERRIERES

Ernest Webb OCT 99

CHELTONIA—" And there's still room."

Fig.1 *Drawing by Ernest Webb published in 'The Cheltenham Sketch-Book',
Volume III, Cheltenham 1900, depicting Cheltonia adding the new Art Gallery
to the ornaments of the town.*

Foreword

In 1994 we published *Good Citizen's Furniture: The Arts and Crafts Collections at Cheltenham* as the first part of a catalogue of our British Arts and Crafts Movement collections. By all accounts it has become a very well used resource across the land and further afield. This volume completes the picture by demonstrating the depth and richness of our holdings in the decorative arts besides furniture. We may be best known for our Arts and Crafts furniture collection: we should be known for much besides.

Independent validation of the range and quality of our British Arts and Crafts Movement collections came in June of this year with the award of Designated Status for them. The Designation Scheme aims to draw attention to non-national, pre-eminent museum collections in England, recognising both the excellence of a particular collection and the institution that houses it. At the time of writing there are just fifty-one Designated collections, held by forty-three museum services, across all of the country.

The collections would not be as rich as they are without the generosity of donors, trusts and grant-giving bodies. We owe them a great debt, as we do to those bodies that have provided much valued financial support for this catalogue, in particular the Paul Mellon Centre for Studies in British Art, but also the Pilgrim Trust and the Oldham Foundation in memory of Orlando Oldham.

Good Citizen's Furniture was written by Annette Carruthers and Mary Greensted. Both have had a major hand in the creation of this volume, ably assisted on this occasion by Helen Brown and Sophia Wilson. We thank them all, as well as Woodley and Quick for continuing to undertake the onerous work of photographing nearly all the pieces and Lund Humphries Publishers for their willingness once again to co-publish the catalogue.

Finally, I must mention our centenary, which falls in October 1999. This volume is published as part of our celebrations of 100 years of serving the public. In October 1899 William Morris had only been dead three years and there seemed little incentive at our founding to build a related collection. The story of how such an impressive collection came about is told in the first volume. Ensure you have both catalogues, but above all ensure that you visit the collections themselves.

GEORGE BREEZE
Head of Art Gallery and Museums
Cheltenham Borough Council

Acknowledgements

As always, we are very grateful to the many people who have provided information and helped with the production of this catalogue.

For access to archives we thank: Roger Beacham and Lynne Knight at the Cheltenham Reference Library; Christina and Simon Biddulph; Trevor Chinn at the Gordon Russell Trust; the family of John Paul Cooper; Jane May, Leicester Museums Service; Charles Newton, Prints, Drawings and Paintings, V&A; Robert Welch; Jane Wilgress.

For information on designers, makers and techniques we thank: Maureen Batkin; Gerry Carter; Margot Coatts; Irene Cockroft; Alan Crawford; Derek Elliott; Bryant Fedden; Herald Goddard; the Guild of Handicraft Trust; Chinks Grylls; David Hart; Alice and Frank Johnson; Natasha Kuzmanovic; Dr Cathy Ross, Museum of London; Muriel Wilson.

For information on the history of items before they came to the Museum collections we thank: Alan Crawford; Chris Morley; Paul Reeves; Joyce Winmill.

At Lund Humphries Publishers we thank: Alan Bartram; Anjali Bulley; Lucy Myers.

We also thank: Steven Blake; George Breeze; Wendy Malpas; Rosemary Roden; Alan Saville; Anna Stanway.

Most of the new photographs were taken by Jamie Woodley and Sarah Quick of Bristol. Other new photographs are by:
Christie's, London Figs 117-19
Freezeframe Figs 65, 203 and 205

Other photographs are from the Museum's archives. We are grateful for permission to reproduce the following:
Felicity Ashbee Fig.132
Birmingham Library Services Figs 27, 28 and 29
Birmingham Museums and Art Gallery Fig.23
The Board of Trustees of the Victoria & Albert Museum, London Fig.23
Cheltenham Library Local Studies Collection Figs 1 and 19
City of Nottingham Museums, Castle Museum and Art Gallery Fig.20
The family of John Paul Cooper Figs 137 and 138
Corinium Museum, Cotswold District Council Fig.182
Anthony Crane Fig.121
G. Davies Fig.155
Derek Elliott Fig.173
Ray Finch Figs 192 and 195
Mr and Mrs H. Goddard Fig.177
Kay Martin Fig.198
Private Collections Figs 4, 24, 156, 157, 158, 159, 160 and 162
Robert Welch Fig.174
Jane Wilgress Fig.172
William Morris Gallery, London Borough of Waltham Forest Fig.31
Jean Wilson Fig.153

Chapter I is by Mary Greensted, Chapter II by Annette Carruthers and Chapter III by Sophia Wilson. The cataloguer's initials appear at the end of each introductory essay, apart from the entries on William De Morgan pottery and A. Masson's tile panel which are by Helen Brown.

Notes will be found at the end of each chapter. The following abbreviations have been used in the notes:

CAGM	Cheltenham Art Gallery and Museums
GCF	Carruthers, A. and Greensted, M., *Good Citizen's Furniture: The Arts and Crafts Collections at Cheltenham*, Cheltenham and London 1994
GOHT	Guild of Handicraft Trust, Chipping Campden, Gloucestershire
GRO	Gloucestershire Record Office, Gloucester
GRT	Gordon Russell Trust, Broadway, Worcestershire
RA	Royal Academy of Arts, London
RIBA	Royal Institute of British Architects, London
V&A	Victoria & Albert Museum, London
V&A AAD	V&A Archive of Art and Design, Blythe Road, London
V&A AAD, A&CES	V&A Archive of Art and Design, Archive of the Arts and Crafts Exhibition Society (later the Society of Designer-Craftsmen)
V&A PP&D	V&A Prints, Paintings and Drawings Department

Any numbers following these abbreviations are the accession numbers of the objects.

HB, AC, MG & SW

I 'Simplicity or Splendour': the Arts and Crafts domestic interior

'The great advantage and charm of the Morrisian method is that it lends itself to either simplicity or splendour. You might be almost plain enough to please Thoreau, with a rush-bottomed chair, piece of matting, and oaken trestle-table; or you might have gold and lustre (the choice ware of William De Morgan) gleaming from the side-board, and jewelled light in your windows, and walls hung with rich arras tapestry.'[1]

The scene for the Arts and Crafts domestic interior was set by May Morris's description of her father's drawing room at Kelmscott House, Hammersmith, west London as 'a haven of peace and sweet colour, breathing harmony and simplicity'.[2] The overall simplicity of the surroundings was set off by highlights of rich colour, pattern, and texture. The centrepiece of the room was a painted cabinet originally made for Red House, Bexleyheath, its tones complemented by the *Bird* hanging, 'a perfect blue with pale gleams of colour in the birds and foliage'. A plain blue carpet was 'overlaid here and there with some flower-like Eastern rugs'. Light played an important part in creating the atmosphere. In winter the fire in the open hearth of Philip Webb's 'massive pillared grate' was the dominant feature. During the summer months, shifting patterns of reflected light from the River Thames at the bottom of the garden took over. At different times throughout the year reflections from both sources were echoed in the panels of the Red House settle, on lustre plates, and in 'the discreet glimmer of old glass in closed cupboards sunk in the walls'.

William Morris, throughout his working life, emphasised the importance of the home environment. In an unequivocal vein he wrote, 'If I were asked to say what is at once the most important production of art and the thing most to be longed for, I should answer, A beautiful House'.[3] However 'A beautiful House' in Arts and Crafts terms was not a straightforward creation. It involved a complex, and sometimes tortuous, balance between monotony and individuality, reticence and elaboration, comfort and inspiration. To create a harmonious, comfortable, and charming domestic interior, according to the architect and designer, M. H. Baillie Scott, 'the eye must be soothed and satisfied as well as the body'.[4] C. F. A. Voysey further emphasised the importance of moral and social issues, particularly fitness for purpose and anti-materialism, writing: 'The love of sincerity and truth is the mainspring of individuality, it is the secret of the impulse to have all around in harmony with mind and heart. The desire for home is born of this holy impulse'.[5]

Walter Crane highlighted the potential anomaly in Morris's ideas about the Arts and Crafts interior when he described it as encompassing either simplicity or splendour. However Morris saw and accepted this; beauty did not necessarily mean luxury, while luxury and the show of wealth rarely produced beauty. 'This simplicity you may

make as costly as you please … you may hang your walls with tapestry instead of whitewash or paper; or you may cover them with mosaic, or have them frescoed by a great painter: all this is not luxury if it be done for beauty's sake and not for show.'[6] Morris realised that even minimalism could cost money and these two terms, simplicity and splendour, remain pivotal to descriptions of the Arts and Crafts domestic interior.

In theory the Arts and Crafts enthusiasm for simplicity altered the domestic interior quite drastically from its mid-nineteenth-century emphasis on show and novelty. Morris's forthright statement that 'I have never been in any rich man's house which would not look the better for having a bonfire made outside of nine-tenths of all that it held',[7] was echoed in milder form by other writers and designers. In *The Studio Yearbook* of 1906, Aymer Vallance emphasised the need for proportion, asserting that 'costliness and elaboration demand a foil for their appraisement; without it they are virtually wasted'.[8] The Arts and Crafts ideal, as represented by drawings of interiors by Baillie Scott and other architects, by illustrations in magazines and journals, and by *Country Life* photographs of Arts and Crafts interiors, swept away the vast array of decorative work, furniture, soft furnishings and ornaments which were found in the typical Victorian house. In practice it was often replaced with built-in fixtures, such as inglenooks or settles, decorative wall treatments and friezes, and bold concentrated areas of colour and decoration.

The drive towards simplicity came from a number of sources, aesthetic, practical and moral in inspiration. Certainly a new stylistic trend had developed through the second half of the nineteenth century pioneered by Richard Norman Shaw's work in the Queen Anne style and by the highly influential and personal style of Philip Webb. In 1874, Shaw designed for himself a house at 6 Ellerdale Road, Hampstead, London, which was significant for future developments, particularly as many of the next generation of Arts and Crafts architects trained in his office. Webb's Red House, built for William and Jane Morris in 1859, has often been cited as the first Arts and Crafts house. His subsequent work at Forthampton Court, Gloucestershire, in 1890 was much admired by the next generation of architects, including Ernest Gimson and Ernest Barnsley, although the owner, John Yorke, at first found it difficult to live up to Webb's injunction to keep the house 'simple and quiet when fitting it for use'.[9] In particular, the restrained interiors designed by Webb at Standen, Sussex, in the early 1890s set the tone for the next two decades. They incorporated a careful mix of furniture and furnishings, including innovative electric light fittings by W. A. S. Benson, with predominantly white-painted panelling.

Wood panelling, also known as wainscoting, was the simplest option for providing a plain but rich and long-

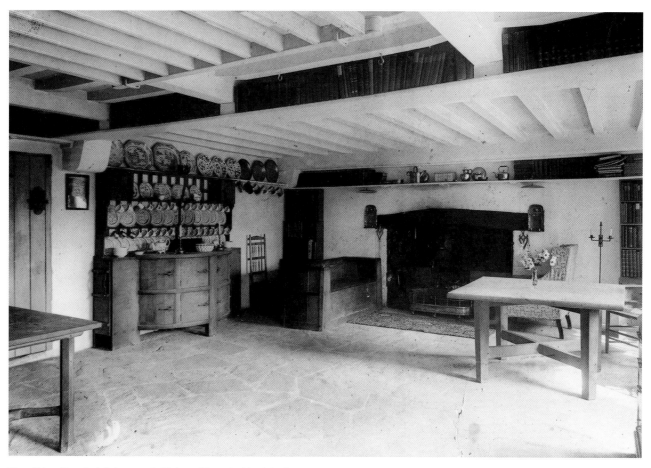

Fig.2 *Sidney Barnsley's living room in Pinbury, Gloucestershire, late 1890s, one of a series of photographs taken by his brother, Herbert.*

lasting wall surface. It was also the most desirable wall covering, described by *The Studio Yearbook* of 1906 as providing a sense of comfort and finished appearance. However it was also one which required a significant financial outlay. Where they could be afforded, oak panels, usually on a frame of pitch pine, were ideal. The musician, Violet Gordon Woodhouse, who became a patron of Arts and Crafts designer-makers in Gloucestershire in the 1920s, moved to Southover Grange, Sussex, in 1901. One of the attractions of this Elizabethan house was that it was panelled throughout in old oak. Cheaper woods such as pine or deal could be stained green or painted white or creamy-white; the lightness and cleanliness of this effect was especially appreciated for town houses. Baillie Scott described dining room woodwork painted white as having 'a quiet dignity of effect'.[10] The same theme runs through the description of the house in H. G. Wells's novel, *Marriage*:

The room downstairs was shapely, and in ripping off the papered canvas of the previous occupier, some very dilapidated

but admirably proportioned panelling was brought to light.... The panelling must be done and done well, anyhow; that would be no more than a wise economy, seeing it might at any time help them to re-let; it would be painted white, of course, and thus set the key for a clean brightness of colour throughout.[11]

At Rodmarton Manor, Gloucestershire, designed by Ernest Barnsley for Claud and Margaret Biddulph in 1909, the main reception rooms were at first used primarily for communal activities, classes, musical and theatrical entertainments, fulfilling the role of a village hall. The Biddulph family used the more intimate two-storey wing on a daily basis. As they began to make regular domestic use of the main house in the late 1920s, Barnsley's austere stone-walled interiors were considered too spartan for family life. The architect and designer Alfred Powell, the Biddulphs' friend and frequent guest at Rodmarton, produced new designs for the drawing room. The walls were panelled with oak by the estate workshop and round

Fig.3 *The conservatory at Emery Walker's house, 7 Hammersmith Terrace, London, which leads out to the garden and the River Thames.*

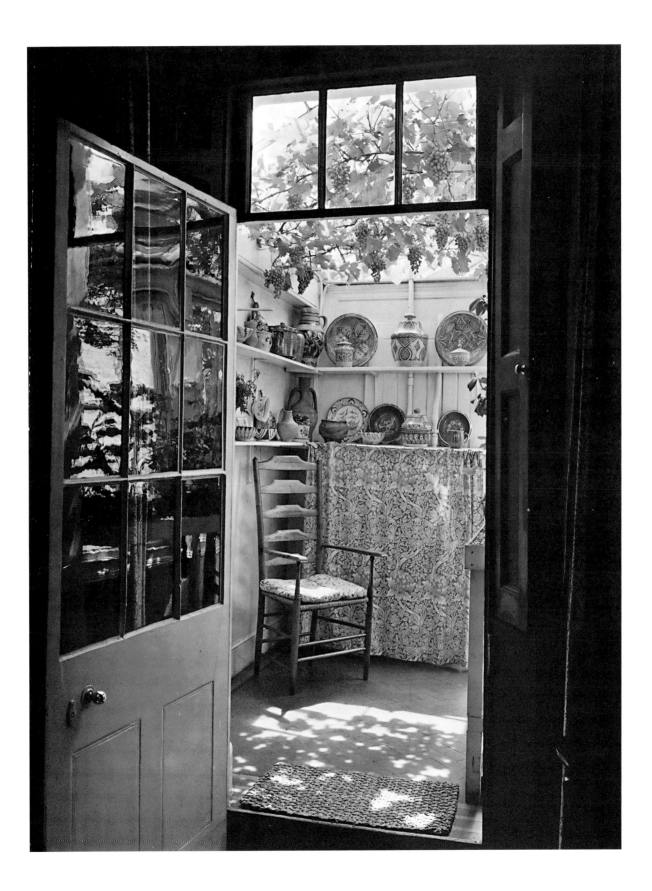

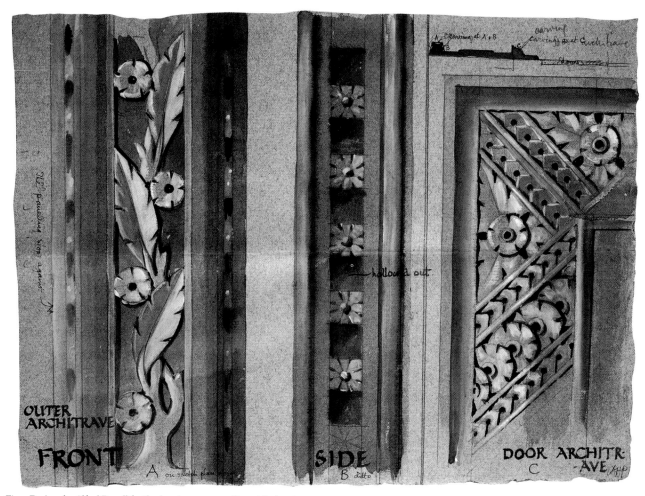

Fig.4 *Designs by Alfred Powell for the drawing room panelling at Rodmarton Manor, Gloucestershire, 1929.*

the door frames and along the picture rail ran a scheme of carved designs based on floral motifs seen by Powell at the Victoria & Albert Museum (Fig.4). This created a warmer, richer, more intimate space for domestic use.

The Arts and Crafts architects' concern for detail also helped to create a visual simplicity and coherence in their interior work. When curtains were required for an interior scheme, Voysey's input extended to details such as the depth of the hems and the size and placing of curtain rings. Normally one width of fabric was used to cover a single light without any pleats or gathers. In many instances, keys were designed in keeping with the furniture they served and a variety of other mundane fixtures and fittings also came under the scrutiny of the architect-designer. Voysey designed furniture and light fittings, door furniture, bell pulls, window latches, ventilator grilles and letter plates.

He often produced designs for one particular building which then entered his standard range. The brass double inkwell (Cat.29) was first shown in 1896. He also used this design for a range of single inkwells in his interior scheme for the Essex and Sussex Equitable Insurance Society Offices in the City of London, in 1906. Ashbee shared Voysey's concern for the details of architectural design as did Gimson, writing to his brother on one occasion, 'What are you going to do with those vile finger plates on the door? You should get some like ours in the drawing room. They are from Elgood's'.[12] He may have recommended fittings from Montague Fordham some years later for a town house (Fig.5). When he began designing such items himself in the 1900s they were much less *fin de siècle* in feel. Designs at Cheltenham include hinges, handles for doors and furniture, locks and catches, bell pulls, and door knockers,

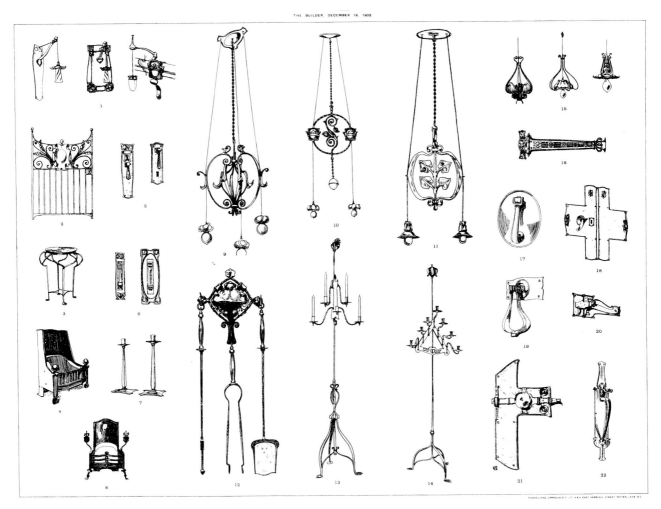

Fig.5 *Examples of metalwork from the workshops of the Montague Fordham Gallery, Maddox Street, London W1, reprinted from 'The Builder', 19 December 1903. From Ernest Gimson's collection of reproduction photographs.*

usually in brass or polished steel (Fig.151). They were made in the smithy at Sapperton, combining strength in shape and construction with efficiency and pleasure in use.

Apart from aesthetics, simplicity was also chosen for Arts and Crafts interiors for moral reasons. Voysey recommended the use of unpolished oak, stone, brick, or slate in building and furnishing houses because the raw materials were readily available in Britain, had been traditionally used for these purposes, and were in keeping with the climate, light, and national character. For his buildings, he specified slate floors throughout the service areas, kitchens, sculleries and such like, as they were hard-wearing and functional with a natural beauty and light-reflective quality. Above all simplicity was necessary to achieve repose. 'Confusion and restlessness and fatigue are the inevitable result of walking over marble, wood, and wool alternately.'[13] In practice, a

variety of floor coverings was used. An insurance valuation of 1929 at the Gloucestershire country home of Emery Walker, a close friend and associate of William Morris particularly in conjunction with the Kelmscott Press, detailed the floor coverings which would have been used over the old stone and wooden floors of Daneway House. These included the kelims, Indian, Persian and Moorish rugs so popular in Arts and Crafts circles, a large brown Iceland sheepskin rug (could this have been a gift from William Morris?), and a wool rug with white and brown lines, possibly like the rugs designed by Louise Powell and made locally by George Lambert for Rodmarton Manor. The inventory also listed a small green bordered 'art carpet' in the cook's room and a blue 'art' stair carpet, probably machine-made examples produced by firms such as Tomkinson & Adam who reproduced some of Voysey's

Fig.6 *Pages from a letter written by Ernest Gimson in 1890.*

designs in their Axminster range, as well as a number of straw and cocoa mats, and two long lengths of string carpet.[14]

Simplicity or the absence of clutter ensured that there were no distractions from the emotional connotations of a building. Voysey was typical in his emphasis on the importance of a large, welcoming hall, continuing the Gothic Revival's enthusiasm for a living hall to provide an initial point of contact with the outside world. He wrote:

The hall should receive its guests with composure and dignity, but still with brightness, open arms, and warmth; warmth of colour rich and luxurious as you like, but above all things, sober and reposeful, not dotted all over with bazaar and museum articles, and tables and chairs that repel you.[15]

Very often the focal point of the hall was the ingle or fireplace. Norman Shaw included a massive inglenook in his own house in Hampstead designed in 1874, the first to

be used in a town house according to Shaw's biographer, Andrew Saint.[16] This became an important feature by the 1890s and the wood fire blazing on a wide brick hearth was seen to provide both physical and emotional warmth. The treatment of the fireplace, particularly in older houses with early nineteenth-century surrounds in cold grey marble, was given much consideration. In about 1890, Ernest Gimson wrote to his brother, Sydney, with some suggestions for alterations in the latter's newly-acquired home, saying:

If you are very anxious to improve your fireplace and are willing to spend 6 or 7£ here is an idea for you. It would be in deal painted white. The top shelf would be 9" higher than the present one which would be an advantage.

It would look very jolly and would make the fireplace one of the pleasantest features of the room.[17] (Fig.6)

Voysey described the fireplace as 'the eye of a room to

which you look and gravitate as to the embrace of a friend'. Its design should therefore be 'clear, open, frank and large, deep set if you will, but simple and true … not low down and blinking up at you as the glare from a snake'. [18] In connection with the inglenook, the settle, either free-standing or built in, became the archetypal piece of Arts and Crafts furniture with its connotations of communal fellowship. Many architects, particularly Gimson and Baillie Scott, designed settles and incorporated them into their interiors.[19]

The idea of 'the simple life', and the puritanical approach of some of the architects, designers and patrons involved with the Movement, was reflected in the houses they designed and lived in. Ashbee and Alfred Powell were typical of many architect-designers of the period in their interest in rural housing and traditional country buildings. There was often a link between town houses and splendour and a more simple approach for country dwellings. Traditional country values: fresh air, communal living, plentiful but plain fare, were aspired to, with the farmhouse and the farmhouse interior providing suitable models. At Hilles, the Gloucestershire house designed in 1910 by Detmar Blow for himself and his family, all the household dined together in a room based on a medieval great hall with massive fireplaces at either end. The servants rather than the family brought an end to this social experiment some years later.

A concern for the development of the countryside brought with it a renewed appreciation for traditional country crafts and for the unknown country craftsmen. The concept of the maker and the marks of handwork became a potent force in the philosophy of the Arts and Crafts Movement. William De Morgan was not unusual in giving credit to individual painters in the catalogues of the Arts and Crafts Exhibition Society while in 1890 the furniture workshop set up by architects, Kenton & Company, set out to acknowledge both the designer and maker of each piece. Voysey expressed the strong emotional element characteristic of the Movement when he wrote, 'The very poker at your fireside becomes of interest to you the moment you recognise the sentiments of its maker'.[20]

On practical grounds simplicity was a way of achieving cleanliness, an important consideration in the second half of the nineteenth century as a weapon in the fight against typhoid, tuberculosis and other diseases. Morris found it difficult to respond to a request for advice for inexpensive but good design for the working-class home. His main suggestion was to '… keep it as clean as a new pin'.[21] Conventional comforts, the 'useless and trumpery rubbish'[22] found in the typical Victorian middle-class interior were believed to be a breeding ground for dirt and disease and a source of work for servants and doctors. Aymer Vallance condemned the swathes of Victorian soft

furnishings as adding to 'the expense, snobbishness and unhealthiness of a room without in any way adding to its beauty'.[23] In the same article, Vallance warned of the potential health hazards of 'dark heavy inharmonious colours, and the combinations of strong opposites'. Cleanliness and healthiness became associated with lightness, brightness and simplicity as an antithesis to the dark, overcrowded and dust-gathering Victorian interior.

Voysey in particular showed a concern for cleanliness in the details of his designs. In halls and bedrooms in particular, a variation to panelling was achieved by converting furniture into built-in fixtures – wardrobes, chests, washstands. This had the advantage of getting rid of clutter and potential dirt traps by providing clean lines and flush surfaces. Ernest Barnsley developed a device in the construction of ceilings, using joists set at an angle rather than square, with the space between joists plastered in a curve. This was used at Rodmarton Manor and at Rowbrook, Dartmoor. The daughter of one of his clients commented that it had a practical effect of throwing off dust and cobwebs.[24]

Changes in social attitudes and employment meant that domestic service was no longer an inevitability, or even an attractive option for many working-class women so that 'the contentment of servants in the country is a thing of which it is quite worth while to make sure'.[25] Philip Webb designed Clouds, a house at East Knoyle, Wiltshire, for the Wyndham family in the 1880s. When the main house was seriously damaged by fire, the owners had to move into the servants' quarters while it was rebuilt. They quickly came to appreciate the advantages of a socialist architect who had given equal consideration to this part of the commission and ensured that servants' quarters were well-planned, light and airy. A growing unease about the master-servant relationship had developed from the mid-nineteenth century onwards and remained a consideration for Baillie Scott and other architects when considering the way that the different groups of occupants would circulate within a building. By commenting on one design that, 'the servants need never pass through any of these three family sitting rooms',[26] Baillie Scott indicated the importance placed on providing some relatively private areas for the family.

Although the mainstay of the Arts and Crafts interior was simplicity, ornamental and decorative work abounded. Walter Crane's concept of 'splendour' was provided by the use of a wide range of materials, areas of intense colour and decoration, and pattern. The Arts and Crafts Movement had developed from the decorative traditions of the nineteenth century and shared with the Aesthetic Movement of the 1870s and '80s a similar interest in integrating the arts. Its concern with the lesser or decorative arts, with the 'beautiful House', and the interest in craftsmanship of the medieval and Renaissance periods led to the revival of

Figs 7a and 7b *Two images of Ernest Gimson's living room at Pinbury, Gloucestershire, c.1900. The drawing is by Alfred Powell and the photograph by Herbert Barnsley.*

neglected crafts. Those involved in the Movement realised early on that it needed a public face; the Arts and Crafts Exhibition Society was founded in 1888 to act as its showcase. Inevitably much of the work put forward for exhibition was richly decorated, sumptuous pieces which showed off the art of the designer and the skill of the maker.

The Arts and Crafts Movement continued and encouraged the revival of numerous crafts associated with building in the second half of the nineteenth century. Plasterwork was one such craft which, although it was still practised, was carried on in a debased, semi-skilled form with workshops producing either standard cornices and roses or highly elaborate panels and mouldings, often cast from heavily sculpted wooden or brass originals. An article in *The Architectural Review* in 1908 on a large, traditional firm of plasterworkers, George Jackson & Sons of Rathbone Place, London, gives a vivid impression of the complex yet mechanical creativity of even the most prestigious workshop.[27] In the 1880s Sedding, Burne-Jones and Webb all produced designs for plasterwork and talks on the craft were held at the Art Workers' Guild. Gimson began his association with the London firm of plasterworkers, Whitcombe and Priestly, in mid 1890. He wanted to learn how to execute his own designs, much to the surprise of the workmen. He spent part of each day modelling standard friezes and ribbed ceilings until he was confident enough to make up his own designs. He appears to have paid the firm £20 a month for this facility for well over six months.[28] He was not the only young architect to develop a practical connection with an established craft firm. Early in 1891 he wrote, 'Tomorrow Blow begins work with me at W & P's, he is taking up wood carving. We shall have a room to ourselves that we can use as we please …'[29] referring to his friend and colleague, Detmar Blow. Blow was one of

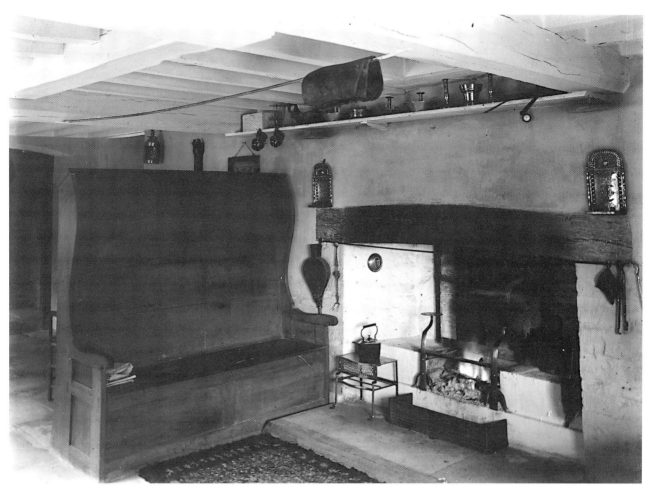

Fig.7b

a group of architects including Alfred Powell, who were influenced by Webb and acquired a variety of skills connected with the building crafts. As individual architects in the 1890s, they rejected the idea of an office base and instead brought together teams of craftsmen to travel round with them from commission to commission.

Gimson, along with G. P. Bankart, John Paul Cooper and William Aumonier, was one of a select group who were prepared to get their hands dirty in order to execute their plasterwork designs. Others such as Baillie Scott, George Jack and Henry Wilson either employed craftsmen for specific architectural projects or sent designs to workshops which specialised in plasterwork, such as that of Lawrence Turner in London. The Arts and Crafts approach to the use of the medium was described by Ernest Gimson:

… it will be impossible for the plaster-worker to get anything more than a suggestion of nature into his work, if he gives any thought to the suitability of the design to the material…. Indeed something of dulness is always noticeable in good plaster-work, where there is no intention of disguising the material; and it is a quality which … gives it a character of its own, and distinguishes it more than anything else from the sister art of carving. For dulness suggests the softness of the material, and the process of adding and pressing, by which the right relief is obtained, suggests the application of the design to a prepared surface….[30]

Gimson used this approach for a variety of commissions from the simple cottage interior of Upper Dorval House, Sapperton, to the rich elaborate library for Sir Ernest Debenham's house in Addison Road, Kensington, London. Although not a craftsman himself, the same approach to the medium was found in the writings of Baillie Scott who included decorative plasterwork in a number of commissions including Blackwell, Westmoreland, built for

Sir Edward Holt. Baillie Scott wrote, 'Do not necessarily finish your plaster with fine stuff but preserve the texture which the sand gives…. Let the finished plaster still retain some hint that it was soft and yielding when used: let it flow round the woodwork, perhaps engulfing it partially as if it had risen like a flood which has been frozen.'[31]

Sgraffito was another decorative technique which had been revived in the nineteenth century, firstly in Germany and then by Henry Cole and his associates, most notably in the decoration of the building which is now the Henry Cole Wing of the Victoria & Albert Museum, London. It became a significant medium in the hands of the designer, Heywood Sumner, who used it in a freely-drawn, colourful, and pictorial manner epitomising the Arts and Crafts approach in its simplicity of design and speed of execution. The effect was very different to that of decorative plaster panels because of the nature of the process; it was hard, sharp-edged and solid, the effect created by a sharp knife cutting through the top layer of plaster to reveal the different coloured grounds below. It called for a linear approach ideally suited to Sumner whose first artistic interest had been drawing and etching. He was able to use the same skills in his stained-glass work where the simple, regular leading enhances the decorative effect, in his wallpaper designs, and even in his few furniture designs.[32] In developing a personal style and approach which was then used in a variety of materials, Sumner was typical of the multi-disciplinary first generation of Arts and Crafts designers.

Although the craft of leatherwork had been neglected for many years and techniques and skills had been lost, there were concerted attempts to create a new interest, in part because of the adaptability of the medium. There had been a revival in Germany in the mid-nineteenth century and, according to an article in *The Studio*, one of its leaders, Hartwig Jacobsen, was trying to give an impetus to British work by teaching and producing designs.[33] An example of his work, an embossed leather panel featuring a coat of arms, was shown at the fifth Arts and Crafts Exhibition in 1896. Leatherwork had featured in the 1888 Arts and Crafts Exhibition with Sedding, Clement Heaton, and Crane showing embossed leather papers produced mainly by Jeffrey & Company. Important work was included in subsequent exhibitions, particularly by Ashbee who expressed an interest in trying to develop an English tradition for decorative leatherwork. His enthusiasm for the medium relates to his general interest in Spanish art and design, particularly furniture. He combined leatherwork with his furniture designs, on chairs, settles, and his distinctive 'vargueno' cabinets. The Guild of Handicraft leatherworkers produced a frieze for Bryngwyn, Wormelow Tump, Herefordshire (Cat.31), as part of the decorative scheme of 1892 for the owner, James Rankin, which

Fig.8 *Plaster mould for a decorative frieze made by Norman Jewson in the 1920s.*

included panelling and painting as well as metalwork and furniture. One of the Guildsmen, William Hardiman, also executed the leatherwork for the staircase at the Magpie and Stump, Cheyne Walk, Chelsea, London, one of Ashbee's masterpieces of architecture and design, sadly demolished in 1968. Fortunately a fragment of this design, an embossed painted and gilded triangle featuring the Craft of the Guild progressing into the rays of the sun, is preserved at the Victoria & Albert Museum.

Colour was used to provide both a focus and a unifying element in the Arts and Crafts interior as illustrated by this passage from the novel *Marriage* by H. G. Wells:

The deep rose-red of the cherries that adorned … [the plates on the dresser] was too isolated, usurped too dominating a value. And while this was weighing upon her mind she saw in a window in Regent Street a number of Bokhara hangings very nobly displayed. They were splendid pieces of needlework, particularly glorious in their crimson and reds, and suddenly it came to her that it was just one of these, one that had ruby flowers upon it with dead-blue interlacings, that was needed to weld her gay-coloured scheme together.[34]

Janet Ashbee's description of her first home in Chipping Campden, Woolstaplers' Hall, which 'glowed with colour like a plum',[35] emphasises the relationship between colour and nature in the Arts and Crafts Movement. According to Voysey, green, the colour most closely associated with nature, was the most soothing, while red should be used

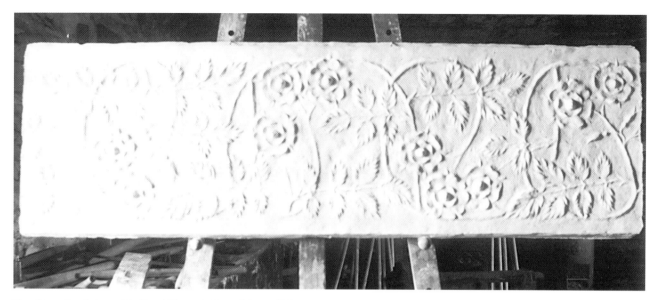

Fig.9 *Decorative plasterwork by Ernest Gimson in the workshop at Pinbury, Gloucestershire, late 1890s.*

sparingly. He chose a rich dark red twill fabric for the curtains of his own house, The Orchard at Chorleywood, Hertfordshire, and for his domestic interiors whenever he was able to specify such details. This emphasis on concentrated areas of rich colour is well illustrated by the use of enamel combined with metalwork (Cats 39 and 63).

The treatment of walls in the Arts and Crafts home could vary from plain painted surfaces in distemper or whitewash to a plethora of hangings or coverings, including papers, tapestry, other textiles, leather, plaster relief or wood panelling. Voysey did not always use wallpaper in his own buildings although the hall of his own home was at one stage papered with a plain Eltonbury silk-fibre paper in a strong shade of purple. His interior scheme for the London home of William and Haydee Ward-Higgs included a first-floor drawing room with walls of gold leaf separated by a low picture rail from the pale paintwork above. He stated in *The Studio* that he preferred 'a simple or quite undecorated treatment of the walls' but conceded that patterned papers had their uses, either for improved wear or even to distract from poor furniture and 'the ugliness of modern life'.[36] In fact it was his wallpaper and fabric designs which launched his career and provided Voysey with a regular income after 1914. Patterned wallpapers were considered particularly suitable for the more intimate family rooms. Typically, in about 1901, Violet Gordon Woodhouse papered the small sitting room at Southover Grange with an Arts and Crafts paper, featuring a design of brambles with pale grey-green leaves and maroon berries and purchased from Liberty's in Regent Street, London.[37]

Morris emphasised that both colour and pattern should be derived from nature and used some of his time at Kelmscott Manor to experiment with vegetable dyes. Voysey used a technique which he called 'Hyslop's Prints' to get an accurate, almost scientific, image of plant forms. It involved rolling leaves with ink then pressing them to

make prints of their outlines and the delicate pattern of their veins.[38] He also used early botanical photographs and collected book illustrations and botanical drawings for reference. Yet the characteristic strengths of Voysey's pattern designs for wallpapers and textiles are their boldness and simplicity, achieved by analysing natural forms, selecting and paring them down to their essentials. This approach is one shared by many Arts and Crafts designers, including Gimson, Powell and others (Cats 69 and 72). In an essay entitled 'Of Design, and of the Study of Nature' in *Plain Handicrafts*, Selwyn Image encouraged designers to draw from nature but suggested looking for the typical not individual forms.[39]

Imagery and symbolism as well as the written word have a central role within the Arts and Crafts Movement. Some popular decorative motifs of the Aesthetic Movement, particularly the sunflower, the lily and the song bird, reappear in Arts and Crafts designs such as De Morgan tiles, Crane wallpapers, and Voysey metalwork. For Voysey, the heart motif which became such an important part of the Movement's design repertoire was expressive of both human emotions and God's love. He was commissioned to design the cover for the first bound volume of *The Studio* published in 1893. His design featured two asexual figures kissing chastely under a rose tree circled by song birds. The figures symbolise 'Use' and 'Beauty', echoing Morris's dictum, 'Have nothing in your houses that you do not know to be useful, or believe to be beautiful'.[40] Voysey used the words of another influential writer, Thomas Carlyle, as the inspiration for the design of an inlaid work box dating from about 1893.[41] He used the inscription, 'Head, Hand & Heart', in conjunction with a pair of figures in puritan dress. They are both engaged in useful occupations, drawing and knitting, while a flowering bough suggests a pastoral setting.

The use of mottoes, proverbs, and quotations developed

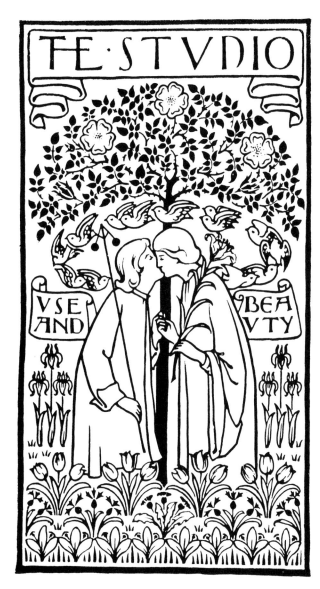

Fig.10 *Cover design by C. F. A. Voysey for the first bound volume of* The Studio, *1893.*

from a folk art tradition. It indicated a desire to add a human touch, even of whimsy, and was not confined to middle-class interiors. The House of Falkland in Fife, Scotland, was redesigned by Robert Weir Schultz for Lord Bute. One of the bedrooms includes a mantelpiece with the legend, 'Better a wee fire to warm ye / Than a big fire to burn ye'. Gavin Stamp's comment that, 'Schultz shared with his contemporary, Herbert Baker, a sometimes regrettable penchant for the sentimental in didactic decoration'[42] can be applied to the Movement as a whole. Mottoes or quotations were applied liberally (Cat.112) and the term 'inscription mania' was used in *The Studio*.[43] The inscription from

Horace's *Odes* cast by Ernest Gimson in the plasterwork over the fireplace in the library at Pinbury Park, Gloucestershire: *Ille Terrarum Mihi Praeter Omnis Angulus Ridet* (That corner of the world smiles for me beyond all others) echoes Sidney Barnsley's sentiments in 1894 when he first discovered this house in its secluded setting. Barnsley himself found one inscription particularly appealing according to a letter to Humphrey Gimson: 'Architecture has many extra troubles attached to it since the War due to cost and deterioration of craftsmanship and materials and I came across an inscription a man had put over the Porch of his new house that I thought delightful "Building is sweet impoverishing". It sounds like Bacon and it will come in useful for quoting to clients when they grumble at their extras.'[44] Inscriptions were all very well when they could raise a wry smile but they became an easy route to quaintness and an even easier target for satirists such as Osbert Lancaster and E. F. Benson.

Decorating a home, particularly one's first home at the start of married life, became a major issue, with books and articles providing advice. The choice of decorations, a few select objects, and above all the way they were put together was a matter of some concern among the middle classes. As a young architectural student in London, Ernest Gimson wrote to his elder brother, Sydney, shortly after the latter's marriage in 1886:

Bye the bye if you have any particular desire to possess anything that a fellow with £150 a year could afford to buy you might let me know. Do you want a pendant lamp for either room, or two Copper Candlesticks or a Burne Jones Autotype, or would you like four Morris chairs for drawing room (1 arm and 3 not)? You might let me know. I have my eye on good examples of the things I mention…. I know of a jolly lamp that is not pendant would you like that?[45]

And again the same month,

Is 3/- a yard too much for your drawing room curtains? If not I should get them at Morris's. He has some delightful ones, printed cottons mostly. His shop is a treasure house for anyone furnishing. He has now … two pieces of tapestry designed by himself and B. Jones only £250 each, try to persuade a rich friend to buy them.[46]

Mrs Haweis, author of *The Art of Decoration* in 1881, vigorously promoted individuality and self-expression in design and interior decoration. This approach, which Morris inspired and nurtured through his writings and practical example, was associated with skills often regarded as female. In fact many of the crafts with which Morris himself was most closely involved, such as dyeing, embroidery and weaving, were traditionally female. Marjorie Pope, H. G. Wells's heroine in the novel, *Marriage*, was described setting up her first home in London: 'She had always loved colour in the skies, in the landscape, in the texture of stuffs

Fig.11 *The living room of Brewery Cottage, Christchurch, Hampshire, home of Eric and Marian Sharpe, 1921. Sharpe's water-colour includes his wife and cat; the chair was made by him in 1920.*

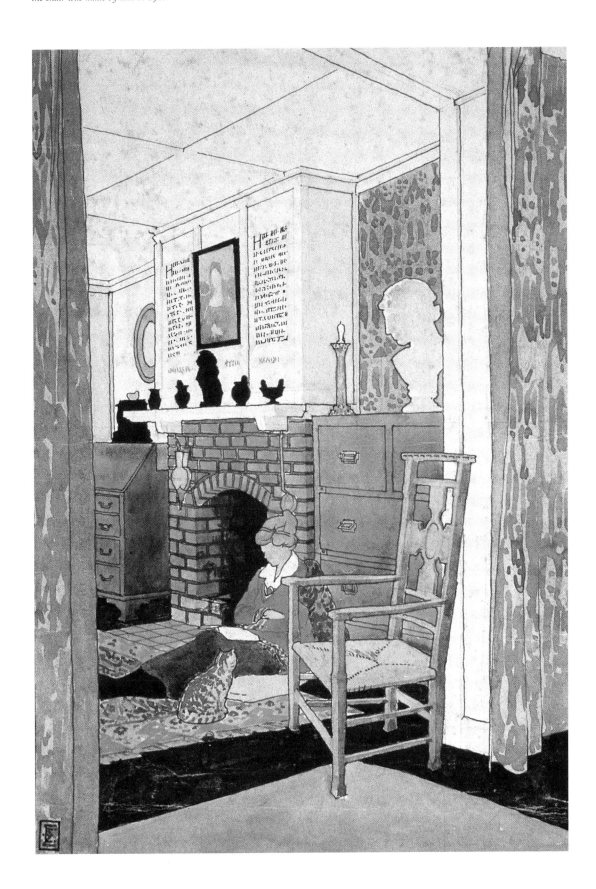

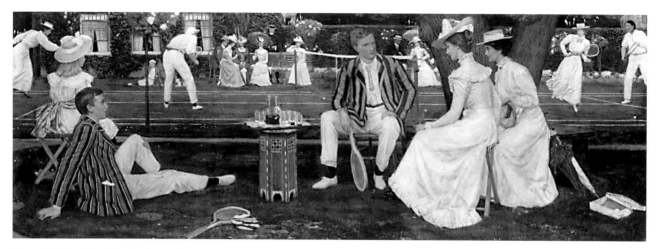

Fig.12 'The Tennis Party' by Charles March Gere, 1900. This painting illustrates the changing social climate at the beginning of the twentieth century with the small Indian table brought out for an impromptu picnic. A member of the Birmingham School of painters, Gere moved to Gloucestershire in 1902, as did a number of others whose work is represented at Cheltenham. They include Gere's sister Margaret, depicted playing tennis on the far left, and Edith and Henry Payne on the right.

and garments; now out of the chaotic skein of countless shops she could choose and pick and mingle her threads in a glow of feminine self-expression'.[47]

Another H.G. Wells character, Margaret Remington, in the novel *The New Machiavelli*, was deemed to share the feminine superiority in her appreciation of form and colour. Mrs Orrinsmith, the married name of Lucy Faulkner who painted tiles for Morris and Company, espoused the female skills in her book, *The Drawing Room*, one of a series of manuals on interior decoration in the series *Art at Home*. The particular skills which she saw as female were 'accuracy of perception' and 'refined judgement as to graceful effects', and among the 'good decorative household work' that could be undertaken were 'instructive and interesting' painted friezes.[48]

The Arts and Crafts Movement encouraged amateurs. Inevitably many were women; if they were financially independent they had time to develop craft skills while if they were not, the crafts provided a socially acceptable way of earning some money. Practical advice was given by Heywood Sumner's article in *Plain Handicrafts* entitled 'How to make stencil-plates and how to use them'. Appealing to the amateur, *The Studio* ran regular competitions and featured stencilled fabrics for decorative wall hangings[49] similar to Cat.184 or the work described by H.G. Wells in his novel, *Ann Veronica*: 'Constance Widgett's abundant copper red hair was bent down over some dimly remunerative work – stencilling in colours upon rough white material'.[50] This type of work, as well as embroidery and small-scale jewellery making, was ideally suited to the amateur female as it could be carried on within the domestic environment. In practice, a wider range of crafts was involved including metalwork: 'The amateur metalworker is practically reduced to what he can do with his hands and the simplest possible tools; that is, to hammered work, chased work and cut work'.[51] Voysey's pen tray (Cat.30) could be cut by hand and needed no soldering. Leatherwork also provided scope for the amateur and much of the work produced both in Britain and America was small scale and ephemeral. Articles in *The Studio* and books such as E. Ellin Carter's *Artistic Leather Work* (she used the book to advertise her 'charming studio in the heart of the West End shopping centre, where she gives lessons in every description of Cut and Relief Work, Staining, Lacquering, and making up Students' own work. Terms: £5 5 o for Twelve Lessons.') and *Artistic Leather Craft* by Herbert Turner in the Pitman craft series in the 1920s provided inspiration for students and amateurs.[52]

Numerous articles, written in an increasingly reverential tone, on individual architects and designers as well as descriptions of their homes or workshops were featured in *The Studio*, the *British Architect*, *Country Life* and other periodicals. The designer as a figure of public interest emerged by the turn of the century, with Baillie Scott and Voysey in particular becoming the young darlings of *The Studio*. Between 1893 and 1903 these two architect-designers contributed or featured centrally in fourteen articles in that periodical. Adulatory articles were also written on others, including Nelson and Edith Dawson at the start of their careers (see p.105).

The cross-fertilisation of design through different media as part of the Arts and Crafts Movement led to a period of intense creativity in the domestic arts and a growing interest in new areas of craftwork. The scale and variety of work produced, its application to both simplicity or splendour, the encouragement given to non-professionals, and the connection with homemaking ensured that its impact was felt by a large number of people. In many ways, however, the Arts and Crafts message was an intensely personal and unprescriptive one, allowing for personal taste but suggesting that design and the home should be seen as part of a complete life. In many ways it is summed up by Lethaby who concluded his essay on 'Cabinet Making' with this statement: 'Should you make all these, with a bookcase which you must yourself design – I think you might buy a nice clock – then, with some flowers in the window, a cat, and good plain things to eat, I am sure you ought to be happy'.[53]

1. Crane, W., 'The English Revival in Decorative Art', *William Morris to Whistler*, London 1911, p.54.
2. Morris, M. (ed.), *The Introductions to the Collected Works of William Morris 1*, London 1910, p.363. (All quotations in this paragraph are from this source.)
3. Morris, W., 'Some Thoughts on the Ornamental Manuscripts of the Middle Ages', c.1892, quoted by Poulson, C. (ed.), *William Morris on Art and Design*, Sheffield 1996, p.142.
4. Baillie Scott, M. H., 'A Small Country House', *The Studio*, Vol.12 1897, p.169.
5. Voysey, C. F. A., *Individuality*, London 1915, p.31.
6. Morris, W., 'The Beauty of Life' (lecture) 1880, Morris, M. (ed.), *Collected Works of William Morris*, London 1914, p.77.
7. Morris, W., 'The Art of the People', 1879, Morris, M. (ed.), *ibid*, p.48.
8. Vallance, A., *The Studio Year Book*, London 1906, p.14.
9. Quoted by Aslet, C. in *The Last Country Houses*, New Haven and London 1982, p.259.
10. Baillie Scott, M. H., 'An Ideal Suburban House', *The Studio*, Vol.4 1894, p.128.
11. Wells, H. G., *Marriage*, London, first published 1912, 1933 edition, p.139.
12. Unpublished and undated letter, Ernest Gimson to Sydney Gimson, 1890, CAGM.
13. Voysey, C. F. A., *Op.cit.*, p.110.
14. Daneway House file, Emery Walker Library, CAGM.
15. Voysey, C. F. A., 'Remarks on Domestic Entrance Halls' in *The Studio*, Vol.21 1901, p.244.
16. Saint, A., *Richard Norman Shaw*, New Haven and London 1976, p.179.
17. Unpublished and undated letter, Ernest Gimson to Sydney Gimson, 1890, CAGM.
18. Voysey, C. F. A., *Individuality*, London 1915, p.109.
19. See *GCF*, p.80.
20. Voysey, C. F. A., *Op.cit.*, p.97.
21. William Morris, letter to Thomas Coglan Horsfall, 11-28 February 1881, quoted by Poulson, C. (ed.), *Op.cit.*, 1996, p.126.
22. Baillie Scott, M. H., 'A Small Country House', *The Studio*, Vol.12 1897, p.168.
23. Vallance, A. 'The Furnishing and Decoration of the House' 5, *Art Journal* 1892, p.311.
24. Unpublished letter from Diana Woolmer to the author, Barnsley file, CAGM.
25. *Country Life*, Vol.6, 30 September 1899, p.389.
26. Baillie Scott, M. H., 'An Ideal Suburban House', *The Studio*, Vol.4 1894, p.129.
27. 'Architects' Craftsmen', *The Architectural Review*, Vol.24 1908, pp.53-62.
28. Unpublished letter, Ernest Gimson to Sydney Gimson, 4 November 1890, ('I have paid 20 pounds to Whitcombe & Priestly today and I am poor again'), CAGM.
29. Unpublished letter, Ernest Gimson to Sarah Gimson, 25 January 1891, CAGM.
30. Gimson, E., 'Plaster-work', in *Plain Handicrafts*, Mackmurdo, A. H. (ed.), London 1892, p.35.
31. Quoted by Haigh, D., *Baillie Scott: The Artistic House*, London 1995, p.73.
32. See *GCF*, pp.62-3.
33. Kruekl, F., 'Leather Embossing as an Artistic Handicraft', *The Studio*, Vol.3 1894, pp.51-4.
34. Wells, H. G., *Marriage*, *Op.cit.*, p.140.
35. Quoted by MacCarthy, F., *The Simple Life: C. R. Ashbee in the Cotswolds*, London 1981, p.95.
36. 'An Interview with C. F. A. Voysey', *The Studio*, Vol.1 1893, p.233.
37. Douglas Home, J., *Violet, The Life and Loves of Violet Gordon Woodhouse*, London 1990, p.65.
38. Hitchmough, W., *C. F. A. Voysey*, London 1995, p.55.
39. Image, S., 'Of Design and of the Study of Nature', in Mackmurdo, A. H. (ed.), *Op.cit.*, pp.1-6.
40. Morris, W., 'The Beauty of Life' (lecture) 1880, Morris, M. (ed.), *Op.cit.*, p.76.
41. This design appears in *The Studio*, Vol.1 1893, p.235. The relevant piece from Carlyle, 'Men are grown mechanical in head and heart, as well as in hand. They have lost faith in individual endeavour, and in natural force of any kind' is quoted by Naylor, G. in *The Arts and Crafts Movement*, London 1971, p.12 .
42. Stamp, G., *Robert Weir Schultz, Architect, and his Work for the Marquesses of Bute*, Mount Stuart 1981, p.29.
43. MacCarthy, F., *The Simple Life*, *Op.cit.*, p.29.
44. Unpublished letter, Sidney Barnsley to Humphrey Gimson, 27 July 1923, CAGM.
45. Unpublished letter, Ernest Gimson to Sydney Gimson, March 1886, CAGM.
46. Unpublished letter, Ernest Gimson to Sydney Gimson, 31 March 1886, CAGM.
47. Wells, H. G., *Marriage*, *Op.cit.*, p.139.
48. Orrinsmith, Mrs, *The Drawing Room*, London 1877, p.9.
49. *The Studio*, Vol.5 1895, pp.181-0.
50. Wells, H. G., *Ann Veronica*, London 1909, 1980 edition, p.27.
51. Blomfield, R., 'On Metal-work', in Mackmurdo, A. H. (ed.), *Op.cit.*, p.37.
52. 'Incised and embossed leatherwork peculiarly fitted to amateurs' in *The Studio*, Vol.6 1895, pp.108-13; Ellin Carter, E., *Artistic Leatherwork*, London & New York 1923; and Herbert Turner, *Artistic Leather Craft*, London 1926.
53. Lethaby, W. R., 'Cabinet making', in Mackmurdo, A. H. (ed.), *Op.cit.*, p.16.

II Defining the Arts and Crafts Movement

This catalogue records and analyses a collection of objects which can loosely be categorised as 'decorative' or 'applied' arts, what Morris called the 'lesser arts' of life.[1] Although such objects have been collected by museums since their inception, defining the boundaries of the decorative arts and their overlaps with 'fine art', with 'design' and with 'social history' remains a subject for discussion among curators and scholars.[2] Decorative art is still very much a museum-based subject, traditionally focused on the interests of collectors and connoisseurs but changing in recent years to reflect new attitudes and ideas raised in the pursuit of design history, an area of study pioneered by the old polytechnics and new universities. Curators in the decorative arts have also embraced methods from other subjects, especially from social history, and new approaches such as material culture studies have invigorated what has always been a very undisciplined discipline.

The furniture in Cheltenham's collections was described in the first volume, *Good Citizen's Furniture*, and so is not included here, though the appendix gives details of items acquired since 1994, providing evidence of the Museum's continued interest in this field and its success in raising grant-aid towards the purchase of increasingly expensive items. The furniture catalogue was relatively self-defining and included everything in the collection of the right period and of sympathetic style and also covered later makers working loosely within a craft tradition. The question of what to include or omit is more complex when dealing with the entire range of the decorative arts because the number of items in the collection is much larger and the size of the book is therefore potentially enormous.

For this reason we have deliberately excluded paintings, prints and drawings from the catalogue, except as illustrations to the text. Many of the designers represented in the collection also worked as painters or illustrators and all were closely associated with artists, but the publication would be too big and complex if all the artworks associated with the Arts and Crafts were included. In many ways this is regrettable, since the Arts and Crafts Movement was dedicated to breaking down the barriers between the arts and the hierarchies which grew out of the Academic tradition in Europe, but it is reasonably easy to make the division between flat 'fine art' and three-dimensional 'decorative art'. In the case of sculpture and carving the definition is less clear, and we have included work by Eric Gill, Alec Miller, Eric Sharpe and William Simmonds which might be considered not to fit here. Are these pieces 'fine art' or 'decorative art'?

Also omitted is the Museum's now extensive collection of books and other publications. This comprises the Max Burrough Collection; Ashendene Press material given by members of the Hornby family; an extensive range of books and papers from Jane Wilgress, the daughter of Alec Miller;

and the priceless resource of the Emery Walker Library, purchased in 1990 (Figs 13 and 14). As well as a wide range of private-press books and important and rare publications, Emery Walker's collection includes rich works by Arts and Crafts binders and many of his books contained notes or inscriptions from major figures in the Movement. The books deserve a catalogue of their own, as does the Museum's Arts and Crafts archive.

A checklist of the Gimson and Barnsley designs and drawings was published in 1984 in a very basic format to accompany a microfilm of the collection.[3] Since that time the archive has grown, for instance through the purchase of Paul Woodroffe's books of watercolours of his stained glass (Fig.15) and by donations of Norman Jewson's scrapbooks, Basil Fairclough's collection of Gordon Russell catalogues (Figs 18a and b), and material relating to Romney Green and Eric Sharpe given by Oliver Morel. In addition, the photograph collections have been more fully listed and increased by gift, and many items connected with the making of craftwork have been acquired. These include tools, patterns, moulds, samples and stencils and are an important resource for those wishing to understand the processes of making. Again, these have had to be omitted because cataloguing them would be an enormous task, but one which could produce another volume in the future or a publication in CD-ROM form.

So what is included here is a collection of the decorative arts which has grown up in Cheltenham partly by accident and partly by design as a complement to the furniture collections. It covers ceramics, dress, glass, jewellery, metalwork, leather, plasterwork and textiles. Cheltenham has a large and varied applied art collection with the kind of curious strengths and weaknesses which are typical of regional museums – the Isher Bequest of pewter, the Berkeley Smith Collection of Chinese ceramics made specially for the Indian and Middle Eastern markets, the groups of scent bottles and Scottish snuff mulls and English eighteenth-century drinking glasses – are all examples of its multifarious riches. The collection of Arts and Crafts furniture, growing in scale and scope over seventy years, is its claim to national and international attention.

Given the importance of the furniture, the Museum's holdings of the smaller applied arts of the Arts and Crafts period are perhaps not as strong as might be expected. Cataloguing for publication in this way reveals what has been missing from the collecting policies of the past as well as showing what has been acquired, sometimes for particular historical reasons in too great abundance.[4] As was discussed in *Good Citizen's Furniture*, the first Arts and Crafts items were acquired for the collection by D. W. Herdman, the Librarian Curator in the 1920s and 1930s, who organised numerous exhibitions of this work but bought only sparingly. His purchases were interesting,

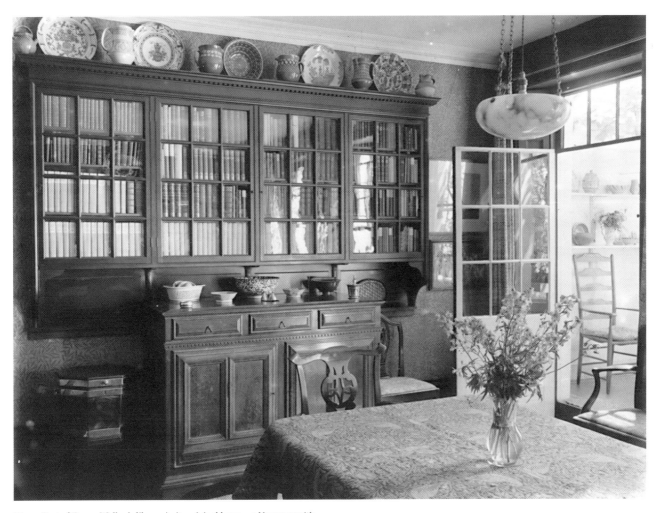

Fig.13 *Part of Emery Walker's library in its original home – 7 Hammersmith Terrace, London.*

and included a humble door handle and a poker as well as a silver cup, but they were few (Cats 75, 77 and 193). H. G. Fletcher, Herdman's successor, acquired a lot of furniture but not a great deal of Arts and Crafts material in other media. For the ceramics collections he purchased large quantities of the then fashionable eighteenth-century blue and white Worcester porcelain, but little Art Pottery or Studio Pottery, then unfashionable and reasonably priced; and he acquired virtually no metalwork or glass or textiles of the Arts and Crafts period. With hindsight this was a missed opportunity, but Fletcher was not alone. At the V&A it was the Circulation Department which collected such material, not the established curatorial departments, and the 1952 *Exhibition of Victorian and Edwardian Decorative Arts* marked the beginning of the rehabilitation of nineteenth-century design within applied art sections in museums.[5] It took a long time however, and when Charles Handley-

Read tried in the late 1960s to find a home for his large and varied private collection of Victorian and Edwardian decorative art, several regional museums turned him down.[6]

More in-depth collecting and documenting of locally-made small-scale work from the 1920s onwards would have made Cheltenham's collection more interesting and valuable to us now. However, curators have always had to balance their desire to provide for a local audience what are considered to be good and representative examples of their type against the longer-term need to preserve for the future whatever the future might discover to be important. The curator, spending public money rather than pursuing individual tastes as a private collector, generally reflects the ideas and values of the time. In the decorative arts the focus continues to be on a story of the 'development' of style, on the roles of selected star designers and makers, and on

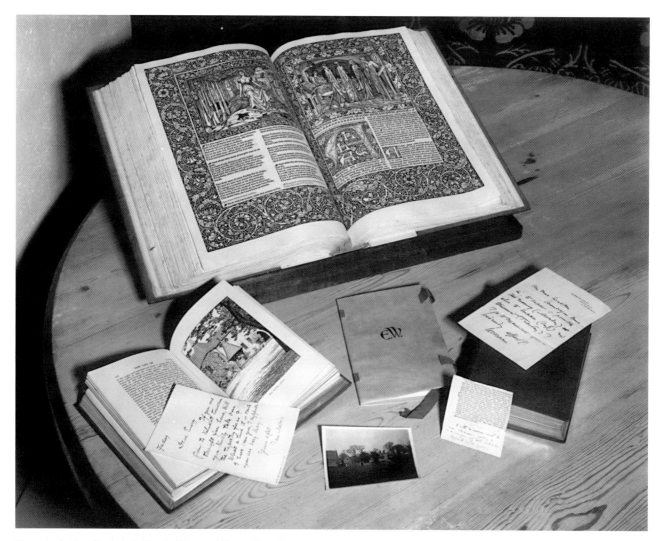

Fig.14 *A selection of books including the Kelmscott 'Chaucer' from the Emery Walker Library, Cheltenham. It also holds letters from Jane and William Morris.*

the outstanding object – the 'museum piece'. As long as 'nationally important' continues to be understood as 'by nationally known artists, designers, or makers', regional museums will never get away from using scarce resources to follow collecting fashions rather than to find local collecting areas for themselves.

From the 1970s considerable additions were made to Cheltenham's collection within a wider range. These included the generous and varied gift of metalwork and jewellery from Mrs Anne Hull Grundy; Gordon Russell glasswares from Mrs Waterson and the Gordon Russell Trust gift of items from Russell's home; Gimson metalwork from the Tangye family; the Summerfield Bequest; and numerous purchases of ceramics and textiles. Given the

logistical problems of storing and displaying furniture, even with exciting new proposals for extensive development of the Museum in Cheltenham, the collection of smaller items is the obvious area in which to expand the Arts and Crafts holdings. The preparation of this catalogue will help in the process of both redefining and reaffirming the collecting policy.

Having decided what media to include here, the next question is how to determine what is and is not Arts and Crafts. Museum collections are usually divided for management purposes into readily recognised categories, normally based on material and date and incidentally into groups of similarly sized objects for sensible storage. Museum cataloguing systems are tools for the retrieval of

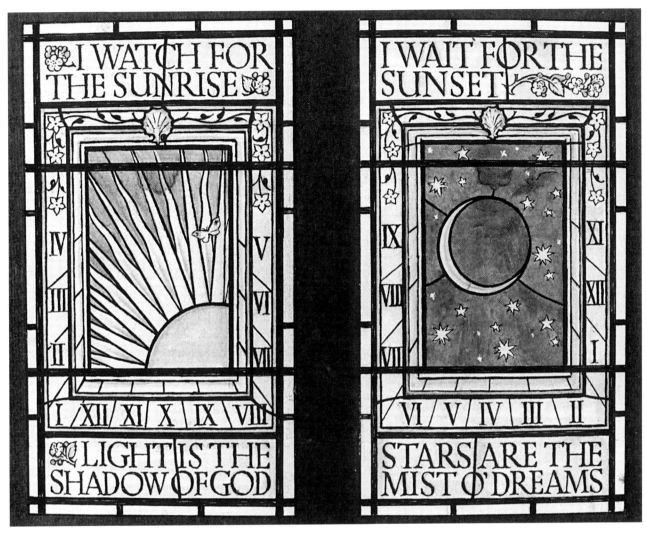

Fig.15 *Designs by Paul Woodroffe for a pair of 'sundial' windows for Campden House, Chipping Campden.*

information, and accuracy of definition is important to enable the speedy identification and location of objects required for study, but it is not absolutely crucial because there are always several ways in which a search can be approached. In the arts, the names of artist, designer and maker are usually given great prominence and a date range can narrow down a search. The names of donors with particular interests also provide a starting point and the curator's knowledge of the collection can give short cuts. A look at the stores is what many researchers need to start their work. Few museums have indexing systems which include 'Arts and Crafts' as a category of information through which a search could be made, but for a published catalogue of this kind some clear guidelines are needed.

Unfortunately it is hard to define the Arts and Crafts succinctly, as the many publications on the Movement in the past thirty years have shown.

In her pioneering and still essential book of 1971, Gillian Naylor described how the term 'Arts and Crafts' was adopted in 1887 as an alternative to 'Combined Arts' by a group of London-based architects, artists and designers who wished to challenge the supremacy of the fine arts at the Royal Academy and hold exhibitions of the decorative arts.7 The name was confirmed in the public mind by the series of exhibitions held by the Arts and Crafts Exhibition Society and by T. J. Cobden-Sanderson's book of 1905, though other contemporary publications refer to the 'Morris Movement', giving credit to the inspirational force

of William Morris.[8] Many designers also contributed to publications of collected 'Arts and Crafts' essays, often derived from lecture series, and to W. R. Lethaby's series of technical handbooks, published by John Hogg from 1903.

By surveying such literature, by seeing the work of these architects and designers in houses, churches and museums, and by reading the recent histories by Naylor, Crawford and others, one can get a good idea of what the Arts and Crafts Movement was about, despite its complexities; but is it possible to find a systematic definition for accurate cataloguing?

It seems to be generally accepted now that the Arts and Crafts Movement, while concerned with standards in architecture and design, was not primarily about style. As Holbrook Jackson put it as early as 1913, surveying *The Eighteen Nineties*, 'The main tendency of the handicraft revival was therefore social when it was not actually Socialistic. It was rarely individual and private after the manner of the old fine arts and the new.'[9] Taking their cue from Morris, even those designers who rejected his socialist views believed that art should be produced within a moral framework which provided guidelines on the roles of designers and makers, on useful labour and useless toil, on the place of decoration in art and architecture. Some designers – Ashbee, Gimson, Wilson – so clearly accepted all of the defining features of the Movement that it is easy to say they were Arts and Crafts figures; others working at the time – Knox, Mackintosh, Silver – rejected elements that were so fundamental that it is difficult to know whether or not to include them, though they are featured in recent accounts of the Movement.

Many of them had work in *The Studio* magazine, first published in 1893. This was by no means a mouthpiece for the Arts and Crafts, however, and it included much that was not connected with the Movement, including numerous reports from Gabriel Mourey in Paris charting with increasing enthusiasm the opening and success of Bing's gallery, *L'Art Nouveau*, and later exhibitions of the New Art in France and Germany.[10] Coverage in *The Studio* cannot, therefore, be seen as a guarantee of a designer's Arts and Crafts credentials.

Is it possible to define the Movement purely by looking at the membership of the societies which played such an important role in it? The list of those who joined the Art Workers' Guild includes almost everyone of note, with the intriguing omissions of M. H. Baillie Scott and William De Morgan.[11] Baillie Scott would seem to have been an archetypal candidate for membership since he was an architect-designer of the kind who played a central role in the Arts and Crafts Movement. Since De Morgan made tiles and the main purpose of the Guild was to provide a meeting place for architects, artists and craftsmen involved in the arts connected with building, his absence is also a

surprise. Few other potters belonged, however, and although De Morgan is generally seen as a fundamental part of the Movement because of his close relationship with Morris's circle, the role of other makers of ceramics is much less clear.

In some ways the place of ceramics was similar to that of textiles and different from those crafts such as woodworking and silversmithing which were still largely workshop-based rather than sited in factories by the mid-nineteenth century. At one extreme were amateurs, embroidering by hand or painting on pottery at home and sending the work to be fired by Howell & James and others. At the other were the large firms such as Morton or Wardle in textiles, and Maw and Pilkington in ceramics, which bought designs from freelance designers and adapted them to industrial production. Some also set up smaller workshops where the decorators had more freedom than in the factory situation, the major example being Doulton's of Lambeth.[12] In addition there were a few people experimenting with the materials and trying to make by hand; Morris's weaving is the obvious example in textiles and Sir Edmund Elton's pottery is a parallel in ceramics. In both cases a considerable outlay for equipment was required and it is not surprising that so few became involved in this kind of work. The production of ceramics also required access to the trade secrets of the potter's craft, which the Martin brothers gained in their early careers, or the enthusiasm for chemistry and physics of Elton, whose privileged social position also gained him entry to the kilns of the Bristol Pottery where he took detailed measurements.[13] Until small-scale kilns were developed around 1920, few were able to take up the production of ceramics, and even in the art schools there was virtually no practical making, as opposed to decorating.

Although Morris lectured in Burslem to ceramics workers, his views on pottery, based on the premise that it should show the nature of the clay and the hand of the potter, were virtually guaranteed not to appeal to the Staffordshire manufacturers.[14] His comments on the need first to influence the customer to ask for the 'right thing' show that he was aware that he was campaigning for change in a huge industry and in a mass market which was accustomed to finely turned, smooth, highly decorated and cheap wares. Ultimately he was suggesting that the customer would have to be prepared to pay more and own less pottery, so that the makers could exercise what he believed to be workmanlike skills. Inevitably, this appealed only to those with similar anti-capitalist views to his own.

The Studio was also highly critical of ceramic manu-facturers, suggesting that they should follow the lead of the makers of wallpapers and textiles in educating the taste of the public by making available the work of modern designers.[15] A typical article provides a discussion between the 'Lay Figure' and the 'Manufacturer', rehearsing the

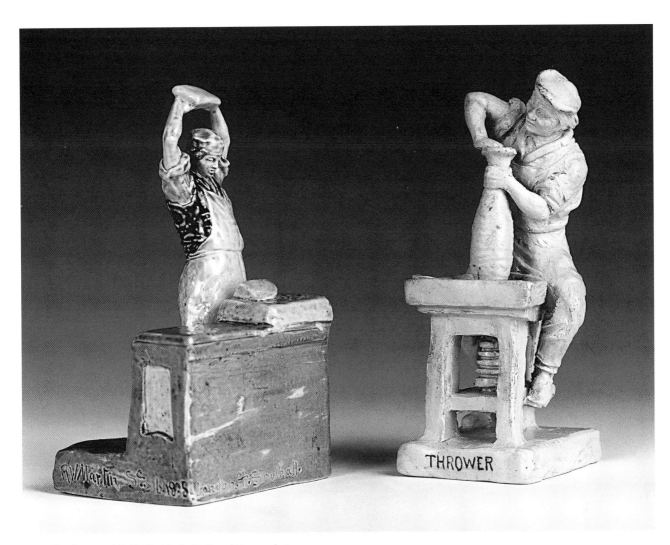

Fig.16 *Two figures modelled by the Martin Brothers, Cats 21 and 26.*

arguments for art on one side and commercial realism on the other which recur throughout the debate on standards of design in British industry. The magazine also took the view on ceramics that the decoration of blanks with painted designs was often attractive but was not using the nature of the material for itself: 'It is high time that the potter should take his position as an Art-craftsman amongst us, and throw off his servitude to the painter-decorator'.[16] This was in the first of numerous articles reporting on the experimental work of French and German potters, most written by Gabriel Mourey, though Gleeson White made similar comments when reviewing work by the Home Arts and Industries Association.[17] They repeatedly called for 'pottery devoid of all line work and decorative ornament, relying for its richness and beauty on the charm of the vitrified material, on the various effects of the fusion on the enamels,

and on the oxydations'.[18] This must have had an influence on those such as W. Howson Taylor and Bernard Moore who began to experiment with glaze effects at the turn of the century, and perhaps provided the climate in which Studio Pottery flourished a little later on.

Interestingly, one of the ceramic decorators who gained the approval of *The Studio* was Marc Louis Solon, the well-known creator of *pâte-sur-pâte* for Minton. Solon's work consisted of highly elaborate figurative schemes on classical shapes, similar in appearance to cameo cutting. It appealed to the magazine because it was an attempt to decorate pottery 'not by mere applied pigment, but in glazes which are absolutely part of the finished product'.[19] Today Solon is not seen as an Arts and Crafts figure, but the fact that he was one of the regular exhibitors of ceramics in the early Arts and Crafts exhibitions suggests either that our

definitions have become too narrow or that inclusion in these displays is not a reliable guide to the status of the work within the Movement. A comprehensive data base of the names of members and exhibitors and their crafts and the frequency of their contributions would be an excellent research tool for all who are interested in the Arts and Crafts, but no one has yet undertaken this mammoth task.[20]

If coverage by *The Studio* and membership of the Art Workers' Guild and the Arts and Crafts Exhibition Society cannot provide clear listings of the people involved in the Arts and Crafts Movement, a definition might be found by looking at the relation of Arts and Crafts to other movements concerned with the same range of work – the Aesthetic Movement, Art Nouveau and Modernism.

The Aesthetic Movement, with its emphasis on 'art for art's sake', was in some ways the complete antithesis of the Arts and Crafts Movement. It did, however, share a concern for the integration of the fine and decorative arts, most famously in the decoration of the Peacock Room of 1877 by Thomas Jeckyll and J. M. Whistler, though this was more of a takeover by fine art than an Arts and Crafts collaboration of architect and artist. The two movements both turned back to earlier periods of design in Britain and found inspiration in Japanese art, producing work which could be richly decorated but was usually more simple in form than accepted mid-Victorian decorative arts. They also shared a few major figures, the most significant being Walter Crane, who was well known in the 1860s and 1870s for his Japanese-influenced book illustrations. Crane got to know Morris, Webb, and De Morgan in the early 1870s and became one of the most active members of the Arts and Crafts Movement, taking a leading role in the formation of the Art Workers' Guild and the Arts and Crafts Exhibition Society.

Crane was also concerned with the reform of Victorian dress, along with Henry Holiday and others, and involved himself from 1893 in the publication of *Aglaia*, the journal of the Healthy and Artistic Dress Union. The story of 'rational dress' is often regarded as an amusing sideline to the history of the arts in late nineteenth-century Britain, but clothing was important as an expression of shared values, as a means of displaying textile craft skills, and as a background to the jewellery produced by the 'artistic jewellery movement'. Its omission from many accounts of the Arts and Crafts Movement is another example of the effects of the accident of survival of work in different media.

Elizabeth Aslin in her book *The Aesthetic Movement*[21] was more concerned to differentiate the Movement from the Art Nouveau style that followed than from the Arts and Crafts, and included many Arts and Crafts figures in her survey. It could be said that the Arts and Crafts Movement was in many ways made possible by the change in taste brought about by the 'Aesthetes', but it is important to remember also the differences between the groups. In particular, the interest in medievalism, and the moral dimension extrapolated from medieval art and architecture by Pugin and Ruskin, were absent from the Aesthetic Movement, which focused on the taste of a small élite and did not question the social issues involved in the production of art and the crafts. In addition, few Aesthetic designers worked from personal knowledge of practical skills and their work does not reflect an interest in the specific qualities of materials, as does Arts and Crafts work.

Art Nouveau is usually considered to be the Continental offspring of the Aesthetic Movement and the Arts and Crafts, arising in the 1890s as aestheticism died away and the Arts and Crafts Movement was at the height of its reputation. Art Nouveau has itself been subject to shifting definition in recent years and rectilinear Viennese and Scottish designs have increasingly been included in books on the subject, but it is in the curvilinear style of French and Belgian Art Nouveau that the earliest overlaps are found. It is probably no coincidence that the Arts and Crafts designers whose work was closest in style to Art Nouveau – Ashbee (Fig.17), Crane and Day – were among the most vociferously opposed to the 'wild and whirling squirms' of the 'contagion' from France.[22] Art Nouveau designers shared with Arts and Crafts enthusiasts a concern for the decorative and useful arts and for the domestic interior within an architectural whole. They also espoused the crafts, producing luxury goods for a wealthy clientele but without the soul-searching of Morris and Ashbee. This closeness of interests and the likelihood of confusion in the public mind must be the reasons why these Arts and Crafts designers felt so threatened.

Lewis F. Day, writing in *The Art Journal* in 1900, embarked on a detailed critique of 'L'Art Nouveau', providing a useful summary of the objections felt in Britain.[23] There is an unmistakable note of chauvinism in his initial account of the spread of the French 'decadency' but his lament about the increasing cosmopolitanism of design is based on principles laid down by Pugin and Ruskin about the expression of national character in art. Day noted the rejection by Art Nouveau designers of tradition and of the accumulated experience of generations of workers, and accused them of 'playing at work'.[24] Art Nouveau designers said they rejected tradition in the search for a modern style for a new age, but were in reality heavily indebted to rococo, while the Arts and Crafts Movement's emphasis on learning from tradition gave it, in the twentieth century, a reputation for being blinkered which it sometimes deserved, but often did not. Interest in gothic design led to enthusiasm for a theory about the social relations which produced that design and a questioning of the social conditions of the workplace, which does not appear to have happened in France and Spain. In Britain the Industrial Revolution had

Figs 17a and 17b *Line drawings of leatherwork designed by C.R. Ashbee and made by the Guild of Handicraft for the Magpie and Stump, London, 1893. This almost Art Nouveau decoration was published in* The Studio, *Vol.12 1897, p.32.*

transformed production in many crafts and industries, whereas on the Continent much was still made in local centres and by traditional means; change engenders debate, as the status quo does not.

In discussing French skills, Day differentiated between those such as the 'artist amateur' potters, and 'designers', who were presumably working in a similar position to himself. Unlike *The Studio* he disapproved of the experiments of the potters, claiming that they were too easily satisfied with accidental effects that betrayed their lack of expertise.[25] His view of the designers was that those 'of this country have less skill …' but '… more originality than their Continental rivals', and he criticised the French for choosing motifs for patterns – flames, smoke, waves, hair, drapery, 'the stalks of abnormal and sapless flowers', worms, reptiles and wriggling things – to fit the fashionable 'contorted lines', rather than to express something about nature.[26] Here is one of the fundamentals of disagreement between the two movements, the one expressing a mood of mystery and decadence through the use of naturally based but composite and imagined images, the other representing nature in a stylised but recognisable form and usually evoking the refreshing effect of nature on the human spirit. The work of Mackmurdo and Image, and to an extent Ashbee, however, adds confusion to this argument since their forms were often far removed from their original source.

Ashbee's use of complex and personal symbolism might also seem to separate him from Day, who criticised what he saw as the pretensions of Art Nouveau design 'to signify something beyond mere finite comprehension'.[27] The symbols in Ashbee's work have been analysed in detail by Crawford[28] but symbolism in the Arts and Crafts in general has perhaps not received as much attention as it deserves, partly because interest in it belonged to an early phase of the Movement and it was overlaid by the robust 'common sense' approach of later writings. Lethaby in particular, although himself always interested in the most complex and obscure symbols, had a major influence on attitudes to functionalism in design through his down-to-earth view that art is 'the well-doing of what needs doing'.[29]

Just as the two concurrent movements, Arts and Crafts and Art Nouveau, shared concerns, so did the Arts and Crafts with the movement that followed, Modernism. When Pevsner and others claimed Voysey as a pioneer of the Modern Movement he strongly rejected the idea, just as some modernists looked with horror at the traditional materials and decorative designs of their Arts and Crafts predecessors. Common interests, however, are undeniably present. Paul Greenhalgh's book, *Modernism in Design*, provides a useful checklist of twelve principles of the movement which helps in making comparisons.[30] Of these, half were derived from the Arts and Crafts Movement.

The first theoretical feature of Modernism as defined by Greenhalgh is decompartmentalisation, the breaking down of 'barriers between aesthetics, technics and society'[31] so that the best possible design could be produced for the mass of the population. Such interest in the population as a whole, rather than those of an élite who had hitherto been the consumers of art and design, indicates a concern for social morality, and in turn leads on to the idea of good design being socially improving. Truth to the way an object had been made or to the materials of its construction was considered an essential, and the 'successful functioning of all designed produce was deemed of great importance'.[32] Adherence to these principles would bring about a 'transformation of consciousness', improving the lives of the users of designed goods, and this belief among the pioneers of Modernism can be seen as an almost theological quest. All these ideas can be closely related to the concerns of Arts and Crafts designers.

Of the remainder in Greenhalgh's list, the concept of the 'total work of art', the *gesamtkunstwerk*, is shared but somewhat different in the two movements. The Arts and Crafts building or interior was more often achieved through the collaboration of architect and several craftspeople rather than being the creation of a single designer. In this the modernists were much closer to Art Nouveau figures such as Horta and Guimard, but there is some overlap of interests.

Where the Modern Movement departed from the Arts and Crafts Movement was in its rejection of traditional craft skills and its embracing of technology, with the goal of making well-designed products affordable. Mass production and standardisation were seen as the means of supplying good design to all, and Morris's attempts to change the role of the worker were rejected. In this the modernists were helped by their belief in the concept of progress, in their optimism about the twentieth century, whereas the questioning by Arts and Crafts designers of changes in the nineteenth century was often gloomy and pessimistic. Confidence about the present led modernists to reject much of the past, including historical styles of ornament. The combination of interest in function, use of technology, and anti-historicism resulted in the adoption of abstraction, and again this was totally contrary to the ideas of the Arts and Crafts Movement, which favoured figurative and symbolic elements in design. Finally, whereas a belief in internationalism characterised the Modern Movement, helped by the move to abstraction and away from forms with particular cultural references, Arts and Crafts ideology favoured the local and national, though not exclusively, as can be seen from the disparate foreign influences in the work of such designers as Ashbee, Gimson and Wilson.

These definitions are not completely clear-cut. Individuals within each movement formed their own sets of beliefs

Fig.18a *Promotional leaflet, c.1940. Part of the collection of Gordon Russell Ltd catalogues and printed ephemera in the Arts and Crafts archive at Cheltenham.*

according to their personal interests but within certain parameters which allowed them to find common cause with others. A few, such as Gordon Russell, moved on from an interest in the Arts and Crafts to an acceptance of the commercial necessity of new design in the changing conditions of the late 1920s and early 1930s, and modernist products of his firm have been included here. In each movement there were also some who thought deeply about their principles and others who simply latched on to an attractive style. There is probably less common ground between the Aesthetic Movement and Art Nouveau and Arts and Crafts than there is between Arts and Crafts and Modernism, because the two later groups worked towards the democratisation of the arts, but the gap between them is still large.

Having compared the principles of four design

SPRING
is
on the way

GREET IT
with a little refurnishing

HERE ARE SUGGESTIONS FROM
GORDON
RUSSELL
LTD

BROADWAY, WORCESTERSHIRE
AND 40 WIGMORE STREET, W.1

If undelivered please return to Broadway, Worcestershire

Fig.18b *A printed envelope, late 1930s. Part of the collection of Gordon Russell Ltd catalogues and printed ephemera in the Arts and Crafts archive at Cheltenham.*

movements of the nineteenth and twentieth centuries, it is possible to compile a checklist of features of the Arts and Crafts Movement. This must include: the desire to break down barriers between architecture, art, design, and making; interest in the whole building and its interior; concern for the working life of the maker; truth to materials and the methods of production and, by extension, enjoyment of these; acceptance of technology for certain tasks but rejection of it for its own sake; emphasis on the function and fitness for purpose of objects; use of historical exemplars for inspiration; looking to nature for inspiration; interest in symbolic meaning; regard for the variety of local and national styles; belief in the importance of art and design for society as a whole and a campaigning zeal to persuade others of this. All of these ideas can be found in the objects included in this catalogue.

1. 'The Lesser Arts' was Morris's first lecture in 1877, originally entitled 'The Decorative Arts'. It was published as a pamphlet and reprinted in Morris, M. (ed.), *The Collected Works of William Morris*, London 1914, Vol.XXII, pp.3-27.
2. For a survey of the range of issues, see Wolfenden, I., Introduction to Re-Thinking the Decorative Arts?, *Bulletin of the John Rylands University Library of Manchester*, Vol.77, No.1, 1995, pp.5-12.
3. Carruthers, A., *Gimson and Barnsley: Designs and Drawings in Cheltenham Art Gallery and Museums*, Cheltenham 1984.
4. For example, the furniture catalogue showed how over-represented is the work of Peter Waals in Cheltenham's collection, as it is also in Leicester. This is partly because the owners did not usually have as strong personal links to it as did the owners of Gimson's work.
5. Victoria & Albert Museum, *Exhibition of Victorian and Edwardian Decorative Arts*, London 1952. Several social history museums had popular Victorian room displays by this date but few decorative art curators were collecting in this area.
6. See Wainwright, C., 'Tell me what you like, and I'll tell you what you are', in Fischer Fine Art, *Truth, Beauty and Design: Victorian, Edwardian and Later Decorative Art*, London 1986, p.13.
7. Naylor, G., *The Arts and Crafts Movement*, London 1971; and Naylor, G., 'Formative Years of the Arts and Crafts Exhibition Society: 1888-1916', *Craft History One*, Bath 1988, pp.1-7.
8. Cobden-Sanderson, T. J., *The Arts and Crafts Movement*, London 1905; e.g. Anon., *A brief sketch of the Morris Movement and of the Firm founded by William Morris to carry out his designs and the industries revived or started by him*, privately printed 1911.
9. Jackson, H., *The Eighteen Nineties*, London 1913, p.303.
10. Mourey, G., *The Studio*, Vol.7 1896, pp.51-2, Vol.10 1897, pp.123-4, Vol.13 1898, pp.83-91, Vol.20 1900, p.164; Anon., *The Studio*, Vol.20 1900, pp.129-30.
11. For a list of members see Brighton Museum, *Beauty's Awakening: The Centenary Exhibition of The Art Workers Guild 1884-1984*, Brighton 1984, pp.50-64.
12. Morris & Company's embroidery department could perhaps be seen as the textile equivalent.
13. See Haslam, M., *Elton Ware*, Ilminster 1989, pp.34-5.
14. See 'The Lesser Arts of Life' in Morris, W., *Hopes and Fears for Art*, London 1882.
15. *The Studio*, Vol.14 1898, p.224.
16. *The Studio*, Vol.3 1894, p.181.
17. Mourey, G., *The Studio*, Vol.10 1897, pp.123-4, Vol.12 1898, pp.113-18, Vol.13 1898, pp.83-91; Gleeson White, J., *The Studio*, Vol.8 1896, pp.91-101.
18. *The Studio*, Vol.14 1898, p.118.
19. *The Studio*, Vol.9 1897, p.268.
20. The Arts and Crafts Exhibition Society Collection is at the V&A Archive of Art and Design, Blythe Road, London, Cat.AAD/1980/1.
21. Aslin, E., *The Aesthetic Movement: Prelude to Art Nouveau*, London 1969.
22. Crane, W., *Ideals in Art*, London 1905, p.128; Day, L.F., 'L'Art Nouveau', *The Art Journal*, No.190, Oct.1900, p.293.
23. Day, L.F., *ibid*, pp.293-7.
24. *Ibid*, p.294.
25. *Ibid*, p.295.
26. *Ibid*, p.293.
27. *Ibid*, p.294.
28. Crawford, A., *C.R. Ashbee: Architect, Designer & Romantic Socialist*, London 1985, pp.221-31.
29. Lethaby, W.R., *Form in Civilization*, London 1922, p.166.
30. Greenhalgh, P., 'Introduction', in Greenhalgh, P. (ed.), *Modernism in Design*, London 1990, pp.1-24.
31. *Ibid*, p.8.
32. *Ibid*, p.10.

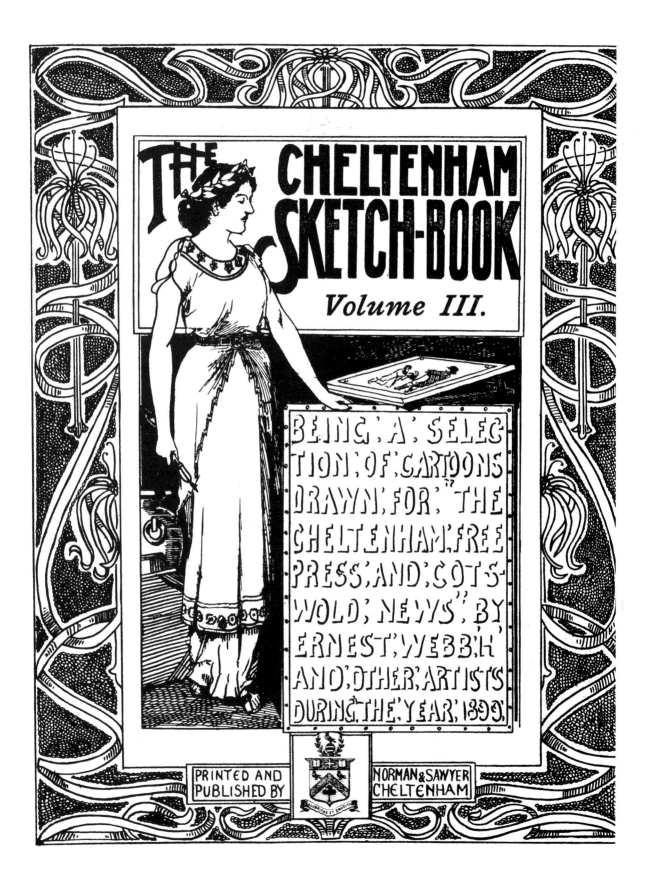

III Artistically attired: Arts and Crafts dress and jewellery

Although the collections in Cheltenham contain only a few examples of aesthetic dress, it is useful to look at this alternative style which was worn by a number of Arts and Crafts designers and their associates. It also helps to set the scene for Arts and Crafts jewellery which is well represented in the collections. During the nineteenth century several forms of anti-fashion emerged which shared their roots in the Aesthetic Movement and the work of the Pre-Raphaelite painters. They can all be loosely grouped under the term 'aesthetic dress'.

The Aesthetic Movement, which affected all aspects of art and design, was concerned with encouraging an appreciation of art and an understanding of what was beautiful. It was not an organised grouping like the Pre-Raphaelite Brotherhood, rather artists and designers who were sympathetic to the Movement applied shared ideas of beauty to their work. Walter Hamilton noted in his book, *The Aesthetic Movement in England*, published in 1882, '… the essence of the movement is the union of persons of cultivated taste to decide and define upon what is to be admired'.[1] In designing dress, the Movement's followers, such as the artist Walter Crane, drew upon classical and Greek sources because they felt that clothes worn during these times showed a true understanding of the human figure. These influences are evident in the figures in classical dress designed by Crane for a set of doilies (Cat.2).

The Pre-Raphaelite Brotherhood – William Holman Hunt, Dante Gabriel Rossetti and John Everett Millais, and their followers – were keen to represent a true picture of nature, something they felt had been lost in contemporary nineteenth-century painting. To accomplish this they aimed to re-create the style and approach of painters before Raphael, hence their name. Using references such as Camille Bonnard's *Costume Historique*, which illustrated dress from the thirteenth to the fifteenth centuries, they often had dresses and gowns made in these period styles for their models to wear. Rossetti's painting, *Marigolds* (Fig.20), of 1873/4 shows Annie, one of the servants at Kelmscott Manor, wearing a waisted dress with an apron and velvet hood, all reminiscent of medieval clothing.

Pre-Raphaelite dress developed as the complete antithesis to conventional fashions of the 1850s, mainly because these garments, particularly women's, distorted the natural figure. Corsets were worn, often laced too tightly, to achieve a tiny waist. The artist and dress reformer Henry Holiday referred to the corset as a 'crime against the law of beauty'.[2] A small waist was imperative to fashionable women and many would go to great lengths to achieve this. Doctors had expressed concerns about the effects of tightly-laced corsets on women's health as early as 1832, but little notice was taken until the last decades of the century. Full skirts required numerous petticoats to hold them out and bodice sleeves were cut below the shoulder, making it difficult for

Fig.20 'Marigolds', by D. G. Rossetti, 1873/4.

Fig.19 OPPOSITE *Drawing by Ernest Webb illustrating the widespread association of classical dress with artistic styles, published in* The Cheltenham Sketch-Book, *Volume III 1900.*

women to lift their arms. The weight of women's clothing, which could be more than three kilograms compared to an average of one-and-a-half kilograms for today, also impeded their freedom of movement.[3] In 1856 the cage crinoline was invented to support the enormous fashionable skirts. It helped to alleviate some of the weight of women's clothing (Fig.21). However, because the crinoline was so large and impractical, moving around and sitting down became a challenge. Aggie Burne-Jones 'complained that her crinoline would not fit into the little bedroom'.[4]

In contrast to this uncomfortable and awkward style of dress, the Pre-Raphaelites and their associates wore clothes which were compatible to the figure and gave maximum freedom of movement by dispensing with all the above

Fig.22 *'Elizabeth Siddal', by D. G. Rossetti, 1854.*

Fig.21 OPPOSITE *Fashion Plate: 'Petit Courrier des Dames', 3 July 1858, showing conventionally fashionable clothing of the day.*

contraptions and many layers of underwear. Sometimes the changes were quite subtle, simply being a more comfortable version of conventional Victorian dress, and in other cases they were obviously different, taking the form of a medieval A-line gown or waisted classical robe which both looked odd to Victorian eyes (Fig.22).

Men's attire was criticised in artistic circles but more for being unimaginative, especially in the use of colour. Aesthetes also argued that some garments disguised the body's natural beauty. For example they were opposed to trousers and suggested breeches should be worn so that the shape of men's legs could be fully appreciated.

Specific fabrics were used to make artistic clothes. These were much softer and lighter than the fashionable taffetas and moiré silks. Unbleached holland, which is a coarse linen, fine cottons such as cambric, poplin and muslin, velveteens and lightweight silks, including tussore made from the cocoons of wild silkworms, were particularly popular.[5] One of the main suppliers of these fabrics was Liberty & Company. Some of their materials were made in this country, for example 'thetis' brocade, which was described as an artistic fabric specifically for mourning, was probably produced at Spitalfields. Others, including fine silks and woollens, were imported from Asia and created specially for Liberty, such as the Umritza cashmere which was advertised in their catalogue of *Art Fabrics* in 1883 as 'soft, light and warm and the colours are all that the most aesthetic and artistic devotees could desire'.[6]

These colours were in subdued tones achieved by using vegetable dyes, in contrast to the bright and garish fashionable colours created with recently invented chemical dyes. Gentle greens, blues and browns and pale golden yellows were most common, as suggested in a satirical but accurate report in *Punch* in 1876: 'Among other extraordinary mélanges of colour, we saw stone and green, grey and violet, bronze and moss green … the mixture of bronze and green might suggest the introduction of a costume which shall imitate the tints of beans and bacon'.[7] Decoration on clothing was kept to a minimum. Traditional techniques such as smocking, hand embroidery and appliqué were revived. Both the Liberty cloak (Cat.134) and child's dress (Cat.140) have appliqué motifs. As well as being decorative, smocking gave additional movement to the bodice and sleeves, and by the 1880s it was also being used in conventional dress.

Most women who wore aesthetic dress were accomplished seamstresses as sewing was an enforced part of a woman's education during the Victorian period. It was also a necessity for women who could not afford to have clothing and linens made. Both Jane Morris and Elizabeth Siddal made their own clothes and some of the dresses in which they modelled.[8] There was a certain amount of snobbery attached to employing a dressmaker

Fig.23 *Jane Morris seated on a divan, 1865.*

while making one's own clothes implied one could not afford to do otherwise. This may have contributed to the decision taken by some 'artistic' women to find dressmakers who were sympathetic to the aesthetic style. The actress Ellen Terry was a client of Mrs Nettleship who had a successful dressmaking business at 58 Wigmore Street, London, where she employed a team of staff including skirt-girls, pin-girls and embroideresses. The jeweller Edith Dawson bought some of her clothes from Madame Forma who had a workshop on Bond Street and was well known for her artistic gowns with embroidered detail.[9] From 1884 it was possible to buy an aesthetic dress to order from Liberty. A new department was established under the directorship of the architect, Edward Godwin, who made an important contribution to aesthetic dress through his designs for theatrical costumes.

As with other new developments in Victorian fashion and society, the aesthetes received scathing ridicule from the press for their lifestyle and dress. From about 1873 to 1882, the critic George du Maurier ran a series of cartoons in *Punch* depicting various aspects of the aesthetes' views on life. There were illustrations of empowered women in loose-fitting gowns and submissive men in knee breeches, which were obviously exaggerating the growing demand for equal rights for women, something which terrified a male-dominated society. These scenes were usually set in aesthetic interiors which included lacquered furniture, Japanese blue and white china, peacock feathers and sunflowers.

In spite of being ridiculed, aesthetic dress played an important role in the dress reform movement. People were encouraged to think about what they wore in the context of their health. Various organisations such as the Rational Dress Society and the Healthy and Artistic Dress Union were established to discuss and promote issues about dress, health and beauty. Through publications and exhibitions these groups promoted their views and in 1883 the Rational Dress Society held an exhibition showing outfits which were both fashionable and comfortable. Towards the end of the nineteenth century, more women were leading more independent lives as it became easier for them to further their education and pursue a career. A greater interest in health led to women taking part in more sports such as cycling. Naturally these factors had an effect on women's clothing as fashions of the 1900s indicate with the introduction of the more practical jacket, blouse and skirt.

Among the first to wear aesthetic dress were some of the Pre-Raphaelites, their friends and models, notably the Morris family, the Burne-Joneses, and Elizabeth Siddal, painter, poet and model, and eventually Mrs Rossetti. Elizabeth Siddal, Jane Morris and Georgie Burne-Jones all wore loose-fitting artistic dresses. William Morris was described as being careless and untidy in his dress; he wore

Fig.24 *Pamela Wyndham, later Lady Glenconner, a member of the Souls and a noted needlewoman, about 1890.*

soft collared shirts rather than stiff white collars and seldom wore a necktie. Rossetti was probably the most conventional dresser of the group, he wore high-cut waistcoats, a frock coat and cape coat. Edward Burne-Jones remembered Rossetti in his studio wearing a 'long flannel gown over a plum-coloured frock coat …'.[10] Aesthetic dress provided a fairly wide circle of people with an avenue for self-expression and a reflection of an artistic lifestyle. It was worn by artists, designers, actors, and writers as well as aristocrats who were interested in the arts, for example the Souls. The Souls, who had connections with the Pre-Raphaelites and some Arts and Crafts designers, included Mrs Percy Wyndham, and her daughter Lady Elcho, who was based at Stanway House, Gloucestershire, Lady Desborough of Taplow Court, Buckinghamshire, and the Duchess of Rutland. Both the Duchess of Rutland and Mrs Percy Wyndham were artists, while Lady Elcho and Lady Desborough were renowned for their grand parties. Other people, for example Jeanette Marshall, adopted an artistic style of dress because they found conventional fashions too

THE HEIGHT OF ÆSTHETIC EXCLUSIVENESS.

Mamma. "WHO ARE THOSE EXTRAORDINARY-LOOKING CHILDREN?"
Effie. "THE CIMABUE BROWNS, MAMMA. THEY'RE *ÆSTHETIC*, YOU KNOW!"
Mamma. "SO I SHOULD IMAGINE. DO YOU KNOW THEM TO SPEAK TO?"
Effie. "OH *DEAR* NO, MAMMA—THEY'RE MOST *EXCLUSIVE*. WHY, THEY PUT OUT THEIR TONGUES AT US IF WE ONLY *LOOK* AT THEM!"

Fig.25 *George du Maurier, 'The Height of Aesthetic Exclusiveness'*, Punch,
1 November 1879.

expensive. She was aware of the Pre-Raphaelites through her father who was doctor to Ford Madox Brown and Rossetti, among others. Even though she was critical of the aesthetes, she was influenced by their approach to dress and remarked in her diary on 11 May 1883, 'as we cannot do the ultra fashionable we'll be artistic at any rate'.[11]

The Arts and Crafts designers, Ernest Gimson, Ernest and Sidney Barnsley and their families, wore a softer, countrified style of fashionable dress, as photographs of about 1900 show (Fig.26). In one of the photographs Sidney Barnsley is wearing breeches, which in addition to being usual country clothing of this time were also favoured by aesthetic dressers. Norman Jewson, Gimson's architectural assistant from 1907, described Gimson's normal attire: 'His tweed suit hung loosely on him over a soft shirt and collar, with a silk tie threaded through a ring. Being summer he wore a

panama hat instead of a cloth cap, but in all seasons he wore hobnailed boots, made for him by a cobbler at Chalford.'[12]

Many Arts and Crafts designers were unconventional in their clothes. In the Cotswolds, the designer Louise Powell is remembered as wearing her own style of peasant dress, a simple low-waisted shift, and never dressing for dinner.[13] Janet Ashbee was noted for her practical approach to dress and gave up wearing a corset regularly after her marriage to Ashbee.[14] In Chipping Campden she was often seen in 'a tunic and sandals, her hair kept short to save trouble ...'.[15] However, a photograph of late 1900, taken in Chicago, shows Janet wearing the buckle (Cat.35) and other examples of Guild of Handicraft jewellery with a conventional skirt and blouse, and probably a corset, though not tightly laced. No doubt she was dressed like this because she was travelling with her mother-in-law as well as her

Fig.26 *The Barnsley family outside Ernest Barnsley's house, c.1900.*

husband who was on a lecture tour of the United States
to raise funds for the National Trust. Ashbee also took an
interest in clothing and enjoyed dressing up for theatricals
but for most of the time he wore 'a Norfolk jacket with
knickerbockers, woollen socks and good stout boots'.[16]
Janet Ashbee's close friend Gwendolen Bishop, a talented
amateur actress, was described as wearing loose flowing
artistic clothing.[17] The two women had met at a meeting
on dress reform and by 1906 both were on the committee
of the Healthy and Artistic Dress Union.

Some Arts and Crafts designers wore or collected smocks.
Ernest Gimson owned one, now in the collections of
Owlpen Manor, Gloucestershire, but there is no evidence
of him wearing it. It seems more likely that he bought the
smock because of his interest in rural life and embroidery.
He designed embroidery for textiles which his sisters,

Margaret and Sarah, and others executed. At Chipping
Campden, Paul Woodroffe, the stained-glass artist, wore a
Surrey shepherd's smock which was given to Cheltenham
Art Gallery and Museums in 1936, and both Alec Miller and
his wife wore smocks for work (Fig.30).

Photographs of the jewellers Arthur and Georgie Gaskin
and their children, taken by William Smedley Aston of
Birmingham in about 1900-13, show them wearing a form
of aesthetic dress. Georgie wears a medieval-style gown
with sleeves made from William Morris's *Lea* fabric and
a necklace she had designed. Arthur was photographed in
breeches while their children appear in shapeless dresses
(Figs 27 and 28). Although posed photographs, they give an
indication of the Gaskins' taste in clothing which was far
from conventional. Children of conventionally fashionable
parents wore clothes which echoed adult styles, although

a break away from this practice was emerging which the aesthetes encouraged by their more practical approach to clothing.

When Phyllis Barron and Dorothy Larcher, two of the leading block printers of the early twentieth century, moved to Gloucestershire, they were noted for their individual style of dress. For their customers they produced a range of printed and woven dress fabrics and had some ready-made garments available (Fig.162). They both wore clothes which they created from their own fabrics. The etcher Robin Tanner described their dress after a visit:

That morning she (Phyllis) was dressed in a long linen garment printed in one of her favourite designs which she called 'Guinea', in the galled iron black she was so fond of…. And all down the front were old gold silver buttons. She was wearing men's brogues…. Dorothy wore cotton printed in iron rust in her own design called 'Old Flower', the very first she ever cut…. (She) was a most distinguished embroideress. I observed at once the immaculate stitchery and the embroidered collar and cuffs of her dress, and the amber cut glass buttons chosen with perfect appropriateness….[18]

Changes in fashion contributed to new developments in jewellery. This was noted by *The Watchmaker, Jeweller and Silversmith* in 1886, which reported: 'The rage for aesthetic colours in dress fabrics is also producing a demand for soft coloured stones such as peridot, tourmaline….'[19] There was also a growing trend in jewellery for the luxury market of setting diamonds with pale stones, such as moonstones, opals and pearls. Diamonds had been much in use from the mid-1870s after the discovery of the South African mines in 1867.

Jewellery of the Victorian period can be divided roughly into three different levels. These were chiefly defined by cost and therefore acted as a means of displaying wealth and status. Rules about what should be worn and when existed for all levels. The most expensive jewellery, available only to the wealthy, included pieces made from diamonds and gems set in precious metals such as gold. For formal evening functions wealthy women would have worn a full parure, a set of matching jewellery comprising a tiara, necklace, earrings and bracelets. Jewellery made from semi-precious stones, pastes and set in less expensive metals like pinchbeck or silver were popular. For those less well off there was an increasing amount of manufactured jewellery on the market, including numerous types of brooches inspired by sporting motifs, flowers and animals, which were described by C. R. Ashbee as 'cracker toys'.[20]

As might be expected, Queen Victoria set the trend for wearing particular kinds of jewellery. Her passion for Scotland secured a market for brooches, necklaces and bracelets with polished pebbles set in silver, while her predilection for cameo jewellery ensured its popularity. At the Paris *Exposition* of 1878 the jeweller Alessandro

Fig.27 *Arthur and Margaret Gaskin, photographed by William Smedley Aston, c.1903.*

Fig.28 OPPOSITE *Georgie Gaskin, photographed by William Smedley Aston, c.1903.*

Castellani defined three types which would have been among the most exclusive and expensive: these were Scottish, sumptuous jewels of gold and Italian ancient jewellery.[21] In addition to Queen Victoria's influences, the greater ease of travel led to more people bringing back souvenirs such as cameos, mosaics and lava jewellery from Italy. This fashion for Italian jewellery was fostered by Alessandro Castellani and Carlo Giuliano who attracted clients with an interest in the arts, including some aesthetes, with their copies of Etruscan jewels.

Women who wanted to wear jewellery which was less conspicuous and which complemented their artistic attire found it harder to find suitable pieces. Photographs show them wearing single strings of beads such as amber, long chains inspired by medieval jewellery, and brooches and buckles which tended to be functional as well as decorative. In 1881 a writer in *Queen* noted that 'amber is as pretty as coral and even more fashionable with those who dress artistically.... The oriental cornelian is the most beautiful and best ... the finest comes from India and Arabia. It is not expensive being out of fashion except with some few artistic persons'.[22] Indian jewellery also appealed because of its handmade qualities and in 1886 there was an exhibition of Indian jewellery at the South Kensington Museum. Some years later, in about 1894, Indian silver pieces were available for sale at Liberty. Also in 1881, *Queen* published an article about making jewellery from home-dried and dyed marrow fat peas, melon seeds, berries, lacquer beads, shells and glass beads, indicating that people were making jewellery at home.[23] There are a number of reasons why women would have made their own jewellery, one being affordability and another not finding what they wanted commercially. The ease of carrying out this particular craft at home would have encouraged them too. Some women became quite skilled and exhibited their work at the Arts and Crafts Exhibition Society shows, which in addition to providing an outlet for professional craftspeople, also opened the doors to keen amateurs. The catalogues for these exhibitions show a significant number of entries by unknown people for textiles and jewellery. These might have been students attending evening classes offered by art schools, for example the Central School of Arts and Crafts in London, or by those who worked at home, either for pleasure or to make a small income.[24]

In 1899, May Morris entered ten necklaces and two rings to the Arts and Crafts Exhibition Society. She probably began making jewellery when she started teaching embroidery at the Central School of Arts and Crafts in 1897, where she would have had direct access to the necessary equipment. She also had a collection of European peasant jewellery, the influence of which shows in her work. Other designers who were represented in 1899 include Nelson Dawson, Arthur and Georgina Gaskin, Henry Wilson and

C. R. Ashbee. Interestingly none was trained as a jeweller: Nelson and Edith Dawson and the Gaskins were fine artists while Wilson and Ashbee had trained as architects. This was symptomatic of many Arts and Crafts designers who applied their design skills to various media in which they had an interest or saw a need for improvement. This was carried further through the establishment of schools and guilds for teaching students. C. R. Ashbee's School of Handicraft offered goldsmithing and silversmithing from 1891 partly because Ashbee had been presented with a collection of gems for this very purpose by one of his Gloucestershire clients, Abraham Booth. The collection included finely-cut cameos and examples of amber with preserved insects and plant forms.

C. R. Ashbee was one of the first to design jewellery and he established many of the characteristics of the Arts and Crafts style which are apparent in the work of those who followed. As with other media, the Renaissance provided a valuable source of inspiration for him. Ashbee was especially interested in fifteenth-century Italy because he saw it as a period when jewellery was appreciated as an art. It was also a time when jewellery was designed as part of an outfit, an approach he thought important and which had been lost during the Victorian period. He was particularly influenced by Benvenuto Cellini, whose manuscript on goldsmithing and sculpture, *I Trattati dell'oreficeria e della scultura* was translated and published by the Essex House Press in 1898 for use as a practical handbook by metal-workers at the Guild of Handicraft. A copy was also available at the Birmingham Municipal School of Art.

Many of the stylistic qualities and motifs used by Arts and Crafts designers derived from the Renaissance, for example, the chain and pendant style necklace employed by Henry Wilson, the Gaskins and Omar Ramsden (Cats 67, 106 and 149). One of the most popular sources of imagery for Arts and Crafts designers was nature, especially plants and some animals, particularly birds and fish. These provided the basis for both the shape and decoration of pieces. Edith and Nelson Dawson were recorded as going 'to the country for their forms just as they did (and do) for subjects in the watercolour days'.[25] Most of the Gaskins's designs were based on flowers, as the examples in Cheltenham's collections illustrate (Cats 105-9), while Edgar Simpson's buckle (Cat.142) takes the form of two fishes joined by their heads and tails.

The careful choice of stones and settings which complemented one another gave a unity of form and colour to Arts and Crafts jewellery. The use of soft-coloured stones such as pearls, moonstones and opals, a limited combination of colours and simple forms inspired by nature, resulted in subtle pieces such as Ashbee's necklace of about 1902 (Cat.41) with its use of mother-of-pearl and dark green chrysoprases. They were often easy to wear

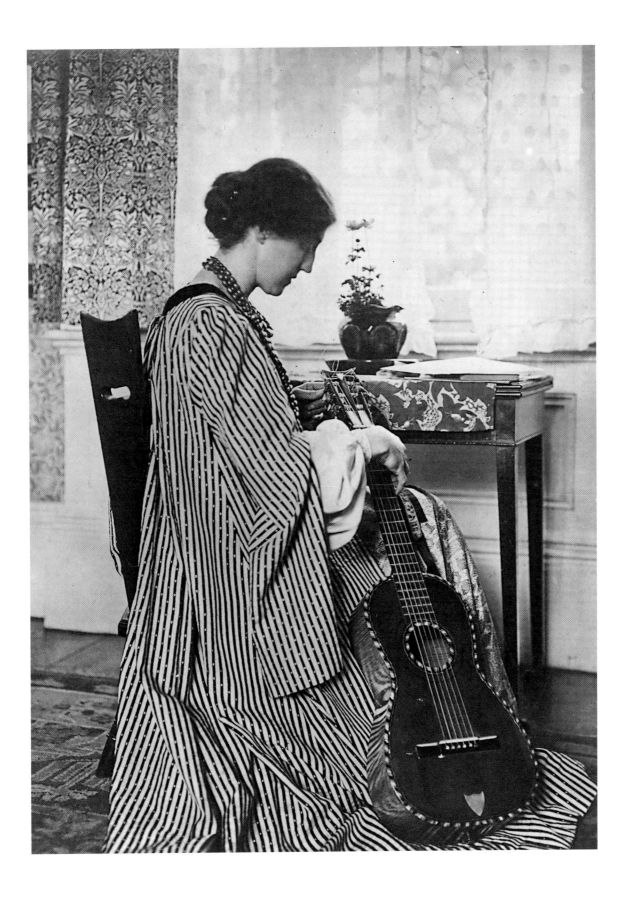

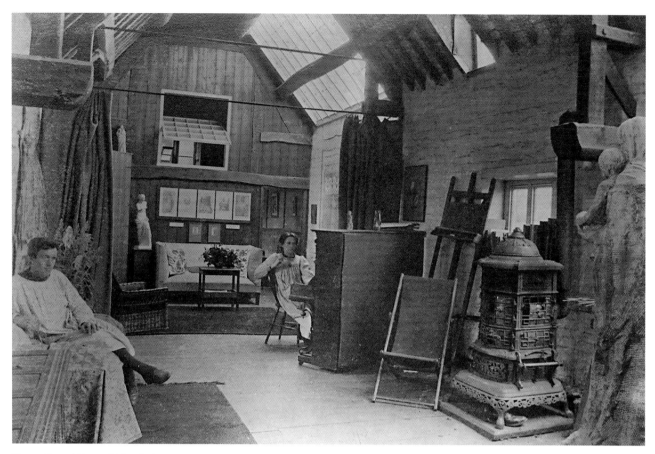

Fig.30 *Alec and Eleanor Bishop, both wearing smocks, in their home at Chipping Campden, c.1910. The house, known as 'The Studio', had been converted from a malt barn by C.R. Ashbee.*

because of their simplicity, particularly with artistic dress. The natural beauty of the stones was also important. Usually these were cabochon-cut, leaving the surface of the stone smooth, although designers did use facet-cut stones as well.

Settings were carefully considered and designed as an integral part of the jewel, unlike the trend in commercial Victorian jewellery which tended to swamp the setting with the use of large stones. It was an area in which craft skills could be shown off. In 1901 Edward Strange wrote, '… in Mr Dawson's rings and pendants, the beautiful metal which frames his jewels or enamels is always treated with conspicuous dignity as a worthy element in the composition; and it repays the craftsman accordingly'.[26] Most settings were made of silver because it was cheaper to use than gold. Arts and Crafts designers preferred their work to be affordable to a wide clientele. This might explain why so many brooches, buckles and buttons were produced in addition to the popular pendant necklaces. In addition pieces were sometimes made on an experimental basis, particularly at Ashbee's Guild of Handicraft. The choice of silver also reflected the influence of Indian and European peasant jewellery. Gold was used from time to time, for example by Ashbee for his more luxurious pieces and both Henry Wilson and John Paul Cooper produced outstanding

work in gold (Cats 60 and 67). Cooper's brooch also illustrates his interest in Gothic architecture and the overall style is similar to fifteenth-century ring brooches.

In making Arts and Crafts jewellery one of the main concerns was that, in addition to producing the piece by hand, it should be executed largely by one person, thus maintaining the essence of individuality. This was a characteristic which Arts and Crafts designers believed to be lacking from other contemporary jewellery because of the process by which it was made. In the most exclusive jewellery houses, pieces were created by several people each working on their speciality, for example casting, engraving, or setting the stone. These were all executed by hand and to the greatest perfection. These pieces were considered almost too technically brilliant in the eyes of Arts and Crafts designers because their handmade qualities, such as the hammered surface of the metal, were hidden. At the other end of the market cheap trinkets were being churned out by machine with no regard for design, creativity or technique.[27]

One of the most important techniques to be revived by Arts and Crafts designers was enamelling. After very little use since the eighteenth century, it was rediscovered by designers such as A.W.N. Pugin who used it for his gothic-style jewellery of the late 1840s. It later became a typical

characteristic of Arts and Crafts pieces. The main instigator of this revival was Alexander Fisher (1864-1936). Fisher's interest in enamelling was inspired by his father who was a potter and enamelled on ceramics. Fisher studied at the National Art Training School in South Kensington from 1884 to 1886 and a series of demonstrations given by Louis Dalpayrat from Sèvres encouraged Fisher to develop his skills. After studying enamelling in France and Italy, he established a workshop and became head tutor for teaching enamelling techniques at the Central School of Art. Fisher taught professional jewellers, including Nelson Dawson, as well as amateurs such as Mrs Percy Wyndham and her daughter Lady Elcho. He exhibited at the Arts and Crafts Exhibition Society on a number of occasions and his first entries in 1893 were an enamel panel and two enamelled buckles. *Champlevé*, *cloisonné* and Limoges were the three techniques chiefly used by Arts and Crafts designers. The latter, executed by firing the metal in white then adding the various colours and refiring after each addition, was favoured by Fisher. In *champlevé*, each area taking a different colour was hollowed out of the metal background then the different colours were applied, while *cloisonné* is recognised by its distinctive metal strips which divide the colours. Edith Dawson became one of the most accomplished jewellers in this style and probably executed the brooch (Cat.62) decorated with snakes and flowers in *cloisonné* enamel.

By the early twentieth century enamelled jewellery was highly fashionable. Even though the technique itself was difficult, the equipment needed was small, enabling people to pursue the craft at home and thus contributing to its popularity. In 1909 *Vogue* noted:

Everywhere enamel, it is the basis of trinkets and accessories of various kinds.... It finishes off a toilet most delightfully, as any colour scheme of the costume may be carried out with it, and whether combined with precious stones or set merely by a background of gold or silver, it is unfailingly attractive. Pendants are its most popular form.[28]

This suggests that one of Ashbee's concerns about dress and jewellery, that one was hardly ever designed with the other in mind, had been, in part, accomplished by the early twentieth century. In fact the couturier Paul Poiret was designing outfits complete with jewellery during this period.

At about the same time, in 1915, C.F.A.Voysey published a book entitled *Individuality* which included a comment about dress, illustrating its significance to some of the most eminent designers. Indeed William Morris had written on the subject earlier in his article on *The Lesser Arts of Life* (1882) as had Walter Crane in the Healthy and Artistic Dress Union's magazine, *Aglaia* (October 1894), and all were of the opinion that dress should echo the natural beauty of the human figure. They also saw dress as an integral part of people's lives and an avenue for self-expression which was not always appreciated, particularly by victims of fashion. Voysey wrote, 'Change the motive for our dressing from competitive rivalry into an act of reverence towards the body, expressive of the higher qualities of mind, and you then convert the costume into a means of culture and minister of beauty'.[28] This eloquently sums up the aims of artistic dress and jewellery.

1. Quoted by Squire, G. in *Simply Stunning*, Cheltenham 1996, p.8.
2. From a paper, *The Artistic Aspect of Dress*, given by Henry Holiday to the Healthy and Artistic Dress Union, 6 May 1892, published in *Aglaia*, No.1 July 1893.
3. In the first issue of the Rational Dress Society's *Gazette*, April 1888, Lady Harberton stated that underwear should weigh no more than 7lbs. Carter, A., *Underwear, The Fashion History*, London 1992, p.50.
4. Fitzgerald, P., *Edward Burne-Jones*, London 1975, p.92.
5. Shonfield, Z., Miss Marshall and the Cimabue Browns, *Costume*, Vol.13 1979, p.68.
6. Liberty Catalogue, No.3, 1883, *Art Fabrics*, V&A Art Library.
7. *Punch*, Vol.71 1876, p.86.
8. 'Jane would have been expected to make a fair number of garments for herself and possibly shirts for her husband; we know she was a good needlewoman …', Marsh J., *Pre-Raphaelite Sisterhood*, London 1985, p.169.
9. There is an example of a dress by Madame Forma in the Victoria & Albert Museum Dress Collections, ref.Circ.638 & A-1964.
10. Fitzgerald, P., *Op.cit.*, p.48.
11. Shonfield, Z., *Op.cit.*, p.68.
12. Jewson, N., *By Chance I Did Rove*, published privately, 2nd edition, 1973, p.14.
13. CAGM. Unpublished notes of a conversation between the daughter of C.H.StJohn Hornby and Maureen Batkin and Mary Greensted.
14. MacCarthy, F., *The Simple Life: C.R.Ashbee in the Cotswolds*, London 1981, pp.93-4.
15. Crawford, A., *C.R.Ashbee, Architect, Designer & Romantic Socialist*, London 1985, p.109.
16. MacCarthy, F., *Op.cit.*, p.94.
17. Crawford, A., *Op.cit.*, p.93
18. Roscoe, B., 'Phyllis Barron and Dorothy Larcher', in Greensted, M., *The Arts and Crafts Movement in the Cotswolds*, Stroud 1993, p.123.
19. Bradford, E., *English Victorian Jewellery*, London 1959, p.114.
20. Crawford, A., *Op.cit.*, p.350.
21. Flower, M., *Victorian Jewellery*, London 1951, p.30.
22. *Queen*, 26 March 1881, p.307.
23. *Queen*, 2 April 1881, p.334.
24. *The Studio*, Vol.60 1914, p.268.
25. *The Architectural Review*, Vol.1 1897, p.41.
26. *The Studio*, Vol.22 1901, p.171.
27. 'Some Examples of Modern English Jewellery', *The Studio*, Vol.60 1914, pp.265-72.
28. Mulvagh, J., *Costume Jewellery in Vogue*, London 1988, pp.30-1.
29. Voysey, C.F.A., *Individuality*, London 1915, p.70.

Fig.31 *William Morris in a working smock, c.1876.*

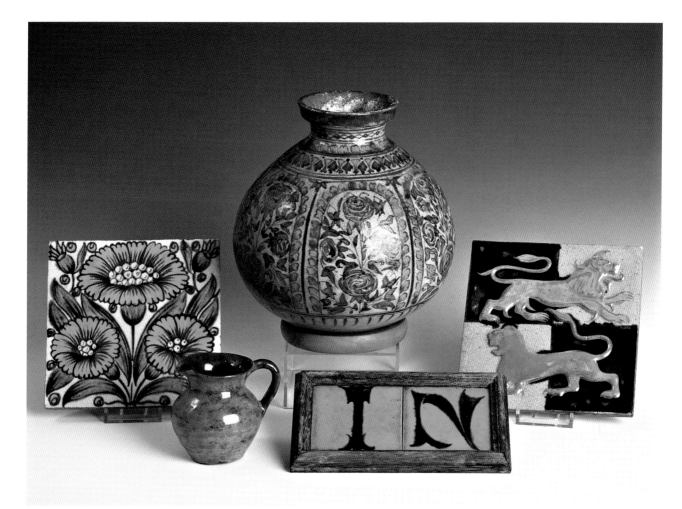

Fig.32

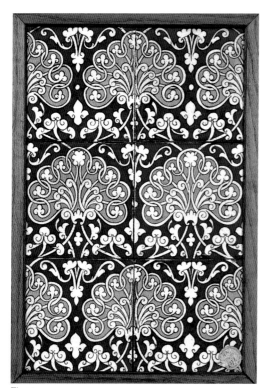

Fig.33

Fig.34

Fig.32 *William De Morgan pottery made at Sands End, Fulham, 1888-97:*
Cat.10 *Bedford Park Daisy tile;* **Cat.12** *Cream jug;* **Cat.13** *Vase;*
Cat.11 *Alphabet tile panel;* **Cat.8** *Raised Lion tile.*

Fig.33 **Cat.4** *Panel of tiles by William De Morgan, c.1872.*

Fig.34 **Cat.3** *Tiles by William De Morgan, 1872-6 (two of three examples are illustrated).*

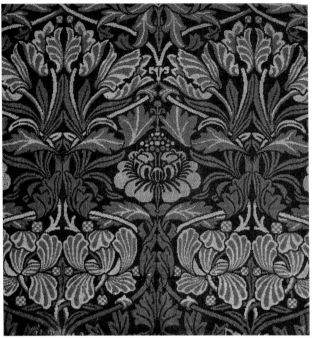

Fig.35

Fig.36

Fig.35 **Cat.16** *Detail of a curtain by William Morris, 1876.*

Fig.36 **Cat.15** *Curtain fragment by William Morris, 1875.*

Fig.37 **Cat.2** *Dessert doilies or table mats by Walter Crane, c.1893 (only part of the set is illustrated).*

Fig.38 **Cat.9** *Tile, 1888-97, and* **Cat.7** *Dish, c.1880, by William De Morgan.*

Fig.39 **Cat.5** *Panel of tiles by William De Morgan, 1872-81.*

Fig.40 **Cat.6** *Panel of tiles by William De Morgan, 1872-81.*

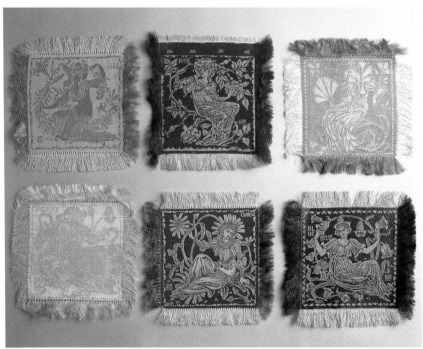

Fig.37

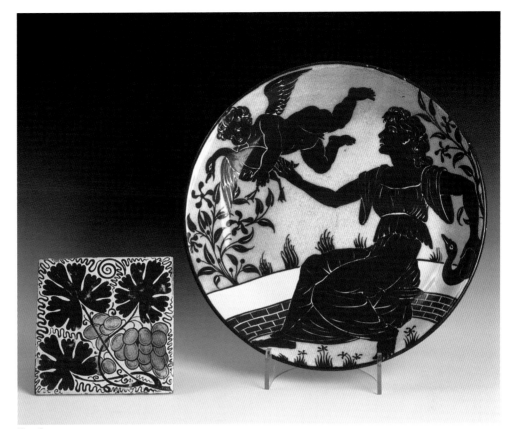

Fig.38

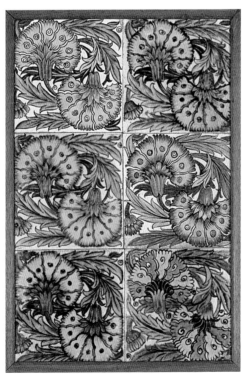

Fig.39

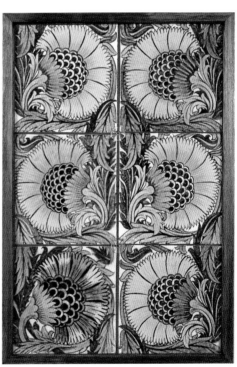

Fig.40

Fig.41

Fig.42

Fig.43

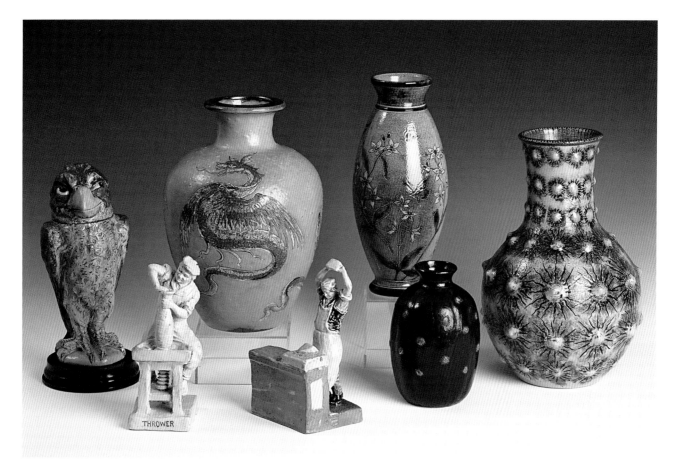

Fig.44

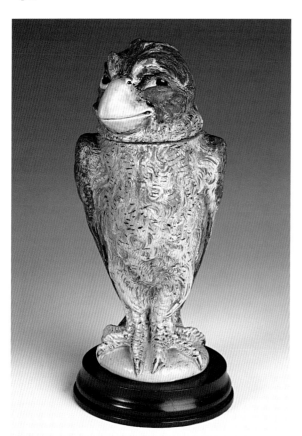

Fig.41 **Cat.19** *Cup and cover by Heywood Sumner, 1898.*

Fig.42 **Cat.20** *Wine glasses by Philip Webb, c.1862-3 (part of a set of six).*

Fig.43 **Cat.1** *Candleholder by W. A. S. Benson, c.1900.*

Fig.44 *Pottery by the Martin Brothers:* **Cat.25** *Tobacco jar, 1899;* **Cat.26** *Figure of a thrower, 1900;* **Cat.27** *Vase, 1903;* **Cat.21** *Figure of a bench boy, 1885;* **Cat.22** *Vase, 1886;* **Cat 24** *Vase, 1894;* **Cat.23** *Vase, 1893.*

Fig.45 **Cat.25** *Tobacco jar by Robert Wallace Martin, 1899.*

Fig.45

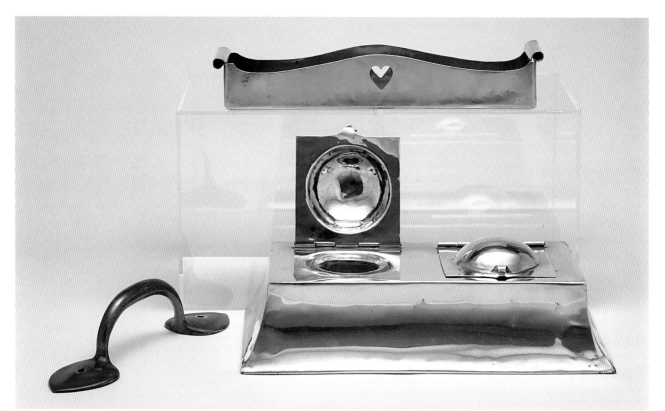

Fig.46

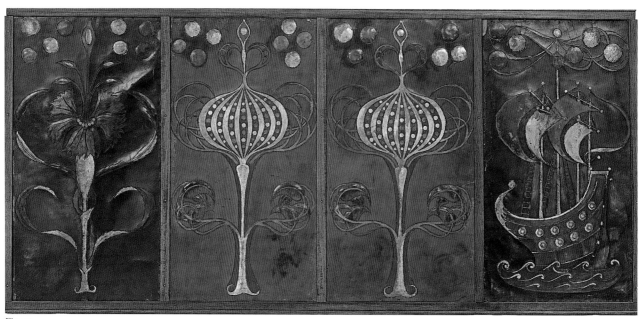

Fig.47

Fig.46 *Metalwork by C. F. A. Voysey, c.1895-1900:* **Cat.28** *Handle;*
Cat.30 *Pen tray;* **Cat.29** *Double inkwell.*

Fig.47 **Cat.31** *Embossed and tooled leather panels by C. R. Ashbee and the
Guild of Handicraft, 1892.*

Fig.48 **Cat.55** *Mace head by C. R. Ashbee and the Guild of Handicraft, c.1903-9.*

Fig.49 **Cat.34** *Sporting cup by C. R. Ashbee and the Guild of Handicraft, c.1895.*

Fig.50 **Cat.33** *Sporting cup or sugar basin by C. R. Ashbee and the Guild of
Handicraft, c.1893.*

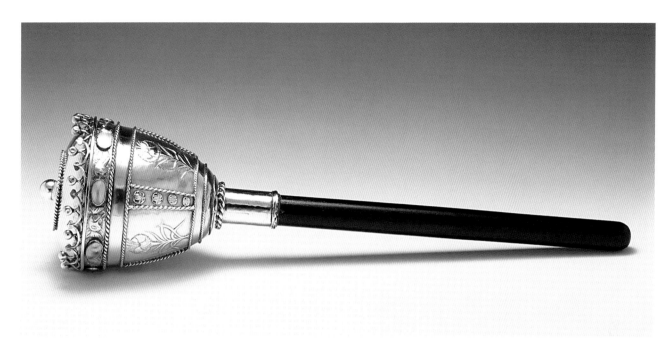

Fig.48

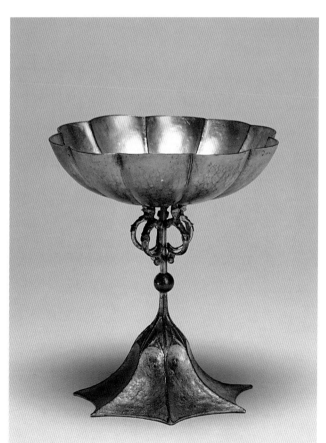

Fig.49

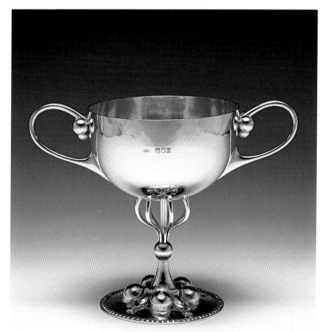

Fig.50

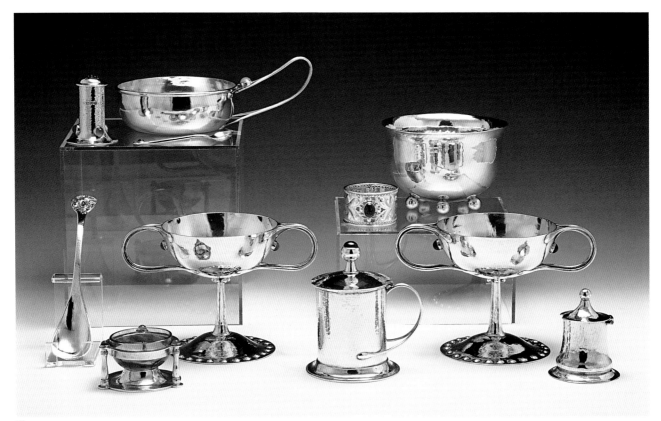

Fig.51

Fig.51 *Silverwork by C. R. Ashbee and the Guild of Handicraft, 1900-6. Top:* **Cat.45** *Pepper pot,* **Cat.52** *Dish,* **Cat.50** *Salt spoon,* **Cat.37** *Napkin ring, and* **Cat.53** *Bowl. Bottom:* **Cat.51** *Jam spoon,* **Cat.44** *Salt dish,* **Cat.43** *Pair of cups,* **Cat.46** *Mustard pot, and* **Cat.49** *Mustard pot.*

Fig.52 *Metalwork by C. R. Ashbee and the Guild of Handicraft:* **Cat.38** *Muffin dish, c.1900;* **Cat.54** *Pair of salts, 1907;* **Cat.32** *Mustard pot, c.1893.*

Fig.53 **Cat.57** *Haircomb by Fred Partridge, c.1901-6.*

Fig.54 **Cat.56** *Necklace by C. R. Ashbee and the Guild of Handicraft, c.1913.*

Fig.55 **Cat.36** *Brooch, pendant or hair ornament by C. R. Ashbee and the Guild of Handicraft, c.1900.*

Fig.56 *Enamelled silverwork by C. R. Ashbee and the Guild of Handicraft:* **Cat.47** *Hand mirror, 1903;* **Cat.39** *Box and cover, 1901;* **Cat.42** *Box and cover, 1902;* **Cat.192** *Box and cover, 1913.*

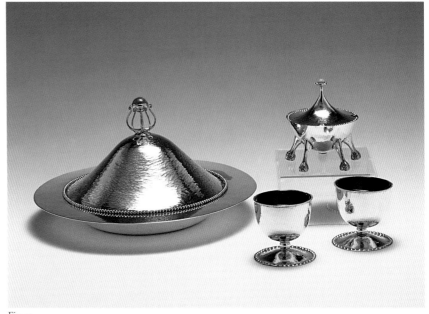

Fig.52

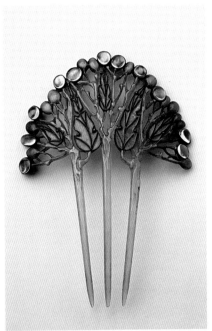

Fig.53

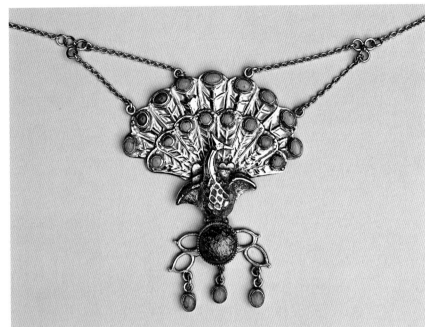

Fig.54

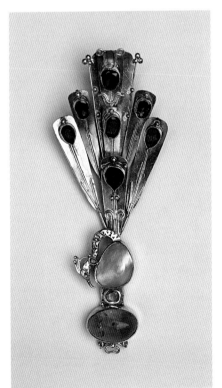

Fig.55

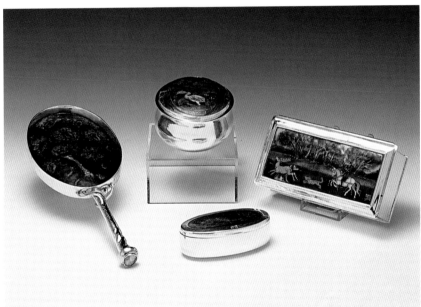

Fig.56

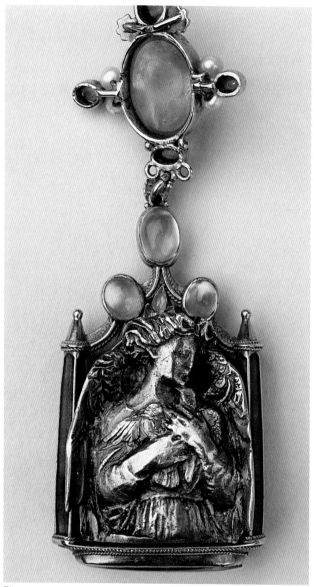

Fig.57

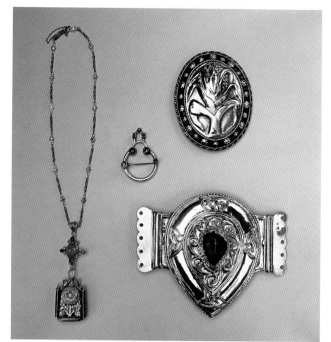

Fig.58

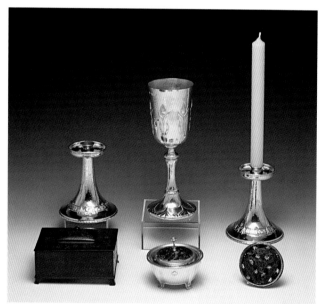

Fig.59

Fig.57 **Cat.67** *Detail of a double-sided pendant by Henry Wilson, c.1907-10.*

Fig.58 **Cat.67** *Pendant and chain by Henry Wilson, c.1907-10;* **Cat.65** *Belt buckle or cope clasp by Edward Spencer and the Artificers' Guild, 1928;* **Cats 59 and 60** *Belt buckle, 1905, and Brooch, 1911, both by John Paul Cooper.*

Fig.59 *Top:* **Cat.147** *Cup by Gilbert Marks, 1900;* **Cat.112** *Pair of candlesticks, by A. E. Jones, 1908. Bottom:* **Cat.146** *Box by Gilbert Marks, 1898;* **Cats 63 and 62** *Bowl and cover, 1901, and Brooch, c.1895, by Edith and Nelson Dawson.*

Fig.60 **Cats 72 and 74** *Sconces, c.1906, and a pair of candlesticks, c.1905-15, by Ernest Gimson.*

Fig.61 **Cats 71 and 77** *Toasting fork and poker designed by Ernest Gimson, c.1900-15, made by Norman Bucknell in 1985 and 1948.*

Fig.62 **Cat.76** *Fire tools and fire iron rests by Ernest Gimson, made in his smithy in 1915.*

Fig.63 **Cat.75** *Door handle by Ernest Gimson, c.1905-15, made by the Bucknells, c.1934.*

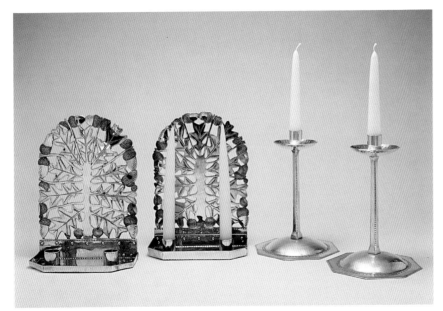

Fig.60

Fig.61

Fig.63

Fig.62

Fig.64

Fig.65

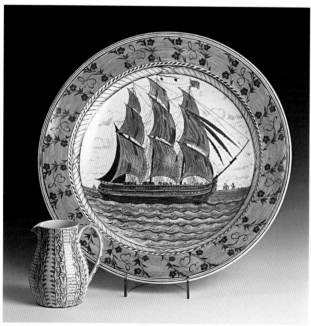

Fig.66

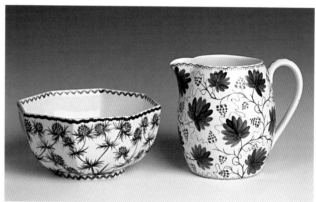

Fig.67

Fig.64 **Cat.82** *Wedgwood saucer painted by Louise Powell, c.1916-20 (one of two examples).*

Fig.65 *Wedgwood pottery painted by Alfred Powell. From left to right:* **Cat.92** *Cup, c.1939 (one of four);* **Cat.81** *Dinner plate c.1905;* **Cat.87** *Plate, cup and saucer, c.1932; and* **Cat.88** *Jug, 1932.*

Fig.66 **Cats 83 and 86** *Wedgwood jug painted by Louise Powell, c.1916-20 and charger painted by Alfred Powell, 1929.*

Fig.67 **Cats 80 and 79** *Wedgwood jug and bowl painted by Grace Barnsley, 1920-4.*

Fig.68 **Cat.85** *Wedgwood punch bowl painted by Alfred Powell, 1928.*

Fig.69 **Cat.84** *Wedgwood pottery charger painted by Alfred Powell, c.1920.*

Fig.70 **Cat.90** *Wedgwood jar and cover by Alfred Powell c.1937.*

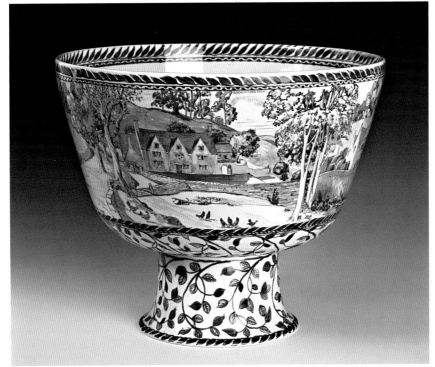

Fig.68

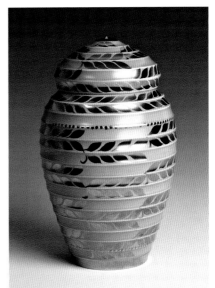

Fig.70

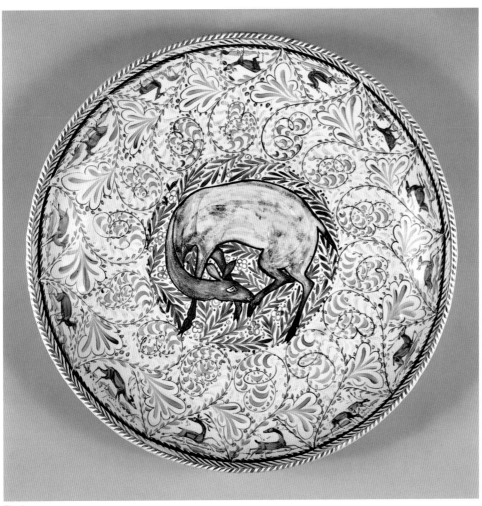

Fig.69

Fig.71

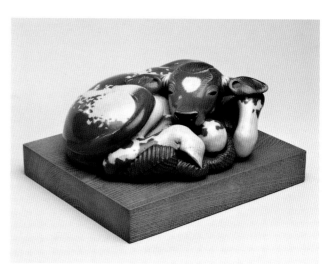

Fig.72

Fig.73

Fig.74

Fig.75

Fig.76

Fig.71 **Cat.93** *Embroidery by Eve Simmonds, 1916.*

Fig.72 **Cat.100** *Autumn calf by William Simmonds, 1952.*

Fig.73 **Cat.98** *Little pigs carved in ivory by William Simmonds, 1937.*

Fig.74 **Cat.99** *Ducklings by William Simmonds, 1950.*

Fig.75 **Cat.94** *Horse and waggon, puppet and working model by William Simmonds, 1923.*

Fig.76 **Cats 95 and 96** *Puppets by William Simmonds, c.1920-5.*

Fig.77

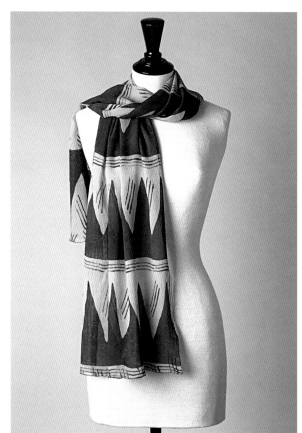

Fig.78

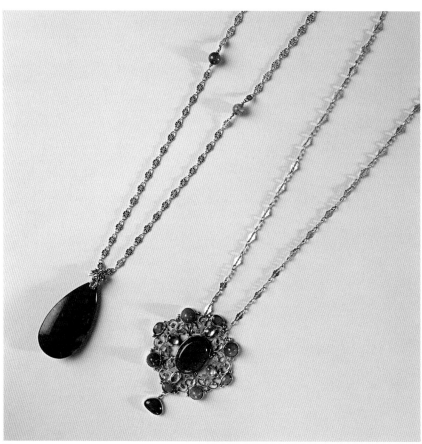

Fig.79

Fig.77 **Cat.102** *Cushion cover by Phyllis Barron and Dorothy Larcher, c.1930.*

Fig.78 **Cat.101** *Scarf by Phyllis Barron and Dorothy Larcher, c.1925.*

Fig.79 **Cats 159 and 110** *Jewellery by unknown makers, c.1915.*

Fig.80 *Clockwise from top left:* **Cats 105, 107, 108, 106 and 109** *Jewellery by Arthur and Georgina Gaskin, c.1900-11.*

Fig.81 *Jewellery by unknown makers, c.1900-20. From top to bottom:* **Cat.158** *Necklace;* **Cat.144** *Necklace;* **Cat.111** *Brooch;* **Cat.143** *Pendant.*

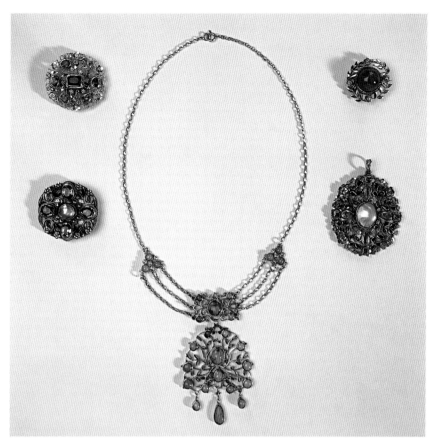

Fig.80

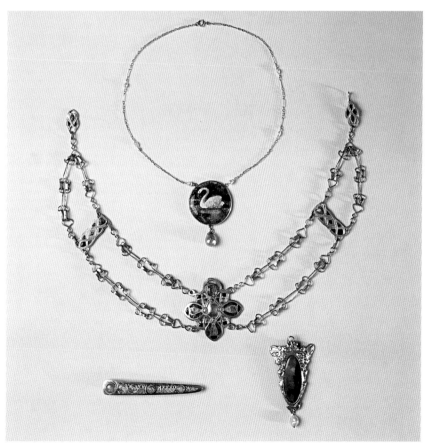

Fig.81

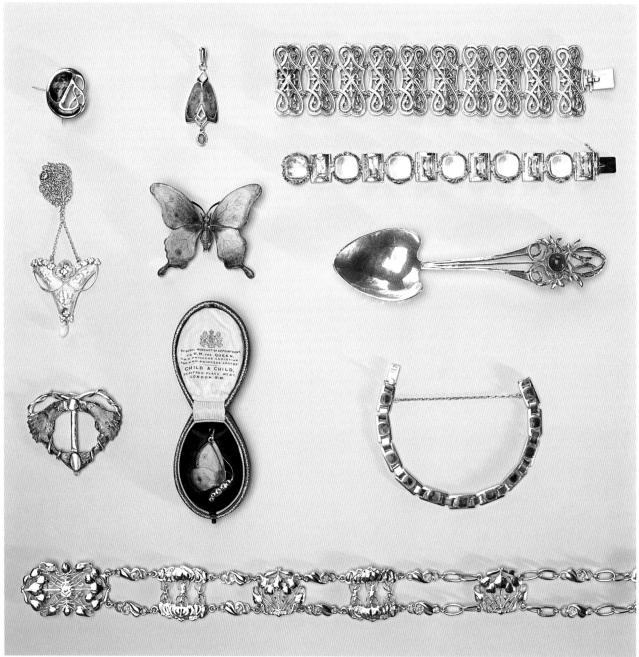

Fig.82

Fig.82 *Trade jewellery and metalwork in the Arts and Crafts style, c.1900-62. From top to bottom, first column:* **Cat.125** *Brooch by Charles Horner;* **Cat.126** *Necklace by Jessie M. King;* **Cat.142** *Belt buckle by Edgar Simpson;* **Cat.115** *Belt by William Comyns. Second column:* **Cat.124** *Pendant by W. H. Haseler;* **Cats 113 and 114** *Brooch and Pendant by Child & Child. Third column:* **Cats 118, 117 and 116** *Bracelets and Spoon by Sybil Dunlop;* **Cat.141** *Bracelet by Murrle Bennett & Co.*

Fig.83 **Cat.137** *Woman's dress by Liberty, c.1928.*

Fig.84 **Cat.134** *Cloak by Liberty, c.1900-5.*

Fig.85 **Cat.140** *Child's dress by Liberty, c.1920.*

Fig.86 *Silverwork by Archibald Knox:* **Cat.131** *Menu holder, 1903;* **Cat.132** *Buttons, 1907;* **Cat.130** *Buttons in case, 1903;* **Cat.127** *Cloak clasp, 1901;* **Cat.129** *Buttons, 1903.*

Fig.83

Fig.84

Fig.85

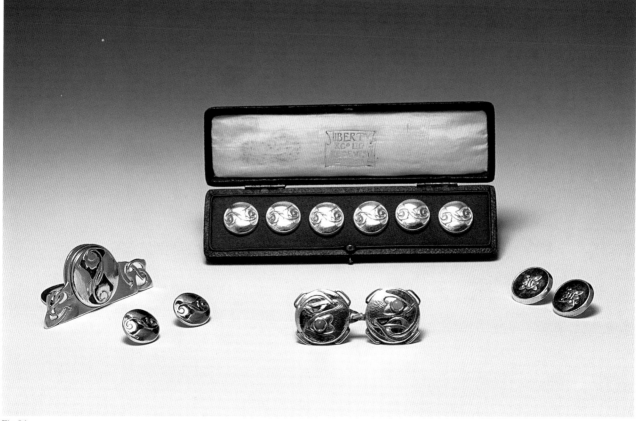

Fig.86

Fig.87 Top: **Cat.123** *Bowl by Kate Harris, 1904;* **Cat.156** *Plaque by Harold Stabler, c.1912-13;* **Cat.157** *Figure of a young girl by Phoebe Stabler, c.1915.* Bottom: **Cat.135** *Inkwell by Liberty, 1902;* **Cat.136** *Belt buckle by Liberty,* 1903; **Cat.121** *Belt buckle probably by Kate Harris, 1902;* **Cat.133** *Belt buckle by Liberty, 1901;* **Cat.120** *Belt buckle by Kate Harris, 1899; and* **Cat.122** *Buttons by Kate Harris, 1903.*

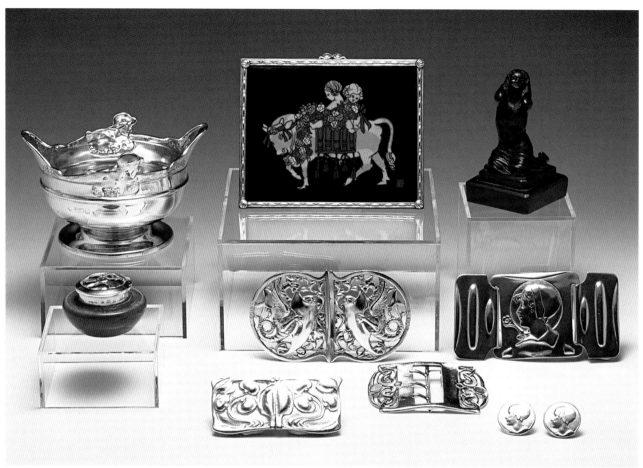

Fig.87

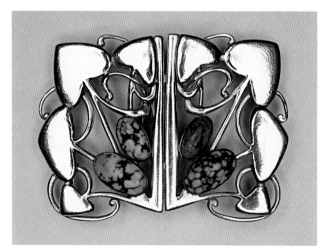

Fig.88

Fig.89

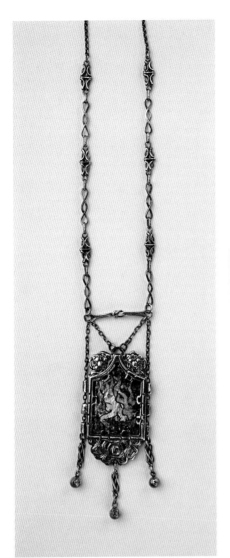

Fig.90

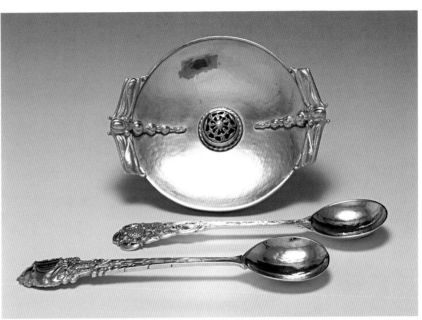

Fig.91

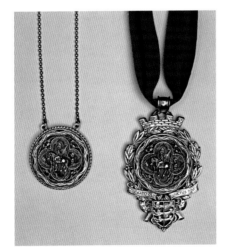

Fig.92

Fig.93

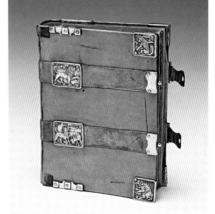

Fig.94

Fig.95 **Cat.164** *Jardinière by Burmantofts, Leeds, 1890-1904.*

Fig.96 **Cat.161** *Pair of vases by Bretby Art Pottery, 1900-18;* **Cat.162** *Vase by Burmantofts, 1885-90;* **Cats 176 and 175** *Two vases by Pilkington's, c.1919 and 1904-5;* **Cat.163** *Vase by Burmantofts, c.1885;* **Cat.177** *Vase by Pilkington's, 1924;* **Cat 178** *Cup and saucer by Ruskin Pottery, c.1920.*

Fig.97 *From left to right:* **Cats 170, 173, 171, 172, and 174** *Art pottery by Bernard Moore, Stoke-on-Trent, 1905-15.*

Fig.98 *From left to right:* **Cats 169, 168, 165, 167, and 166** *Art Pottery by Sir Edmund Elton, Clevedon, Somerset, 1879-1920.*

Fig.99 **Cats 180 and 179** *Examples of Ruskin Pottery, 1925-6.*

Fig.95

Fig.96

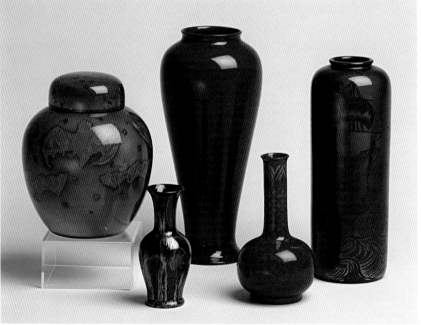

Fig.97

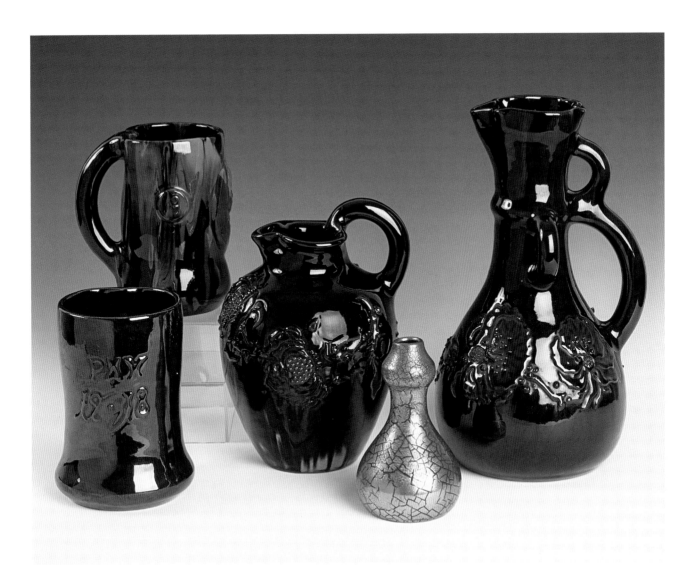

Fig.98

Fig.99

Fig.100

Fig.101

Fig.100 **Cat.181** *Tile panel by A. Masson, c.1876.*

Fig.101 **Cat.184** *Textile sample by Herbert C. Oakley, c.1896.*

Fig.102 **Cat.190** *'Nativity' by Eric Gill, 1920.*

Fig.103 **Cat.193** *Cup and cover by George Hart, 1935.*

Fig.104 **Cat.204** *'Taffy was a Welshman', painted and stippled glass panel by Paul Woodroffe, c.1930-7.*

Fig.105 **Cat.201** *Fruit bowl by Sidney Reeve, 1935. From left to right:* **Cats 195, 196 and 194** *Spoons by George Hart, 1936-9 and* **Cat.197** *Beaker by Derek Elliott, 1988-9, all for Hart's Silversmiths.* **Cat.198** *Bowl by Hart and Huyshe, c.1920.*

Fig.102

Fig.103

Fig.104

Fig.105

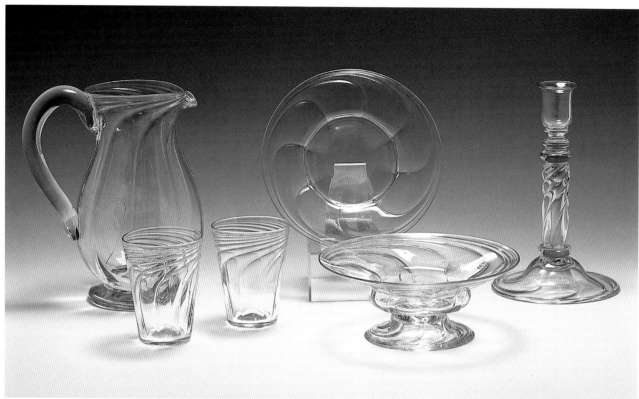

Fig.106

Fig.107

Fig.108

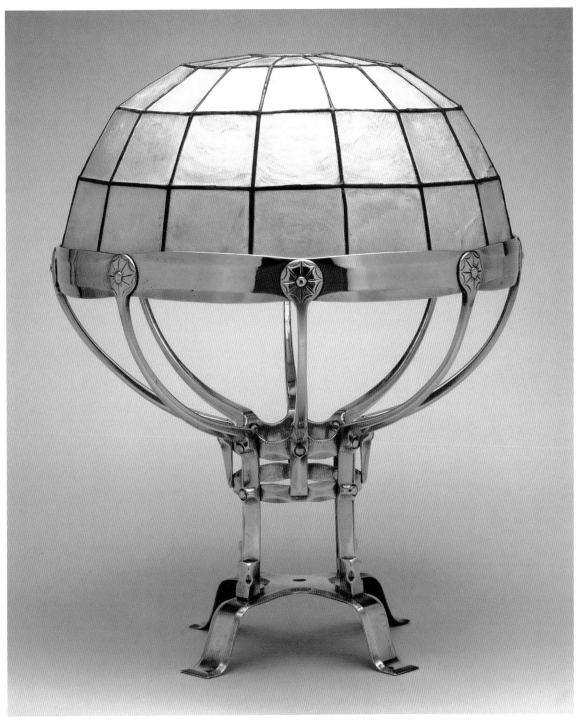

Fig.109

Fig.106 **Cat.205** *Glasswares by Gordon Russell for Stevens & Williams, c.1923.*

Fig.107 *Clockwise from bottom left:* **Cats 212, 213 and 214** *Textiles retailed by Gordon Russell Ltd, c.1935-7.*

Fig.108 **Cat.210** *Rug by Marian Pepler for the Wilton Royal Carpet Factory, c.1933.*

Fig.109 **Cat.208** *Reading lamp by Gordon Russell and Russell & Sons, 1924.*

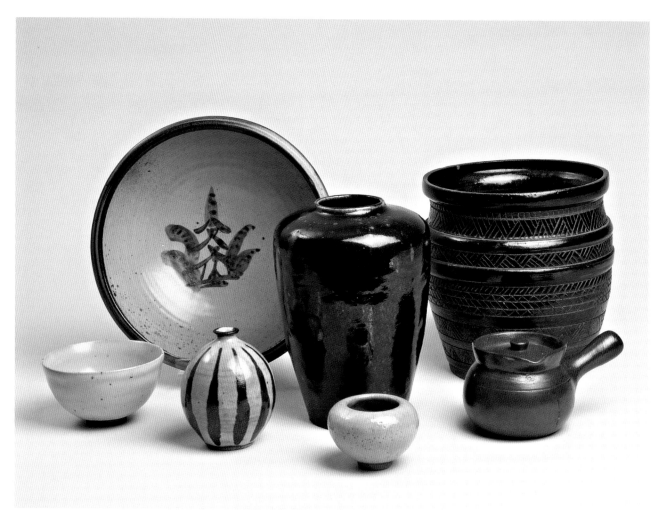

Fig.110

Fig.110 *Clockwise from top left:* **Cat.219** *Bowl by Bernard Leach, c.1947;*
Cat.225 *Vase by William Staite Murray, 1922;* **Cat.224** *Jar probably by Ada
Mason, 1924-7;* **Cat.220** *Lidded soup bowl by Margaret Leach, c.1950;*
Cat.218 *Bowl by Bernard Leach, c.1936;* **Cats 222 and 223** *Vase and Bowl by
Katharine Pleydell-Bouverie, c.1937.*

Fig.111 *From left to right:* **Cat.229** *Cider jar, c.1930;* **Cat 235** *Bread plate,
c.1935;* **Cat.227** *Jug, c.1930;* **Cat.237** *Jug, c.1935-9 or 1942; and* **Cat.231** *Jug,
c.1935. All by Michael Cardew at Winchcombe Pottery.*

Fig.112 *Clockwise from top left:* **Cat.226** *Dish, 1926-32;* **Cat.236** *Jug, c.1935;*
Cat.230 *Plate, c.1930;* **Cat.232** *Salt dish, c.1935; and* **Cat.233** *Bowl, c.1935;*
all by Michael Cardew at Winchcombe Pottery. **Cat.253** *Baking dish, c.1936*
Winchcombe Pottery.

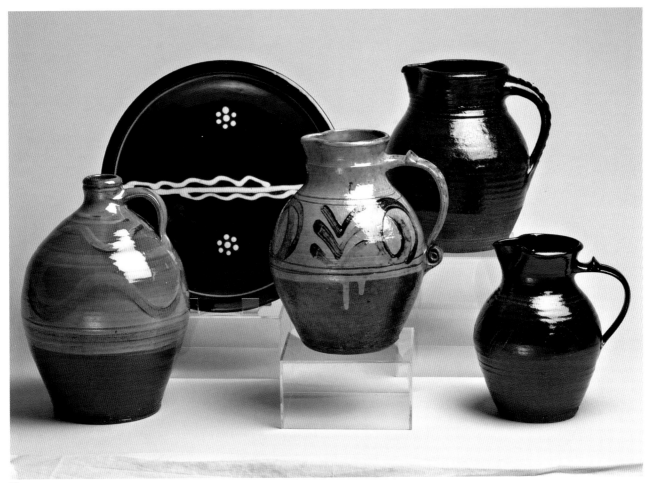

Fig.111

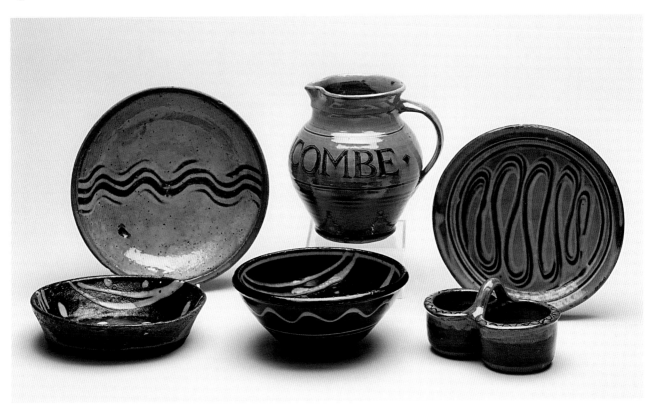

Fig.112

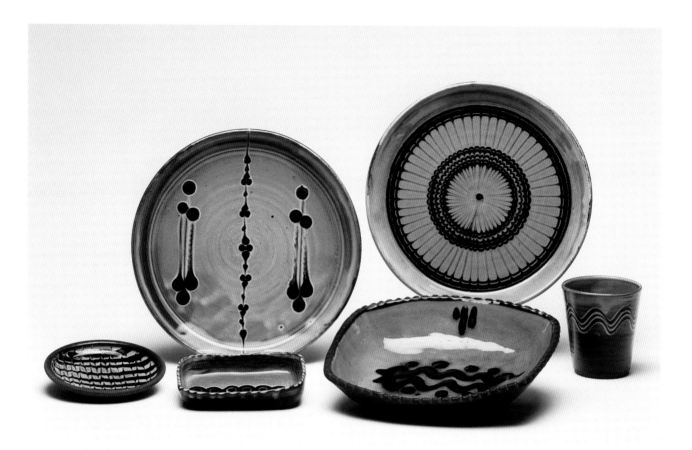

Fig.113

Fig.113 *Clockwise from left:* **Cat.255** *Small dish, c.1955;* **Cats 251 and 250** *two Plates by Sid Tustin, 1954-64;* **Cat.252** *Beaker by Sid Tustin, 1954-64;* **Cat.246** *Dish by Pat Groom, 1947-53;* **Cat.254** *Small dish, 1954-60; all made at Winchcombe Pottery.*

Fig.114 *Clockwise from left:* **Cat.238** *Storage jar by Peter Dick, 1967-9;* **Cat.244** *Jug by Ray Finch, 1965-70;* **Cat.245** *Large dish by Ray Finch, c.1967;* **Cat.256** *Casserole dish, c.1975; and* **Cat.257** *Baking dish, 1975-80; all made at Winchcombe Pottery.*

Fig.115 *From left to right:* **Cats 267, 270, 269, and 268** *Boxes made by Hugh Birkett, Moreton-in-Marsh, Gloucestershire, 1996.*

Fig.116 **Cat.266** *Framed set of timber samples by Darren Harvey at the Edward Barnsley Educational Trust Workshop, Froxfield, Hampshire, 1988.*

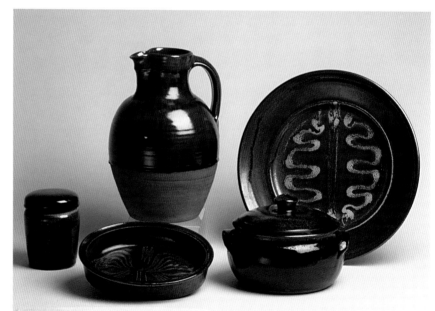

Fig.114

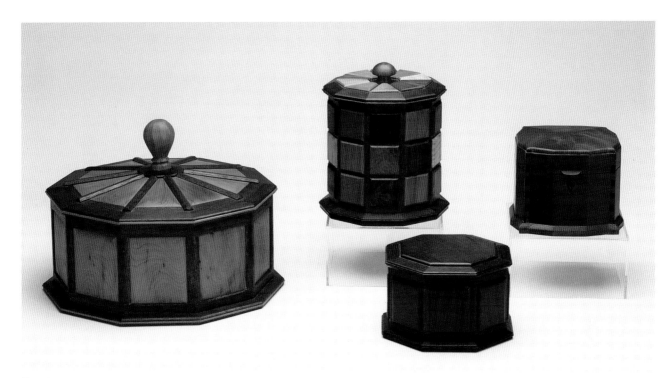

Fig.115

Fig.116

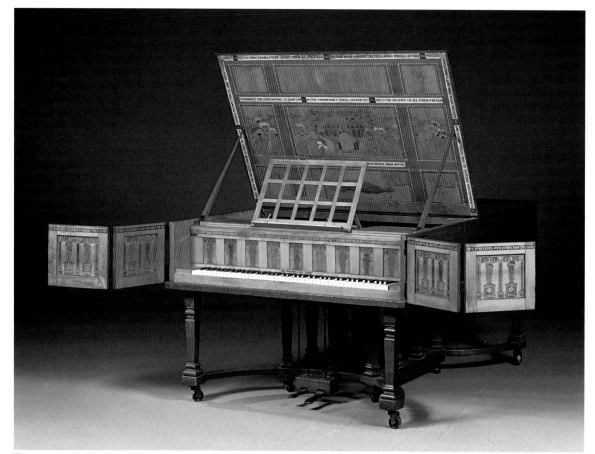

Fig.117

Fig.118

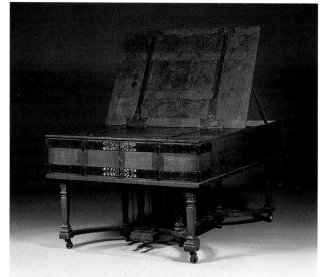

Fig.119

Fig.117 **Cat.262** *Semi-grand piano by C. R. Ashbee and John Broadwood & Sons, 1898-1900. The instrument opens out in similar fashion to Baillie Scott's 'Manx' pianos to show the light, highly decorated interior with painting by Walter Taylor.*

Fig.118 **Cat.262** *Detail of a wrought iron strap hinge by the Guild of Handicraft blacksmiths.*

Fig.119 **Cat.262** *The closed piano showing its severe rectangular form and sober exterior.*

IV Catalogue

Note on the catalogue

Details of individuals and groups of designers are arranged in roughly chronological order of when they became active. Because many of them overlap, there is no single obvious order, but we hope that this rather loose arrangement will give a better sense of groupings and influences than an alphabetical one. Within these headings, the objects are divided up by designer alphabetically and then arranged in order of date of design or execution.

We have included as much information as we can about the original owners of the pieces, but such portable items lose their provenance more quickly than larger objects such as furniture, and the history of many of them is unknown.

Dimensions are given in inches because most of the pieces were made in imperial measurements, but are followed by millimetres. The height is given first, then width and depth.

When reference is made to objects in museums or other publications, the accession number is usually given, since any enquiry about the object will be hastened by quoting the number. The Museum's accession numbers are given with the details of acquisition.

Many grants towards the purchase of objects have been received from the fund administered by the V&A. In April 1985 this changed from the Victoria & Albert Museum Purchase Grant Fund to the Museums and Galleries Commission/Victoria & Albert Museum Purchase Grant Fund, but the shorter version has been used.

The following abbreviations have been used:

*** Indicates that the object is illustrated in the colour plate section (pages 49-80)**

CAGM	Cheltenham Art Gallery and Museums
EBET	Edward Barnsley Educational Trust, Froxfield, Petersfield, Hampshire
GCF	Carruthers, A. and Greensted, M., *Good Citizen's Furniture: The Arts and Crafts Collections at Cheltenham*, Cheltenham and London 1994
GOHT	Guild of Handicraft Trust, Chipping Campden, Gloucestershire
GRO	Gloucestershire Record Office, Gloucester
GRT	Gordon Russell Trust, Broadway, Worcestershire
RA	Royal Academy of Arts, London
RCA	Royal College of Art, London
RIBA	Royal Institute of British Architects, London
V&A	Victoria & Albert Museum, London
V&A AAD	V&A Archive of Art and Design, Blythe Road, London
V&A AAD, A&CES	V&A Archive of Art and Design, Archive of the Arts and Crafts Exhibition Society (later the Society of Designer-Craftsmen)
V&A PP&D	V&A Prints, Paintings and Drawings Department

Any numbers following these abbreviations are the accession numbers of objects.

William Morris (1834-96) and his circle

W. A. S. Benson, Walter Crane, William De Morgan, George Jack, William Morris, Heywood Sumner, Philip Webb

William Morris experienced the contribution which everyday household objects could make to creating a home when decorating and furnishing Red House. The architect of this house, Morris's first married home, was his friend and colleague, Philip Webb. The two men had met in the Oxford office of the architect G. E. Street, and Webb provided crucial support in the formation in 1861 of the firm of Morris, Marshall, Faulkner & Company and its subsequent development. The firm exploited successfully the needs of a growing middle class with a taste for decorative domestic work. Morris's influence ensured an emphasis on both quality and experiment in the firm's products.

The firm's reputation and early financial stability in the 1860s was ensured by stained-glass work but the production of fabrics and wallpapers on a commercial scale carried it through the second half of the nineteenth century. Large commissions in the 1880s and 1890s for, amongst others, the state rooms at St James's Palace and Stanmore Hall for the Australian industrialist, Knox D'Arcy, established its dominant position in the field of interior decoration and ensured its survival well into the twentieth century.

The continuing success of the firm was propelled by the force of Morris's personality in attracting a group of talented and experimental designers, as well as the original members of Morris, Marshall, Faulkner & Company, including Walter Crane, William De Morgan, W. A. S. Benson and Heywood Sumner. Apart from De Morgan, they were all instrumental in founding the Art Workers' Guild in 1884 and all four, as well as an initially cautious and reluctant Morris, were leading figures in the Arts and Crafts Exhibition Society set up in 1888. Julia Cartwright's description of her visit to the first exhibition emphasised their dominance of the decorative scene:

… when the New Gallery opened its doors, a thrill of pleasure and surprise ran through the spectators. Many of us remember the beautiful effect of the central Court – the pyramid of De Morgan tiles glowing with the ruby lustre of old Gubbio ware, with Persian and Rhodian blues, Mr Benson's luminous copper fountain, Mr Sumner's sgraffito designs and gesso roundels, the glorious tapestries from Merton Abbey, and all the lovely colour and pattern in silk embroideries and exquisitely tooled morocco that met the eye. Even wallpapers might become things of beauty, we felt, when we saw the joy of springtime reflected in Walter Crane's 'Under the Greenwood Tree' and 'The Golden Age' return in his embossed leather of silver and gold.[1]

Walter Crane made his reputation in the 1870s as a nursery book illustrator, his best known work being *The Baby's Opera* published in 1877. His work, dominated by the

Fig.120 *William Morris, photographed on 21 March 1877 by Elliott & Fry, London.*

romantic portrayal of women and children, appealed to a wide audience and influenced Art Nouveau artists such as Alphonse Mucha, but could be repetitive. *The Studio* described Crane's designs for printed silks at the 1893 Arts and Crafts Exhibition as 'better suited for picture books than house decoration'.[2] He acknowledged the common source saying, 'My nursery papers grew out of my nursery books; from the nursery paper to those for general use was but a step, and one that followed naturally enough'.[3]

Crane was first President of the Arts and Crafts Exhibition Society and, apart from three years between 1893 and 1896 when Morris took over, remained in that role until 1912. He designed wallpapers, fabrics, carpets, decorative ceramics and tiles for a number of different companies. His work for Morris & Company was closely related to that of Edward Burne-Jones; in 1883 he designed the first tapestry, *Goose Girl*, to be produced commercially by the firm.

William Frend De Morgan was born in London. His father was a mathematician while his mother combined family life, including the deaths of four children from tuberculosis, with a variety of concerns including anti-slavery and education for women. De Morgan trained as

Fig.121 *Designs by Walter Crane of dresses inspired by Greek costume, c.1895.*

Fig.122 *William De Morgan, c.1910.*

an artist at the Royal Academy Schools where one of his fellow-students, Henry Holiday, introduced him to Morris in 1863. A strong-willed and inventive character, he was quickly disillusioned with the artistic establishment but he also realised that he was not a great painter. Instead he began designing stained glass and subsequently tiles to be sold through Morris's firm. In his Chelsea workshop he began experimenting with kilns and glazes and rediscovered techniques for lustre glazes. Halsey Ricardo, the architect who became his partner in 1889, described him as a 'scientific enthusiast'.[4] De Morgan employed potters and painters but maintained overall control of the work. In 1882 he moved to larger premises at Merton Abbey on the outskirts of London next door to Morris's tapestry works. Six years of travelling from London to Merton took its toll and, in 1888, he set up his third pottery at Sand's End, Fulham, London.

His wife from 1887, the artist Evelyn Pickering, actively encouraged De Morgan in all his enterprises. However, from 1892 onwards ill health and fear of tuberculosis led the De Morgans to spend the winter months in Florence, Italy, sending designs and tiles back and forth and corresponding regularly with Ricardo to try to maintain day-to-day control over the business. The partnership between the two men was dissolved in 1898 and De Morgan gave up designing in 1904, although the Sand's End Pottery survived for a further three years, providing a unique contribution to the decoration of Ernest Debenham's house in Addison Road, Kensington, London. With the publication of *Joseph Vance* in 1907, De Morgan began a second career as a successful novelist.[5] De Morgan's biographer, Mark Hamilton, notes that May Morris described *The Old Man's Youth* (1921) as

partly autobiographical and relates other passages to De Morgan's own experiences.

Benson was named after his uncle, William Arthur Smith, who inspired Benson with his own enthusiasms for science and the crafts and taught him to use lathes and other simple machinery. Benson studied Classics at Oxford with a childhood friend, Heywood Sumner. As students they met Burne-Jones and, in 1878, Morris himself. Benson trained as an architect before deciding to set up in business as a designer in wood and metal in 1880 with his father's financial backing and Morris's encouragement. Fiona MacCarthy relates how Benson, referred to by Morris as 'Mr Brass Benson', advised Burne-Jones on armour and made the crown as a prop for the painting, *King Cophetua and the Beggar Maid*.[6] Burne-Jones was captivated by the attractive features of both Benson, who modelled for the king, and his sister Agnes.

His first workshop was in Fulham; he then moved to Hammersmith with showrooms in Campden Hill Road, Kensington. By 1890, his showrooms were at the prestigious address of New Bond Street. Examples of his work shown at the Manchester Arts and Crafts Exhibition in 1895 led to the following comment: 'A collection of lamps such as Messrs Bensons' show may ultimately influence the taste of a greater number than the superb Morris-Burne-Jones tapestries'.[7] Benson's contribution was to recognise the importance of lighting in the domestic setting. Oil and gas lamps required specific fittings but he realised that the move towards electricity demanded a radical approach to the design of electric light fittings. Light fittings by Benson were used regularly in Morris and Webb interiors and his work was praised for its innovative nature in the influential *Das englische Haus* by Hermann Muthesius. He also designed furniture and wallpapers for Morris & Company from the 1880s. In the 1890s he worked with Webb, providing wall lights and free-standing lamps for Standen, East Grinstead, Sussex, one of the first private houses to be wired for electricity. After Morris's death, he became a director of the firm and went on to become a founder member of the Design and Industries Association in 1915.

George Heywood Maunoir Sumner, the son of an Anglican clergyman, was brought up in Alresford, Hampshire. He studied law and was called to the Bar in 1879. At the same time he was producing drawings and etchings; he published his first illustrated book in 1881. He married Benson's sister Agnes in 1883. Shortly afterwards he began a loose association with the Century Guild and a closer involvement with the Arts and Crafts Exhibition Society, designing the colophon used in the Society's catalogues.

As well as illustrations, embroideries and wallpapers, Sumner is also known for his experiments with sgraffito, an Italian technique for incising designs into coloured plaster, mosaic work, stained glass, and inlaid alabaster. With Benson he designed two pieces of furniture incised and inlaid with coloured wax stopping.[8] All of his decorative work has a strong graphic element.

George Washington Jack was born in New York, USA; his family moved to Glasgow where he was subsequently articled to a local architect, Horatio Bromhead. By 1880 he had moved to London and was working as Webb's assistant. He became Morris & Company's chief furniture designer in 1890 and also produced designs for decorative plasterwork and embroidery.

Following Morris's example this group of designers formulated and disseminated ideas about art, design and society. Crane, Benson and Sumner all joined Morris in contributing to the volume *Arts and Crafts Essays*, published to coincide with the 1893 Arts and Crafts Exhibition. Benson published an illustrated booklet in 1883, *Notes on some of*

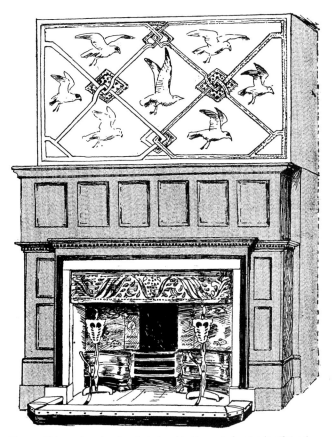

Fig.123 *Chimney breast and grate designed by George Jack, 1893 (see Cat.14). From a drawing in 'The Studio', Vol.2 1893.*

the Minor Arts, which set out his design principles, and the practical handbook, *Notes on Electrical Wiring and Fittings* in 1897. In the 1890s, Crane became involved in teaching at Manchester Municipal College and at the Royal College of Art in London, and subsequently in writing on art education. De Morgan wrote and lectured about the decoration of pottery, particularly the use of lustre. Jack taught at the Central School of Arts and Crafts and his seminal work, *Woodcarving: Design and Workmanship*, was published in 1903, one of the handbooks on Artistic Crafts, the series edited by William Lethaby.
MG

1. Quoted by Lambourne, L., *Utopian Craftsmen*, London 1980, p.61.
2. *The Studio*, Vol.2 1893, p.24.
3. *The Studio*, Vol.4 1894, p.76.
4. Quoted by Hamilton, M., *Rare Spirit, a life of William De Morgan*, London 1997, p.30.
5. *Ibid*, p.17.
6. MacCarthy, F., *William Morris*, London 1994, p.600.
7. *The Studio*, Vol.5 1895, p.134.
8. *GCF*, pp.62-3.

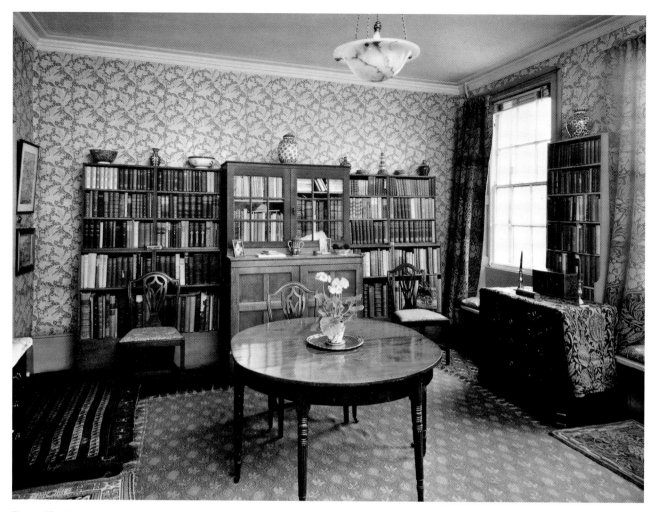

Fig.124 *The sitting room at Emery Walker's house in London with Morris's 'Tulip and Lily' carpet (see Cat.15).*

William Arthur Smith Benson (1854-1924)

1* Candleholder

Designed by W. A. S. Benson in about 1900 and made in his Hammersmith workshop.

Silver plate, cast, in two pieces with three prongs to support a candle. The bowl-shaped surround is a separate piece.
Stamped on the centre of the candleholder:
W. A. S. BENSON

$5\frac{1}{4} \times 7 \times 6\frac{1}{8}$ (133×178×158)

Given in 1989 by the Summerfield Charitable Trust through the Friends of Cheltenham Art Gallery and Museums. 1989.918

This was one of a number of pieces acquired by Cheltenham Art Gallery and Museums after the death of the local antique dealer Ronald (Ron) E. Summerfield. Summerfield had been in negotiation with the Art Gallery and Museums about a major bequest before his final illness. After his death, Cheltenham was given the opportunity by his executors to choose a number of items from his collection before the bulk of it was sold. The largest auction sale in the twentieth century of a single collection, over 14,000 lots, was held by Christie's and Bruton Knowles over twenty-five days in November 1989 and the proceeds were used to set up the Summerfield Charitable Trust which has been a generous benefactor to Cheltenham Art Gallery and Museums.
 See Col.Fig.43.

Walter Crane (1845-1915)

2* Set of dessert doilies or table mats

Designed by Walter Crane about 1893 and manufactured by John Wilson & Sons, 159 New Bond Street, London W1.

Twelve doilies woven in silk and linen damask in assorted colours with designs featuring a rose, lily, pink, bluebell, or poppy.

$7 \times 6\frac{7}{8}$ (179×175) sizes vary

Given in 1998 by Gillian Winter. 1998.88

Record: Arts and Crafts Exhibition, London, 1893.[1]

The donor is the great-grand-daughter of John Wilson, the owner of a linen warehouse established in the early nineteenth century. In 1902 he sold the business and married his second wife, Maude Worthington, daughter of

William Wardle of Leek, Staffordshire. The mats were a wedding gift to the donor in 1957 from Sybil Worthington, daughter of Maude.

This set of doilies, entitled *Flora's Retinue*, was accompanied by an undated booklet, *Note on a tablecloth designed by Walter Crane for John Wilson & Sons*, with a commentary by Lewis F. Day, which contains an advertisement for the doilies. They were available in white or in colours at 18/6d a dozen assorted. The booklet also advertised another set of doilies, *Ornamental Lily*, designed by Day for the firm.
See Col.Fig.37.

1. Designs by Crane Cat.158-9, reproductions by Wilson Cat.160-1. Illustrated in *The Studio*, Vol.2 1893, p.28.

William Frend De Morgan (1839-1917)

3* Three tiles

Designed by William De Morgan and decorated at Orange House, Chelsea, on tile blanks made by the Architectural Pottery Company, Poole, Dorset, 1872-6.

Pressed earthenware with a white slip and painted decoration.
Pressed stamp on back of tiles:
ARCHITECTURAL
POTTERY.
POOLE . DORSET

$6 \times 6 \times \frac{1}{2}$ (153×153×13)

Given in 1949 by Mr A. F. Venn. 1949.97

Design: V&A E 5092-1917, design for a tile panel no.592.

These tiles came from a fireplace at Fauconberg House, Cheltenham, built in 1847 for a local surgeon. It was bought by Cheltenham Ladies' College in 1870 and became the College's first boarding house. The tiles were installed between the early 1870s and 1908, during which time various alterations and additions were made to the house. They were removed during alterations in 1949.

De Morgan began producing designs for tiles around 1870, at first decorating ready-made tiles. He used blanks from the Architectural Pottery Company at Poole for early experiments with white slips. The slip was applied over the red clay tile before painting and glazing. This faience tile technique he later perfected at Merton and Fulham, where

he also made his own tiles. These tiles have a Persian design, known as *Mongolian*, which decorates a pair of tiles, placed one above the other, creating a sense of movement upwards through a decorative curving band. Moorish and Persian designs became fashionable in the 1860s after examples were shown at the South Kensington Museum and illustrations were published. The style was taken up by British designers, the first Persian tiles being produced by Minton, Hollins & Company in 1871.
See Col.Fig.34.

4* Panel of six tiles

Designed by William De Morgan and made by William De Morgan & Company, first produced about 1872.

Earthenware with a white slip and painted decoration.
Sealed in oak frame. Small circular label on bottom right-hand corner printed: MORRIS & COMPANY, 17 *… part of label missing …* ST., HANOVER SQ., W.1. *with handwritten initials H.M and price £3/-/-.*

Tiles: 6 square (153 square)
Framed panel: $19\frac{3}{4} \times 13\frac{1}{2} \times 1$ (503×343×25)

Given in 1941 by Mr H. C. Mossop. 1941.97

Design: V&A E 6084-1917, design for a tile no.684.

H. C. Mossop, a London solicitor, was interested in pottery and collected De Morgan's work. His sister had painted in De Morgan's studio in the late 1870s and early 1880s. Mossop, noting that De Morgan was already well represented in the Victoria & Albert and the Staffordshire Museums, gave several pieces from his collection to what he described as 'important museums' including Leicester and Cheltenham. He wrote to the curator: 'in closing my house I came across several tiles and panels, the work of the late Wm De Morgan … I think … they should go to Museums rather than private collections … their character is like the work of no other man'.[1] He thought that De Morgan's 'best work went into wall tiles. So I suggest 3 small panels … one of so-called Persian style & two of somewhat Pre-Raphaelite feeling, as befits the friend of Wm. Morris'.[2]

Panels such as this were sold by Morris & Company as framed pictures or for fireplaces. This panel in its original frame probably dates from the 1920s when the company moved to its Hanover Square

premises. Earlier versions produced at Chelsea were made using tile blanks from the Architectural Pottery Company. The design, known as *Chatterton*, uses an Islamic palmette motif.
See Col.Fig.33.

1. Letter from H. C. Mossop to the Curator, 24 February 1941, CAGM.
2. Letter from H. C. Mossop to the Curator, 28 February 1941, CAGM.

5* Panel of six tiles

Designed by William De Morgan and made by William De Morgan & Company, first produced about 1872-81.

Earthenware with a white slip and painted decoration.
Sealed in an oak frame.

Tiles: 8 square (203 square)
Framed panel: $25\frac{5}{8} \times 17\frac{1}{4} \times 1\frac{1}{8}$ (650×440×30)

Given in 1941 by Mr H. C. Mossop. 1941.56

Design: V&A E 6050-1917, design for a tile no.650.

This is the *Double Carnation* design.
See Col.Fig.39.

6* Panel of six tiles

Designed by William De Morgan and made by William De Morgan & Company, first produced about 1872-81.

Earthenware with a white slip and painted decoration.
Sealed in stained ramin frame (this is replacement frame).

Tiles: 8 square (203 square)
Framed panel: $25\frac{5}{8} \times 17\frac{1}{2} \times 1\frac{3}{4}$ (650×443×45)

Given in 1941 by Mr H. C. Mossop. 1941.55

Design: V&A E 5080-1917, design for a tile panel no.580.

This pattern, the *B. B. B.*, was one of De Morgan's most successful designs, named after Barnard, Bishop & Barnard, a Norwich firm which made cast-iron fireplaces and sold a range of tiles to be used with them. The tiles were designed to be arranged in a particular sequence (rather than in strict repetition), in pairs with the flowers facing inwards and in the row above outwards, creating interweaving stems and a sense of movement through the flower heads.
See Col.Fig.40.

7* Dish

Designed by William De Morgan and probably decorated at Orange House, Chelsea, about 1880.

Thrown and turned earthenware with a white slip and painted copper lustre decoration. Unmarked.

$2 \times 14\frac{1}{4}$ diam. (50×362 diam.)

Given in 1939 by Mr and Mrs S. D. Scott. 1939.155

The dish also has decoration of stems of daisy-like flowers and foliage on the back. The main product at Chelsea was tiles, although some pots were also produced usually by decorating pottery blanks. The dish was probably supplied as a blank by the firm Davis of Hanley, which provided De Morgan with '14-in rice dishes'[1] which the company made for export to the East. H. C. Mossop describes De Morgan as being '… most scrupulous about marking tiles; very careless about pots and bowls.'[2] This may have been because it would have been difficult to use the impressed mark normally used on a blank.
 See Col. Fig. 38.

1. Greenwood, M., *The Designs of William De Morgan*, Ilminster 1989, p.8.
2. Letter from Mossop to the Curator, 1 March 1941, CAGM.

8* Tile

Probably designed by Halsey Ricardo, based on a drawing by William De Morgan and made by William De Morgan & Company at Sand's End Pottery, Fulham, 1888-97.

Hand-made earthenware tile with cobalt and gold and copper lustre glazes.
Impressed stamp on back of tile with rose and WM DE. MORGAN & CO. SAND'S END POTTERY FVLHAM.

$6\frac{1}{16} \times 6\frac{1}{4} \times \frac{3}{8}$ ($156 \times 157 \times 10$)

Given in 1941 by Mr H. C. Mossop. 1941.52

Design: V&A E 1074-1917, design for a tile no.174, Chelsea.

A drawing for this *Raised Lion* design of a male and female lion on a quartered background, inspired by heraldic beasts, was made by De Morgan whilst at Chelsea. Ricardo was probably responsible for the relief design of this pattern.
 See Col. Fig. 32.

9* Tile

Designed by William De Morgan and made at Sand's End Pottery, Fulham, 1888-97.

Hand-made earthenware tile with a white slip and painted copper lustre design.
Impressed stamp on back of tile with wing design and WM DE MORGAN & CO SAND'S END POTTERY *(partly obliterated).*

$6\frac{1}{4} \times 6\frac{1}{4} \times \frac{1}{2}$ ($159 \times 159 \times 12$)

Given in 1941 by Mr H. C. Mossop. 1941.50

De Morgan devised an ingenious technique for producing tiles in repetition without losing the quality of hand-painting. The outline design was traced on thin paper and then coloured and glazed. The paper was placed face down on the slip-coated tile; when fired the paper was reduced to a thin layer of ash and the slip, ash, colours and glaze fused. This did not work with lustre and the outline would be stencilled onto the tile, the pattern enlivened by strokes of hand-painting. Here the outline of the vine and grapes has been stencilled and the details of the grapes and wavy lines around the vine are hand-painted.
 See Col. Fig. 38.

10* Tile

Designed by William De Morgan and made at Sand's End Pottery, Fulham, 1888-97.

Hand-made earthenware tile with a white slip and painted decoration.
Impressed stamp on back of tile with rose and WM DE MORGAN & CO SAND'S END POTTERY FVLHAM.

$6 \times 6 \times \frac{5}{8}$ ($152 \times 152 \times 16$)

Given in 1941 by Mr H. C. Mossop. 1941.51

Some of De Morgan's early designs were influenced by William Morris. The pattern for this tile *Bedford Park Daisy* derives from Morris's wallpaper *Daisy* (1864) and his *Columbine* design for tiles.
 See Col. Fig. 32.

11 Tile panel

Designed by William De Morgan and made at Sand's End Pottery, Fulham, 1888-97.

Hand-made earthenware tiles with a white slip and painted design.

Impressed stamp on back: W. DE. MORGAN.
In sealed stained oak frame (the frame is a replacement).

Tiles: 3 square (76 square)
Framed panel: $4\frac{1}{8} \times 7\frac{1}{4} \times \frac{3}{4}$ ($105 \times 184 \times 20$)

Given in 1941 by Mr H. C. Mossop. 1941.49 a & b

Mossop described this panel of two alphabet tiles, with the letters I N, as '… made so that children in the nursery should learn their letters in the fireplace & so without tears'.[1]
 See Col. Fig. 32.

1. Letter from H. C. Mossop to the Curator, 28 February 1941, CAGM.

12* Cream jug

Made by William De Morgan & Company at Sand's End Pottery, Fulham, 1888-97.

Thrown earthenware with a white slip and cobalt glaze.
Impressed stamp on base: DM *above small tulip.*

$3\frac{1}{4} \times 3\frac{3}{4} \times 3$ ($80 \times 95 \times 76$)

Given in 1941 by Mr H. C. Mossop. 1941.54

The company did not make many thrown pots until around 1880 and continued to decorate pottery blanks as well. This may be an experimental glaze, although the poor quality of the throwing is difficult to explain. H. C. Mossop gave a vase collected from De Morgan's Works in 1907 which was an experimental piece of lustre firing, although on a Staffordshire blank, to Leicester Museum.[1]
 See Col. Fig. 32.

1. Letter from H. C. Mossop to Trevor Thomas, Curator of Leicester Museum, 4 April 1941, Leicestershire Museums, Arts and Records Service.

13* Vase

Designed by William De Morgan and made at Sand's End Pottery, Fulham, about 1890.

Thrown earthenware with painted decoration. The vase has a rounded base with no foot-ring (glaze is coming away from the base). It is supported on a wooden stand (probably not original). Unmarked.

$8 \times 7\frac{3}{4}$ diam. (230×197 diam.)

Given in 1982 by Mrs Constance Tangye.
1982.1075

Constance Tangye was the daughter-in-law of Allan Tangye a Birmingham solicitor who collected Arts and Crafts furniture.

This vase was thrown at Sand's End Pottery. De Morgan's designs for thrown pots have been criticised by later potters for their weak shapes. The vase is decorated with a Persian design of roses in panels in Persian colours.

See Col.Fig.32.

George Washington Jack (1855-1932)

14 Plaster panel

Designed by George Jack in about 1893; this cast made in the London workshop of Laurence Turner in about 1900.

Plaster cast from a mould, with some traces of painted decoration.

22×16 (558×407)

Given in 1996 by Miss Joyce M. Winmill.
1996.168

Record: Drawing of a chimney breast and grate by Jack from the 1893 Arts and Crafts Exhibition, The Studio, Vol.2 1893, p.16.

The donor is the daughter of the original owner, Charles Canning Winmill. For information about Winmill himself see p.142.

This cast plaster panel of a seagull relates to a chimney breast and grate designed by George Jack and included in the 1893 Arts and Crafts Exhibition (Fig.123). Jack and his wife also exhibited embroideries in that show.

Jack designed decorative plasterwork from about 1890 and wrote a short article on the subject in 1908.[1] He made the point that while one should experiment and look for novelty, plaster was primarily a cheap material and over-elaboration was an anomaly. His designs fall between the very soft-edged two-dimensional plasterwork of Ernest Gimson and George Bankart and the more three-dimensional, sculptural work of Stephen Webb and Walter Gilbert.

The chimney breast features a decorative plaster overmantel with seven seagulls in flight. While praising the 'quiet unostentation' of the main design, *The Studio* commented on the 'uneasy and painfully naturalistic treatment of the flying gulls'.[2] His plasterwork for

Fig.125 **Cat.14**

the dining room at Minsted, Midhurst, Sussex, designed by Mervyn Macartney in 1904, included a succession of birds and animals modelled in depth and detail.

This panel was probably cast from one of the original models in Laurence Turner's studio in London. Turner's studio executed plasterwork for a number of designers but he also designed work himself. In a letter dated 27 November 1942 to Grace Hunter, a friend and wife of the Bishop of Sheffield, Winmill wrote, 'The wings are the most perfect pieces of modelling that I possess. Jack used during the last war to spend hours on the embankment sketching the gulls.'[3]

See Fig.123.

1. 'Modern British Plasterwork II' in *Architectural Review*, Vol.23 1908, pp.277-8; illustrations of his work also appear on pp.224-5.
2. *The Studio*, Vol.2 1893, p.16.
3. Quoted by Winmill, J.M. in *Charles Canning Winmill: An Architect's Life*, London 1946, p.116.

William Morris (1834-96)

15* Curtain fragment

Designed by William Morris in 1875 and made by Morris & Company about 1900.

Woven wool. This piece is hemmed at both ends with a 7in (178mm) border down one side. It is badly faded and worn.

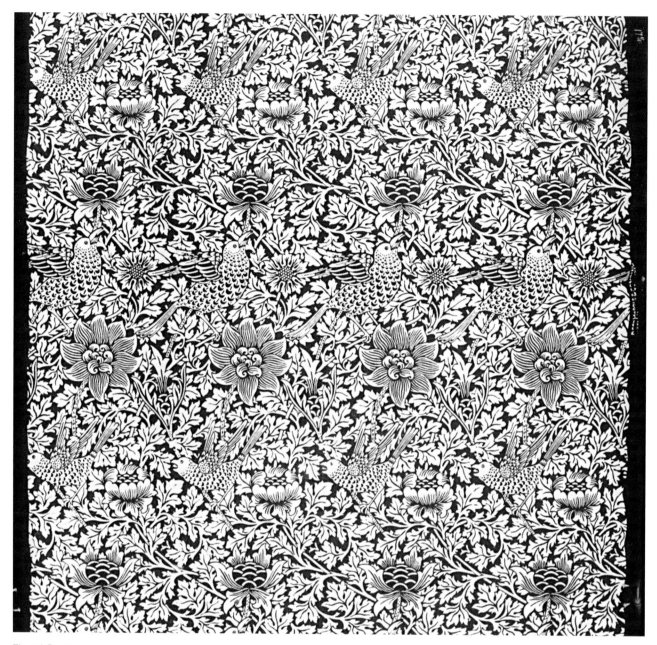

Fig.126 **Cat.17**

$76\frac{3}{4} \times 40$ (1950×1150)

Given in 1994 by Cheltenham College. 1998.257

This design, *Tulip and Lily,* was originally produced by Morris for woven carpets. An example of one such carpet can be seen in a photograph of an interior of Emery Walker's London home at 7 Hammersmith Terrace (see Fig.124). This fragment was part of the organ curtain at Cheltenham College, in use until 1994. It was in very poor condition and only this piece was kept.

　See Col.Fig.36.

16* Curtain

Designed by William Morris in 1876 and made by Morris & Company.

Woven wool.

84×66 (2132×1677)

Purchased in 1989 from Paul Reeves for £1400 with 50 per cent grant from the V&A Purchase Grant Fund. 1989.882

Tulip and Rose design.
　See Col.Fig.35.

17 Fabric length

Designed by William Morris in 1881 and made by Morris & Company about 1917-40.

Indigo discharge print on cotton. The length appears in unused condition and is unsewn. Printed mark on the selvedge: Regd. Morris & Company.

$87\frac{3}{4} \times 37\frac{1}{2}$ (225×95.4)

Purchased in 1989 from Paul Reeves Ltd for £120. 1989.883

Bird and Anemone design; the printed mark suggests the later date.

18 Two wallpaper pieces

Designed by William Morris in 1892 and
printed by Jeffrey & Company, c.1900.

18×21 (457×533) and 42×21 (1066×533)

*Given in 1949 by Freda Derrick and in 1969
by Philip Smith, executor of the estate of
Freda Derrick. 1949.8 and 1969.67*

Freda Derrick was an artist and writer
who lived in Cheltenham. Both these
pieces of wallpaper came from her home.
She was passionately enthusiastic about
the countryside and traditional crafts and
a supporter of the twentieth-century craft
revival. She wrote about Morris and
Kelmscott in a number of her books
and articles. In *Cotswold Stone* she saw
Morris's designs reflected in the flowers
of Kelmscott Manor: 'For at the old home
of William Morris, art and nature were
companionable in a way that they have
been and ought to be, but which is so rare
to-day that I found it as bewildering as a
dream.'[1]

Blackthorn was one of Morris's later
designs for wallpaper. It features typical
flowers of the English countryside:
daisies, fritillaries, violets and blackthorn,
and shows Morris reverting to the
naturalistic designs of his early work.

Despite his diffident comment
that printing patterns on paper for
wallhangings was only a 'quite modern
and very humble but, as things go, useful
art',[2] Morris developed an impressive
capacity to design flat repeating patterns.

His first design for wallpaper was
printed at his workshop in Red Lion
Square with the help of Philip Webb
using the experimental method of oil-
based paints on etched zinc plates in
an attempt to achieve transparent washes
of colour. Subsequently Morris reverted
to the woodblock process; blocks for the
designs were cut by the established firm
of Barrett's in Bethnal Green Road, East
London. By 1890, Morris & Company
offered its customers a choice of fifty-
three designs.

1. Derrick, F., *Cotswold Stone*, London 1948,
 p.47.
2. Morris, W., 'The Lesser Arts of Life', 1882.
 Morris, M. ed Collected Works of William
 Morris, Vol.XXII, London 1914, p.260.

George Heywood Maunoir Sumner (1853-1940)

19* Cup and cover

Designed by Heywood Sumner and
made by James Powell & Sons,
Whitefriars, London, in 1898.

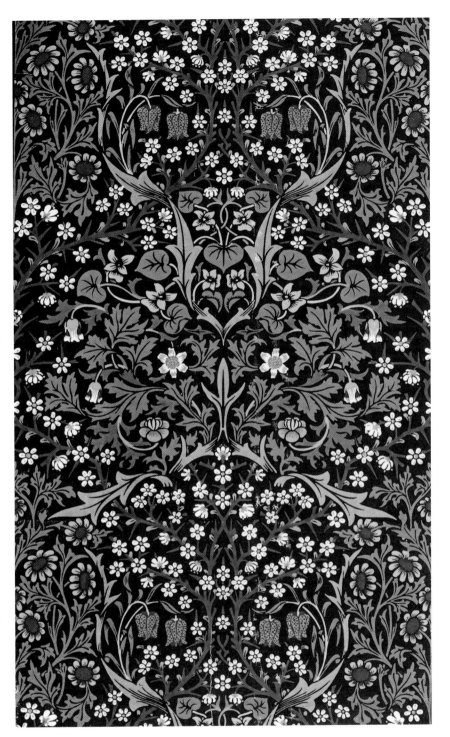

Fig.127 **Cat.18**

*Flint glass, cut and polished, the bowl
engraved and gilt. Engraved:* 'GHG MES
July 26 AD 1898'.

12¾×4¾ diam. (324×121 diam.)

*Purchased in 1996 from Paul Reeves for
£7000 with the support of the V&A Purchase
Grant Fund and the National Art Collections
Fund. 1996.583*

*Design: Museum of London, 80.547/3251,
folios 105-107.*[1]

*Record: Museum of London, Powell Ledger
80.547/3306.*[1]

The piece was designed to celebrate
the golden wedding anniversary of his
parents, George and Mary Sumner.
It remained in the family's possession
until recently.

91

Designs in Harry Powell's notebooks show four engraving motifs based on plant forms annotated 'Heywood Sumner' by Powell. Sumner produced these for Powell without payment; instead he received material for his sgraffito wall decoration.[2]

See Col.Fig.41.

1. The Powell pattern book about 1903-10, pattern no.1030 and 1030A, illustrates a flint, cut and polished, engraved and gilt bowl designed by Heywood Sumner. Also recorded is the price of £2. 10. 0.
2. Recorded in one of Harry Powell's notebooks, quoted by Lisa Kent, unpublished thesis on Whitefriars Glassworks, London University 1987. Information provided by Paul Reeves.

Philip Webb (1831-1915)

20* Six white-wine glasses

Designed by Philip Webb, probably in 1862-3, and made by James Powell & Sons, Whitefriars, London in 1863-73 or about 1900.

Hand-blown and part mould-blown glass. One of the glasses has a small chip on the rim.

$5 \times 2\frac{3}{4}$ max. diam. (127×70 max. diam.)

Purchased 28.10.1998 at Sotheby's, Billingshurst, Lot 850, for £130. 1998.256

Webb first designed table glass with enamel-painted decoration for Morris's personal use in 1860. He looked for inspiration to seventeenth- and eighteenth-century North European glass, particularly German and Venetian examples which he would have seen at the South Kensington Museum (now the V&A). These designs were amended and simplified to form the basis for glasswares made by Powell & Sons and sold exclusively by Morris, Marshall, Faulkner & Company. Morris's firm sold the glassware from 1861 to 1873. After 1900, some of Webb's designs were put back into production.

An identical glass was bequeathed to the V&A by May Morris (C81.-1939).

See Col.Fig.42.

The Martin Brothers

Charles Douglas Martin, Edwin Bruce Martin, Robert Wallace Martin, Walter Fraser Martin

The Martin Brothers are regarded as the first studio potters and have been seen to personify the Arts and Crafts ideal of the artist-craftsman. 'William Morris would have delighted in these men ... and he would have loved to hear Wallace Martin, clay in hand discussing enthusiastically problems of life, commingled with a deeply informed technical interpretation of his craft'.[1]

Robert Wallace Martin (1843-1924) trained as a stone-mason and then worked as a sculptor's assistant. His early work included assisting with the carvings for A.W.N. Pugin's Houses of Parliament. His younger brothers, Edwin and Walter (1860-1915 and 1857-1912), trained at Lambeth School of Art and worked at the Doulton Studio. In 1873 the brothers set up their own studio in Fulham, using the kiln at Fulham Pottery to fire their pots. In 1877 they moved to premises in Southall where they had their own kiln. Wallace designed most of the pottery and decoration, although by the 1880s he began to concentrate more on modelling. Walter threw the larger pots and acted as the chemist. Edwin was the main decorator. In the 1880s, under the influence of the Arts and Crafts architect and collector Sidney Greenslade, he began to develop his own style, designing and throwing vases with relief and modelled decoration. The brothers' work was collected by many patrons, including establishment figures and artists. It was sold in their showroom in Holborn run by the fourth brother Charles (1846-1910). Later, from around 1900, their pots were also sold alongside work by other Arts and Crafts designers in the gallery run by Montague Fordham and later Edward Spencer, owners of the Artificers' Guild.
HB

1. Jackson, H., 'Martinware' *TP's Magazine*, 1910, quoted in D.S.Skinner and J.Evans, *Art Pottery: The Legacy of William Morris*, Stoke-on-Trent 1996, p.7.

21* Figure of a bench boy

Designed and made by Robert Wallace Martin in 1885.

Slab-built and modelled salt-glazed stoneware.
Incised inscription around sides of base slab:
'Bench Boy. Wedging Clay. R W Martin Ss.. 6.1885. London. &. Southall.'

$6\frac{1}{2} \times 4 \times 3$ (165×100×75)

Given in 1982 by Professor and Mrs Hull Grundy. 1982.1224

The Bench Boy was made to accompany R. W. Martin's figure of a thrower (Cat.26), together with a third figure, *The Wheel Boy*. The three are also known on a plaque.
See Fig.16, Col.Fig.44.

22* Vase

Designed and made by Robert Wallace Martin and brothers in 1886.

Thrown and turned stoneware with incised decoration and a salt glaze. Firing cracks to base.
Incised inscription on base:
5-1886
R W Martin & Bros
London & Southall

$9\frac{3}{16} \times 4\frac{1}{8}$ diam. (237×105 diam.)

Purchased in 1937 from Mr T. C. Nixon, Promenade, Cheltenham, for 15s from the Friends Fund. 1937.306

The design of prunus-like and star-shaped flowering branches and butterflies is typical of the Japanese-influenced floral designs produced by the Martin Brothers from around 1885 to 1900. The brothers were inspired by the fashion for Japanese design and collected Japanese wood-block printed books from the 1870s.

Nixon's was a reputable china and glass dealer on the Promenade in Cheltenham. In 1924 they were advertising new china and 'inexpensive & decorative pottery'.[1]
See Col.Fig.44.

1. J.Burrow & Co Ltd, *About and Around Cheltenham*, Gloucester 1924, p.90.

23* Vase

Probably designed and made by Edwin Bruce Martin in 1893.

Thrown salt-glazed stoneware with incised and applied relief decoration of raised nodules.
Incised inscription on base:
10-1893
Martin Bros=
London & Southall

$10\frac{1}{2} \times 7$ diam. (267×176 diam.)

Purchased in 1938 from Mr T.C. Nixon, Promenade, Cheltenham, for £1 from the Friends Fund. 1938.69
See Col.Fig.44.

24* Vase

Probably designed and made by Edwin Bruce Martin in 1894.

Thrown salt-glazed stoneware with modelled and applied relief decoration of raised nodules.
Incised inscription on base:
7-1894
Martin Bros
London & Southall

$5\frac{5}{8} \times 3\frac{3}{8}$ diam. (143×92 diam.)

Given in 1938 by Miss M. Garford. 1938.219
See Col.Fig.44.

25* Tobacco Jar

Designed and made by Robert Wallace Martin in 1899.

Modelled stoneware with a salt glaze. Modelled in two parts, the head of the bird forming the lid which pushes into the jar forming the body of the bird. A piece of leather has been glued to the neck-fitting to ease the push fit. The jar is fitted to an ebonised wood base.
Incised inscription in brown on neck fitting of lid:
R W Martin Bros
London & Southall
11-1899
Incised inscription in black on side of pot below bird's tail:
Martin Bros - London & Southall 11-1899

$12\frac{1}{4} \times 4\frac{5}{8} \times 4\frac{1}{16}$ (231×117×113)

Purchased in 1964 from W. J. Hoggett for £7 10s od by the Friends of the Museum. 1964.87

Robert Wallace Martin began to design and make bird jars around 1879-80. The early birds in particular had human characteristics and this example has a smiling face.
See Col.Figs 44, 45.

26* Figure of a thrower

Designed and made by Robert Wallace Martin in 1900.

Modelled stoneware.
Incised in brown on back of potter's wheel:
RWM *(monogram)*
Southall
12
1900
Incised in brown on side of base slab:
R W Martin & Bros
London & Southall

$6\frac{3}{4} \times 2\frac{3}{4} \times 3\frac{1}{4}$ (170×70×82)

Given in 1982 by Professor and Mrs Hull Grundy. 1982.1223

The Thrower was first modelled in 1879 by Robert Wallace Martin and was repeated many times.
See Fig.16, Col.Fig.44.

27* Vase

Designed and made by the Martin Brothers in 1903.

Thrown and turned stoneware with incised decoration and a salt glaze partially covered by a matt green glaze. Firing crack to neck.
Incised inscription on base:
11.1903
Martin Bros
London & Southall

$9\frac{5}{8} \times 6\frac{3}{4}$ diam. (243×172 diam.)

Purchased in 1967 from Arthur West, The Strand, Dawlish, for £9. 1967. 97

From 1885 to 1900 many of the Martin Brothers' designs were derived from Japanese and Renaissance sources. By the 1890s dragons which had originally been used as part of a Renaissance scheme became a decorative motif in themselves.
See Col.Fig.44.

Charles Francis Annesley Voysey (1857-1941)

Voysey's work as an architect and designer of interiors encompassed a wide range of items needed for an attractive and functional home, including furniture, textiles and metalwork. The genesis of his metalwork appears to have been rather similar to Ernest Gimson's experience; he needed suitable handles, hinges and locks for architectural schemes and then moved on to useful freestanding objects, such as teapots, inkwells, cutlery, and so on. He is known to have designed only one piece of jewellery, a brooch or pin, sadly untraced.

Like most of his early work before his return to overtly gothic forms, Voysey's metal designs were elegant, carefully composed shapes, well-suited to the spare framework provided by his woodwork and furniture. Sometimes, as in the Kelmscott 'Chaucer' cabinet,[1] the metalwork provides the entire decoration of the piece, but often the metal fittings are as severe as the whole. In either case, the fact that the designer has given thought to the fittings adds immeasurably to the success of the finished piece and the enjoyment of the user.

As with his work in all media, once he had found a satisfactory form Voysey was inclined to repeat his metalwork designs, sometimes making minor adjustments but often supplying exactly the same items to a number of clients. This was clearly partly the result of his mode of working with several trusted makers who supplied goods to the standards Voysey expected. In the case of metalwork, it must also have been because of the nature of the manufacturing techniques involved; many of the pieces by Thomas Elsley were cast, requiring a set of prototypes and moulds. Because they were made in this way, they are smooth and polished as befits metal formed in its molten state. In contrast, items worked by hand show evidence of this. Voysey was not particularly interested in promoting the idea of handcraft, however, and evidence of handwork is less seen than in the work of Ashbee or Gimson. He delighted in finding the elegant solution to any design problem and the copper pen tray (Cat.30) is a good example of his simple but ingenious ideas.

Thomas Elsley and Company, London, is the best-known of Voysey's collaborators in this field, and he also had work executed by Barnard & Sons, Longden & Co, H. J. L. J. Massé, R. Ll. B. Rathbone, William Bainbridge Reynolds and possibly by J. Higgins of Pimlico.[2]

AC

1. See *GCF*, pp.68-9, Cat.8.
2. Higgins is mentioned by Brandon-Jones, J. et al., *C. F. A. Voysey: Architect and Designer 1857-1941*, London 1978, p.134, Cat.E3.

Fig.128 *Group of metalwork by C. F. A. Voysey shown at the 1903 Arts and Crafts exhibition, London.*

28* Handle

Designed by C. F. A. Voysey in about 1895-1900 and made by Thomas Elsley & Co.

Cast brass. There appears to be a surface-coating since it is not possible to clean the piece.
Stamped on the back of the terminal:
ELSLEY'S

$8\frac{1}{8} \times 1\frac{7}{8} \times 1\frac{15}{16}$ (206×47×49)

Purchased in 1992 from John Beer for £150. 1998.129

This type of handle appears as No.690 in an undated catalogue of metal fittings made by Elsley to Voysey's designs.[1]
See Col.Fig.46.

1. British Architectural Library collection. See Brandon-Jones, J. et al., *C. F. A. Voysey: Architect and Designer 1857-1941*, London 1978, pp.136 & 139, Cat.E20.

29* Inkwell

Designed by C. F. A. Voysey in about 1898 and possibly made by R. Ll. B. Rathbone.

Sheet brass soldered together, with hammered lids. Clear glass containers for the ink.
No marks.

$3\frac{1}{8} \times 10\frac{3}{8} \times 5\frac{15}{16}$ (76×263×151)

Purchased in 1992 from John Beer for £1400 with a 50 per cent grant from the V&A Purchase Grant Fund. 1998.130

A photograph of a group of metalwork shown at the 1903 Arts and Crafts exhibition includes this form of inkwell and a pen tray like Cat.30, but it seems to have been designed earlier.[1] Versions of this design exist with a pen tray on which the inkwell sits, with brackets to hold pens, or with a single inkpot. It seems to have been made in quite large numbers and nothing is known of the history of this example. A similar one can be seen in a photograph of Haydee Ward-Higgs seated at her desk.[2]

An example catalogued by Fischer Fine Art in 1986 is stamped 'RATHBONE', '672' and '1900'.[3]
See Col.Fig.46.

1. Shirley Bury dates it to *c.*1898 in Brandon-Jones, J. et al., *C. F. A. Voysey: Architect and Designer 1857-1941*, London 1978, p.134, Cat.E7. Photograph from 1903 exhibition reproduced in *The Studio*, Vol.28 1903, p.28.
2. Reproduced in *GCF*, p.65.
3. Tilbrook, A. J., *Truth, Beauty and Design: Victorian, Edwardian and Later Decorative Art*, London 1986, p.56.

30* Pen tray

Designed by C. F. A. Voysey in about 1900 and possibly made by H. J. L. J. Massé, about 1903.

Sheet copper folded into rectangular form, with a heart cut out of each long side.
No marks.

$1\frac{11}{16} \times 9\frac{13}{16} \times 2\frac{1}{4}$ (44×249×57)

Purchased in 1981 with seven pieces of furniture via the Fine Art Society and Michael Whiteway. The acquisition of the collection for £61,000 was supported by a grant from the V&A Purchase Grant Fund (50 per cent) and contributions from the National Art Collections Fund, the National Heritage Memorial Fund and the W. A. Cadbury Charitable Trust. 1981.318

This was one of many items bought from Voysey by William and Haydee Ward-Higgs for their houses in London and Bognor Regis, West Sussex. It is likely that it was used with a writing desk depicted in a photograph of Haydee Ward-Higgs taken in about 1908,[1] though the photograph does not show it.

It is not known when the piece was bought by the Ward-Higgses, but it is possible that it was the pen tray by Voysey shown at the 1903 Arts and Crafts exhibition priced at 10s.[2] In the catalogue this was credited to H. J. L. J. Massé, the Secretary, and later historian, of the Art Workers' Guild.

The ingenious design simply uses sheet metal folded like card, with the ends neatly rolled over, and seems to be the metalwork equivalent of furniture designs by Voysey in which he specified that no nails or screws were to be used in construction. When it was exhibited at the Batsford Gallery in 1931 it was said that it could be made by children since it could be cut by hand and needed no soldering.[3]
See Col.Fig.46.

1. Reproduced in *GCF*, p.65.
2. V&A AAD, A&CES 1/99-1980 Cat. Recess no.12, hh. A photograph of a group of Voysey's metalwork including this piece was printed in *The Studio*, Vol.28 1903, p.28.
3. Catalogue of an *Exhibition of the Works of C. F. A. Voysey*, 2-17 October 1931, cited by Brandon-Jones, J. et al., *C. F. A. Voysey: Architect and Designer 1857-1941*, London 1978, p.135.

Charles Robert Ashbee (1863-1942) and the Guild of Handicraft

C. R. Ashbee, Fred Partridge, John Williams

As a young man at Cambridge in the early 1880s, C. R. Ashbee discovered Ruskin and found friends who shared a vision of a better world through social action and the arts. He trained as an architect with G. F. Bodley and went to live in a University Settlement at Toynbee Hall in the East End of London. There he started a Ruskin reading class and made plans for a community of craftworkers. In 1888 Ashbee formed the Guild and School of Handicraft to undertake 'Simple but high class work in wood and metal (repoussé) …'.[1]

Among the first members were experienced craftworkers, John Williams and John Pearson, and early Guild work was often made by them, of copper or brass, hammered and chased into bold designs of fish, birds, galleons and flowers. The technique was easy for beginners and therefore ideal for classes, so it was popular with the Home Arts and Industries Association as well as in the School of Handicraft. It also resulted in dramatic items such as chargers and vases which made impressive display pieces and were frequently shown at Arts and Crafts exhibitions in London.

From about 1890 the Guild began to experiment with silver and precious metals for domestic wares and jewellery. Initially, casting methods were used to create sculptured feet, handles, knops, and decorative details, while bowls were usually of hammered sheet metal. Casting remained important to the Guild, the preparation of figures and other portions of pieces being part of the job of the carvers, but increasingly items were made entirely by hammering and bending silver sheet and wire. Ashbee liked the rippling surface effect of hammer marks which had not been polished smooth, as they were in trade silver of this date, and this became characteristic of his work, much copied and exaggerated by others. It was not purely a decorative effect, but celebrated the craft skills of the metalworkers, while the sinuous curves of handles and stems reveal the essentially ductile nature of the material. Pierced and chased decoration of foliage or flowers and the inclusion of richly coloured, cabochon-cut, semi-precious stones also became distinctive elements in Ashbee's designs for metalwork and jewellery.

By 1902, the Guild had a high reputation for its products. The Guild of Handicraft had its own shop in Brook Street in the West End and workshops established in 1891 at Essex House, a fine mansion dating from about 1700 in East London. When the lease of Essex House expired in 1902, Ashbee took the opportunity to execute a cherished plan, the idea of moving 'back to the land'. After visits to possible sites and consultations among the Guildsmen, it was decided to move to Chipping Campden in Gloucestershire, where ideal workspace was available in a redundant silk mill.

An influx of Cockneys proved something of a shock for

Fig.129 'Workers in silver at Essex House' drawn by George Thomson for 'The Studio', Vol.12 1897.

the people of this remote country town, but gradually the Guild was assimilated. Ashbee undertook the restoration and building of cottages, organised lectures and practical classes, initiated theatricals, and attended to the physical health of the Guild and town by promoting exercise classes, bicycling, and swimming. Perhaps too much energy went into the communal activities and not enough into the business, or maybe the collapse of the Guild was inevitable now that it was far away from its London customers, but in 1908 after only six years in Chipping Campden, the Limited Company of the Guild of Handicraft was forced to close because of lack of capital. Ashbee himself believed that a major element in its demise was undercutting of price by amateurs and by commercial firms, in particular Liberty & Company. But it would seem that he had been too optimistic in his schemes and too taken with the idea of the country to recognise the advantages of his urban base.

All was not lost, however. A number of Guildsmen continued their work in Chipping Campden (see p.147), while others found careers in teaching and craftwork elsewhere. Ashbee carried on writing and for a few years more published via his Essex House Press in collaboration with Ananda Coomaraswamy. The magnificent volume of elegant lithographs of Guild silver, entitled *Modern English Silverwork*, was a major achievement in 1909. From 1917 to 1922 he worked in Egypt and Jerusalem and then returned to a quiet retirement in Kent, recording the history of the Guild and distilling his extensive journals into six typed volumes of memoirs.

Fred Partridge and John Williams were skilled and independent craftsmen who left the Guild before its closure in 1908, and items designed by them working individually are included below, after the pieces by Ashbee.
AC

1. Letter quoted by Crawford, A., *C. R. Ashbee: Architect, Designer and Romantic Socialist*, New Haven and London 1985, p.29.

Charles Robert Ashbee (1863-1942)

31* Ten leather panels

Designed by C. R. Ashbee and made by the Guild of Handicraft in London in 1892.

Brown leather with embossed and tooled designs, coloured in red and grey and gilded. Eight panels are of highly stylised plant forms, probably pomegranates, one of the Guild pink, and one of a galleon under sail, the 'Craft of the Guild'. The wooden frame in the photograph was made in the Museum for display.
No marks.

$37\frac{1}{2} \times 20\frac{1}{2}$ (953×520) (sizes vary)

Purchased in 1982 at Christie's via the Fine Art Society for £817.87 with a 50 per cent grant from the V&A Purchase Grant Fund. 1982.1216

There were originally twenty panels in this frieze, made for the sitting room of a house at Wormelow Tump, Herefordshire. They were sold at Christie's and the Museum came to an arrangement to buy the two distinctive Guild symbols and samples of the eighteen plant designs, while the remainder went to a private buyer.

The original client was James Rankin MP, who ordered panelling, decorative painting, metalwork and furniture for an extension to his house, Bryngwyn, as well as these panels, at a total cost of £350. Pevsner describes Bryngwyn as $\frac{3}{4}$ mile south-east of Much Dewchurch, '1868. Tudor, stone, gabled, with an asymmetrical front, but all the same like a school or an institution'.[1] This was Ashbee's earliest-known scheme of leatherwork and pre-dates the decoration of his mother's house at 37 Cheyne Walk (Figs 17a and b), with its similarly sinuous designs in embossed leather carried out by William Hardiman, who could have been responsible for this set.[2]

Ashbee was very interested in the craft of tooled leather working, presumably partly because it was a relatively easy skill for beginners to learn and partly because the work has a similar aesthetic appeal to the repoussé metalwork carried out by the Guild in its early years. It was, in addition, a form of decoration which served the art of architecture. There may also be a connection with the fact that this kind of leatherwork was primarily associated with Spain and Ashbee's father was a collector of books on Cervantes, though his relationship with

his father was difficult and they were estranged from 1893. At this time there was a revival of such leather decoration in Germany and some interest in Britain (see p.18). Work by Walter Crane and others was produced by Jeffrey & Company and shown at Arts and Crafts exhibitions.

The imagery used is typical of Ashbee's designs. Sinuous, almost Art Nouveau forms with floating circles above are reminiscent of numerous Tree of Life motifs in his work at this date and later, while the 'Craft of the Guild' represents the uncertainties of life's journey. The Guild pink was derived from manuscripts and early printed books and from the surprise blossoming of pinks in the garden at Essex House in the Guild's first year there.[3]
See Col.Fig.47.

1. *Herefordshire*, Harmondsworth 1963, p.259.
2. See Crawford, A., *C. R. Ashbee: Architect, Designer and Romantic Socialist*, New Haven and London 1985, pp.298-300.
3. For more detail on the emblems of the Guild, see Crawford, *Op.cit.*, pp.221-31.

32* Mustard pot and lid

Designed by C. R. Ashbee and made by the Guild of Handicraft in London, about 1893.

Cast and hammered silver with cast paw feet. Six-petalled flower knop on lid set with a cabochon-cut opal. Punched dots on rim of lid. Gilt interior.
No hallmarks.

$3\frac{3}{8} \times 3\frac{1}{8}$ (86×80)

Purchased from Tadema, London, in 1984 for £330 with a 50 per cent grant from the V&A Purchase Grant Fund. 1984.468

This is an early piece by the Guild and it, or another very similar, appears in a photograph of items used in the dining room at Ashbee's mother's house in Cheyne Walk, Chelsea.[1]

It is not absolutely clear whether it is for mustard or for salt since the Guild made similar items described in early catalogues as 'salts', but the fact that it has a hole in the lid for a spoon suggests that it is for mustard. Mrs Ashbee is also known to have had a salt made of onyx and silver.[2]

The cast feet are typical of the Guild's early metalwork, while the delicate flower motif of the knop, set with a cabochon-cut stone, indicates the direction in which the silverwork was moving.
See Col.Fig.52.

1. *The Studio*, Vol.5 1895, p.69.
2. Illustrated in Crawford, A., *C. R. Ashbee: Architect, Designer and Romantic Socialist*, New Haven and London 1985, p.321.

33* Sporting cup or sugar basin

Designed by C. R. Ashbee in about 1893 and made, or hallmarked, by the Guild of Handicraft in 1902.

Hammered and cast silver.
Hallmarked on bowl: GofH Ltd, sterling, London, 1902.

$6\frac{3}{8} \times 8\frac{3}{8}$ (162×212)

Given in 1983 by Professor and Mrs Hull Grundy. 1983.191

It is possible that this is a cup made in the early 1890s and hallmarked later, since an identical piece was illustrated in *The British Architect* as shown at the 1893 Arts and Crafts exhibition.[1] However, it seems

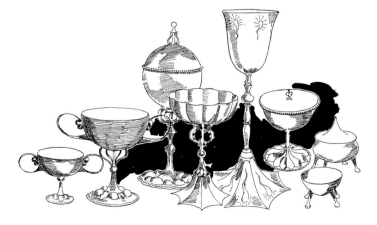

Fig.130 *Chalices, challenge cups and basins made by the Guild of Handicraft and drawn for* The Studio, *Vol.12 1897.*

to have been a design that Ashbee liked and it may have been repeated. An engraving in *The Studio* in 1898 certainly shows a similar cup in a group with the gilt metal cup (Cat.34), though the relative sizes are reversed.[2] Another with a lid appears in a photograph in *The Studio* in 1896 and appears darker in colour than the items with which it is grouped; it may be the same as one described as a 'Bronze Parti-Gilt Sugar Basin' which appeared in the *Art Journal* in an article by Ashbee entitled 'Challenge Cups, Shields and Trophies'.[3]

Ashbee had strong views on the design of sporting cups, and it seems a little curious that there should be confusion between a cup and a sugar basin. He believed that the trophies sold by contemporary manufacturers were unworthy and pedestrian and that this was a good field for the application of new design. He himself donated a challenge cup to the London School Swimming Association and the Guild provided much of the labour for the digging of a swimming pool in Chipping Campden in 1903. Guildsmen also made a challenge mace (Cat.55) and an impressive shield, now at Chipping Campden School.

The design of this cup seems transitional, between the early cast pieces and the later hammered and drawn silverwork: the bowl is hammered but the handles which look like bent wire are actually cast, as is the foot. The balls on the foot must derive from sixteenth- and seventeenth-century pieces in the V&A, and the whole ensemble of foot and stem is reminiscent of the beaten leatherwork panels made in 1892 for Wormelow Tump (Cat.31).

See Col.Fig.50.

1. Vol.40 1893, p.315.
2. Vol.12, p.36.
3. *The Studio*, Vol.9 1896, p.128; *Art Journal*, 1898, pp.230-3.

34* Sporting cup

Designed by C.R. Ashbee and made in the Guild of Handicraft workshop in London, about 1895.

Gilt copper. The bowl is hammered and the stem and foot cast and hand-finished. The gilding is worn, giving a subtly distressed colour effect on the surface.

$4\frac{1}{2} \times 3\frac{7}{8}$ (114×98)

Given in 1982 by Professor and Mrs Hull Grundy. 1982.1115

Record: Illustrated in The Magazine of Art, *Vol.20 1896-7, p.67, and* The Studio, *Vol.12 1897, p.36 (Fig.130).*

This piece was exhibited at the 1896 Arts and Crafts exhibition with a group of metalwork including the mustard pot (Cat.32). A slightly simpler version of this design, with plain brackets and a circular bowl, was shown in 1893, and another, with plain bowl but cast brackets, appeared in *The Studio* in 1900.[1]

The design seems to be based on German pieces such as a lobed standing cup of about 1620 by Michael Müller of Nürnberg in the V&A.[2] This has a similarly lobed bowl and cast term figures on an openwork stem.

See Col.Fig.49.

1. Vol.19, p.161.
2. M25 1953.

35 Belt buckle

Designed by C.R. Ashbee and made by the Guild of Handicraft in London, about 1897.

Cast silver set with turquoises.
No hallmarks.

$3\frac{1}{4} \times 2\frac{1}{2}$ (83×63)

Purchased 31.10.1997 at Sotheby's, Lot 1162, for £3999.25 with grants from the National Art Collections Fund (45 per cent) and the V&A Purchase Grant Fund (35 per cent). Money from the Captain Wild and Leslie Young Bequests was also used. 1997.247

Janet Forbes became engaged to Ashbee in 1897 and it is assumed this buckle was a gift from this period. The couple were married in the following year. A photograph (Fig.132) of late 1900, probably taken in Chicago by Frank Lloyd Wright during the Ashbees' visit to the United States, shows Janet wearing the piece, along with a necklace, flowery corsage, and distinctive Guild buttons. It was clearly intended as day-wear rather than for the evening. The photograph is one of very few showing Guild jewels as worn.

The design is very close to that of a chatelaine illustrated in *The Studio* in 1897, with similarly curvaceous fish and sculpted leaf forms. The author of the accompanying article wrote: 'The jewellery is partly cast and partly hammered in gold or silver. If cast the process is that known as waste wax, now so generally familiar as to hardly require description. Set with stones, or treated in

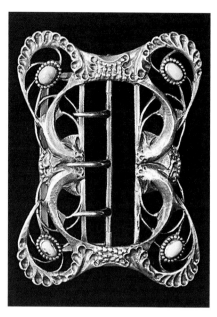

Fig.131 **Cat.35**

enamel, the results are of great richness. A peculiarity of Essex House jewellery is the insistence upon the aesthetic as opposed to the commercial value of precious stones. Colour is a quality always held in view, and thus we find combinations of copper and yellow crystals, gold and topaz, silver and obstein, red enamel and amethyst, blue enamel and opal, and the use of a variety of stones contemptuously regarded by the ordinary jeweller as "off colour" or unmarketable.'[1]

Ashbee's early fish designs appear to have had an influence on the slightly later work of Edgar Simpson (see Cat.142).

See Fig.132.

1. Anon., 'The Guild of Handicraft: A Visit to Essex House', *The Studio*, Vol.12 1897, p.34.

36* Brooch, pendant, or hair ornament

Designed by C.R. Ashbee and made by the Guild of Handicraft, about 1900.

Silver with gold wirework, pearl, garnets, almandines, tourmaline, and amethyst. The fitting on the back is damaged, making it difficult to identify the original function, and it seems likely that the wirework underneath the amethyst held pendent stones which are now missing.
No hallmarks.

$3\frac{7}{8} \times 1\frac{7}{16}$ (98×37)

Given in 1983 by Professor and Mrs Hull Grundy. 1983.197

1. Crawford, A., *C. R. Ashbee: Architect, Designer and Romantic Socialist*, New Haven and London 1985, pp.359-63, and 455-6 n.53-5.
2. *Ibid*, p.455 n.46.

Fig.132 *Janet Ashbee (right) wearing the buckle (Cat.35) probably whilst on a visit to Chicago in 1900.*

Peacocks recur in Ashbee's designs and had significance for him as a symbol of the richness of colour and lavish craftsmanship of the Arts and Crafts Movement. Its combination of pride and 'fine feathers' makes it an apt image for jewellery, providing the wearer with beauty by association and a reminder of the sin of pride. There is also evidence, in a note written by Ashbee about a design by D.S. MacColl of a peacock and fountain, that he was conscious of its role as a symbol of the Resurrection, and it seems likely that in his single-minded way he was referring to the resurrection of the crafts.

This is a fairly modest example in comparison with some of the luxurious peacocks made by the Guild (see also Cat.56). Crawford identifies twelve peacock brooches and pendants of various dates shortly after 1900, when a particularly large and splendid gold and silver bird with a ruby eye was made for Janet Ashbee.[1] These items vary considerably in technique of making, form, and colour. This one is curious in that the garnets are facet-cut though Ashbee declared in 1894 that garnets should always be *en cabochon*.[2]

See Col.Fig.55.

37* Napkin ring

Designed by C.R. Ashbee and made by the Guild of Handicraft, about 1900.

Silver set with a cabochon-cut garnet. The metal is pierced, hammered and chased. No hallmarks.

$1\frac{1}{8} \times 1\frac{7}{8}$ (28×48)

Given in 1983 by Professor and Mrs Hull Grundy. 1983.190

It was quite common for early Guild work, especially small items, to be unmarked. A similar piece with the maker's mark 'CRA' and date letter for 1900-1 is in the collections of the Fitzwilliam Museum in Cambridge.[1]
 See Col.Fig.51.

1. M.27-1983.

38* Muffin dish

Designed by C.R. Ashbee and made by the Guild of Handicraft in about 1900.

Hammered, silver-plated metal with a detachable finial of five silver wirework scrolls. Set with a pink cabochon-cut stone. Stamped on the lid and under the rim of the base: GofH Ltd

$5\frac{1}{2} \times 9\frac{1}{4}$ diam. (140×235 diam.)

Given in 1979 by Mary Comino. 1979.2603

Such items, described as muffin or breakfast dishes, were made in solid or in plated silver with no apparent difference in design. The plated version sold at £2 5s, or £3 5s with a hot-water jacket.
 See Col.Fig.52.

39* Box and cover

Designed by C.R. Ashbee and made by the Guild of Handicraft in 1901. Probably painted by William Mark.

Silver with enamelled and gilt lid. The enamel has been damaged and restored at some time before arrival in the collection. Hallmarks under foot and under lid: GofH Ltd, *1901, sterling, London.*

$2\frac{7}{16} \times 3\frac{7}{16}$ diam. (61×88 diam.)

Given in 1982 by Professor and Mrs Hull Grundy. 1982.1116

The enamelling is not signed but is very similar to work by William Mark (see Cat.47) and is likely to be by him. Mark joined the Guild around 1900 after working for Nelson Dawson. Along with Fleetwood Varley he transformed the Guild's production of enamels by making pictorial plaques for use on boxes such as this.

In the background of the image is the 'Craft of the Guild', a conceit which Ashbee particularly liked and often used (see Cat.31), and the fruiting trees and bird with fish are also familiar from the early work of the Guild.

See Col.Fig.56.

40 Six buttons and case

Designed by C. R. Ashbee and probably made by the Guild of Handicraft at Chipping Campden after May 1902.

Hammered, pierced and chased silver set with cabochon-cut chrysoprases. The long rectangular case is covered with green and white woven fabric and lined with cream satin and velvet.
No hallmarks. Printed inside the lid: THE GUILD OF HANDICRAFT Ld. 16A BROOK STREET BOND ST, W. WORKS: ESSEX HOUSE CHIPPING CAMPDEN, GLOS.

Diam. 1 (25). *Case:* 1×8⅞×2 (2.1×22.5×4.9)

Given in 1982 by Professor and Mrs Hull Grundy. 1982.1124

Janet Ashbee wears buttons of a similar type in the photograph taken in 1900 (Fig.132). In a Guild catalogue of about 1905-6 a set of six buttons with *cloisonné* enamel decoration in a case cost £3 10s.[1]

Each button is slightly different in its basic form, so they appear to have been wrought rather than cast.

1. *The Guild of Handicraft Limited*, Silver Studio Collection 2141, ref.739.23942, p.76.

41 Necklace and case

Designed by C. R. Ashbee and probably made by the Guild of Handicraft at Chipping Campden after May 1902.

Silver and gold wirework around plain silver setting for mother-of-pearl pendant, with four cabochon-cut chrysoprases set in silver mounts, one above the pendant and three hanging on short chains. Silver chain with three gold wirework quatrefoil connecting elements and slim square-section fastener.

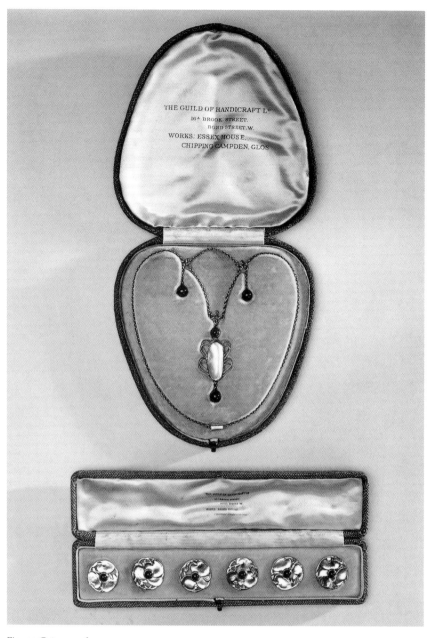

Fig.133 **Cats 40 and 41**

Case covered in blue and stone-coloured fabric in herringbone weave, with cream silk satin lining in the top and velvet in the bottom.

Pendant: 2⁹⁄₁₆×1 (68×24)

No hallmarks. Case printed inside lid: THE GUILD OF HANDICRAFT Ld. 16A BROOK ST, BOND ST, W. WORKS: ESSEX HOUSE, CHIPPING CAMPDEN, GLOS.

Given in 1983 by Professor and Mrs Hull Grundy. 1983.195

Like the buttons above, this is dated by the fact that the case has the Chipping Campden address printed on it, though

it could have been made earlier. It demonstrates the elegant simplicity of much of Ashbee's jewellery design and his preference for stones chosen for their colour and texture.

42* Box and cover

Designed by C. R. Ashbee and made by the Guild of Handicraft in 1902. Painted by Fleetwood Varley.

Silver with enamelled cover.
Hallmarked under base and on top of lid: GofH Ltd, *sterling, London, 1902. Enamel signed at bottom right:* FV.

$1\frac{1}{4} \times 3\frac{7}{8} \times 2$ (33×99×5)

Given in 1983 by Professor and Mrs Hull Grundy. 1983.198

Fleetwood Varley joined the Guild in 1899 and specialised in painting landscape scenes in rich blues and greens. An album containing a large number of similar designs is now in the Prints and Drawings collection at the V&A.
 See Col.Fig.56.

43* Pair of cups

Designed by C. R. Ashbee and made by the Guild of Handicraft in Chipping Campden in 1903.

Hammered silver with handles made of three wires and simple decoration of punched dots on the feet. Each cup is set with two cabochon-cut stones in plain settings under the handles, one with chrysoprases and one with garnets.
Hallmarked: GofH Ltd, *sterling, London, 1903.*

$4 \times 6\frac{1}{4}$ (102×163)

Given in 1982 by Professor and Mrs Hull Grundy. 1982.1117/1-2
 See Col.Fig.51.

44* Salt dish

Designed by C. R. Ashbee and made by the Guild of Handicraft in Chipping Campden in 1903.

Framework of silver with three columns around plain ring and circular raised foot. Columns set at the top with cabochon-cut chrysoprases. The ring and foot support a glass dish.
The original pale green glass dish by Powell's of Whitefriars was damaged before the piece arrived at the Museum. A replacement for display purposes was made by Annette Meech of the Glasshouse in London. The colour proved difficult to reproduce and is more yellow and more mottled than the original.
Hallmarked under base: GofH Ltd, *sterling, London, 1903. Scratched number:* 5211.

$1\frac{3}{8} \times 2\frac{11}{16}$ (36×68)

Given in 1982 by Professor and Mrs Hull Grundy. 1982.1119
 See Col.Fig.51.

45* Pepper pot

Designed by C. R. Ashbee and made by the Guild of Handicraft in Chipping Campden in 1903.

Hammered silver set with cabochon-cut chrysoprases.
Hallmarked on body and on rim of lid: GofH Ltd, *sterling, London, 1903.*

$2\frac{1}{8} \times 1\frac{3}{4}$ (55×44)

Given in 1982 by Professor and Mrs Hull Grundy. 1982.1120
 See Col.Fig.51.

46* Mustard pot

Designed by C. R. Ashbee and made by the Guild of Handicraft in Chipping Campden in 1903.

Hammered silver with drawn wire handle and circular knop set with a cabochon-cut garnet. Dark green glass liner by Powell's of Whitefriars.
Hallmarked on body and inside lid: GofH Ltd, *sterling, London, 1903. Scratched underneath:* 4869.

$4 \times 3\frac{1}{2}$ (102×90)

Given in 1982 by Professor and Mrs Hull Grundy. 1982.1121
 See Col.Fig.51.

47* Hand mirror

Designed by C. R. Ashbee and made by the Guild of Handicraft in 1903. Enamelled back painted by William Mark.

Silver frame and handle set with piece of mother-of-pearl at the end. Enamelled panel of a peacock in blue, green and gold, with faint traces of gilding over the enamel. Bevelled glass mirror.
Hallmarked: GofH Ltd, *sterling, London, 1903. Enamel signed on lower right edge in very faint gilding:* Mark.

$10 \times 3\frac{15}{16}$ (253×99)

Given in 1982 by Professor and Mrs Hull Grundy. 1982.1118

A circular hand mirror with very similar decoration of a peacock was shown at the *Exhibition of Cotswold Craftsmanship* at the Montpellier Rotunda, Cheltenham, in 1951.[1]
 See Cat.36 for Ashbee's use of peacock imagery on jewellery. Its appearance on a hand mirror could be seen as an even

more pointed comment on pride in personal appearance.
 See Col.Fig.56.

1. Cat.169.

48 Biscuit barrel

Designed by C. R. Ashbee and made by the Guild of Handicraft at Chipping Campden in 1903. The stag finial made by Edward, John and William Barnard, London, 1846-68.

Hammered, pierced and chased silver with a cast handle on the lid attached with a butterfly nut. Brass lining, which may be a replacement for a glass one.
Hallmarked on body near rim and on rim of lid: GofH Ltd, *sterling, London, 1903. On base of stag finial: Victoria's head, sterling, (quatrefoil with B surrounded by obscured E J & W). No date letter.*

$7\frac{7}{8} \times 5\frac{5}{8}$ (200×142)

Given in 1982 by Professor and Mrs Hull Grundy. 1982.1123

It is not known whether Ashbee incorporated the stag finial into his design or if it is a later replacement, but it seems likely that he found it and included it because he liked it. It is finely cast and chased and the subject is one that appears in Guild work (see Cat.192), and more widely in the Arts and Crafts Movement (for instance in plasterwork by Gimson at Lethaby's Avon Tyrrell). The stag is perhaps a reminder of the rural hunting pursuits of the medieval past.
 Edward Barnard & Sons Ltd is a long-established firm which has a claim to be the oldest manufacturing silversmith in the world; its roots go back to Anthony Nelme around 1680. It is known for such cast fittings.[1]
 See Fig.134.

1. Culme, J., *The Directory of Gold & Silversmith Jewellers & Allied Traders, 1838-1914: From the London Assay Office Registers,* Woodbridge 1987, Vol.I, *The Biographies,* pp.29-30; Vol.II, *The Marks,* p.76, nos 3460-3466.

49* Mustard pot

Designed by C. R. Ashbee and made by the Guild of Handicraft in 1904. Glass liner by Powell's of Whitefriars, London.

Hammered silver and hand-made green glass.
Hallmarked on body near lid and inside lid: GofH Ltd, *sterling, London, 1904.*

$2\frac{1}{2} \times 2\frac{3}{16}$ (66×56)

Given in 1983 by Professor and Mrs Hull Grundy. 1983.194
 See Col.Fig.51.

50* Salt spoon

Designed by C. R. Ashbee and made by the Guild of Handicraft at Chipping Campden in 1905.

Silver set with a cabochon-cut chrysoprase. Hallmarked on back of handle: GofH Ltd, *1905, London, sterling.*

$3\frac{7}{16} \times \frac{13}{16}$ (87×21)

Given in 1982 by Professor and Mrs Hull Grundy. 1982.1125
 See Col.Fig.51.

51* Jam spoon

Designed by C. R. Ashbee and made by the Guild of Handicraft at Chipping Campden in 1905.

Silver with pierced and chased decoration of a stylised flower on the handle, set with a cabochon-cut chrysoprase. Hallmarked on back of handle: sterling, London, 1905, GofH Ltd.

$6\frac{1}{16} \times 1\frac{1}{4}$ (154×32)

Given in 1982 by Professor and Mrs Hull Grundy. 1982.1126
 See Col.Fig.51.

52* Dish

Designed by C. R. Ashbee and made by the Guild of Handicraft in Chipping Campden, 1905.

Raised silver with wirework handle set with a cabochon-cut amazonite. This would originally have had a pale green glass-liner by Powell's of Whitefriars, now missing. Hallmarked near rim: GofH Ltd, sterling, London, 1905.

$2\frac{1}{4} \times 7 \times 4\frac{1}{4}$ (57×179×107)

Given in 1982 by Professor and Mrs Hull Grundy. 1982.1122

Such items were usually described in Guild catalogues as 'jam or butter dish'. Ashbee made the original design but the Guildsmen were encouraged to add their own variations, so in the many versions

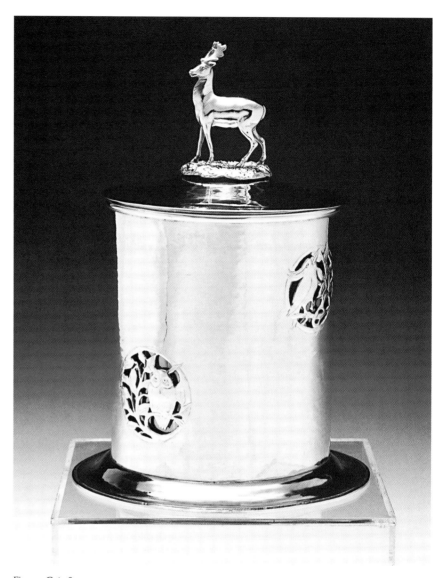

Fig.134 **Cat.48**

of this dish there are always differences in the curve of the handle and the choice of stone and setting.
 See Col.Fig.51.

53* Bowl

Designed by C. R. Ashbee and made by the Guild of Handicraft at Chipping Campden in 1906.

Hammered silver with five cast feet. Hallmarked near rim: GofH Ltd, *sterling, London, 1906.*

$2\frac{15}{16} \times 4\frac{9}{16}$ (75×115)

Given in 1982 by Professor and Mrs Hull Grundy. 1982.1127

A very similar design illustrated in *Modern English Silverwork* is described as

a sugar basin.[1] It also appears in Guild catalogues as a 'porringer' and in 1906-7 would have cost about £3 3s.
 See Col.Fig.51.

1. C. R. Ashbee, Broad Campden 1909, pl.43.

54* Pair of salts

Designed by C. R. Ashbee and made by the Guild of Handicraft at Chipping Campden in 1907. Glass liners by Powell's of Whitefriars, London.

Silver and hand-made green glass. Hallmarked on side: Sterling, London, 1907, GofH Ltd.

$2\frac{1}{4} \times 2\frac{3}{8}$ diam. (57×60 diam.)

Given in 1989 by Mrs J. T. Atkins. 1989.880

These were a wedding present from Mr and Mrs George Hart to the donor's parents, Mr and Mrs W. R. Haines, in 1912. Mr Haines was George Hart's wife's brother, from a long-established Chipping Campden family.

See Col.Fig.52.

55* *Mace head*

Designed by C. R. Ashbee and made by Jack Baily, George Hart and George Horwood at the Guild of Handicraft at Chipping Campden, about 1903-9.

Chased and engraved silver set with green pearl blisters. Short wooden replacement handle.
Marked on stem with maker's mark only: G of H Ltd.

$7\frac{1}{8} \times 5\frac{1}{8}$ (180×113)

Given in 1983 by Professor and Mrs Hull Grundy. 1983.192

Record: V&A AAD 1/110-1980, Cat.574.

In its original form the mace was much richer in appearance, surmounted by an architectural structure held up by sea-horses (Fig.135). Ashbee described it in *Modern English Silverwork* as a: 'Challenge Mace: designed and made for Captain R. M. Glossop as a gift to the Chipping Campden Sports Club, to be competed for by the girls who race at the Annual Swimming Sports for a silken smock.... The head is crowned with a Dover's Castle, an emblem of the Cotswold Games, (see the 'Annalia Dubrensia'). This castle is supported on four cast sea-horses and topped with an amethyst ball. The mace has an ebony handle with little silver tablets for the winners' names.'[1]

The top has been replaced by a plain domed section and the pricked inscription on the band and the handle have been removed. Nothing is known of the history of the piece between the time of the Guild and the present day. The present handle was added for display purposes after the piece came to the Museum.

One of the Guild's contributions to the community life of Chipping Campden was the digging of a swimming pool which was opened on 1 September 1903. Lt R. Montague Glossop presented a Challenge Cup designed by W. A. White and made by Jack Baily. It is not known exactly when he was promoted to Captain, nor when he commissioned the mace for the girls' race. It was exhibited,

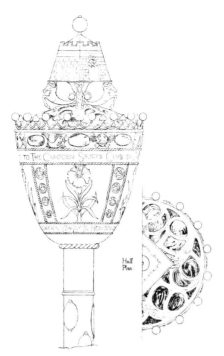

Fig.135 *The mace head in its original form, as drawn by Philippe Mairet for Ashbee's 'Modern English Silverwork', Broad Campden, 1909, plate 89.*

however, at the Arts and Crafts exhibition in 1910 and the makers credited were among those who stayed on in Chipping Campden after 1908, so it is likely to date from 1908-9.

See Col.Fig.48.

1. Broad Campden 1909, p.32.

56* *Necklace*

Probably designed by C. R. Ashbee and made by the Guild of Handicraft in Chipping Campden in 1913 or earlier.

Silver, with seventeen turquoises mounted on the tail and three pendent turquoises. The peacock stands on a mounted plaque of bright turquoise blue enamel on a foil background. No hallmarks.

Pendant: $2\frac{1}{8} \times 1\frac{3}{4}$ (55×45)
Length of chain: $15\frac{3}{4}$ (400)

Given in 1996 by Mrs N. E. Avery. 1996.584

The necklace was given to the donor's mother, Miss Horne of Chipping Campden, when she was a bridesmaid to her aunt in 1913. Since it is unmarked it is difficult to know whether it was made by George Hart at the time or if it was stock from the Guild, but it is clearly derived from an undated design by Ashbee still held at Hart's Silversmiths in Campden.

This design appears to be for a haircomb, but a necklace of almost identical form made in 1901 is in the V&A collection.[1] Miss Horne's necklace is more simple in its construction, having two fan-shaped sheets of metal for the tail instead of single feathers, and no open wirework section above, as shown in the design and the V&A piece. The loop fastener is unlike the small box fasteners used on many Guild pieces, but the chain is identical to that used on other Guild work.

For more information on the peacock motif, see Cat.36.

See Col.Fig.54.

1. See Crawford, A., *C. R. Ashbee: Architect, Designer and Romantic Socialist*, New Haven and London 1985, Fig.178 & p.361.

Fred Partridge (1877-1942)

Partridge joined the Guild in 1902 after studying at Birmingham Municipal School of Art and designing for the Barnstaple Guild of Metalworkers in his home town. He stayed for less than a year and left in March 1903, which was clearly a loss to the Guild since he was an excellent jeweller. In 1906 he married May Hart, an enameller, and they established a workshop in London supplying Liberty's and others.

57* *Haircomb and case*

Designed and made by Fred Partridge in about 1901-6.

Horn with enamelled copper plaques and cabochon-cut moonstones.
The case is covered with buff leather with gold tooling and lined with cream silk and velvet.
The comb has been broken and repaired at some time in the past before arrival in the Museum.

Stamped on the back of one tine: PARTRIDGE
Case labelled inside lid: Pridham & Sons, Goldsmiths & Silversmiths Torquay

Comb: $5\frac{1}{8} \times 3\frac{5}{8}$ (131×91)

Given in 1982 by Professor and Mrs Hull Grundy. 1982.1128

It is difficult to date this piece accurately because Partridge moved around in the years before he set up his own workshop in London. It is clearly influenced by the work of French jewellers such as Paul Follot, Rene Lalique, and Henri Vever,

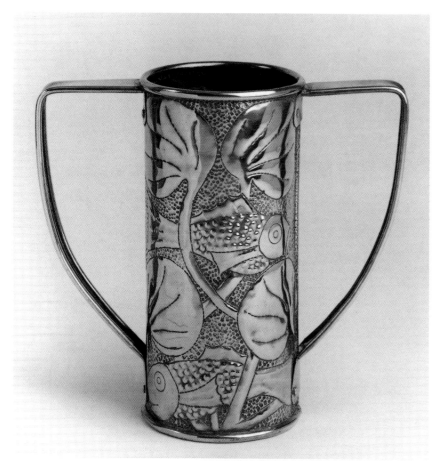

Fig.136 **Cat.58**

perhaps through illustrations in the Studio Special Number on *Modern Design in Jewellery and Fans* of 1902.
See Col.Fig.53.

John Williams (*c*.1870-1951)

John Williams was one of the pioneer members of the Guild and was responsible with John Pearson for most of the early beaten metalwork with bold repoussé designs. He resigned in 1892 and had a successful teaching career at the Northampton Institute in Clerkenwell and then at the Hammersmith School of Arts and Crafts in London until about 1930.

58 *Vase*

Designed and made by John Williams in about 1896.

Sheet copper joined down one side and with two handles riveted on. Hammered repoussé decoration.
No marks.

$7\frac{7}{8} \times 8\frac{5}{8} \times 3\frac{7}{8}$ (200 × 220 × 98)

Purchased in 1981 from the Fine Art Society for £130. 1981.1413

Record: Illustrated in The Studio, *Vol.8 1896, No.42, p.96.*

This item was illustrated in an article about the exhibition at the Albert Hall of work by the Home Arts and Industries Association, in which Williams was very active. The aims of the Association were to encourage workers to use their leisure time productively by practising craftwork for the sake of satisfaction in creativity rather than for financial gain. Williams also provided designs and advice to the Fivemiletown art metalwork classes in County Tyrone, Northern Ireland, spending part of his summer holidays there in the mid 1890s.[1]

The design of the vase is typical of work made by the Guild and by the wide range of amateur groups established at the time around Britain and Ireland. This kind of beaten copper and brass work continued in popularity well into the twentieth century, notably at Glasgow School of Art.

1. Larmour, P., *The Arts and Crafts Movement in Ireland*, Belfast 1992, pp.39-44.

Henry Wilson (1864-1934) and the Artificers' Guild

John Paul Cooper, Edith and Nelson Dawson,
Edward Spencer, Henry Wilson

Henry Wilson, architect, designer and teacher, was a
passionate and persistent campaigner for the Arts and
Crafts Movement. His influence on contemporaries such
as John Paul Cooper, Edward Spencer, Alfred Powell,
and Ernest Gimson was considerable, while his own
contribution to the architecture and metalwork of this
period deserves greater recognition.

Wilson was chief assistant to John Sedding (1838-91)
at the time of the latter's death. He took over Sedding's
practice and continued his work both in terms of
completing architectural commissions (including the
building and furnishing of Holy Trinity, Sloane Square,
London, for which Wilson designed much of the
metalwork) and of emphasising the fundamental role
of craftwork in architecture. In a talk to the Architectural
Association, Wilson described Sedding's buildings as
'jewels beside dunghills' and 'announced the workshop
as the birthplace of art. They must work with plasterers,
at the blacksmith's forge, and in the mason's shed, and
constructional problems should be solved not at a distance,
but on the spot.'[1] Sedding had emphasised the importance
of direct observation from nature; Wilson developed this.
His technical instructions for making a nightingale as the
centrepiece of a pendant begin with the suggestion to 'go
and watch one singing'.[2]

In about 1890 he set up a studio at 17 Vicarage Gate,
Kensington, London, and began designing metalwork and
jewellery. The plates in his book *Silverwork and Jewellery*
indicate the breadth of his interest, with Greek and Roman
examples as well as illustrations of Anglo-Saxon, medieval
and later European work. In the preface to the same book,
he described how he would read old inventories of church
plate and use them to stimulate his imagination when
designing metalwork. He employed skilled jewellers to
execute his designs and his work was technically of a very
high quality. It is also rich in imagery and surface texture,
employing gold, cabochon-cut gems, gold ropework, and
enamelling, to a level not always found in Arts and Crafts
work.

In 1896 Wilson began teaching metalwork at the Central
School of Arts and Crafts. He also taught at the Royal
College of Art and his book, *Silverwork and Jewellery*,
published in 1903, has remained an important technical
reference volume for students.

A founder-member of the Art Workers' Guild, he
continued to urge his friends and colleagues to keep alive
the spirit of the Movement through the First World War.
He helped organise the exhibition of British Decorative Arts
in Paris in 1914 and was the moving force behind the 1916
Arts and Crafts Exhibition, the first such show to be held at
the Royal Academy, seen as the bastion of elitism in the arts.
In 1917, he was elected Master of the Art Workers' Guild.
He moved to France in 1922, where he spent his remaining
years.

John Paul Cooper took up architecture as a sop to his
parents' desire for a professional career for their son and
was apprenticed to Sedding in 1889. It was Wilson who
directed his interest towards decorative work and the crafts.
In the early 1890s, Cooper learnt to model plasterwork to
Wilson's design and began to design and model work in
low-relief gesso. He exhibited a box decorated with gesso
in the 1893 Arts and Crafts Exhibition and experimented
with other materials including tortoiseshell, mother-of-pearl
and shagreen. In 1897 he set up a workshop at 16 Aubrey
Walk, Kensington, London, not far from that of Wilson.
He employed three assistants on a part-time basis: Lorenzo
Colarossi and George Romer, who had also worked for
Wilson, and May Oliver, his future wife.

On Wilson's recommendation, Cooper was appointed
Head of Metalwork at Birmingham Municipal School of Art
in 1902. Colarossi and Romer provided technical instruction
while Cooper taught design. He resigned in 1906 to
concentrate on his own work, leasing a house at Hunston,
Kent. He built his own house, Betsom's Hill at Westerham,
Kent, in 1910. From his workshop he produced work for
Montague Fordham and the Artificers' Guild and also
made silver handles for Ernest Gimson. During the First
World War, he worked at W. A. S. Benson's metalworks
and subsequently returned to his craftwork.

Cooper kept very detailed records from which it is
possible to estimate that nearly one-third of his output
was for the Artificers' Guild, the longest lasting of all the
workshops of the Arts and Crafts Movement. For over
thirty years, first under the leadership of Nelson Dawson
and then, from 1907, of Edward Spencer, it produced
consistently high-quality jewellery and metalwork in
conjunction with a number of talented designers.

Dawson was born in Stamford, Lincolnshire. He studied
architecture and painting and in 1893 married Edith
Robinson, an artist from a Quaker family in Scarborough.
He worked independently as a metalworker from 1891 and
both husband and wife may have attended lectures on
enamelling given by Alexander Fisher. By 1896 they were
living and working at The Mulberry Tree, Manresa Road,
Chelsea, London. They seem to have made an immediate
impression, with enthusiastic articles in a number of
periodicals.[3] They moved to Chiswick in 1897 and set up
a workshop in Hammersmith Mall, sharing premises with
a factory making margarine from coconut oil. The Dawsons'
daughter recalled the foul-smelling barrels of margarine
placed on either side of the passage to the workshop.[4]
The new site, however, brought the Dawsons into contact
with the craft community already based in or around

Fig.137 *A page from John Paul Cooper's stock book showing the buckle (Cat.59).*

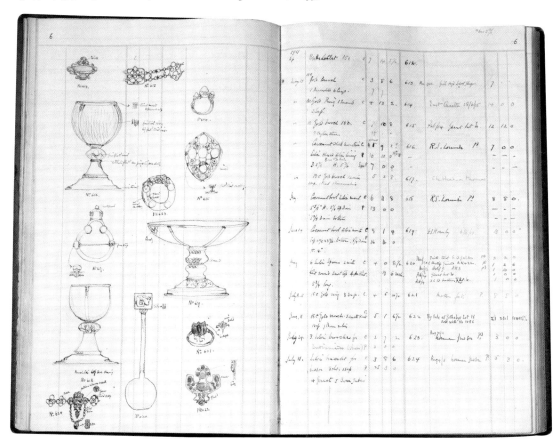

Fig.138 *A page from John Paul Cooper's stock book showing the brooch (Cat.60).*

Hammersmith Mall, including May Morris, Emery Walker, and Arthur Romney Green; a few years after their arrival, Eric Gill and Douglas Pepler also moved there, as well as Spencer, the Dawsons' chief assistant. About twenty craftspeople were employed and by 1900 the Dawsons were able to put together an exhibition at the Fine Art Society which included 125 pieces of jewellery.

In 1901 the Artificers' Guild was founded and registered as a limited company with Edith and Nelson Dawson and Spencer named as principals. A number of Dawson's pupils were also involved, including Edgar Simpson (Cat.142). Dawson bound himself to work solely for the Guild for five years.

Dawson and Spencer's partnership was not happy and in 1903 Dawson gave up his interest in the Guild to Montague Fordham, a solicitor and member of a Hertfordshire brewing family, who had taken on the voluntary position as Director of the Birmingham Guild of Handicraft in 1890 and in 1899 had opened a gallery in his own name in Maddox Street, London W1, showing the best contemporary decorative work. He described himself as a 'house furnisher, jeweller and metalworker'.[5] The Guild and the gallery were run together from Maddox Street with a workshop at Hammersmith, west London.

The Dawsons continued to design metalwork and jewellery, with Edith undertaking most of the enamelling. In 1906 she wrote a volume, *Enamels,* in the series 'Little

Books on Art' published by Methuen; the following year Methuen also published Nelson Dawson's *Goldsmiths' and Silversmiths' Work.* He found the business side of the workshop an increasing burden; that and the impact of the First World War led them to give up metalworking in 1914 to concentrate on their painting.

In 1905 the Artificers' Guild failed because the business had been seriously undercapitalised, despite Fordham's personal wealth and the growing involvement of designers such as Cooper. Spencer set up the short-lived Guild of St Michael but in 1907 re-established the Artificers' Guild under his own control with premises in Conduit Street, London W1. Wilson, Cooper, John Bonnor, May Morris, Phoebe Traquair and F.S. Robertson all designed for the Guild as well as Spencer but they were no longer bound to work for it exclusively. After the First World War the Guild opened a second outlet in Cambridge and survived Spencer's death until 1942.
MG

1. *The Architect,* 4 December 1891, p.351.
2. Wilson, H., *Silverwork and Jewellery,* London 1903, p.127.
3. *The Studio,* Vol.6 1895, pp.176-7; and *The Architectural Review,* Vol.1 1897, pp.35-41.
4. See Rhoda Bickerdike née Dawson, 'The Dawsons: An Equal Partnership of Artists', *Apollo,* 1988, pp.320-5.
5. Unpublished paper by Muriel Wilson, November 1992 (Spencer file CAGM).

John Paul Cooper (1860-1933)

59* *Belt buckle*

Designed by Cooper in 1905 and made in his workshop.

Chased silver and copper on a copper back. The design is of a leek within a border of double ropework. There are two copper hooks on the reverse to fasten on to the belt. Two small card labels attached inscribed 'J.P.C 216' and 'J. Paul Cooper 216'

$3\frac{3}{8} \times 2\frac{3}{4}$ (85×68)

Given in 1982 by Professor and Mrs Hull Grundy. 1982.1196

Design: Cooper archive, uncatalogued drawing.

Record: Cooper's costing book 1, p.106. Design No.216 (Fig.137).

Cooper's meticulous workshop records, including drawings, costing and stock

books remain in the possession of his family.

It took 30 hours work and was costed at £1 9s 9d.
See Col.Fig.58.

60* *Brooch*

Designed by John Paul Cooper in 1911 and made in his workshop.

*Fibula brooch of a horseshoe shape, made of 18-carat gold set with cabochon stones: zircon, sapphire, tourmaline, olivine and pearl.
Stamped on the reverse:* CP 18[1]

$1\frac{3}{4} \times 1\frac{1}{4}$ (45×33)

Given in 1982 by Professor and Mrs Hull Grundy. 1982.1195

Design: Cooper archive, uncatalogued drawing.

Record: Cooper stock book 2, p.124. Design No.617 (Fig.138).

Costed at £5 2s $7\frac{1}{2}$d.

The design relates to thirteenth- and fourteenth-century pieces which Cooper could have seen in the British Museum.
See Col.Fig.58.

1. 'CP' was a monogram used occasionally by Cooper.

61 *Box and lid*

Designed by John Paul Cooper in the 1920s and made in his workshop.

*Round box of cedarwood covered with grey shagreen. Four bands of silver mounts with simple tooling fixed by plain pinheads. There are three pins missing.
Silver label pinned inside the lid stamped:* J. Paul Cooper.

$2 \times 3\frac{1}{2}$ diam. (50×88 diam.)

Given in 1982 by Professor and Mrs Hull Grundy. 1982.1194

See Fig.139.

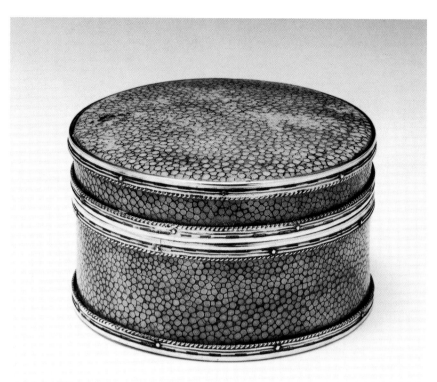

Fig.139 **Cat.61**

Shagreen, the skin of small tropical sharks – dogfish or rays – was first introduced into Europe as a decorative medium from the Far East in the seventeenth century. Cooper is credited with its revival in the twentieth century. Other designers used the medium, including Spencer and Omar Ramsden, but it was Cooper's experimental work with shagreen which established his reputation during his lifetime.

Cooper's interest was aroused by his meeting in 1898 with a collector of shagreen, Andrew Tuer. Until Tuer's death in 1900, both men experimented with the preparation and colouring of skins. Cooper had already used gesso to decorate boxes and he found he could do the same with shagreen in combination with silverwork. His earliest design dated 30 January 1899 was for a stamp box exhibited at the Arts and Crafts Exhibition and singled out for comment in a review by Henry Wilson.[1]

His earliest designs in shagreen in London were experimental and occasionally crude, based round a rectangular box with silver hinges and snap catches. From 1903 he fulfilled an increasing number of elaborate commissions and extended the variety and quality of his silverwork while teaching metalwork at Birmingham School of Art. He varied the shapes and used silver bands and mounts to secure the pieces of shagreen. Twisted and plain bands of silver moulding, wirework, chased decoration, and fixing pins with decorative heads added to the restrained yet rich surface effect. The work was unusual with an element of the exotic which, combined with the simple, elegant shapes designed by Cooper and the very competitive cost compared to silver boxes, ensured a constant demand.

Cooper bought in skins already filed and had boxes or caskets made for him in cedarwood or walnut. In his studio he employed three part-time assistants who would take on the staining, polishing and mounting of the shagreen; he himself would carry out any special decoration. From his stockbook records, it has been calculated that about 948 shagreen items were made, including vases, candlesticks and frames as well as boxes.[2]

The box in the Art Gallery and Museum's collections is characteristic of Cooper's work in the 1920s. His designs towards the end of his working life were pared down and simplified, consisting mainly of oblong and round boxes with narrow mounts, tooled in a repetitive, almost mechanical fashion, and with decorated press catches.

1. *Architectural Review*, Vol.6 1899, pp.213-14.
2. Kuzmanovic, N., 'The Shagreen work of John Paul Cooper', *Antiques*, September 1995, pp.348-57.

Edith and Nelson Dawson (1862-1920 and 1859-1942)

62* *Brooch*

Designed by Nelson and Edith Dawson about 1895 and made at their workshop in Chelsea, London.

Silver and cloisonné *enamel.*

$2\frac{3}{4}$ diam. (71 diam.)

Given in 1982 by Professor and Mrs Hull Grundy. 1982.1152

The Studio, Vol.6 1895, p.176, includes an interview, *A chat with Mr & Mrs Nelson Dawson on enamelling* which illustrates a similar design of three swans with heads interlocked in the centre. This piece is in the collections of the V&A.
See Col.Fig.59.

63* *Bowl and cover*

Designed by Nelson and Edith Dawson in 1901 and made in their Chiswick workshop.

Silver, hammered with a repoussé design of a heart-shaped stemmed leaf on four sides, with a glass liner. The cover is set with an enamelled plaque of an abstract design. Hallmarked: London 1902 ND. The enamel is signed: D.

$3 \times 3\frac{3}{4}$ diam. (76×94 diam.)

Given in 1982 by Professor and Mrs Hull Grundy. 1982.1153
See Col.Fig.59.

Edward Spencer (1872-1938)

64 *Box and cover*

Designed by Edward Spencer and made by the Artificers' Guild in 1920.

Silver with a cloisonné *enamel plaque on the cover.*
Hallmarked: London 1920 and stamped ASGD/LD on side of box and lid. Base stamped: 457 and scratched 200/2434e.

$3\frac{1}{4} \times 2\frac{1}{4}$ diam. (83×56 diam.)

Given in 1982 by Professor and Mrs Hull Grundy. 1982.1146

65* *Belt buckle or cope clasp*

Designed by Edward Spencer and made by the Artificers' Guild in 1928.

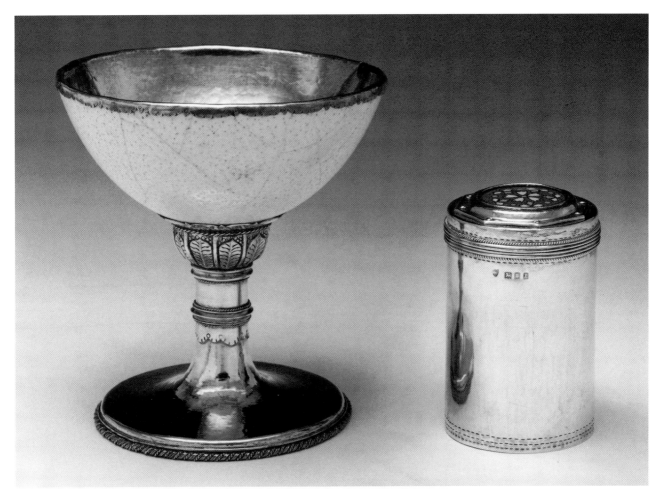

Fig.140 **Cats 64 and 66**

Silver set with a pebble.
Hallmarked: London 1928 and stamped
ASGD/LD *on both fixing pieces.*

$4\frac{1}{8} \times 5\frac{1}{8}$ (115×142)

Given in 1982 by Professor and Mrs Hull Grundy. 1982.1145

It has been suggested by Charlotte Gere that this piece may have religious significance because the stone has a distinctive natural marking in the form of a cross.
 See Col.Fig.58.

66 *Cup*

Designed by Edward Spencer and made by the Artificers' Guild in 1934.

Silver bowl, hand-beaten to fit the interior of half an ostrich eggshell, on a spreading silver foot.
This piece was broken in transit because Mrs Hull Grundy sent everything by post. The egg was broken and there is a dent in the silver bowl. Repairs to the silver were carried

out in 1989 by Frank Johnson at the Guild of Handicraft in Chipping Campden.
Hallmarked: London 1934 and stamped
ASGD/LD *on the side. The base has '190' written in ink and '807' scratched.*

$4\frac{7}{8} \times 4\frac{5}{8}$ diam. (123×117 diam.)

Given in 1982 by Professor and Mrs Hull Grundy. 1982.1225

Henry Wilson (1864-1934)

67* *Pendant and chain and case*

Designed by Henry Wilson, about 1907-10, and probably made in his workshop.

Gold with enamel, set with pearls, moonstones and emeralds. Double-sided with an angel holding a dove and on the reverse a Tudor rose.
Green leather case with gold tooling, lined with cream satin and velvet. Printed underneath is a label: THE ARTIFICERS' GUILD LTD, 9 MADDOX ST LONDON W HENRY WILSON

The small link joining the pendant to the cross is rather crude and may be a replacement for a swivelling link more suitable for a reversible piece.

Pendant: $3\frac{1}{4} \times 1$ (84×27)
Length of chain: 15 (382)

Given in 1983 by Professor and Mrs Hull Grundy. 1983.199

Design: V&A PP&D, E669(296)-1955.

This pendant was bought by Mrs Hull Grundy from Celia Larner, dealer and writer on the Glasgow School.
 A scrapbook of sketches by Henry Wilson given by his daughter to the V&A has a chalk, watercolour, and gold ink sketch of this pendant signed 'HW'. A similar piece was made for the stained-glass artist, Douglas Strachan, in about 1910.[1]
 See Col.Figs 57, 58.

1. Anscombe, I. and Gere, C., *Arts and Crafts in Britain and America*, London 1978, pl.201.

Ernest Gimson (1864-1919)

Following in the footsteps of Morris, Webb, and Sedding, Ernest Gimson looked for a close involvement in the crafts and design. He trained as an architect in Leicester and subsequently in Sedding's London office before becoming involved in Kenton & Company, designing furniture with other young architects. In 1893, he moved to the south Cotswolds with Ernest and Sidney Barnsley.[1] As well as architecture and furniture, he produced designs for leadwork, pierced and chased metalwork, embroidery, bookbinding, bookplates, and plasterwork.

Pattern was an important element in his design work. Lethaby recalled Gimson travelling with 'large pieces of Morris chintz as an easy way of "having something to look at" in his sitting room'.[2] Morris, whom Gimson first met in 1884, was a continuing inspiration; a letter to his elder brother recounts a visit to the Art Workers' Guild in the company of Lethaby and Robert Weir Schultz to hear Morris talk on *The Origin of Ornament*.[3] He also sketched enthusiastically and collected photographs, many from the South Kensington Museum, which survive in Cheltenham's archive and give an indication of his interests and sources.

As an architectural student, Gimson was attracted to fine examples of early English plasterwork. Writing in 1886 from the Swan Inn, Bradford-on-Avon to his brother, he described the fourteenth-century plasterwork at South Wraxall Old Manor, 'magnificent uninhabited rooms with wrought plaster ceilings and carved chimney pieces – a paradise sir a paradise'.[4] His experience of learning the techniques of plasterwork with Whitcombe and Priestly is described elsewhere in this volume (see p.16).

His first major commission for plasterwork came via Lethaby in 1892 for Avon Tyrrell, Hampshire, which Lethaby had designed for Lord Manners. Early work was also executed in two houses in Leicester: Inglewood, and the White House designed for his half-brother, Arthur Gimson. The latter includes two exterior panels modelled in Keen's cement to Gimson's design by George P. Bankart (1866-1929) in 1897. Bankart and Gimson met in the architectural office of Isaac Barradale, where both men began their training. Bankart continued to work in plaster and wrote widely on the craft; his designs bear a close kinship to those of Gimson. Although they do not appear to have collaborated subsequently, they remained close; Bankart's wife, Emily, was one of many female family and friends who executed Gimson's embroidery designs.

Gimson designed and made decorative plasterwork throughout his career. His designs were based on natural forms; he often drew flowers and plants and adapted these drawings into designs to suit the particular medium for which they were intended. Inspiration also came from other sources including historic plasterwork, stonework and embroidery (Figs 141 and 142). After the move to Sapperton in 1902, he would execute his plaster designs in an open shed below his drawing office with the help of his wife, Emily, and Norman Jewson who joined Gimson as an architectural 'improver' in 1907. Simon Verity described how Jewson taught him to make low-relief plasterwork in the 1960s:

He was a wonderful teacher, encouraging and patient. He told me that Lethaby approved of the method, 'simple as piecrust', and that Gimson had taught him to use his fourth finger as it would have more delicacy of touch for modelling. He and Gimson scorned the 'jelly' moulds which enabled fancy undercutting. They concentrated on fine modelling and soft shadows that were more attuned to their buildings.[5]

Some major commissions for which drawings survive in the archives at Cheltenham include designs for Borden Wood, Hampshire (Fig.143); Bradford Town Hall; Sheffield Park, Sussex; the London department store, Debenham and Freebody; and Ernest Debenham's house in Addison Road, Kensington, London, designed by Halsey Ricardo.

Gimson's collection of photographs, amassed while he was an architectural student in London, includes examples of Spanish and Italian wrought ironwork of the sixteenth century. He began designing metalwork in about 1900 at the same time that he set up a furniture workshop with Ernest Barnsley. He saw some hinges that Alfred Bucknell, son of the village blacksmith at Tunley, had made for Powell's house in the village, gave him some designs to make and then set up a smithy at Sapperton in the wheelwright's yard on the site of the present village hall. By 1910 he was employing Bucknell, Steven Mustoe, another trained and skilled blacksmith crippled from an injury to his spine as a youth, and two local apprentices, Harry Gardiner and Fritz Whiting. The names of two other craftsmen, Poulton and Holmes, also appear in Gimson's workbook. As well as hinges, latches, lockplates, handles and other door furniture, they made fire dogs and fire tools in polished steel and iron, and smaller items such as candlesticks, sconces, lanterns, and other light fittings in brass, polished steel and iron. Gimson also collaborated with other architects in the design of architectural metalwork, in particular with Robert Weir Schultz at the Old Place of Mochrum, Wigtownshire, Scotland. Some of the drop handles and knobs in silver or brass for Gimson's most elaborate furniture were made in John Paul Cooper's workshop.

After Gimson's death in 1919, Bucknell set up as wheelwright and smith in the nearby village of Waterlane. In 1924, his son Norman (1910-) was apprenticed as a furniture maker for six years to Peter Waals in Chalford. He returned to Waterlane in 1930 and continued to work in metal, receiving orders from Peter Waals, Jewson, and others. After his father's death, Norman Bucknell moved to Lypiatt in about 1957 and then to Bisley where he built a workshop next to his house. He retired in 1994.
MG

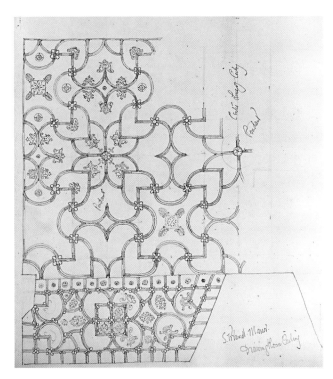

Fig.141 *Plasterwork ceiling in the drawing room at South Wraxall Old Manor, Wiltshire, drawn by Ernest Gimson in 1886.*

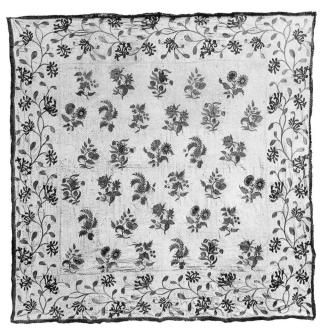

Fig.142 *An embroidered bedspread, probably seventeenth century, from Ernest Gimson's photograph collection. He used a combination of a flowing border with individual floral motifs in his plasterwork designs.*

Fig.143 *Gimson's design for a fireplace and a coloured plaster frieze for Borden Wood, near Liphook, Hampshire, signed and dated 4 June 1903.*

1. For further details see *GCF*, pp.29-37 and 83.
2. Lethaby, W. R., Powell, A. H. and Griggs, F. L., *Ernest Gimson, His Life and Work*, Stratford-upon-Avon 1924, p.4.
3. Unpublished letter, Gimson to Sydney Gimson, 20 February 1888, CAGM.
4. Unpublished letter, Gimson to Sydney Gimson, undated 1888, CAGM.
5. Mander, N., Verity, S. and Wynne-Jones, D., *Norman Jewson, Architect (1884-1975)*, Bibury 1987.

68 Plaster panel

Designed and made by Ernest Gimson about 1905-15.

Cast from a mould.

$17 \times 7\frac{1}{4}$ (432×184)

Given in 1989 by Alan Knight. 1989.892

Rescued with Cat.69 from the cellar of Gimson's house at Sapperton after the roof caught fire in 1940.

Alan Knight (1911-95) was an artist-blacksmith who worked in Bromsgrove and Hampton Lovett, near Droitwich, Worcestershire. He was inspired by the craft philosophy of Morris and Lethaby and specialised in traditional wrought ironwork and silver. He undertook restoration work for churches, including Tewkesbury Abbey, and for the National Trust as well as producing fine new work for Gloucester Cathedral among others. Alan Evans (Cat.258) was one of a number of apprentices who trained in his workshop.

Vine and grapes motif; a drawing by Gimson for plasterwork at Bradford Town Hall, includes a similar design.[1]

1. CAGM 1941.224.108.

Fig.144 **Cats 68 and 69**

69 Plaster panel

Designed and made by Ernest Gimson about 1905-15.

Cast from a mould.

$11\frac{3}{4} \times 7\frac{1}{4}$ (298×184)

Given by Alan Knight in 1989. 1989.893

Gimson produced designs using the oak leaf and acorn motif in different media including plaster, stone and metal (Cat.72).

70 Fire tongs

Designed by Ernest Gimson and made by Alfred Bucknell about 1905.

Wrought iron with chased decoration.

Given in 1961 by Mrs D. W. Herdman. 1961.39d

The donor was the widow of D. W. Herdman who conceived the idea of holding an Exhibition of Cotswold Craftsmanship in Cheltenham as part of the nationwide Festival of Britain celebrations. The exhibition opened in the summer of 1951 after his retirement from the post of Librarian Curator at

Fig.145 **Cat.70**

Cheltenham. This pair of fire tongs was one of the items Herdman lent to the exhibition.[1] According to the catalogue, Gimson kept them for his own use in his drawing office at Sapperton.

1. CAGM, *An Exhibition of Cotswold Craftsmanship*, 1951, Cat.222.

71* Toasting fork

Designed by Ernest Gimson, about 1900-10, and made by Norman Bucknell in 1985.

Polished steel with chased decoration on the handle and fire guard.

$18\frac{3}{4} \times 11$ (472×128)

Purchased in 1985 from the maker for £120. 1985.676

Design: CAGM 1941.223.28.
 See Col.Fig.61.

72* Two brass sconces

Designed by Ernest Gimson in 1906. One made probably by Alfred Bucknell about 1919, the other by Norman Bucknell about 1930-9.

Brass with pierced and chased decoration. According to Norman Bucknell, the sconce with the chasing closer together is his work and later than the other.

$10 \times 7\frac{1}{8} \times 3\frac{1}{2}$ (254×180×90)

Given in 1952 by Mrs E. Scrutton. 1952.106

Design: CAGM 1941.223.236.

A number of drawings for this design survive in the Museum's collection. One is signed and dated January 1906.
 Sconces were made regularly, to commission, for exhibition or for stock. They were produced in a variety of designs and the acorn and oak leaf motif was a popular version. The work was relatively straightforward and was often carried out by apprentices under the supervision of Bucknell or one of the other experienced blacksmiths.
 See Col.Fig.60.

73 Set of fire dogs

Designed by Ernest Gimson, probably 1905-10, and made by Alfred and Norman Bucknell at the Waterlane smithy, probably 1919-24.

Fig.146 **Cat.72**

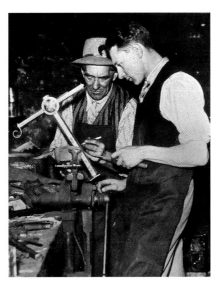

Fig.147 *Norman and Alfred Bucknell in the smithy at Waterlane, Gloucestershire, early 1930s.*

Polished steel with welded discs and pierced and chased roundels. The leg support, hooks and bars with twisted decoration are made of forged iron and attached to each dog by a single pin.

$24 \times 20\frac{1}{4} \times 11$ (610×515×280)
Length of bars: $26\frac{3}{4}$ (698)

Purchased in 1956 at auction from G. H. Bayley & Sons, Cheltenham, for £14 from the Friends Fund. 1956.78

Design of roundel: CAGM 1941.223.24.

Gimson sketched a stone squirrel on a visit to Winchester Cathedral in about 1888 which inspired this squirrel motif.[1] Several versions of this design were made.
 See Fig.148.

1. CAGM 1941.225.119, p.53 (Fig.149).

74* Pair of candlesticks

Designed by Ernest Gimson about 1905-15 and made in the Sapperton smithy.

Each one made in four pieces and brazed. Brass with stamped decoration.

$8\frac{3}{4} \times 6 \times 6$ (22.3×152×152)

Given a 'not-accessioned' number in 1965 indicating that it was an uncatalogued part of the Museum's collection at that date. 1998.263.
 See Col.Fig.60.

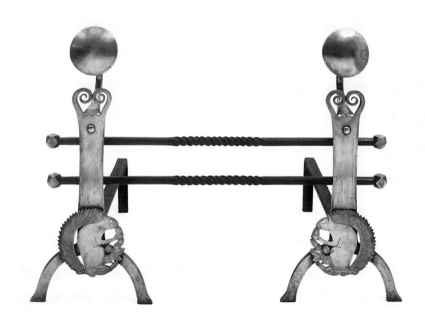

Fig.148 **Cat.73**

Fig.149 *Squirrel carved in stone at Winchester Cathedral, drawn by Ernest Gimson, 1888.*

75* Door handle

Designed by Ernest Gimson about 1905-15 and made by Alfred or Norman Bucknell about 1934.

A pair of lock plates and handles in polished steel with stamped decoration, mounted on two pieces of oak as a sample.

$6\frac{5}{8} \times 9 \times 6\frac{3}{4}$ (168×229×171)

Purchased in 1937 for £1 10s from the Friends Fund. 1937.41

Correspondence in the Museum files indicates that this door handle had been on loan to the Museum since Herdman saw it in an exhibition in Montpellier Gardens, Cheltenham, in the summer of 1934.[1] It had subsequently been exhibited in various parts of the country. It was than bought as an example of good craftsmanship. Alfred Bucknell reduced the price he was asking from £2 to £1 10s od because it was being acquired for the Museum.
 See Col.Fig.63.

1. Letters from Herdman to Bucknell dated 14.12.36 and from Bucknell to Herdman dated 16.12.36, CAGM.

76* Fire tools and fire iron rests

Designed by Ernest Gimson and made in the Sapperton smithy in October 1915.

The fire iron rests were made by Steve Mustoe in 86 hours and Alfred Bucknell in $1\frac{1}{2}$ hours; the fire irons were made by Bucknell in $94\frac{1}{2}$ hours and Fritz Whiting in 12 hours. Polished steel with pierced and chased decoration. The tools, a shovel, poker and tongs, fit on to a pair of fire iron rests.

Fire iron rests: $12 \times 9\frac{1}{4} \times 10\frac{3}{4}$ (304×235×274)
Length of poker: $26\frac{3}{8}$ (675)
Length of tongs: $27\frac{1}{8}$ (688)
Length of shovel: $27\frac{3}{8}$ (694)

Given in 1982 by Constance Tangye. 1982.1071 and 1073

Design: CAGM 1941.223.25 and 180.

Record: CAGM 1941.225.121, Gimson's workshop book p.71.

Made for the Birmingham solicitor, Allan Tangye. The donor, his daughter-in-law, recalled that the care of these fire irons was a cause of great pride to the parlourmaid who did not expect them to be used.
 The most demanding blacksmith's work was the heavy fire dogs and polished steel fire irons with spiral twist decoration. In his journal, C. R. Ashbee recalled a visit to the Sapperton smithy: 'In the middle of our talk Gimson suddenly seized the iron fire clippers. "There!" said he. "Can any smith of yours make a piece like that? Oh yes you may well pore over it – it's the most difficult double joint you can forge. Oh yes you may well pore over it. Can they? Can they?"
 I thought of Bill Thornton & Charley

Downer also at work in their Cotswold valley. "It's all a matter of time!" '[1]
 See Col.Fig.62.

1. Ashbee Journals, May 1914, information supplied by Alan Crawford.

77* Poker

Designed by Ernest Gimson about 1905-15 and made by Norman Bucknell in 1948. The engraving is by G. T. Friend.

Polished steel with chased and stamped decoration.
Engraved: A. Norman Bucknell fecit. 1948

$22 \times 1\frac{5}{8}$ (560×42)

Purchased in 1948 from the maker for £3 10s. 1948.143

George Taylor Friend was an engraver based in London who worked with a number of Arts and Crafts designers including Ashbee. He contributed an article on engraving to *Fifteen Craftsmen on Their Crafts*, edited by John Farleigh and published in 1945.
 See Col.Fig.61.

78 Latch and handle

Designed by Ernest Gimson about 1905-15, maker unknown.

Made in forged metal with chased and stamped decoration and mounted on rough wood.

Fig.150 *A lock plate, probably sixteenth century, from Ernest Gimson's photograph collection. Gimson used the bold forms and chased decoration of sixteenth-century metalwork as an inspiration for his own designs.*

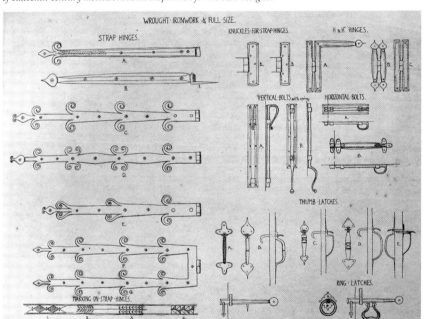

Fig.151 *Designs by Ernest Gimson for wrought ironwork, c.1910.*

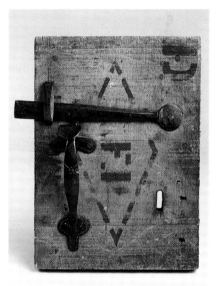

Fig.152 **Cat.78**

$15\frac{1}{8} \times 9\frac{1}{8} \times 1\frac{3}{8}$ (384×235×35)

Found in the Museum's collections in 1998. 1998.262

This piece is the type of handle used by Gimson on exterior doors. The handle is similar to those used by him on a thatched cottage, Coxen, Budleigh Salterton, Devon, built in 1910. One of the doors from the cottage is in the Museum's collections.[1] Similar pieces were also made at Russell & Sons, Broadway, in the 1920s. It was probably mounted up to demonstrate its working parts and to ensure that they were kept together.

1. *GCF*, Cat.28, p.92.

Alfred and Louise Powell (1865-1960 and 1882-1956) and their circle

Grace Barnsley, Alfred and Louise Powell

Alfred Hoare Powell and his wife, Louise, are best known as decorators of pottery. Having trained in Sedding's office, Powell began his career as a 'wandering architect' and master of works, working on site with craftsmen. He undertook a number of commissions for the Society for the Protection of Ancient Buildings, including overseeing the repairs on the Old Clergy House, Alfriston, Sussex in 1895.[1] He tried his hand at numerous building crafts including stonecarving, blacksmith's work, and woodcarving. He was also a prolific artist and experimented with wood engraving. He probably began making pottery at the turn of the century. Red earthenware pieces with high relief modelling and lustre glazes on a black or white ground were designed and made by him, and fired at Millwall, London.

In 1906 he married Louise Lessore from a French family of distinguished artists settled in Britain. She studied art, design and calligraphy at the South Kensington School, the Slade School of Art, and the Central School of Arts and Crafts. She also designed and executed needlework, calligraphy and illumination and painted freehand on furniture. In July 1900, while a student at South Kensington, she entered a national competition for students. Two of her designs, for tiles and for dessert plates 'quiet and delicately coloured', were featured in *The Studio*.[2]

Their connection with Josiah Wedgwood & Sons began in 1903. Alfred Powell submitted designs to this established Staffordshire firm which was looking for new designers to revive its fortunes. His earliest attempts at freehand pottery decoration were very simple (see Cat.81). Louise Powell also became involved in this new enterprise. While working at the factory in 1905, she discovered Wedgwood's eighteenth-century creamware pattern books and both husband and wife used these designs as the basis for a range of hand-painted domestic wares. These were subsequently produced by Wedgwood exclusively for James Powell of Whitefriars, London.[3]

In 1901, Alfred Powell moved to the Cotswolds, initially to convalesce with his friend from Sedding's office, Ernest Gimson. After their marriage, he and Louise moved to the nearby village of Tunley where Sidney Barnsley built them the house which remained a base until the 1940s. They led a simple but sociable existence in the Cotswolds with regular summer camps and musical entertainments which attracted other artists, designers and craftspeople to the area.[4]

The Powells worked very much as a team, with studios in London and in the Cotswolds for most of their careers. The majority of their pottery after 1906 is marked with one or the other's painted monogram. Occasionally both monograms were used suggesting that both worked on a particular piece. The pattern numbers of each designer

appear to be consecutive. From dated pieces it is possible to work out a rough chronology. The largest collection of Powell painted pieces is documented in the catalogue of the 1992 exhibition of their work.[5]

Their distinctive style of pottery decoration was inspired by historical work: Italian maiolica, Chinese blue and white, Persian and Isnik pottery, Elizabethan embroideries, and early illuminated manuscripts, but freely interpreted and combined with their personal observations of plants, flowers and animals. Most of their work was painted free-hand underglaze in their studio and transported to the factory for glazing. They began training pupils from 1906 and set up a hand-painting studio at Wedgwood.

One pupil was Grace Barnsley, daughter of Sidney and Lucy Barnsley, who probably learned to decorate pottery while still a child. The Powells were close family friends and she would have visited their studio regularly. She attended classes at Birmingham School of Art and began decorating pottery in about 1915. That year Sidney Barnsley ordered a decorator's wheel from Gimson, presumably for her use. It was made in the Sapperton smithy for £1 11s in December 1915.[6] From September 1917, Grace began ordering her own blanks from Wedgwood. She collaborated with the architect and engraver, Fred Griggs, and later with her husband, Oscar Davies, who had spent the first years of their married life in the Merchant Navy. In 1934 they took over a pottery which they renamed Roeginga Pottery in Rainham, Kent. They made, as well as decorated, domestic earthenwares, in a thicker and more textured body than that used by Wedgwood, covered with a matt glaze.

Towards the end of Louise Powell's life, she lost her sight. Alfred Powell wrote to a young friend about her contribution, 'I've been thinking about the vast amount of work she has done, & so well done – we are near our 6000th pot & she was always quicker than I a-doing! and then the embroidery – flower painting – illumination – a lot of work and all, as I have seen it, done *right* at the beginning & never altered, & very beautiful!'[7]

MG

1. This was the first property owned by the National Trust.
2. *The Studio*, Vol.20 1900, pp.255 and 265.
3. Harry Powell, director of the company, was Alfred Powell's cousin.
4. For a full account see Sarsby, J., 'Alfred Powell: Idealism and Realism in the Cotswolds', *Journal of Design History*, Vol.10 No.4 1997, pp.375-97.
5. See Batkin, M., *'Good Workmanship with Happy Thought': the work of Alfred and Louise Powell*, Cheltenham 1992.
6. CAGM 1941.225.121, Gimson work book, p.72.
7. Unpublished letter from Alfred Powell to Kenneth Garlick, 12 April 1952, CAGM.

Fig.153 *Alfred Powell, 1952.*

Fig.154 *Designs for pottery decoration by Alfred Powell, from a sketchbook given by him to Gimson in 1917.*

Grace Barnsley (1896-1975)

79* Bowl

Designed and painted by Grace Barnsley about 1920-4 and made by Wedgwood.

Earthenware painted in underglaze colours. Impressed mark on base: WEDGWOOD, *year mark unclear. Painted mark on base: Grace Barnsley monogram,* 187.

$3\frac{1}{4}\times7\frac{1}{4}\times6\frac{5}{8}$ (83×185×169)

Purchased in 1982 from Richard Dennis for £75.[1] 1982.1069

This piece, and Cats 80, 83 and 85, were purchased from an exhibition to launch the publication by Richard Dennis of *Wedgwood Ceramics 1846-1959* by M. Batkin in 1982.
 See Col.Fig.67.

80* Jug

Designed and painted by Grace Barnsley in 1924 and made by Wedgwood.

Earthenware painted in underglaze colours. Impressed mark on base: WEDGWOOD 3SW24, *painted mark: Grace Barnsley monogram,* 239.

$5\frac{1}{2}\times6\frac{3}{8}\times4\frac{1}{8}$ (140×162×105)

Purchased in 1982 from Richard Dennis, for £75. 1982.1070
 See Col.Fig.67.

Alfred and Louise Powell (1865-1960 and 1882-1956)

81* Dinner plate

Designed and painted by the Powells about 1905, made by Wedgwood.

Moulded earthenware painted mainly in overglaze colours. The glaze is badly crazed and discoloured.
Impressed mark on base: WEDGWOOD.
Painted mark on base: double leaf mark, 268.

$10\frac{1}{8}$ diam. (257 diam.)

Given in 1997 by the Lupton family. 1997.268

The simple border design with its five-dot flowers relates to an early design described by Alfred Powell writing to his mother in February 1905, '… a powdering of little violets over cups and saucers … just five little blobs of blue to each flower leaving the little white centre the two blobs of green for each leaf – the brown

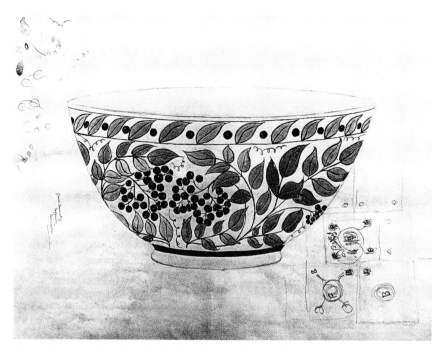

Fig.155 *Design for pottery decoration by Grace Barnsley dating from her student days at Birmingham School of Art, about 1912.*

stalk being put on first the flower and the leaves all nice and snug.'[1]
 Maureen Batkin has suggested that the double leaf mark was used by Louise Lessore before her marriage to Alfred Powell in 1906.
 The Lupton and Powell families had close links through Bedales School. Geoffrey Lupton was also Gimson's pupil-apprentice in 1905 and subsequently took on Edward Barnsley as a pupil-apprentice in his workshop at Froxfield, Hampshire. He and his family bought and used Powell pottery throughout their lives.
 See Col.Fig.65.

1. Quoted by Batkin, M., *Wedgwood Ceramics 1846-1959*, London 1982, p.140.

82* Saucer

Designed and painted by Louise Powell about 1916-20 and made by Wedgwood.

Moulded earthenware painted in underglaze colours, with a border pattern and four leaf sprays on the underside of the rim. Impressed mark on base: WEDGWOOD, *date stamp unclear. Painted mark on base: Louise Powell monogram,* 1162.

$5\frac{7}{8}$ diam. (149 diam.)

Given in 1997 by the Lupton family. 1997.273
 See Col.Fig.64.

83* Jug

Designed and painted by Louise Powell about 1916-20, made by Wedgwood.

Thrown earthenware painted in underglaze colours and pink lustre.
Impressed mark on base: WEDGWOOD.
Painted mark on base: Louise Powell monogram, 1674.

$6\times5\frac{1}{2}\times4\frac{1}{4}$ (152×140×108)

Purchased in 1982 from Richard Dennis, for £75. 1982.1067
 See Col.Fig.66.

84* Charger

Designed and painted by Alfred Powell and made by Wedgwood about 1920.

Earthenware painted in underglaze colours and yellow lustre. The back of the charger has four deer painted round the rim and four leaf patterns on the base. The foot of the base is chipped.
Impressed mark in the base: WEDGWOOD.
Painted mark: 2669.

$3\frac{1}{2}\times16\frac{1}{4}$ diam. (83×413 diam.)

Purchased 14.7.1998 from Phillips, London, Lot 578, for £480. 1998.255

Powell painted a number of chargers and large bowls with designs featuring deer and stags.
 See Col.Fig.69.

85* Punch bowl

Designed and painted by Alfred Powell in 1928 and made by Wedgwood.

Earthenware painted in underglaze blue with views of Gloucestershire houses. Painted round the inside rim of the bowl is a simple border design and a leaf spray on the base. There are three long cracks in the glaze round the curve of the bowl.
Impressed mark on inside of foot:
WEDGWOOD MADE IN ENGLAND. *Painted mark on base: Powell monogram, 3395. Painted inscription on base: Tunley, Glos. Sept 1928.*

$12\frac{1}{8} \times 15$ diam. (308×380 diam.)

Purchased in 1982 from Richard Dennis, for £1500 with a 50 per cent grant from the V&A Purchase Grant Fund. 1982.1068

The three houses depicted are Daneway House, Owlpen Manor, and Rookwoods Farm. Daneway House was the site of Ernest Gimson's workshop and showrooms from 1902-19; in 1920 it was leased to Emery Walker, the printer and friend of William Morris who printed some of Powell's wood engravings. Owlpen Manor was bought and restored by Norman Jewson in 1925. Rookwoods Farm was a mainly seventeenth-century farmhouse near Tunley which Powell would have seen regularly during walks up the Througham Valley.[1]
See Col.Fig.68.

1. Jewson, N., *By Chance I Did Rove*. Privately published 1951, 2nd edition 1973, p.43 '… one of my favourite walks … continues up past Tunley to a fine old house called Rookwoods'.

86* Charger

Designed and painted by Alfred Powell in 1929 and made by Wedgwood.

Earthenware painted in purple lustre.
Impressed mark on base: WEDGWOOD MADE IN ENGLAND 1D29. *Painted mark: Alfred Powell monogram, 3623.*

$3\frac{1}{2} \times 16\frac{1}{4}$ diam. (83×413 diam.)

Purchased in 1944 from the Red Cross Treasures Sale in aid of the Duke of Gloucester's Red Cross and St John's Fund held in Gloucester on 25 May 1944, for £6. 1944.30

Record: CAGM, history file. Letter from Powell to the curator dated 29 May 1944.

Like Ashbee and other Arts and Crafts designers, Powell found the romantic

image of the sailing ship appealing and he used it on a number of pieces.
The charger was presented for sale by the Powells. Alfred Powell replied to D. W. Herdman, Librarian Curator at Cheltenham, saying, 'I am glad to know about my wanderers! & that you have one at Cheltenham. The purple lustre used is made from gold by a firm in Hatton Gardens & is rather like treacle!'
See Col.Fig.66.

87* Plate, cup and saucer

Designed and painted by Alfred Powell about 1932 and made by Wedgwood.

Earthenware painted in underglaze colours. The glaze on the cup is worn and discoloured; there is a chip on the rim of the saucer.
Impressed mark on bases: WEDGWOOD; *on plate and saucer only:* 6L32 MADE IN ENGLAND. *Painted mark on base: Alfred Powell monogram, 4290.*

Plate: $9\frac{1}{4}$ diam. (235 diam.)
Saucer: $6\frac{5}{8}$ diam. (169 diam.)
Cup: 4 diam. (102 diam.)

Given in 1997 by the Lupton family. 1997.271
See Col.Fig.65.

88* Jug

Designed and painted by Alfred Powell in 1932 and made by Wedgwood.

Earthenware painted in underglaze colours. The body and handle are cracked, the rivet repairs were removed by Cheltenham Museum in 1997 for display purposes.
Impressed mark on base: WEDGWOOD MADE IN ENGLAND
Painted mark on base: Alfred Powell monogram
Painted inscription on the handle: GH & HL 1932.

$4\frac{5}{8} \times 6\frac{1}{2} \times 4\frac{7}{8}$ (117×166×125)

Given in 1997 by the Lupton family. 1997.267

This jug was decorated as a wedding present for Geoffrey Lupton and his second wife, Helen Carlos (GH & HL: Geoffrey Henry and Helen Lupton).
See Col.Fig.65.

89 Two saucers

Designed and painted by Alfred Powell about 1937 and made by Wedgwood.

Earthenware with painted decoration. The

glaze is crazed and slightly discoloured.
Impressed mark on base: WEDGWOOD, *date stamp unclear. Painted mark on base: Alfred Powell monogram 5239.*

$6\frac{5}{8}$ diam. (168 diam.)

Given in 1997 by the Lupton family. 1997.272

The design is the same as the earlier Cat.87, so these may have been replacement pieces and have therefore not been illustrated.

90* Jar and cover

Designed and painted by Alfred Powell about 1937 and made by Wedgwood.

Earthenware with a matt glaze painted in silver lustre.
Impressed mark on base: WEDGWOOD MADE IN ENGLAND. *Painted mark on base: Alfred Powell monogram, 4655.*

$9\frac{1}{2} \times 5\frac{3}{4}$ diam. (242×146 diam.)

Given in 1938 by the designer. 1938.13

Record: Photograph of Powell wares at the Brook Street Gallery, London, 1937, includes this or an identical, piece.[1]

Correspondence at Cheltenham indicates that in January 1938 Alfred Powell offered the Museum a choice of two pieces for the collections, this jar or a plaque. A letter from Herdman states: 'The decision is for the Pot Pourri Jar and Cover as it can more conveniently take its place with Wedgwood examples of other days.'[2]
The faceted form of this jar and cover was developed by Alfred Powell. It was probably developed at the Millwall Pottery as part of a series of designs relating to ginger jars. An early example of Wedgwood ware with a more pronounced point to the lid was shown at the Arts and Crafts Exhibition in 1913.[3] It anticipates the modernist shapes designed by Keith Murray for Wedgwood in the 1930s.
The glaze treatment of this piece relates to the Veronese range introduced by Wedgwood in conjunction with the Powells in 1930. This range featured soft and subtle coloured glazes and simple lustre decoration on hand-thrown contemporary shapes. The emphasis was on simplicity of form and colour combined with modernity in an attempt to develop new markets following the Wall Street crash of 1929.
See Col.Fig.70.

1. Illustrated in Batkin, M., *Wedgwood Ceramics 1846-1959*, London 1982, p.138, pl.340.
2. CAGM 1938.13 history file, letter dated 9.3.1938.
3. Illustrated in *The Studio*, Vol.58 1913, p.27.

91 Seven dinner plates

Designed and painted by Alfred Powell in 1939 and made by Wedgwood.

Earthenware painted in underglaze colours. One plate has a chipped rim. Impressed mark on base: 'WEDGWOOD 12W38'. *Painted mark on base: Alfred Powell monogram and 5359. In addition one plate has a painted inscription:* Tarlton 1939.

$9\frac{7}{8}$ diam. (252 diam.)

Given in 1997 by the Lupton family. 1997.269

These plates are decorated with the same pattern as Cat.81; they may have been made as replacement pieces and have therefore not been illustrated.

In 1920, Alfred Powell built a summer cottage in the village of Tarlton on the estate of his friends and clients, Claud and Margaret Biddulph, owners of Rodmarton Manor. He and Louise used this cottage as a studio during the 1920s and 1930s.

92* Four cups

Designed and painted by Alfred Powell about 1939 and made by Wedgwood.

Earthenware painted in underglaze colours. The glaze on one cup has discoloured round the base. Painted mark on base: Alfred Powell monogram and 5448.

$4\frac{1}{8}$ diam. (105 diam.)

Given in 1997 by the Lupton family. 1997.270

These cups are decorated with the same pattern as Cat.81; they may have been made as replacement pieces.
 See Col.Fig.65.

Eve and William Simmonds
(1884-1970 and 1876-1968)

William and Eve Simmonds made a reality of Morris's belief that art could be the visible expression of an individual's delight in work and the natural world.

Simmonds spent four years in his father's architectural office while attending art classes at Windsor. He studied painting at the Royal College of Art from 1893 under Walter Crane and took classes at the Royal Academy Schools, including one in scene painting. He first exhibited at the Royal Academy in 1903; one of his watercolours, *The Seeds of Love* 1907, was bought by the Chantrey Bequest for the Tate Gallery in London. From 1905, he worked for part of every year with John Sargent as assistant to the painter, Edwin Austin Abbey (Fig.156). At the time, Abbey, an American anglophile, was living in Fairford, Gloucestershire, and working on a series of mural paintings for the Pennsylvanian State Capitol. After Abbey's death in 1911, Simmonds installed the last of the paintings at Harrisburg, Pennsylvania.

Eve Peart also studied art at the Slade under William Sickert. She and Simmonds met in London and began their married life in Fovant, Wiltshire, in 1912. During the First World War they rented a flat on the top floor of the Powells' house in Hampstead, London, while Simmonds worked as a precision draughtsman on tank and aircraft design. Encouraged by Louise Powell, Eve Simmonds began to embroider, exhibiting a baby's smock at the 1916 Arts and Crafts Exhibition. In 1919 the Simmondses moved to the village of Far Oakridge, Gloucestershire.

Simmonds had made his first puppet, based on Dan Leno playing Widow Twankey, before 1912. The following year, he filled idle hours at his dying father's bedside by carving puppets and that Christmas he held his first performance for the children of family and friends at Fovant. The Simmondses held professional puppet shows in the 1920s and 1930s with the occasional assistance of Barnet Friedman and Casty Cobb. The organisation for some public performances was undertaken by Muriel Rose, owner of the Little Gallery, off Sloane Street, London. Normally a private performance fee of £60 was charged for shows at venues such as the Art Workers' Guild and at the homes of enthusiasts including the Duke of Westminster, William Rothenstein, and Violet Gordon Woodhouse.

In 1913 Simmonds exhibited his first wood carving, the painted figure of 'Spring' in oak, at the Arts and Crafts Exhibition. In the Cotswolds, he watched and drew wild and domestic animals in their habitats, and converted a barn next to their house into a workshop. He produced a few carvings in stone, marble and alabaster, but most of his work was in local timber. His work was regularly included in the Royal Academy shows and invariably sold quickly.
MG

Fig.157 ABOVE *Embroidery design by Eve Simmonds from a sketchbook, c.1915-20.*

Fig.156 TOP LEFT *William Simmonds, John Singer Sargent and Edwin Austin Abbey at Fairford, Gloucestershire, 1909.*

Fig.158 BOTTOM LEFT *Behind the scenes at a performance of William Simmonds's puppet theatre, c.1925. The pig puppet (Cat.95) is hanging in the centre of the photograph.*

Eve Simmonds (1884-1970)

93* *Embroidery*

Sampler of wild flowers designed and made by Eve Simmonds in 1916.

Embroidered in silk threads on cotton. The cotton ground has discoloured and the dyes on the embroidery have faded.

$34\frac{1}{4} \times 14\frac{3}{8}$ (883×365)

Given in 1996 by Mrs Hannah Taylor. 1996.51

Record: a sketchbook in a private collection shows drawings of wild flowers and details of a border design (Fig.157).

The sampler illustrates a variety of sprays of wild flowers including flax, sundew, bog pimpernel, forget-me-not, and campanula within a flowing border design.

After their move to the Cotswolds in 1919, Eve Simmonds devoted many of her energies to cultivating their garden at Far Oakridge. She loved wild flowers, grew unusual plants and drew from nature. Her sketchbooks also show drawings of details from Elizabethan embroideries, Egyptian textiles and Hispano-Moresque pottery.

Hannah Taylor was the daughter of Mr and Mrs W. A. Cadbury who were patrons of the Arts and Crafts and bought this sampler from the original owner, the poet John Drinkwater. Drinkwater had a house in the Cotswolds in the early twentieth century and was a friend of the Simmondses.

See Col.Fig.71.

William Simmonds (1876-1968)

94* *Horse and waggon*

Designed and made by William Simmonds in 1923.

The waggon is a working model made of oak, partly painted, and plywood. The horse is carved in wood, with a hollow body and jointed head and legs, and painted. Its mane, tail, harness and saddle are made of leather, fabric, string and wood. It was worked with four strings, one of which is broken.

*Waggon: $15\frac{1}{2} \times 44 \times 14\frac{1}{2}$ (393×1119×368)
Horse: $13 \times 20 \times 5\frac{1}{2}$ (330×508×140)*

Purchased in 1995 with the four other puppets from the Verey family, for £750 from the Captain Wild Bequest. 1997.36a

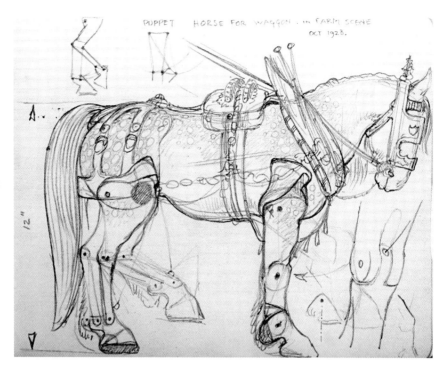

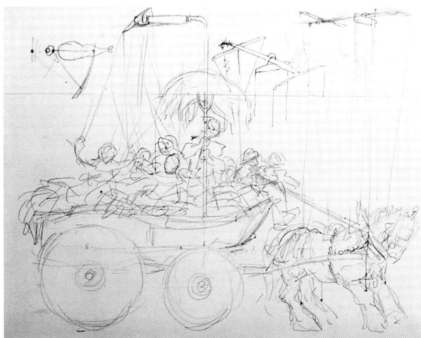

Figs 159 and 160 *Two sketches by William Simmonds of the puppet horse and the horse and waggon from the 'Farm Scene', October 1923.*

Design: two sketches in a Simmonds notebook from a private collection (Figs 159 and 160).

The horse and waggon formed the finale of the *Harvest Home* puppet show. The puppets would all be seated in the waggon and pulled along the stage by the horse.

These puppets were part of the Arts and Crafts collection built up by the writer, David Verey, at his private museum, Arlington Mill, Bibury. He acquired them from Hermione Peart, Eve Simmonds's niece, after the latter's death. Verey's collection was dispersed when Arlington Mill was closed in 1995, some years after his death.

See Col.Fig.75.

95* Pig

Puppet designed and made by William Simmonds about 1920-5.

Carved in wood, probably ash, with a hollow body, jointed legs and head. Painted, with leather ears and tail, and worked by four strings, one of which is broken.

$6\frac{1}{2} \times 13 \times 3$ (165×32×76)

Purchased in 1995, as Cat.94. 1997.36b

Record: this puppet can be seen in the photograph of backstage at a puppet show (Fig.158).

Most of Simmonds's puppets were worked with four strings rather than the more usual six, the swing of the figure providing additional movement. Because each one had individual characteristics, no two puppets were meant to move alike. Therefore the mechanism of each one was slightly different.
See Col.Fig.76.

96* Fox

Puppet designed and made by William Simmonds about 1920-5.

Carved and painted wooden head with a leather tongue and ears, and glass bead eyes. Wooden joints fixing the leather legs to a wire body covered in artificial fur. Worked by three strings.

$5\frac{1}{2} \times 15 \times 2$ (140×381×51)

Purchased in 1995, as Cat.94. 1997.36c
See Col.Fig.76.

97 Two cocks

Toys or puppets designed and made by William Simmonds about 1920-5.

Both have carved and painted wooden heads and bodies with leather, string and fabric details. The head of one cock can be pushed up by a wire like a jack-in-the-box; the wings of the other are attached by wire to its feet so that they flap when the cock is pushed down.

$12 \times 7 \times 3$ (306×178×76)
$8 \times 4\frac{1}{2} \times 4$ (203×114×101)

Purchased in 1995, as Cat.94. 1997.36d & e

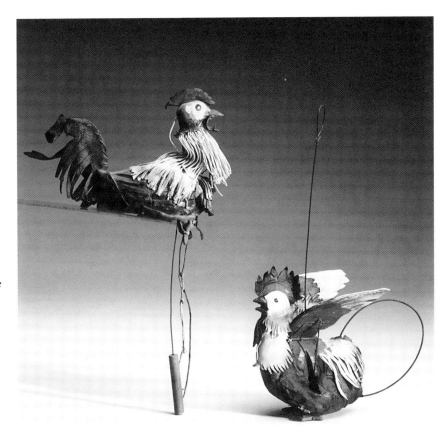

Fig.161 **Cat.97**

98* Little pigs

Designed and made by William Simmonds in 1937.

Carved in ivory on an octagonal ebony stand. Incised mark on base of carving: W.G.SIMMONDS 1937. *Paper labels written in ink on base of stand:* LITTLE PIGS *and* W.G.SIMMONDS FAR OAKRIDGE STROUD GLOS.

Carving: $\frac{5}{8} \times 2 \times 2$ (16×51×51)

Bequeathed in 1996 by Anna Hornby. 1997.39

Simmonds made numerous sketches and several carvings of sleeping pigs.
Anna Hornby was the daughter of C.H.St John Hornby, founder of the Ashendene Press and a patron of the Arts and Crafts Movement.
See Col.Fig.73.

99* Ducklings

Designed and made by William Simmonds in 1950.

Carved in boxwood with ebony inlay on a laburnum stand. The laburnum has two distinctive strips of lighter coloured sapwood. Incised mark on base of stand: W.G.S.

$4\frac{3}{4} \times 12\frac{5}{8} \times 6\frac{5}{8}$ (120×320×168)

Bequeathed in 1994 by Miss G.P. Younghusband. 1994.254

Record: RA Summer Show, 1950, Cat.1396.

The stands for Simmonds's carvings were usually made for him by the cabinetmaker, Fred Gardiner.
See Col.Fig.74.

100* Autumn calf

Designed and made by William Simmonds in 1952.

Carved in English oak and painted, on a stand of ash.

$9 \times 16 \times 13\frac{5}{8}$ (228×406×347)

Purchased in 1952 by the Friends Fund and public subscription for £250. 1952.140

Record: RA Summer Show, 1952, Cat.1563.
See Col.Fig.72.

Phyllis Barron and Dorothy Larcher
(1890-1964 and 1884-1952)

Phyllis Barron and Dorothy Larcher produced hand-block printed textiles to their own distinctive designs in London and, from 1930, in Painswick, Gloucestershire. On her return from India in 1921, Larcher, who had trained as an artist, visited her friends, William and Eve Simmonds and according to the latter's account[1] was very excited to see a scrap of fabric printed by Barron in indigo blue with the *Lizard* design. Barron, who had trained at the Slade, was a founder member of the London Group which included Augustus John and Harold Gilman, but turned to designing and printing textiles following the fortuitous discovery of old French hand blocks on a visit to France. She began researching what was a lost craft, learning by a process of trial and error to print fabrics using old blocks. Ethel Mairet's book on vegetable dyes published in 1916 became her source book and the two women became friends.[2] She used cutch (brown), iron (black) and indigo (blue) on unbleached linen and cut her first design in 1915. Very quickly her 'astringent yet elegant approach to design'[3] won her the attention of Roger Fry, and an invitation to exhibit with the Omega Workshop.

The subsequent meeting of Barron and Larcher at a joint exhibition of Mairet's and Barron's work at the Brook Street Gallery, London, quickly led to their joining forces in Barron's cramped basement workshop on Hampstead High Street. In 1923 they moved to a workshop in Park Hill Road, Hampstead, and employed two girls to print their designs. Their work was seen regularly in London with exhibitions at the Mayor Gallery, the Three Shields Gallery and the Little Gallery in the 1920s.

Through the architect, Detmar Blow, Barron and Larcher received a commission to furnish the coming-out dance of the Duke of Westminster's daughter in 1925. Included were floor cushions of Chinese silk dyed with madder and trimmed with red and white fringes. Another commission for the Duke's hunting lodge in Bordeaux led to an introduction to the fashion designer, Coco Chanel, and an opportunity to design cushions for her garden in Paris.

In 1930 they moved to the Cotswolds where friends such as the Powells, William and Eve Simmonds, and the painter Bernard Adeney and his fashion-designer wife, Noel Gifford, were part of a loose arts and crafts community. They settled in the village of Painswick where they were able to expand the printing workshop and install a large vat for indigo dyeing. The local water was particularly suitable for madder dyeing and the nearest town, Stroud, had an established textile industry with mills, such as the West of England Mills, still producing the woollen cloth used for uniforms.

In 1933 they received a major commission to advise on the decoration of the extension and new library at Girton College, Cambridge. As well as providing fabrics for

Fig.162 *Eve Simmonds wearing a skirt in 'Peach' printed in black on velvet by Barron and Larcher, 1920s. The outfit, a skirt and jacket, is in the collections of the Crafts Study Centre, Holburne Museum, Bath.*

curtains and furnishings, they were also able to put together a simple yet classic interior scheme which included furniture by Eric Sharpe and Fred Gardiner. The detailed account of this commission has been researched by Barley Roscoe.[4]

By 1930 Barron and Larcher were printing on a variety of fabrics but always choosing those of the highest quality. As well as the unbleached linen with which Barron had first experimented, they used Rodier wool, undyed velvet, natural and dyed silks from China, unbleached cottons, and Indian fabrics, including dhoti cloths. It was the impossibility of obtaining good quality fabrics which forced them to give up printing during the Second World War.
MG

1. CAGM: Tanner, R., *Phyllis Barron 1890-1964*, privately published leaflet.
2. Mairet, E., *Vegetable Dyes*, Ditchling 1916.
3. Andrews, G. and Comino, M., *William and Eve Simmonds*, Cheltenham 1980, pp.23-5.
4. Roscoe, B., 'The Biggest and Simplest Results', *Crafts*, 144 1997, pp.61-6.

101* Scarf

Designed and made by Barron and Larcher about 1925.

Cream silk crêpe with a stencilled geometric design in two colours.
The scarf has been made up with hand-rolled edges stitched in silk thread.

$19 \times 60\frac{3}{4}$ (483×1544)

Given in 1984 by Mrs Hannah Taylor.
1984.63.1
 See Col.Fig.78.

102* Cushion cover

Designed and made by Barron and Larcher about 1930.

Silk fabric, hand-block printed in dark brown and red. The cushion has been hand-sewn with a machine-made silk fringed trim round the edge. The fabric is very worn and the colour has faded.

24×24 (610×610)

Given in 1984 by Mrs Hannah Taylor.
1984.63.3

Kite pattern overprinted with a 'V' motif.
 See Col.Fig.77.

The Bromsgrove Guild, Arthur and Georgina Gaskin, Albert Edward Jones

Birmingham has been a major centre for metalwork and jewellery making for a long time, with evidence of goldsmiths going back to the fourteenth century. During the seventeenth century Birmingham metalworkers turned their skills to producing fashionable buckles and buttons and the industry flourished, becoming one of the city's main employers by the late nineteenth century. Most workers were based in one part of the town, known as the Jewellery Quarter, where they had their workshops and homes. Much of this jewellery produced in Birmingham during the nineteenth century was stamped and cast and some was machine-made and catered for the cheaper end of the market.

In 1887 the Birmingham Jewellers' Association was founded and one of its main aims was to improve the artistic skills of young people working in the trade. Initially it had workrooms at the Birmingham School of Art where full technical training in jewellery was given. Eventually it became apparent that these apprentices required a more structured approach as regards learning to draw and understanding design. As a result, their own training school, the Vittoria Street School for Silversmiths and Jewellers, was opened in 1890. Students were taught to draw from nature and to appreciate the importance of 'simple but right decoration, and to avoid that over abundance of ornament which is always a danger in the jewellery trade'.[1] A number of influential designers taught in Birmingham, including Robert Catterson Smith who became headmaster of the Vittoria Street School in 1901, Arthur Gaskin who succeeded him in 1903, and John Paul Cooper who was head of the metalwork department at the Birmingham School of Art from 1902-6 (see p.105).

This re-evaluation of the craft of jewellery inspired a number of designers living in Birmingham and the surrounding area to turn their attention to its design and manufacture. In the spirit of C. R. Ashbee's Guild of Handicraft, the Bromsgrove Guild was formed in about 1894 by the sculptor, designer and metalworker, Walter Gilbert (cousin of the sculptor and jewellery designer, Alfred Gilbert) who had previously taught art at the Bromsgrove School. He developed his interest in metalwork through taking over an old foundry and designing decorative metalwork. A local businessman, Mr McCandlish, provided the financial backing for the Guild and went into partnership with Gilbert. The Guild expanded into a former police station and neighbouring buildings which provided offices for drawing and designing, and various workshops for metalwork, wood carving, plaster and lead casting, and stained glass. In 1900

the Guild entered an Art Nouveau style bedroom in the Paris Exhibition and won an award. This was followed by several prestigious commissions including the design and execution of the gates and railings for Buckingham Palace in 1905. In 1908 the Guild received a Royal Warrant and in 1921 it became a limited company. It continued operating until 1966.

Arthur Gaskin and Georgina Evelyn Cave France, known as Georgie, met while they were both students at the Birmingham School of Art and married in 1894. Arthur Gaskin was primarily a painter and illustrator. Georgie had designed a number of metalwork pieces during her training. They both entered their work for the National Competition art examinations organised by the South Kensington Museum and won awards. They began making their first pieces of jewellery in 1899; although neither of them had any technical skills in this field they had a sense of design and artistic sensibility. In 1900 *The Studio* noted that the reason the Gaskins started making jewellery was because, 'living as they do in Birmingham, a principal centre of the manufacture of jewellery, they have always before them the painful evidences of the need of reform in that industry'.[2] This would have certainly concerned them but it also seems likely that they took up this craft to supplement Arthur Gaskin's income as a painter. They learned some skills themselves, such as enamelling, and employed assistants to help carry out other technical processes. In a letter of 1929, written to Kaines Smith, the Director of Birmingham City Art Gallery, Georgie told him that, 'in the jewellery I did all the designing and he [Arthur] did all the enamel, and we both executed the work with our assistants'.[3] In 1903 they registered a punch at the Assay Office in Birmingham and traded under the name of Arthur and Georgie Gaskin. In the same year Arthur took over as headmaster of the Vittoria Street School from Robert Catterson Smith who moved to the Central School of Arts and Crafts and an exhibition of his work was organised to mark the appointment. He was a natural teacher with a real gift for inspiring his students; many examples of craft jewellery in the style of the Gaskins were made during this period. Teaching also gave Arthur the opportunity to meet other craftsmen such as Bernard Cuzner, and he received a number of prestigious commissions. Georgie continued designing until her death in 1934.

Another important designer based in Birmingham was Albert Edward Jones who studied at the Birmingham School of Art under Edward Taylor and later worked with the Birmingham Guild of Handicraft. In 1902 he left the family firm and in 1904, established his own business working in bronze. He used as his trade-mark St Dunstan, the patron saint of silversmiths, raising a bowl. Both his approach to working and his designs were influenced by Ashbee. For example, there was no division of labour in the workshop and pieces were given a hammered finish. Jones designed pieces for Liberty and worked with the Gaskins by providing them with the silver backgrounds for enamelling. He also carried out a number of commissions for the Birmingham and Bromsgrove Guilds.
SW

1. *The Studio*, Vol.18 1900, p.193.
2. *Ibid.*
3. Quoted by Breeze, G. and Wild, G., 'The Gaskins as Craftsmen' in *Arthur and Georgie Gaskin*, Birmingham 1981, p.62.

Bromsgrove Guild (1894-1966)

103 Plaque

Made by the Bromsgrove Guild in about 1900.

Bronze with cast decoration, screw fitting on the centre back for attaching.
Moulded on the front: 'BROMSGROVE GUILD.WORCESTERSHIRE.ENGLAND'

3 diam. (76 diam.)

Given in 1982 by Professor and Mrs Hull Grundy. 1982.1156

A similar plaque is in the collections at Birmingham Museum and Art Gallery and was used to fix to crates for shipping export orders from the Guild.

104 Paperweight

Made by the Bromsgrove Guild after 1921.

Cast bronze.
Moulded on the front: BROMSGROVE GUILD LTD.

$4\frac{1}{8} \times 3\frac{7}{8}$ (105×98)

Given in 1982 by Professor and Mrs Hull Grundy. 1982.1157

The Guild became a limited company in 1921.

Arthur and Georgina Gaskin (1862-1928 and 1866-1934)

105* Brooch

Designed and made by Arthur and Georgina Gaskin in about 1900-10.

Silver flowers and settings with facet-cut green pastes.
Hinged pin and hook fastening across the back.
Stamped on the back: G.

$1\frac{11}{32} \times 1\frac{3}{8}$ (34×35)

Given in 1982 by Professor and Mrs Hull Grundy. 1982.1174
 See Col.Fig.80.

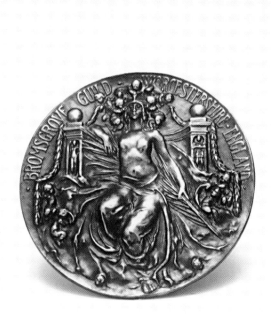
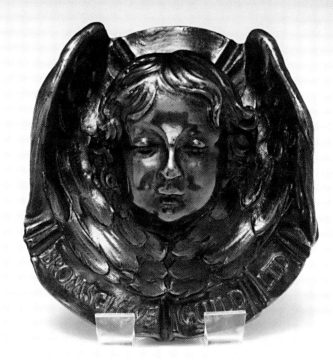

Fig.163 **Cats 103 and 104**

106* Necklace

Designed and made by Arthur and Georgina Gaskin in about 1902-6.

Silver chain, leaves and settings with cabochon-cut turquoises and chrysoprases. Push-back ring catch. Unmarked.

Pendant: $3\frac{1}{16} \times 1\frac{11}{16}$ (78×43)
Length of chain: $16\frac{5}{8}$ (422)

Given in 1982 by Professor and Mrs Hull Grundy. 1982.1173

A simpler version of this design, entitled 'Briar Rose', was shown at the Arts and Crafts Exhibition of 1903. The Gaskins named their pieces according to the wire structure as opposed to the choice of stones, therefore it would seem that this is also a 'Briar Rose' necklace.[1]
 See Col.Fig.80.

1. Breeze, G. and Wild, G. *Arthur and Georgie Gaskin*, Birmingham 1981, Cat.G4, p.77.

107* Brooch

Designed and made by Arthur and Georgina Gaskin in about 1909.

*Silver, cabochon-cut amethyst quartz. Hinged pin and hook fastening across the back.
Stamped on the back:* G.G.

$1\frac{1}{32}$ diam. (26 diam.)

Given in 1982 by Professor and Mrs Hull Grundy. 1982.1175

The Gaskins often worked with semi-precious stones which they had found on their travels in this country, including cornelian, agate and quartz.
 See Col.Fig.80.

108* Pendant

Designed by Arthur and Georgina Gaskin in about 1911.

*Silver, pearl, crystals, mauve and green pastes.
The pastes and crystals are softly faceted. There are pearls missing from the bottom flowers and it is possible that originally there was a pendent pearl attached. Ring attachment at the top for a chain.*

$2\frac{1}{2} \times 1\frac{3}{4}$ (57×44)

Given in 1982 by Professor and Mrs Hull Grundy. 1982.1172

This is very similar to a design entitled 'Friendship' in Georgina Gaskin's Drawing Book,[1] but the drawing includes a pendent pearl. In making their pendants with chains attached by rings it is likely that the Gaskins were influenced by Norwegian and Swedish peasant jewellery, a source used by several Arts and Crafts designers.
 A version of this design is illustrated in Breeze, G. and Wild, G. *Arthur and Georgie Gaskin*, Birmingham 1981, Cat.G31, p.84.
 See Col.Fig.80.

1. V&A PP&D, E701-1969, dated July 1911.

109* Brooch

Designed and made by Arthur and Georgina Gaskin in about 1911.

*Silver, enamel, pearl and amethyst which is slightly faceted.
Hinged pin and hook fastening across the back.
Stamped on the back:* G

$1\frac{1}{2} \times 1\frac{1}{2}$ (37×37)

Given in 1982 by Professor and Mrs Hull Grundy. 1982.117

This design appears in several versions in Georgina Gaskin's Drawing Book. The closest[1] is a pencil and watercolour drawing inscribed 'Brooch, Pearl and Amethyst concave front Rose Lattice', which lies between pages dated 1910-11.

Versions of the 'Rose Lattice' design are illustrated in Breeze, G. and Wild, G. *Arthur and Georgie Gaskin*, exhibition catalogue, Birmingham 1981, Cat.G26 and G27, p.83.

See Col.Fig.80.

1. V&A PP&D, E688-1969.

110* Necklace

Anonymous, made in about 1915.

Silver, cabochon-cut injected quartz and moonstone. Ring and pin catch fastening.

Pendant: $3\frac{9}{16} \times 2\frac{9}{16}$ (84×65)
Length of chain: $27\frac{3}{16}$ (69)

Given in 1982 by Professor and Mrs Hull Grundy. 1982.1147

The overall appearance of the pendant is reminiscent of the Gaskins' work, particularly the leaf motifs which link the settings.

See Col.Fig.79.

111* Brooch

Anonymous, made in about 1900-20.

Silver, gold and opal. Hinged pin and hook fastening.

$\frac{1}{16} \times 3\frac{3}{16}$ (12×78)

Given in 1982 by Professor and Mrs Hull Grundy. 1982.1184

The gold spiral motifs are similar to some of the Gaskins' work. There is a drawing in Georgina Gaskin's Drawing Book[1] which shows a ring of 1917 called 'Speedwell' which shares many qualities with this brooch. However the Gaskins usually placed their gold spirals against a flat silver background rather than using them as openwork, and the hinge fitting differs from those on other Gaskin brooches in the collection.

See Col.Fig.81.

1. V&A PP&D, E706-1969.

Albert Edward Jones (1879-1954)

112* Pair of candlesticks

Designed by Albert Edward Jones and made in his workshop in 1908.

Silver, cast and hammered, with oak base. Hallmarked at the bottom of the candlestick: Birmingham 1908 A.E.J. Inscribed near the foot: NOW. IS. THE. WITCHING.HOUR. OF. NIGHT.

$5\frac{1}{16} \times 4\frac{5}{16}$ (129×106)

Given in 1982 by Professor and Mrs Hull Grundy. 1982.1160

The repoussé and chased decoration is of bats.

See Col.Fig.59.

Designs for the trade

Child & Child, William Comyns, Sybil Dunlop, Hamilton & Inches, Kate Harris, W. H. Haseler & Company, Charles Horner, Jessie King, Archibald Knox, Liberty & Company, Murrle, Bennett & Company, Edgar Simpson

The growing popularity of Arts and Crafts jewellery and metalwork made tradespeople, both retailers and manufacturers, realise that there was potential for mass production in this field. The relatively simple designs and minimal use of materials made the style easy to copy.

Walter and Harold Child started in business with a retail shop on Seville Street, London, in 1880. However, a different branch of the family had been making jewellery from about 1676. In 1888 Child and Child registered their mark at the Goldsmiths' Company as plate workers and only began manufacturing jewellery when they moved to Alfred Place West, Kensington, in 1891. They prided themselves on employing the best craftsmen, resulting in a high standard of workmanship. Most of their work appealed to conventionally fashionable taste, resulting in a Royal Warrant to Princess Alexandra and other members of the Royal Family. However they also executed some designs for Edward Burne-Jones, whose influence can be seen in their enamels. They became best-known for the superb quality of their enamelled work, often applied to elaborately engine-turned silver grounds. In 1899 the partnership between the two brothers ended but Harold Child maintained the business until about 1916.

William Comyns was a silversmith and jeweller trained in the trade who registered his mark in 1859. The firm, William Comyns & Sons, was continued after his death by his three sons. At the turn of the century, its work had Art Nouveau characteristics, and waist clasps and buckles in stylised natural forms were its speciality. The designs were often protected by registration at the Patent Office.

Although working primarily in the 1920s and 1930s Sybil Dunlop continued to produce silver and jewellery in the Arts and Crafts tradition. Her interest in jewellery began in Brussels where she had been sent to learn French. She was noted for her artistic attire, in particular for her Middle Eastern caftans and Russian boots. In about 1920 she opened a shop in Kensington Church Street, London, employing four craftsmen and a manager, W. Nathanson, who joined her straight from college. In her jewellery Dunlop used brightly coloured stones as well as those of more muted tones. Many of the stones she used were cut in the German gem centre, Idar-Oberstein. Nathanson revived the business after the Second World War, when Dunlop was forced to relinquish day-to-day control due to ill health, and continued the firm until 1971.

Working in Edinburgh as retail jewellers and clock and watch makers, the family firm of Robert Kirk Inches and his uncle, James Hamilton, received a Royal Warrant for their clock-making in about 1887. Hamilton and Inches celebrated its 125th anniversary in 1991 and continues working today.

The Birmingham-based firm, W. H. Haseler & Company, was founded by William Hair Haseler and run by his two sons from 1896. They realised early on the commercial possibilities of Arts and Crafts jewellery and approached Liberty with designs by Birmingham jewellers. In 1901, they registered the joint trade name of 'Cymric' and Haseler made pieces for Liberty to sell in his shop.

Kate Harris was one of a number of independent jewellers who worked with William Hutton & Sons (1800-1930), one of Liberty's main suppliers.[1] She trained as a sculptor at the Royal College of Art and had some involvement with the Art Union of London, whose role was to generate an appreciation of art to a wider audience. Her work clearly shows the influence of both C. R. Ashbee and Art Nouveau styles.

Based in Halifax, the family firm run by Charles Horner and his two sons Charles Henry and James Dobson was among the first to produce machine-made jewellery from start to finish.[2] They specialised in making silver pendants with their own fitted chains and enamelled brooches in the form of winged insects which show the influence of Liberty and Art Nouveau styles. Although not of the same quality as Liberty or Murrle, Bennett & Company, their jewellery was well-made and affordable.

Jessie Marion King was a successful and prolific artist from the Glasgow School. She worked as an illustrator and designed wallpaper and textiles as well as jewellery. She designed a range of silver and delicately enamelled pieces for Liberty.

Originally from the Isle of Man, Archibald Knox moved to London in the late 1890s. He was one of the most important designers to work for Liberty and designed textiles, wallpaper and metalwork for the company from about 1898 to 1912. Prior to this he had designed some pieces for the Silver Studio. He developed an individual style, making use of Celtic knots and versions of the 'whiplash' motif.

The first entrepreneur to take advantage of the market for art wares was Arthur Lasenby Liberty. Liberty worked with a large number of designers and other manufacturers to produce his Arts and Crafts jewellery which began with the launch of the 'Cymric' range in 1899. The firm also produced furniture, fabrics, clothes and accessories in the Arts and Crafts style. During his years of business, Liberty commissioned a number of the most important jewellery designers to work for him. In many ways this was a thankless task because they were not acknowledged for their work, which was altered by Liberty as he saw fit.

The only recognition designers did receive was when they exhibited in an Arts and Crafts exhibition, otherwise their work went under the name of Liberty.

Liberty was both helpful and detrimental to Arts and Crafts jewellers and silversmiths. On the one hand he helped to promote their work by producing well-designed, appealing designs which by being partly machine-made were affordable by a wider audience, but on the other he provided competition for independent designers such as Ashbee and contributed to their demise.

There were a number of smaller companies which manufactured Arts and Crafts jewellery, some for Liberty, others under their own name. The London firm of Murrle,

Bennett & Company manufactured their own work as well as supplying Liberty, and imported pieces from Pforzheim, the centre for commercial jewellery production in Germany.

Originating from Nottingham, Edgar Simpson was making jewellery from about 1896 to 1910, very much under the influence of Ashbee. Among his most favoured motifs were fish and dolphins. He designed pieces for a number of firms including Charles Horner.
SW

1. For an account of her work see Pudney, S., 'A Marriage of Art and Commerce: Kate Harris and the Arts and Crafts Silverware of William Hutton and Sons', *Decorative Arts Society Journal*, 22 1998, pp.32-41.
2. For an account of his work see Klaber, P., 'Charles Horner's Jewellery', *The Antique Collector*, June 1975, pp.8-11.

Child & Child (about 1676-1916)

113* Brooch

Designed and made by Child & Child in about 1900.

Silver, copper and green enamel.
Hinged pin and hook fastening on the back.
The case is covered in green leather with gold tooling and has a lining of cream silk and velvet. Printed on a label inside the lid: CHILD & CHILD. JEWELLERS, GOLD & SILVERSMITHS.35, ALFRED PLACE, WEST QUEEN'S GATE.
Impressed on the back: a marigold and CC *mark.*

$2 \times 2\frac{3}{8}$ (51×61)

Given in 1982 by Professor and Mrs Hull Grundy. 1982.1182
 See Col.Fig.82.

114* Pendant

Designed and made by Child & Child in about 1901-10.

Silver-gilt, blue/green enamel and paste.
The case is covered in blue/green leather-cloth with gold tooling and lined with white silk and blue velvet. Printed on a label inside the lid: BY ROYAL WARRANT OF APPOINTMENT TO H.M. THE QUEEN, H.R.H. PRINCESS CHRISTIAN AND H.R.H. PRINCESS LOUISE. CHILD & CHILD, 35 ALFRED PLACE WEST. LONDON. S.W.
Impressed on the back with a marigold and CC.

$1\frac{9}{16} \times 1\frac{1}{8}$ (43×29)

Given in 1982 by Professor and Mrs Hull Grundy. 1982.1181
 See Col.Fig.82.

William Comyns & Sons (1859-)

115* Belt

Designed and made by William Comyns & Sons in 1901.

Silver, cast with open work.
Hook and link fastening.
Hallmarked on the front of each section except one where the mark may have rubbed off: London, 1901; on the front of the link fastening: W.C. *and stamped on the back of all the links except one:* Rd No. 377759 *and* Rd No. 377559. *The registered numbers are on alternate links.*

$1\frac{5}{16} \times 28\frac{1}{2}$ (30×723)

Given in 1982 by Professor and Mrs Hull Grundy. 1982.1144

The design depicts groupings of the seed head, honesty.
 See Col.Fig.82.

Sybil Dunlop (1889-1968)

116* Spoon

Designed and made by Sybil Dunlop in 1930.

Silver, hammered bowl, cast handle set with a cabochon cornelian.
The spoon is in its original case which is

covered in green leather with gold tooling.
It is lined with green silk and velvet.
Printed inside the lid: SYBIL DUNLOP ART JEWELLERS *and* SILVERSMITHS 69 CHURCH ST. KENSINGTON LONDON, W.
Hallmarked on the back of the stem: London, 1930, SD.

$5\frac{7}{8} \times 1\frac{5}{16}$ (150×39)

Given in 1982 by Professor and Mrs Hull Grundy. 1982.1190
 See Col.Fig.82.

117* Bracelet

Designed and made by Sybil Dunlop in 1960.

Silver-gilt and rock crystal. The square cabochon stones are set in floral decorated mounts and the rectangular facet-cut stones have leaf decorated settings. Both designs are engraved.
Push-in fastening and safety catch.
Hallmarked on the back of various parts: London, 1960, SD.

$9\frac{1}{16} \times 7\frac{3}{8}$ (18×187)

Given in 1982 by Professor and Mrs Hull Grundy. 1982.1188
 See Col.Fig.82.

118* Bracelet

Designed and made by Sybil Dunlop in 1962.

Silver-gilt, cast and engraved.
Push-in fastener.
Hallmarked: London, 1962, SD; *and on the back of some links stamped:* S.DUNLOP.

$1\frac{5}{16} \times 7\frac{5}{16}$ (39×189)

Given in 1982 by Professor and Mrs Hull Grundy. 1982.1189
 See Col.Fig.82.

Hamilton & Inches (1866-)

119 Quaich

Designed and made by Hamilton & Inches in 1906.

Silver, hammered with raised spirals below the rim all the way round.
Hallmarked on the side: Edinburgh, 1906, H&I, stamped: Hamilton and Inches.

$3\frac{1}{2} \times 10\frac{5}{8}$ (90×269)

Given in 1982 by Professor and Mrs Hull Grundy. 1982.1163

The two-handled bowl is a traditional Scottish form and derives from the two-handled drinking cup known as a *quaich*.

Kate Harris (fl.1898-c.1920)

120* Belt buckle

Designed by Kate Harris and made by William Hutton & Sons in 1899.

Silver, made in three pieces; the square central one is cast and the outer two have repoussé motifs. The outer sections hook onto the centre section and each has a loop on the back for passing a belt through.
Hallmarked on the back: London, 1899, WH & SS LD; and stamped: 2059.

$2\frac{1}{4} \times 4\frac{1}{2}$ (58×114)

Given in 1982 by Professor and Mrs Hull Grundy. 1982.1159

One of the most common figurative designs to appear in Huttons' catalogues is this woman in profile, which is described as the 'Puritan' pattern. It was used on a wide range of objects from about 1899 to the 1920s.
 See Col.Fig.87.

121* Belt buckle

Probably designed by Kate Harris and made by William Hutton & Sons in 1902.

Silver, cast, with chased and pierced decoration.
Made in two sections with an interlocking clasp at the centre and loops at either end for passing a belt through.
Hallmarked on the front: London, 1902.
Maker's mark obscured on outer edges of the buckle: W [over] H LD.
Stamped on the back: 1387.

$2\frac{7}{16} \times 4\frac{7}{16}$ (62×112)

Given in 1982 by Professor and Mrs Hull Grundy. 1982.1161

The design depicts two dragons with shields.
 See Col.Fig.87.

122* Six buttons and case

Designed by Kate Harris and made by William Hutton & Sons in 1903.

Silver, cast decoration. The case is covered in brown leather and lined with olive green velvet and satin.
Ring fixed on the back of each button for sewing to clothing.
Hallmarked on the back: Birmingham, 1903, WH & SS LD.

1 diam. (25 diam.)

Given in 1982 by Professor and Mrs Hull Grundy. 1982.151
 See Col.Fig.87.

123* Bowl

Designed by Kate Harris and made by William Hutton & Sons in 1904.

Silver, cast, chased and pierced decoration with two figures spreading their arms round the rim of the bowl.
The bowl is mounted on a spreading foot.
Hallmarked on the surface of the bowl below the rim near one of the figures: London, 1904, WH & SS LD.

$3\frac{3}{8} \times 5\frac{1}{4}$ (80×133)

Given in 1982 by Professor and Mrs Hull Grundy. 1982.1158
 See Col.Fig.87.

W. H. Haseler & Company (1850-1963)

124* Pendant

Designed and made by W. H. Haseler & Company in about 1905.

Silver, enamelled in green and orange.
Loop attached at the top for a chain.
Stamped on the back: SILVER and WHH.

$2\frac{1}{8} \times \frac{3}{4}$ (54×19)

Given in 1982 by Professor and Mrs Hull Grundy. 1982.1180
 See Col.Fig.82.

Charles Horner (fl.1903-12)

125* Brooch

Designed and made by Charles Horner in 1909.

Silver, pierced interlaced Celtic motif, and blue-green enamel.
Hinged pin and hook fastening with safety catch.
Hallmarked on the back: Chester, 1909, CH.

$\frac{7}{8} \times 1\frac{1}{8}$ (23×28)

Given in 1982 by Professor and Mrs Hull Grundy. 1982.1179

A version of this brooch, mounted as a pendant is illustrated in Klaber, P., 'Charles Horner's Jewellery', *Antique Collector*, June 1975, pp.8-11.
 See Col.Fig.82.

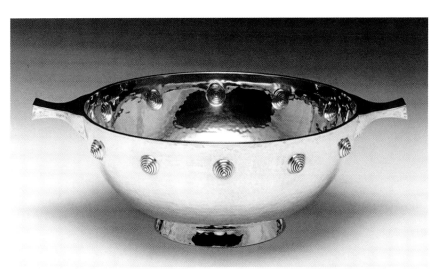

Fig.164 **Cat.119**

Jessie Marion King (1875-1949)

126* Necklace

Designed by Jessie King and made by Liberty & Company, about 1905.

Silver with enamelled decoration and a pendent pearl.

Pendant: $1\frac{3}{4} \times 1\frac{5}{8}$ (45×40)
Length of chain: $16\frac{3}{4}$ (425)

Given in 1982 by Professor and Mrs Hull Grundy. 1982.1193
 See Col.Fig.82.

Archibald Knox (1864-1933)

127* Cloak clasp

Designed by Archibald Knox and made by Liberty & Company in 1901.

Silver, enamel and turquoise.
Made of two separate circular pieces which are joined by a hook and eye fitting in the centre.
Stamped on the back: STERLING *and* CYMRIC.

$1 \times 2\frac{3}{8}$ (26×60)

Given in 1982 by Professor and Mrs Hull Grundy. 1982.1137

For a very similar design on a button see Tilbrook, A.J., *The Designs of Archibald Knox for Liberty & Co*, London 1976, p.182, fig.177.
 See Col.Fig.86.

128* Belt buckle

Designed by Archibald Knox and made by Liberty & Company in 1903.

Silver and turquoise.
Made in two sections joined by a hook and loop clasp in the centre; a loop is fixed on the back of each end for passing through a belt.
Hallmarked on the back: Birmingham, 1903, L&Co. and stamped: 3.

$2\frac{1}{8} \times 2\frac{7}{16}$ (54×71)

Given in 1982 by Professor and Mrs Hull Grundy. 1982.1135

A very similar design appears in the Liberty Design Book.[1] There are also similarities to designs created by Arthur Silver for the Silver Studio which was a major supplier to Liberty's.[2]
 See Col.Fig.88.

1. V&A Library, No.101 B70, p.180, No.10060. Also see Tilbrook, A.J., *The Designs of Archibald Knox for Liberty & Co*, London 1976, p.181, fig.173.
2. See Gere, C. and Munn, G.C., *Artists' Jewellery: Pre-Raphaelite to Arts and Crafts*, London 1989, p.39.

129* Four buttons

Designed by Archibald Knox and made by Liberty & Company in 1903.

Silver, and blue and green enamel.
Ring fitting on the back for sewing on to clothing.
Hallmarked on the back: Birmingham, 1903, L&Co.Ltd and stamped: SILVER

$\frac{7}{8}$ diam. (22 diam.)

Given in 1982 by Professor and Mrs Hull Grundy. 1982.1141
 See Col.Fig.86.

130* Six buttons and case

Designed by Archibald Knox and made by Liberty & Company in 1903.

Silver, cast and hammered motif on the front.
Ring fitting on the back of each button for sewing onto clothing.
The case is covered in green leather-cloth and lined with green suede and white silk.
Hallmarked on the back: Birmingham, 1903, L&Co. and stamped: CYMRIC.
Printed on the inside lid: LIBERTY & CO LTD REGENT ST LONDON

$\frac{3}{4}$ diam. (19 diam.)

Given in 1982 by Professor and Mrs Hull Grundy. 1982.1140

This design appears in the Liberty Design Book.[1]
 See Col.Fig.86.

1. V&A Library, No.101 B70, p.55, No.757.

131* Menu holder

Designed by Archibald Knox and made by Liberty & Company in 1903.

Silver, cast and hammered. Enamelled circle of decoration in blue and green, pierced decoration at sides.
Ring fixed to the back for holding a menu card.
Hallmarked on top of the horizontal ring of the stand: Birmingham, 1903, L&Co.; and stamped: CYMRIC RD455331 475.

$1\frac{7}{32} \times 22\frac{5}{32}$ (31×71)

Given in 1982 by Professor and Mrs Hull Grundy. 1982.1138

This design appears in the Liberty Design Book.[1]
 See Col.Fig.86.

1. V&A Library, No.101 B70, p.454, No.475.

132* Three buttons

Designed by Archibald Knox and made by Liberty & Company in 1907.

Silver, cast and hammered, with blue and green enamelling.
Ring fixing on the back for sewing onto clothing.
Hallmarked on the back: Birmingham, 1907, L&Co. and stamped: CYMRIC.

$\frac{3}{4}$ diam. (19 diam.)

Given in 1982 by Professor and Mrs Hull Grundy. 1982.1139
 See Col.Fig.86.

Liberty & Company (1875-)

133* Belt buckle

Made for Liberty, possibly by W.H. Haseler, in 1901.

Silver, cast and given a hammered finish, with openwork Celtic-style interlacing motifs on either end.
Three-pronged hinged buckle fitting in the centre.
Hallmarked on the back: Birmingham, 1901, L&Co., stamped: CYMRIC. *Silver mark is on the front of the centre prong.*

$2\frac{1}{4} \times 3\frac{1}{8}$ (57×79)

Given in 1982 by Professor and Mrs Hull Grundy. 1982.1162
 See Col.Fig.87.

134* Cloak

Designed and made by Liberty in about 1900-5.

Cashmere with velvet appliqué, silk embroidery, and silk satin lining.
Label of cream silk ribbon printed in gold inside: Liberty and Co. Ltd., 38, Avenue de l'Opera, PARIS.

$35\frac{5}{8} \times 128\frac{3}{8}$ (905×3260)

Given in 1983 by Professor and Mrs Hull Grundy. 1983.120.1

The designs of the appliqué and

Fig.165 **Cats 138 and 139**

embroidery show the influence of
Art Nouveau motifs.

Liberty's opened a branch in Paris
in 1890 after the successful response to
their display of aesthetic gowns at the
Exposition Universelle in 1889.

See Col.Fig.84.

135* Inkwell

Designed and made by Liberty in 1902.

*Stoneware base with a silver top. The hinged
lid has a cast flower with a cabochon
turquoise set in the centre.*
*Hallmarked: Birmingham, 1902, L&Co.;
stamped on the edge of the lid:* CYMRIC.
Part of the hallmark is on top of the lid.
Stoneware base marked: STAM

$1\frac{7}{16} \times 2\frac{5}{16}$ (36×58)

*Given in 1982 by Professor and Mrs Hull
Grundy. 1982.1134*

The ceramic base may have been made
by the Ruskin Pottery. Their catalogue
for 1905 includes several pieces for
mounting as inkwells which are similar
to this example.[1] No information has
come to light about the mark on the
stoneware.

See Col.Fig.87.

1. A similar marked piece is in a private
collection. CAGM history file.

136* Belt buckle

Designed and made by Liberty in 1903.

Silver, cast and hammered.
*Made in two pieces with an interlocking
fastening at the centre and loops at the back
for belt to thread through.*
*Hallmarked on the back: Birmingham, 1903,
L&Co.; stamped: 4.*

$1\frac{9}{16} \times 3\frac{5}{16}$ (39×84)

*Given in 1982 by Professor and Mrs Hull
Grundy. 1982.1136*

This design appears in the Liberty
Design Book.[1]

See Col.Fig.87.

1. V&A Library, No.101 B70, p.179, No.127.

137* Woman's dress

Designed and made by Liberty in about
1928.

*Silk with yoke, waist band, and cuffs smocked
in red, brown and salmon pink silk threads.
There are darning patches under the right
arm, front left of the bodice, under the left
arm and on the front right of the skirt just
below the waist.*
*Fastens with poppers on the left-hand side
seam from below the waist to under the arm.*

$45\frac{7}{16} \times 11\frac{5}{8}$ (1155×295)

Given in 1988 by Mrs Kolzynski. 1988.66

This dress was made in the Liberty
workrooms for Mrs Frere, the donor's
aunt. She lived in Sussex and wore the
dress for going out to the theatre as well
as on other occasions.

See Col.Fig.83.

138 Parasol

Designed and made by Liberty in about
1920-30.

*Wooden stick, plastic handle, plastic ferrule,
metal spokes, silk printed cover, and plaited
cream silk carrying cord.*
*Closes with a metal handspring and kept
open with a metal top spring.*

Length: 35 (895)

*Given in 1989 by an anonymous donor.
1989.394*

139 Parasol

Designed and made by Liberty in about
1920-30.

Frame made by S. Fox & Company.

Wooden stick, bamboo onion-shaped handle, metal spokes, metal ferrule and silk printed cover.
Closes with a metal handspring and kept open with a metal top spring.
Printed label on one of the spokes: Paragon, S. Fox & Co. London.

Length: $29\frac{1}{8}$ (740)

Given in 1989 by an anonymous donor. 1989.395

S. Fox & Company started business in 1847. This particular style of frame known as the 'Paragon' was first produced in 1852. It is likely that Liberty would have bought their frames from the firm and would have made the covers and completed the parasols in their workshops.

140* Child's dress

Designed and made by Liberty in about 1920.

Cotton, decorated with appliqué animals, a domino on the right cuff and a clock on the left.
Machine sewn with motifs applied by hand.
Fastens at the back with three sets of double buttons; the ones on the left have a loop to fasten over those on the right.
Cream silk label stitched in old gold silk inside bodice: Liberty & Co. London and Paris.

$28\frac{3}{4} \times 14\frac{5}{8}$ (730×372)

Given in 1987 by an anonymous donor. 1987.415
 See Col.Fig.85.

Murrle, Bennett and Company (1884-1916)

141* Bracelet

Designed and made by Murrle, Bennett and Co. in about 1900-10.

Silver and blue-green enamelled copper.
The rectangular enamelled pieces are joined by flat silver loops.
Push-in fastener with safety chain.
Stamped on the fastener: SILVER MB & C.

Given in 1982 by Professor and Mrs Hull Grundy. 1982.1177
 See Col.Fig.82.

Edgar Simpson (*fl.1896-1910*)

142* Belt Buckle

Designed and made by Edgar Simpson in about 1902.

Silver, blue-green enamel, and pearl.

$1\frac{13}{16} \times 2\frac{1}{16}$ (46×53)

Given in 1982 by Professor and Mrs Hull Grundy. 1982.1178

There are similarities to designs by Ashbee, particularly a chatelaine illustrated in *The Studio*.[1] A similar piece, apparently without enamel, is illustrated by Holme. It was described as a 'circular pendant where the swirling motion of the water is conveyed by elegant curving lines of silver, with a pearl, to represent an air bubble, issuing from the fish's mouth.'[2]
 See Col.Fig.82.

1. *The Studio*, Vol.12 1897, p.34.
2. Holme, C. (ed), *Modern Design in Jewellery and Fans*, London 1902, pl.26.

Anonymous

143* Pendant

Designer/maker unknown, about 1900-10.

Silver, enamel and pearl.
Cast heart-shaped leaves with central oval plaque depicting a landscape.
Ring attached for a chain.

$2\frac{27}{32} \times 1\frac{3}{8}$ (72×35)

Given in 1982 by Professor and Mrs Hull Grundy. 1982.1176

The enamelling is similar to the work of Fleetwood Varley, who joined C. R. Ashbee at the Guild of Handicraft in about 1900. His speciality was landscape enamels and he produced such plaques for Liberty's 'Tudric' range.
 See Col.Fig.81.

144* Necklace

Designer/maker unknown, about 1900-10.

Silver, enamelled in orange, green, blue and aquamarine. Hook fastening.

Cross: $1\frac{31}{32} \times 1\frac{7}{8}$ (50×48)
Length of chain: $15\frac{3}{4}$ (400)

Given in 1982 by Professor and Mrs Hull Grundy. 1982.1142

The motifs show the influence of Celtic designs, a popular source for Arts and Crafts jewellers, in particular Archibald Knox.
 See Col.Fig.81.

145* Textile Sample

Designer/maker unknown, about 1900-10.

Woven cotton and silk, the green threads in cotton, and the pink and yellow in silk.

$92\frac{1}{8} \times 48\frac{7}{8}$ (2340×1240)

Purchased in 1989 from Paul Reeves for £230. 1989.884

The stylized flower design, probably tulips, is similar to patterns produced by Liberty and the Silver Studio.
 See Col.Fig.89.

Art metalworkers and jewellers

Gilbert Marks, Ernestine Mills, Omar Ramsden and Alwyn Carr, Harold and Phoebe Stabler

The Arts and Crafts Movement inspired many individuals to take up metalwork and jewellery professionally. Some like Gilbert Marks were craftspeople who rejected the growing mechanisation of trade silver and metalwork, others were artists who learned craft skills to produce individual and sometimes experimental work. Quite a number of pieces of technically good, professionally made Arts and Crafts metalwork and jewellery were not marked, possibly because of designers' concern about damage occurring during the hallmarking process. It has proved impossible to attribute two of the pieces of jewellery included in this chapter.

Gilbert Marks began his career as a silversmith with the London firm, Johnson, Walker and Tolhurst, in 1878. While he was there he became acutely aware of the damage commercial manufacturing methods were having on metalwork as a craft. In 1885 this led him to establish his own workshop where he made everything by hand. Every piece he made was unique, hammered by hand and often decorated with his preferred repoussé work. Flowers were his main source of inspiration for decoration and often reflected the use of the object, for example roses on a rose bowl. All his pieces were commissioned; he had several connections in the City which were probably a result of his work with Johnson, Walker and Tolhurst, and which would have helped him in obtaining these commissions. His marriage certificate of 1888 recorded him as a wool broker's manager for the wool merchants, Messrs Masurel, suggesting that silversmithing was not his full-time occupation at this stage. Contemporary critics described Marks as 'one of the most skilful artist-craftsmen in metal in this country'.[1]

Ernestine Mills (née Bell) studied at the Slade School and the Royal College of Art under Alexander Fisher. A metalworker, enameller and painter, she applied her skills to a variety of work. She was a member of the Society of Women Artists, established in 1855 and still operating today, and played an active role in the Women's Suffrage Campaign. Various churches, hospitals and institutions have memorial tablets enamelled by her to those who fell in the two World Wars.

Omar Ramsden and Alwyn Carr met while they were both studying at the Sheffield School of Art. In 1896 *The Studio* reported that a design for a casket by Ramsden: 'is very new in its form and full of graceful detail'.[2] The two men went into business together in 1898, partly in order to execute Ramsden's competition-winning design for a mace for the City of Sheffield. They produced a range of metalwork including jewellery and tableware. Both were from Catholic backgrounds and many of their designs were of a religious character. Ramsden was a chairman of the Church Crafts League. They employed several assistants to help with making, and possibly designing their work, and used machinery for less important pieces. Carr served in the First World War and returned injured in 1918. Their attempt to continue the business partnership after the War failed and the partnership ended in 1919. They both continued to work independently; Carr produced silver and wrought iron through the 1920s while Ramsden only retired in the late 1930s.

Harold Stabler studied woodwork and stone carving at Kendal School of Art; he taught at Keswick School of Industrial Art and also in Liverpool where he met his future wife, Phoebe McLeish. She trained as a sculptor at Liverpool University and the Royal College of Art, London. As well as working as a silversmith and enameller, Stabler was also an artist and potter. He designed for firms working in glass and stainless steel and was a founder member of the Design and Industries Association in 1915. The Stablers worked together designing ceramic figures and plaques for the pottery, Carter, Stabler and Adams.

SW

1. Quoted by Harlow, K., 'Gilbert Marks, Forgotten Silversmith', *Antique Collector*, Vol.55 No.7 July 1984, p.42.
2. *The Studio*, Vol.8 1896, p.228.

Gilbert Marks (1861-1905)

146* Box

Designed and made by Gilbert Marks in 1898.

Gilt-bronze, garnets and cedarwood interior with a hinged lid.
The floral motifs are incised and each flower has a tiny garnet head.
Engraved on the top left hand side: Gilbert Marks 1898.

$3\frac{1}{16} \times 5\frac{1}{8} \times 3\frac{11}{16}$ (78×130×94)

Given in 1982 by Professor and Mrs Hull Grundy. 1982.1148
 See Col.Fig.59.

147* Cup

Designed and made by Gilbert Marks in 1900.

Silver, with hammered, chased and repoussé decoration.
The stem and foot are made in three sections.
Hallmarked on the outside of the cup just below the lip: London G M 1900.

$8\frac{15}{16} \times 3\frac{1}{2}$ (227×89)

Given in 1982 by Professor and Mrs Hull Grundy. 1982.1149

The tulip and leaf motifs are typical of Gilbert Marks's work inspired by late seventeenth-century and Art Nouveau designs.
 See Col.Fig.59.

Ernestine Mills (1871-1959)

148* Plaque

Designed and made by Ernestine Mills in 1950.

Copper and enamel with a gilt wood frame.
The frame was probably made by the Rowley Gallery who framed a number of works by various Arts and Crafts artists.
Hook fitting at the top for hanging.
Enamel signed on the bottom right hand corner of the picture: EM 50.

$6\frac{7}{8} \times 5\frac{3}{16}$ (175×132)

Given in 1982 by Professor and Mrs Hull Grundy. 1982.1192

The subject matter, Pan playing pipes to the moon, was one of her recurring themes.
 See Col.Fig.93.

Omar Ramsden and Alwyn Carr (1873-1939 and 1872-1940)

149* Pendant and chain

Designed and made by Omar Ramsden and Alwyn Carr in 1905.

Silver chain and cast frame, enamel and amethyst.
Hook and ring fastening.
Hallmarks on the back under the bottom edge obscured: 1905 ?, RN (&C) R.

Pendant: $3\frac{9}{16} \times 1\frac{3}{8}$ (90×31)
Length of chain: $18\frac{7}{8}$ (48)

Given in 1982 by Professor and Mrs Hull Grundy. 1982.1169

The pendant depicts a mermaid looking at her reflection in a hand mirror. The design of the chain may have been influenced by peasant jewellery, a source used by a number of Arts and Crafts designers.
 See Col.Fig.90.

150* Book mounts

Designed and made by Omar Ramsden and Alwyn Carr in 1917.

Silver, with cast decoration. Two hinged clip fastenings to close the book.
Hallmarked on two of the decorative plates on the front and back, on the sides of three of the corner plates and on each section of the fastenings: London,1917, RN & CR.

Book: $7\frac{3}{4} \times 6\frac{1}{16}$ (195×155)

Given in 1982 by Professor and Mrs Hull Grundy. 1982.1170

The vellum-bound book is *The History of Reynard the Fox* by F.S.Ellis, illustrated by Walter Crane and published by David Nutt, London, 1897. The mounts depict scenes from the story.
 See Col.Fig.94.

151* Spoon

Designed by Omar Ramsden and possibly Alwyn Carr, and made in their workshop in 1928.

Silver, the handle is cast and the bowl is hammered.
Hallmarked on the back of the handle: London, 1928, RN & CR.

$6\frac{3}{4} \times 1\frac{1}{2}$ (172×39)

Given in 1982 by Professor and Mrs Hull Grundy. 1982.1164

The handle is decorated with a galleon in full sail and a trident below.

 Mrs Hull Grundy noted in her correspondence with Cheltenham Art Gallery and Museums that Omar Ramsden's spoons with ship motifs were his best. Like the Guild of Handicraft spoons (Cats 194 and 195) this is based on sixteenth-century exemplars.
 Ramsden and Carr were working independently after 1919 therefore suggesting that this spoon was either started before this date and finished later in Omar Ramsden's workshop or that their joint mark was used by mistake.
 See Col.Fig.91.

152* Spoon

Designed by Omar Ramsden and made in his workshop in 1928.

Silver, the stem is cast and chased, the bowl hammered.
Hallmarked on the back of the handle: London, 1928, OR.

$6\frac{7}{16} \times 1\frac{1}{2}$ (164×39)

Given in 1982 by Professor and Mrs Hull Grundy. 1982.1165

The handle is decorated with a Tudor rose and interlaced branches.
 See Col.Fig.91.

153* Badge and ribbon in its original case

Designed by Omar Ramsden and made in his workshop in 1932.

Silver-gilt, cast and chased with red and blue enamel backing. In its original case which is blue with gold tooling. The cream satin lining is stamped: OMAR RAMSDEN, Artist Goldsmith, London, England.
Hallmarked on the back: London, 1932, OR *and engraved:* OMAR RAMSDEN ME FECIT.
Inscription on the front: MAIORATU OLIM FUNCTUS DOVOR
on the back: COUNCILLOR CAPTAIN F.R. POWELL MAYOR 1930-31, 1931-32

$3\frac{3}{4} \times 2\frac{1}{8}$ (96×55)

Given in 1982 by Professor and Mrs Hull Grundy. 1982.1167

The decoration depicts St Martin on horseback cutting the cloth and giving half to a beggar.
 Captain F.R.Powell was Mayor of Dover.
 See Col.Fig.92.

154* Pendant, chain and case

Designed by Omar Ramsden and made in his workshop in 1932.

Silver-gilt, cast and chased with blue and red enamel backing.
In its original case which is blue with gold tooling. The cream satin lining is stamped: OMAR RAMSDEN *Artist Goldsmith, London, England.*
Hallmarked on the back: London, 1932, OR, and engraved: OMAR RAMSDEN ME FECIT.
Inscribed on the back: JULIA POWELL, MAYORESS 1930-31, 1931-32

Pendant: $1\frac{3}{4}$ (45).
Length of chain: $31\frac{1}{2}$ (800)

Given in 1982 by Professor and Mrs Hull Grundy. 1982.1168

This was made as a pair to the above.
 See Col.Fig.92.

155* Dish

Designed by Omar Ramsden and made in his workshop in 1937.

Silver, with hammered surface, and a raised and pierced central motif with enamel underneath. Small foot ring and raised rim with two applied handles in the form of dragonflies.
Hallmarked on the back near the edge: London, 1937, OR, engraved on the back in the centre: OMAR RAMSDEN ME FECIT *and scratched:* 2214.

$\frac{13}{16} \times 5\frac{3}{8} \times 4\frac{5}{16}$ $(21 \times 137 \times 11)$

Given in 1982 by Professor and Mrs Hull Grundy. 1982.1166
 See Col.Fig.91.

Harold and Phoebe Stabler (1872-1945 and ?-1955)

156* Plaque

Designed and made by Harold Stabler in about 1912-13.

Copper with cloisonné *enamel and a white metal frame.*
Marked on the front: hs

$4\frac{5}{16} \times 5\frac{1}{8}$ (109×131)

Given in 1982 by Professor and Mrs Hull Grundy. 1982.1150

A similar plaque was shown at the Arts and Crafts exhibition in 1913 and was illustrated in *The Studio*.[1] It was described as 'a panel with a ground of subdued blue relieved by a well-designed composition of an ox decorated with flowers and garlands supporting two children on his back. In the execution of most of the smaller enamels Mr Stabler was assisted by a Japanese collaborator, Mr S. Kato.'
 See Col.Fig.87.

1. *The Studio*, Vol.58 1913, p.25.

157* Figure of a young girl

Designed and made by Phoebe Stabler in about 1915.

Cast bronze, engraved on the side: PHOEBE STABLER.

$3\frac{3}{8} \times 2\frac{1}{8}$ (86×54)

Given in 1982 by Professor and Mrs Hull Grundy. 1982.1151

 See Col.Fig.87.

Anonymous

158* Necklace

Anonymous, made in about 1900-10.

Gold chain and mount, enamel decoration and pearl. Push-back ring fastening.

Pendant: $1\frac{15}{16} \times 1\frac{3}{8}$ (50×35)
Length of chain: $15\frac{9}{16}$ (395)

Given in 1982 by Professor and Mrs Hull Grundy. 1982.1197

The chain and mount for the pearl are standard commercial fittings.
 See Col.Fig.81.

159* Pendant and chain

Anonymous, made in about 1915.

Silver, white metal, Swiss lapis and pale blue beads. Ring and pin catch fastening.
The metal for the chain and pendant differ suggesting that the chain may not be original.

Pendant: $2\frac{13}{16} \times 1\frac{3}{16}$ (71×31)
Length of chain: 37 (94)

Given in 1982 by Professor and Mrs Hull Grundy. 1982.1143

The links of the chain are in the form of four-leaf clover and the fitting at the top of the pendant is in the shape of an acorn with oak leaves.
 See Col.Fig.79.

Art Pottery

C. H. Brannam Ltd, Bretby Art Pottery, Burmantofts, Sir Edmund Elton, Bernard Moore, Pilkington's Tile & Pottery Company, Ruskin Pottery

William Morris in his lecture to an audience of pottery students and manufacturers at Burslem Town Hall, Stoke-on-Trent, in 1881, gave his philosophy as far as pottery was concerned. A pot should be individual, '… you must give it qualities besides those which made it for ordinary use',[1] true to its material and hand-painted. If printing was to be used it should not attempt to suggest a hand-painted finish.

Cheltenham Art Gallery and Museums' collection of art pottery is small but reasonably representative, although it lacks examples by Doulton and Minton who both established art pottery studios. The potters fall into different groups (some with overlapping interests) which meet Morris's criteria to varying degrees. The potteries of Bernard Moore and William Howson Taylor (Ruskin Pottery) were both relatively small concerns, with strong Arts and Crafts links. Moore, who spent his early career in his family's china manufacturing company, was influenced by William De Morgan's experimentation with reduction firing and set up Bernard Moore at Stoke-on-Trent in 1905 to develop the use of high-temperature glazes. The company was briefly very successful, showing in many international exhibitions, but closed in 1915. The pottery, originally founded as the Birmingham Tile and Pottery Works in 1898 by Edward Taylor and his son, William Howson Taylor, took its name, with permission, from that of John Ruskin. Both potteries were interested in glaze effects. They were inspired by Chinese pottery, particularly by the monochrome and *sang de boeuf* glaze effects produced by the potters of the early Ching dynasty (late seventeenth century). They were less concerned with exploring shape and form or with painted decoration.

Bernard Moore did not make pots at his factory, buying in blanks from other Staffordshire factories as William De Morgan had done in London. However he did have some input into these; some came from his old family business, Moore Brothers, and some from firms to which he acted as a consultant, and he may indeed have designed their shapes. Ruskin Pottery began producing art pottery in the early years of the twentieth century. The pottery was relatively small, employing at most sixteen people in the early 1920s. It did make its own pots, producing a large number of different shapes, each given a number and recorded in their pattern books. Many were produced in a variety of glazes and sizes. The shapes were mostly based on the oriental and were conservative in design.

This was to some extent true of most art potteries, with the notable exception of Edmund Elton and the Martin Brothers who most met Morris's concern for truth to material. Morris stipulated '… not only should it be

obvious what your material is, but something should be done with it which is specially natural to it'.[2] Both Edmund Elton and the Martin Brothers explored the plasticity of clay, with Elton exploiting the possibilities of clay slips (clay made to the consistency of thick cream by mixing with water).

For most of the art potters, glaze and decoration was of dominant interest. The work of Pilkington's related to that of Ruskin Pottery and Bernard Moore but with more interest in hand-painted decoration. The company employed Arts and Crafts designers to decorate its pieces. Like William De Morgan & Company, which in some ways it succeeded, Pilkington's shared an interest in glazes and particularly in lustres. 'In pottery the loss of the fine De Morgan ware must somewhat counterbalance the hope for artistic potting suggested by the Pilkington Tile & Pottery Company of Lancastrian and lustre ware, the development of Mr Howson Taylor's Ruskin and Mr Alfred Powell's lustre and china shown by Josiah Wedgwood.'[3] Pilkington Tile & Pottery Company was established in 1893 and began making ornamental wares in 1897. The company specialised in producing glaze effects including lustres, crystallines and *flambé* glazes, working with the firm's two chemists, William and Joseph Burton. Pilkington's employed a range of distinguished artists, including Walter Crane, Lewis F. Day, and C. F. A. Voysey, some on a freelance basis. In 1905 Gordon M. Forsyth became Art Director, continuing until 1920. Their pots were sold by many outlets including Liberty. Pilkington's and Burmantofts were relatively large companies; the former had originally been tile makers, who turned to art pottery in the hope of cashing in on a fashionable market. Wilcock and Company were manufacturers of building bricks, firebricks and drainpipes until they began making architectural terracotta, glazed tiles and art pottery under the name of Burmantofts in the early 1880s. The firm used a range of styles; some of the early designers were French, trained in the Palissy style, and began designing grotesque-style pieces using vivid-coloured glazes.

The size of both these companies was in contrast to the pottery set up by Sir Edmund Elton on his estate at Clevedon in 1879 to make slip-decorated earthenware. The pottery had a small staff consisting of Sir Edmund, George Masters who did most of the throwing, and usually one assistant. Another small-scale enterprise, C. H. Brannam, was established at Litchdon Pottery, Barnstaple, Devon, in 1879. It was set up by Charles Brannam whose father Thomas had potted in Barnstaple for many years making traditional wares for the local community. Charles Brannam, who had trained at art college, took over one of his father's potteries with the intention of making artistic wares. His interest was particularly in slips and glazes. His early pots often use sgraffito techniques: cutting away the slip as

below (Cat.160). Later he became more interested in exploring different forms, often using strong shapes with bold curved handles. Brannam pots were sold by the London retailer Howell & James and from 1882 by Liberty, who became the sole London agent for them. Bretby Art Pottery at Woodville, near Burton-on-Trent, was established in 1883 by Henry Tooth, a modeller and designer who had spent the previous four years working with Christopher

Dresser at Linthorpe Pottery. The pottery made art wares and its work was sold by Liberty around 1900.
HB

1. Morris, W., *Art and Beauty of the Earth*, London 1881, 1898 edition, p.3.
2. *Ibid*, p.22.
3. *Art Journal*, 1906, quoted by M. Batkin, *Good Workmanship with Happy Thought*, Cheltenham 1992, p.17.

Fig.166 **Cat.160**

C. H. Brannam Ltd. (1879-1979)

160 *Jug*

Designed and made by C. H. Brannam at Barnstaple, 1881.

Thrown and turned earthenware with a white slip which has been cut away to create the decoration. Turquoise glaze.
Incised inscription on base:
C H Brannam
Barum Ware
JD *(monogram)* A / Devon
1881

$5\frac{1}{2} \times 5\frac{5}{8} \times 4\frac{3}{4}$ (140×150×120)

Given in 1989 by the Summerfield Charitable Trust through the Friends of Cheltenham Art Gallery and Museums. 1989.975

Bretby Art Pottery (1883-)

161* *Pair of vases*

Designed and made by Tooth & Company Ltd, Bretby Art Pottery, Derbyshire, 1900-18.

Thrown and turned earthenware with mottled and flecked glaze.
Impressed stamp on base: 2217E MADE IN ENGLAND BRETBY

$9\frac{1}{4} \times 5\frac{3}{4}$ diam. (235×145 diam.)

Given in 1989 by the Summerfield Charitable Trust through the Friends of Cheltenham Art Gallery and Museums. 1989.912 a & b
 See Col.Fig.96.

Burmantofts (1882-1904)

162* *Vase*

Designed and made by Burmantofts (Wilcock & Company), Leeds, 1885-90.

Thrown and turned earthenware with flambé glaze.
Impressed stamp on base BF *(reversed)* ENGLAND 644 WEITE. BF *is Burmantofts Faience mark*

$5\frac{5}{8} \times 2\frac{5}{8}$ diam. (142×67 diam.)

Purchased in 1939 from A. W. Newport. 1939.155

This vase has a frilled rim, a shape used a lot in the 1880s. The mark BF reversed for Burmantofts Faience was used from 1882 to 1904, together with a shape number (as here). The pottery discontinued art wares in 1904.
 See Col.Fig.96.

163* *Vase*

Designed and made by Burmantofts (Wilcock & Company), Leeds, about 1885.

Thrown and turned earthenware with a turquoise glaze streaked with green and brown.
Impressed stamp on base BF *(reversed)* 531.
Ink written paper label on base: A.W. Newport 4/- 13/5/39

$7\frac{1}{2} \times 3\frac{3}{4}$ diam. (191×95 diam.)

Purchased in 1939 for 4s od from A.W. Newport. 1939.127

The streaky glazes used by Burmantofts were originally inspired by Christopher Dresser's nearby Linthorpe Pottery. The Linthorpe influence continued after Dresser's pottery closed in 1889 and some of its workers moved to Burmantofts.
 See Col.Fig.96.

164* *Jardinière*

Designed and made by Burmantofts (Wilcock & Company), Leeds, 1890-1904.

Moulded earthenware with raised decoration and coloured majolica glazes. In two parts, the bowl is supported on a baluster-shaped stand.
Impressed stamp on base of bowl:
BURMANTOFT *(partly illegible)*
FAIENCE
2117
ENGLAND
D
Paper label: col 970 108
2

Bowl: $17\frac{3}{4} \times 20\frac{3}{8}$ diam. (450×516 diam.)
Base: $24\frac{5}{8} \times 15$ diam. (625×380 diam.)

Given in 1989 by the Summerfield Charitable Trust through the Friends of Cheltenham Art Gallery and Museums. 1990.77

This technique using moulding to create a raised pattern which was painted in majolica colours sometimes hand-finished with incised designs, was known as parti-coloured ware and was very popular in the late 1890s. Burmantofts often made large pots, such as jardinières and umbrella stands. They were made in a range of styles: Art Nouveau, Renaissance, and some like this in Anglo-Persian style.
See Col.Fig.95.

Edmund Elton (1846-1920)

165* Jug

Designed by Sir Edmund Elton and made at his pottery at Clevedon, Somerset, 1879-1920.

Thrown and turned earthenware with cut and applied decoration of coloured slips and clay pastes.
Painted mark in black on base: Elton

$8\frac{5}{8} \times 6\frac{1}{2} \times 6\frac{1}{8}$ (218×164×156)

Given a 'not-accessioned' number in 1965 indicating that it was an uncatalogued part of the Museum's collections at that date. 1999.7

Elton developed an interesting technique of decoration. Pots were thrown and cut with a design when leather-hard and the pot was then decorated with clay slips with a thicker clay paste being used to raise areas of decoration. Further detail might be added using modelling and incising.
See Col.Fig.98.

166* Jug

Designed by Sir Edmund Elton and made at his pottery at Clevedon, Somerset, 1885-1920.

Thrown and turned earthenware with cut and applied decoration of coloured slips and clay pastes.
Painted mark on base: Elton

$11\frac{3}{4} \times 7\frac{1}{4} \times 6\frac{1}{4}$ (297×182×160)

Purchased 7-8 December 1938 for £1 4s 0d at John E. Pritchard & Co, Auctioneers, 82 Queens Road, Bristol with Cats 168 and 169. 1938.351

This jug with four handles is typical of Elton's designs. His sources of inspiration were eclectic and the idea for multi-handled pots may have come from English slipware or Mediterranean peasant pottery, while overhead handles are used in South American pottery. The raised decoration of flowers, possibly orchids, may have come from Japanese sword-guards.

Three pieces of Eltonware, including this example, were bought from the sale of the collection of Harry Vassall of Oldbury Court, Bristol.
See Col.Fig.98.

167* Vase

Designed by Sir Edmund Elton and made at his pottery at Clevedon, Somerset, 1902-20.

Thrown and turned earthenware with crackled lustre glaze.
Painted mark on base: Elton *and remains of paper label (illegible).*

$5\frac{3}{8} \times 3\frac{1}{2}$ diam. (136×90 diam.)

Given in 1947 by the Revd E. Courtney Gardiner. 1947.55

Elton developed crackle lustre wares after 1902.
See Col.Fig.98.

168* Tankard

Designed by Sir Edmund Elton and made at his pottery at Clevedon, Somerset, about 1914.

Thrown and turned earthenware with applied decoration of clay pastes and poured coloured slips.
Painted mark on base: Elton.

$6 \times 5\frac{5}{8} \times 4\frac{1}{4}$ (152×142×109)

Purchased in 1938 (see Cat.166). 1938.353

The tankard has a portrait bust of Lord Roberts in low relief with his name and the date 1914 impressed on either side. Lord Roberts died in France in November 1914 after a distinguished military career in India, Afghanistan, and South Africa, where during the Boer War he was Commander-in-Chief of the British Army.
See Col.Fig.98.

169* Tankard

Designed by Sir Edmund Elton and made at his pottery at Clevedon, Somerset in 1918.

Thrown and turned earthenware with cut and applied decoration of clay pastes and a lustre glaze.
Painted mark on base: Elton.

$6\frac{1}{8} \times 5\frac{3}{4} \times 4\frac{1}{4}$ (156×146×108)

Purchased in 1938 (see Cat.166). 1938.352

This tankard with the raised lettering *PAX 1918* was made to commemorate the end of the First World War.
See Col.Fig.98.

Bernard Moore (1850-1935)

170* Lidded jar

Designed by Bernard Moore and made at Bernard Moore, Stoke-on-Trent, 1905-15.

Thrown and turned porcelain with painted decoration and a flambé *glaze.*
Painted mark in red on underside of lid: BM *underlined (with two wavy lines).*
Painted mark in red on base of vase: BERNARD MOORE (B *and* MOORE *underlined with two wavy lines).*

$7 \times 5\frac{3}{4}$ diam. (177×147 diam.)

Given in 1929 by Mr and Mrs S. D. Scott. 1929.12

This jar, with decoration of bats, described as a ginger jar, is also known in green lustre on dark blue.[1]
See Col.Fig.97.

1. Dawson, A., *Bernard Moore, Master Potter, 1850-1935*, London 1982, fig.37.

171* Vase

Designed by Bernard Moore and made at Bernard Moore, Stoke-on-Trent, 1905-15.

Thrown and turned porcelain with monochrome sang de boeuf *glaze.*
Painted mark in red on base of vase: BERNARD MOORE *(underlined with a single wavy line).*

$10\frac{1}{4} \times 5\frac{7}{8}$ diam. (260×115 diam.)

Given in 1931 by Mr and Mrs S. D. Scott. 1931.12
See Col.Fig.97.

172* Vase

Designed by Bernard Moore, made at Bernard Moore, Stoke-on-Trent, and painted by Cecily Jackson, 1905-15.

Thrown and turned porcelain with painted decoration and a flambé *glaze.*
Painted mark in red on base of vase: BERNARD MOORE CJ *(monogram).*

$6 \times 3\frac{3}{8}$ diam. (153×84 diam.)

Given in 1933 by Mr and Mrs S. D. Scott.
1933.57

Like Howson Taylor, Bernard Moore was inspired by Chinese pottery, particularly Chinese glazes, but he also designed pots in the Chinese style, like this example. Little is known of Cecily Jackson's work but existing examples for Bernard Moore include designs of birds and arabesques.
 See Col.Fig.97.

173* Vase

Designed by Bernard Moore and made at Bernard Moore, Stoke-on-Trent, 1905-15.

Thrown and turned porcelain with a cobalt and poured copper lustre glaze.
Painted mark in blue on base of vase: BERNARD MOORE

$5 \times 2\frac{3}{8}$ diam. (125×60 diam.)

Given in 1934 by Mr and Mrs S. D. Scott.
1934.258

Cheltenham's accession register records this as being an experiment with two glazes, a cobalt and a crystalline aventurine glaze with iron; where the latter glaze runs over the cobalt it turns the blue black.
 See Col.Fig.97.

174* Vase

Designed by Bernard Moore, made at Bernard Moore, Stoke-on-Trent, and painted by E. Hope Beardmore, 1905-15.

Thrown and turned porcelain with painted decoration and a flambé *glaze.*
Painted mark in red on base of vase: BERNARD MOORE *(underlined with two wavy lines)* HB *(monogram).* MADE IN ENGLAND *and paper label £2. 2. 0.*

$9\frac{1}{2} \times 3\frac{1}{2}$ diam. (240×90 diam.)

Purchased in 1945 from Allen's of Bournemouth for £2 2s od. 1945.29
 See Col.Fig.97.

Pilkington's Tile & Pottery Company (1897-1938)

175* Vase

Designed and made by Pilkington's Tile & Pottery Company, Clifton Junction, near Manchester, 1904-5.

Thrown and turned earthenware with crystalline sunstone glaze.
Painted mark on base in white: letter P entwined with bees for Pilkington's, and impressed stamp P.

$11\frac{3}{4} \times 7\frac{1}{2}$ diam. (298×190)

Given in 1989 by the Summerfield Charitable Trust through the Friends of Cheltenham Art Gallery and Museums. 1989.914

This crystalline glaze, named after the glittering crystals it contained, resembled the mineral sunstone.
 See Col.Fig.96.

176* Vase

Designed and made by Pilkington's Tile & Pottery Company, with painted decoration by Richard Joyce, about 1919.

Thrown and turned earthenware with painted lustre decoration.
Painted mark on base in gold: R with crown above, and impressed stamp 2869 ROYAL LANCASTRIAN ENGLAND

$10\frac{1}{4} \times 4\frac{1}{4}$ diam. (260×108 diam.)

Given in 1937 by Messrs Pilkington (per T. C. Nixon). 1938.58

R is the monogram of the artist Richard Joyce. Pilkington's traded on its patronage of artist-designers, developing elaborate monograms which were used to sign their work. The company took the name Royal Lancastrian in 1914. This shape is known to have been in production by 1914, but this is the earliest lustre design known for the shape. Richard Joyce specialised in fish, animal and bird designs, some of which show a Japanese influence. He worked at Pilkington's from 1903-31.
 For information about T. C. Nixon see Cat.22.
 See Col.Fig.96.

177* Vase

Designed and made by Pilkington's Tile & Pottery Company with painted decoration by William Mycock, 1924.

Thrown and turned earthenware with painted lustre decoration.

*Painted mark on base 19*WMS*24, and impressed stamp 2912* ROYAL LANCASTRIAN ENGLAND

$7\frac{3}{4} \times 2\frac{1}{2}$ diam. (197×64 diam.)

Purchased in 1937 from Mr T. C. Nixon for £2. 1937.307

The monogram is for W. S. Mycock with date 1924, before and after his initials. William Mycock worked for Pilkington's from 1894 to 1938 and specialised in flower and ship designs.
 For information about T. C. Nixon see Cat.22.
 See Col.Fig.96.

Ruskin Pottery (1898-1935)

178* Cup and saucer

Designed by William Howson Taylor and made at Ruskin Pottery, Smethwick, about 1920.

Thrown and turned stoneware with Kingfisher blue lustre.
Impressed stamp on base of saucer: ENGLAND RUSKIN

Cup: $2 \times 3\frac{3}{8} \times 4\frac{1}{4}$ (50×91×110)
Saucer: $\frac{7}{8} \times 5\frac{5}{8}$ diam. (22×142 diam.)

Given in 1989 by the Summerfield Charitable Trust through the Friends of Cheltenham Art Gallery and Museums. 1989.913

Howson Taylor was interested in glazes, developing lustre and high temperature crystalline and *flambé* glazes for his pottery. Lustre glazes were in use at the pottery from 1904 with the Kingfisher blue lustre being especially popular.
 See Col.Fig.96.

179* Jar

Designed by William Howson Taylor and made at Ruskin Pottery, Smethwick, in 1925.

Thrown and turned stoneware with a sang de boeuf *glaze.*
Impressed stamps on base: RUSKIN ENGLAND 1925 *(three separate stamps), and two paper labels:* CADDY & LID FOR STAND, RUSKIN POTTERY, MADE IN ENGLAND, Shape 1 *(?).* This colour scheme cannot be repeated, PRICE = £8=10=0 *and* RUSKIN POTTERY, HIGH TEMPERATURE, FLAMBE *and letter* A *painted in black*

$10 \times 8\frac{5}{8}$ diam. (255×220 diam.)

Given in 1927 by Mr W. Howson Taylor.
1927.17

Record: Ruskin Pottery catalogue 1913.

Described as a caddy and recorded in Cheltenham's collections as a ginger jar, this shape, No.362, appears in the Pottery's 1913 catalogue and may have been designed around 1912. It also appears as a pot-pourri with pierced decoration available in a variety of sizes and glazes. This is probably Howson Taylor's *sang de boeuf* glaze about which there was great secrecy. Pots to be glazed with this and other *flambé* glazes were fired in a separate 'red kiln' and only Howson Taylor mixed the glaze. Howson Taylor gave collections of his pottery to several museums, including Wednesbury Museum and Art Gallery and Birmingham Museum and Art Gallery (the gift to Birmingham was made in 1926 to celebrate his fiftieth birthday, in commemoration of his father's work).

See Col.Fig.99.

180* Bowl on stand

Designed by William Howson Taylor and made at Ruskin Pottery, Smethwick about 1926.

Thrown and hand-built stoneware with a flambé glaze.
Impressed stamps on base of bowl: RUSKIN ENGLAND 1926 *(three separate stamps), and two paper labels:* RUSKIN POTTERY, MADE IN ENGLAND, Shape 8, This colour scheme cannot be repeated, PRICE = £4=15=0 *and* RUSKIN POTTERY, HIGH TEMPERATURE, FLAMBE
Impressed stamp on underside of stand: RUSKIN ENGLAND *and paper label* RUSKIN POTTERY, MADE IN ENGLAND, Shape 8, STAND FOR BOWL *with hand-written* no. 8.

Bowl: $4 \times 10\frac{1}{8}$ diam. (100×256 diam.)
Stand: 6×7×7 (152×180×180)

Given in 1927 by Mr W. Howson Taylor. 1927.16

Howson Taylor was inspired by Chinese ceramics, particularly the high-temperature glazes that were used. Some shapes also come from the Chinese, such as the design of this pierced stand. Stands were produced for pots particularly from around 1926, some for specific pots, but these were also made to be marketed as stands to be sold alone. This design is shape no.8.

See Col.Fig.99.

Amateurs and prize winners

The Arts and Crafts Movement attracted many people who had an interest in the arts and had a desire to make pieces for their personal fulfilment. The craft revival also gave women who needed to earn an income the chance to have some part-time paid work. Smaller-scale crafts such as needlework, which was also an accepted pastime for women, jewellery, and book binding were particularly popular amongst amateurs because the work could be carried out at home with relative ease and minimum equipment.

By the end of the nineteenth century, a number of art colleges and associations offered evening classes and gave support to semi-professionals and amateurs. In 1884 the Home Arts and Industries Association was formed to help people who were carrying out crafts at home. It held annual exhibitions at the Albert Hall in London for those people to show and sell their work. Other exhibitions and competitions, both regional and national, were organised for amateurs by art colleges, retailers (see Cat.181), the Arts and Crafts Exhibition Society and *The Studio*. The Arts and Crafts Exhibition Society was based in London although similar exhibitions were organised throughout the country particularly in Manchester and Birmingham, while *The Studio* had a programme of regional competitions as well as national ones. These gave amateurs something to aim for in addition to enjoying the experience of making an object. From the Arts and Crafts Exhibition Society catalogues of about 1893-1903 it is clear that there were many amateurs as well as professionals showing their work, and a significant number were women working in needlework.

Unfortunately, due to its very nature, little is known about this group of designer-makers. Of the five named makers in this chapter, Charles Canning Winmill (1865-1945) is the best known. He was a trained architect who worked for the London County Council's Architect's Department at the turn of the century and was the lead designer for the Euston Fire Station, a fine example of Arts and Crafts architecture. He was a friend of Ernest Gimson and visited him often at Sapperton. His interest in embroidery was probably inspired by his mother who worked in the medium.

Lilian Simpson seems to have worked in a variety of materials. An article in *The Studio* described some tiles and a casket by her which received glowing compliments: 'This very clever student shows in a casket (812) that the honours she has reaped in former years have not made her careless; the exquisite daintiness of her conception and the delicate grace of execution, force one to break into rather more fluid praise, that could, fairly be bestowed on many items less worthy … and has (the judges point out) barely escaped a gold medal.'[1] Coincidentally the same volume mentions Herbert C. Oakley, a student at South Kensington

who had entered designs for metalwork into the National Competition. His designs were well-received: 'The designs for metalwork by Herbert C. Oakley are strong and expressive; the silver medal they secure is well won.'[2] Three of his designs were illustrated, a door-knocker, metalwork and firedog. Ann Haywood was born in Cheltenham and studied at Cheltenham School of Art, where she sat her City and Guilds embroidery examinations, and at the Royal College of Art, London.

SW

1. *The Studio*, Vol.8 1896, p.228.
2. *Ibid.*

181* Tile panel

Designed by A. Masson of London, about 1876.

Pressed earthenware with painted decoration. Framed in oak.
Back of frame: Inscription in pen: YE SEVEN AGES BY A. MASSON, COMPTON STREET, N. ISLINGTON. HOWELL AND JAMES, ART POTTERY EXHIBITION, 1876; *and original printed paper label:* HOWELL & JAMES' Art Pottery Exhibition, 1876. Exhibitor's *(the rest missing)*

$8\frac{3}{8} \times 43\frac{3}{4} \times \frac{1}{2}$ (214×1113×20)

Given in 1990 by the Summerfield Charitable Trust through the Friends of Cheltenham Art Gallery and Museums. 1990.77

The tiles depict the seven ages of man as described by Shakespeare.[1] They are captioned: 'Ye Infants' 'Ye Schoolboye' 'Ye Lovvers' 'Ye Soldyer' 'Ye Justvce' 'Ye Leane & Slipper'd Pantaloone' 'Ye Seconde Childhood'. They were exhibited by Howell & James, a London retailer, in their first Annual Art Pottery Exhibition in 1876. Henry Stacey Marks made a similar tile panel for Minton, *Seven Ages of Bird Life* no.1653, which has slightly different captions. The design also relates to the anthropomorphic birds made by the potter Robert Wallace Martin (Cat.25). Howell & James sold tile blanks and materials for amateur painters, encouraging sales by exhibiting the results. Masson's work almost certainly fits this category, particularly as the glaze finish on the seven tiles varies.
See Col.Fig.100.

1. *As You Like It*, Act II scene vii.

182 Cushion cover

Designed and made by Charles Winmill in about 1890-1900.

Fig.167 **Cat.182**

Linen ground, wool embroidery on the front, the back has an all-over design of small flowers printed in yellow with some filled in with yellow-gold silk threads.
Open at one end to insert a cushion pad.

$18\frac{1}{8} \times 18\frac{1}{2}$ (460×470)

Given in 1995 by Miss Joyce M. Winmill. 1995.269

Miss Winmill, daughter of the maker, remembers her father telling her that he invented the stitch for the blue ground.

183 Book mounts

Designed and made by M. Lilian Simpson in about 1894-6.

Silver-plated copper mounts with a silver-plated hinged clasp on a vellum-bound book. Engraved mark on the front, back and spine, ART UNION OF LONDON 1st JANUARY 1896.
The front spine is splitting.

$9\frac{11}{16} \times 7\frac{7}{8}$ (246×200)

Given in 1982 by Professor and Mrs Hull Grundy. 1982.1198

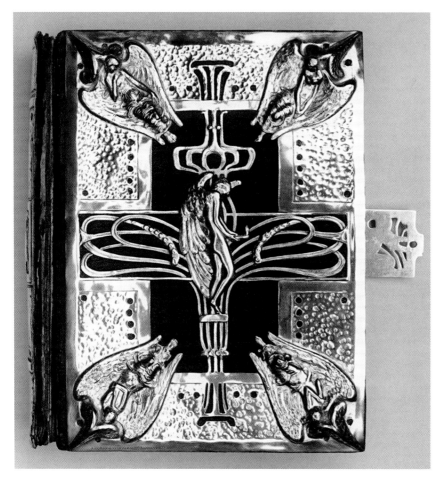

Fig.168 **Cat.183**

The following inscription is printed on the title page: 'The cover which encloses these pages was designed and modelled by Miss M. Lilian Simpson, on a commission from the Council of the Art Union of London, and gained for the Artist a gold medal in the National Competition of all the schools of Art under the Science and Art Department in 1894.

'The idea embodied in the design is that of the growth of life (represented by the flowering and fruit) watched over by Spirits (shown in the eight angles), whilst Love (the central figure) kisses the buds into bloom, and, as shown on the clasp, binds together the pages of the Book of Life.

'THE WORK IS ISSUED TO THE MEMBERS OF THE ART UNION OF LONDON.'

The book contains blank paper and has been used as a sketch book.

184* Textile sample

Designed and made by Herbert C. Oakley, about 1896.

Linen, with stencilled design depicting laburnum.
Three edges hand-stitched, the fourth a selvedge.
Sticky paper label on the bottom in the centre, which is slightly torn, reads PART OF A SET FOR WHICH BOOK (?) PRIZE WAS AWARDED. ESK *printed in brown on the left hand bottom corner,* DESIGN FOR FRIEZE, OAKLEY *printed in brown on the right-hand bottom corner.*

$24 \times 44\frac{1}{2}$ (610×130)

Purchased in 1989 from Paul Reeves for £200. 1989.885
 See Col.Fig.101.

185 Brooch

Anonymous, made in about 1910.

Copper, white metal and ceramic centrepiece with a soufflé-type glaze.
Hinged pin with safety ring fastening.

$2\frac{1}{32}$ (51)

Given in 1982 by Professor and Mrs Hull Grundy. 1982.1154

The ceramic centrepieces for this brooch and Cat.186 were probably made at the Ruskin Pottery in Smethwick (see above pp.141-2). They produced many 'stones' in a wide variety of shapes and colours which were mounted by both professional and amateur jewellers.

186 Brooch

Anonymous, made in about 1910.

Pewter, white metal and ceramic centrepiece.
Hinged pin and hook fastening.

$2\frac{1}{32}$ (51)

Given in 1982 by Professor and Mrs Hull Grundy. 1982.1155

187 Pendant

Anonymous, made in about 1913-20.

Gold-coloured metal, ceramic centrepiece.
Ceramic 'stone' impressed on the back :
MOORCROFT.
Loop attached for chain.

$1\frac{15}{16} \times 1\frac{7}{16}$ (49×37)

Given in 1982 by Professor and Mrs Hull Grundy. 1982.1191

A similar piece to this with an identical mount but different centrepiece has been identified with 'Kensington Art Ware' stamped on the back. This particular piece was probably assembled by an amateur.

William Moorcroft (1872-1945) set up his own factory in 1913. He specialised in pottery decorated with slip-trailing and coloured glazes in Art Nouveau designs. Like the Ruskin Pottery, the factory also produced centrepieces and other small ceramic items which could be bought and used by amateurs.

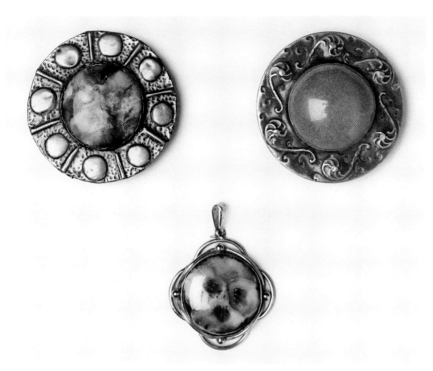

Fig.169 **Cats 185, 186 and 187**

188 Woman's glove

Designed and made by Ann Haywood, about 1920.

Soft suede, possibly chickenskin, embroidered with silk.

Length: 14 (357)

Given by Miss Georgina Haywood in 1968. 1968.75

The donor was the sister of the maker.
 This piece was designed and made as part of Ann Haywood's City and Guilds embroidery examinations.

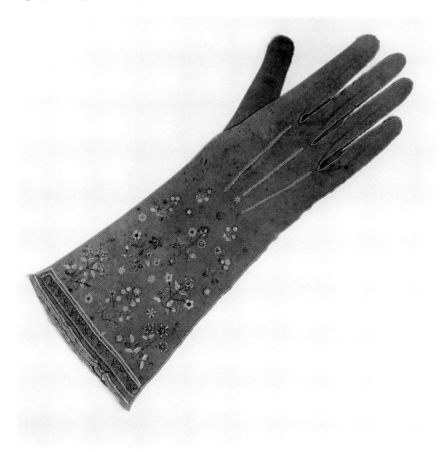

Fig.170 **Cat.188**

Eric Gill (1882-1940) and the Ditchling community

Joseph Cribb, Eric Gill

While he was a pupil in an architectural office in London in 1901, Eric Gill enrolled for classes in writing and illumination at the Central School of Arts and Crafts. Here he encountered Edward Johnston and experienced the thrill, 'as though a secret of heaven were being revealed',[1] of recognising the practice of lettering as his destined craft. He spent the rest of his life working as a letter cutter, typographer, illustrator and stone carver, and preaching the virtues of a life dedicated to the crafts.

From 1905 to 1907 Gill lived and worked at Hammersmith, still at the time a focus for Arts and Crafts activities, and then he moved to Ditchling in Sussex in pursuit of his particular vision of family life. His conversion to Roman Catholicism in 1913 and his move to Ditchling Common drew others to gather around him, including Edward Johnston, Douglas Pepler, and Ethel and Philip Mairet.

At Hammersmith Gill had taken on his first apprentice, Joseph Cribb, who went with him to Ditchling. Cribb married a local girl and joined the Guild of Saint Joseph and Saint Dominic in 1921, shortly after it was founded. He remained there when Gill moved to Capel-y-Ffin in Wales in 1924. In all his workshops, but especially at Pigotts in Buckinghamshire from 1928, Gill continued to train pupils and assistants. Through practical example and his writings he inspired a generation of stone carvers and letter cutters, particularly by his advocacy of direct carving. One of his most distinguished pupils was David Kindersley (see pp.171-4).
AC

1. Gill, E., *Autobiography*, London 1940, p.119.

Fig.171 **Cat.189**

Joseph Cribb (1892-1967)

189 Inscribed stone

Designed and cut by Joseph Cribb in 1920.

Hoptonwood stone with carved lettering, the smaller letters coloured red. The front is polished and the back rough-hewn. No marks.

$12\frac{1}{2} \times 29\frac{7}{8} \times 1\frac{3}{4}$ (317×759×44)

Purchased in 1990 from the Gillian Jason Gallery, London, for £6000 with a 50 per cent grant from the V&A Purchase Grant Fund. 1990.848

Record: Photograph of Cribb and others in the weavers' cloister at Ditchling with the stone set into a wall behind, 1959. Copy at CAGM.

On the dissolution of the Guild of St Joseph and St Dominic in 1989 this inscription and other items from Ditchling were purchased by the Gillian Jason Gallery. The stone had been set into the wall of the weavers' cloister since at least 1959.

The text is particularly apt for a group of craftworkers with Utopian ideals trying to lead the 'good life' in the country. It was purchased by the Museum partly because the message is very appropriate for the predominantly domestic Arts and Crafts collections but also because it adds the medium of lettering to the range of work represented. The revitalisation of letter forms by Morris, Johnston and Gill was one of the lasting achievements of the Arts and Crafts Movement.

Eric Gill (1882-1940)

190* Nativity

Designed and carved by Eric Gill in 1920.

Limestone, carved and coloured in blue and sanguine. The figures are the Christ child, the Virgin Mary and Joseph, and the lettering reads: S. MARY & S. JOSEPH *(on the haloes) and* VERBUM CARO FACTUM EST *(the Word was made flesh) (on the base). No marks.*

$6\frac{1}{4} \times 8\frac{1}{4} \times 1\frac{1}{2}$ (159×210×38)

Purchased in 1993 from the Gillian Jason Gallery, London, for £6300 with a 50 per cent grant from the V&A Purchase Grant Fund and a contribution from the estate of G. W. Edwards via the Friends of Cheltenham Art Gallery and Museums. 1993.46

The carving was made to a design by one of Gill's children and came from the estate of his daughter, Joan, and her husband, René Hague. It was shown at an exhibition at the Gillian Jason Gallery, London, in late 1992 with other items from the estate. Judith Collins dates it to 1920[1] because there is an entry in Gill's record book for an otherwise unidentified nativity relief at that date and Gill made several works in this naïve style around 1920.
See Col.Fig.102.

1. Collins, J., *Eric Gill: The Sculpture. A Catalogue Raisonné*, London 1998, p.118, Cat.103.

See also Cat.261, Inscribed stone by David Kindersley.

Chipping Campden Arts and Crafts

T. J. Gill, Hart's Silversmiths, Hart & Huyshe, Alec Miller,
J. Sidney Reeve, Thornton & Downer, Robert Welch, Paul
Woodroffe.

After the Guild of Handicraft closed as a Limited Company
in 1908 a number of the Guildsmen decided to remain in
Chipping Campden or nearby, including Charley Downer,
George and Will Hart, William Mark, Alec Miller, Jim
Pyment, Sidney Reeve, and Bill Thornton. Along with Paul
Woodroffe, the stained-glass artist, who was associated with
the Guild but never formally part of it, these makers carried
on Ashbee's ideals. They worked separately but came
together to continue Ashbee's Campden School of Arts
and Crafts and they organised Summer Schools until 1916
(Fig.172). After the First World War the School was revived
and classes in silversmithing have been held in the town
at various times since, under the tutelage of Harry
Warmington and later John Reeve.

From 1924 they also put on exhibitions which often
transferred to Cheltenham Museum and to Painswick in
southern Gloucestershire. Their stated aims were 'to
perpetuate the reputation of the town as an art centre, and
to continue as far as possible the work of the Guild founded
by Mr Ashbee …'.[1] These exhibitions attracted a wide range
of contributors from the local area and further afield.

The Old Silk Mill in Chipping Campden is still home to
Hart's Silversmiths, Pyment's building firm and to Robert
Welch, who brought a new input of modern design ideas
to the town when he arrived in 1955.

T. J. Gill's work is included in the catalogue here because
he exhibited with the Campden group in 1935,[2] though little
is known of him or whether he had any sustained contact
with the Guild. Local trade directories list stone masons
named Gill at Bourton-on-the-Hill, about four miles from
Chipping Campden, from about 1870. Thomas Gill seems to
be from the second generation and is listed as 'quarryman
& assist. overseer' until 1935, when he is described as a
'specialist in Roman lettering', and 1939, when he becomes
'wood carver'. This suggests someone developing skills
related to his own trade, perhaps through classes, and
exhibiting with the nearest local group.

George Hart and his brother Will, a woodcarver, joined
the Guild just before it moved to Chipping Campden, after
Ashbee saw their work at an exhibition in Hitchin. Their
stepfather, the flamboyant figure Wentworth Huyshe, also
moved to Chipping Campden with his family and the Harts
were soon firmly rooted in the town. George Hart took over
the silversmith's workshop at the Silk Mill after 1908 and in
1912 registered the 'GofH' mark to himself. He also bought
land at Broad Campden and from the First World War to
about 1927 occupied himself with farming, leaving the
metalworking in the hands of his first apprentice, Harry
Warmington and his half-brother, Reynell Huyshe. George's

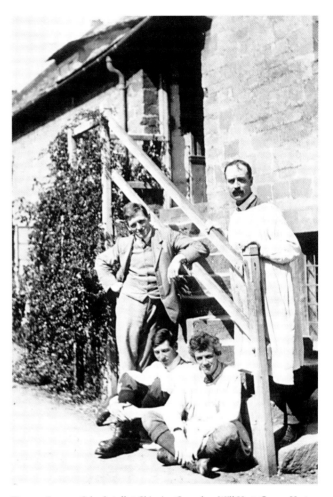

Fig.172 *Summer School staff at Chipping Campden: Will Hart, George Hart,
Alec Miller and William Mark, c.1914.*

sons, George and Henry, trained as silversmiths, and
Henry's son, David, now runs the business, assisted by
Derek Elliott, who served a five-year apprenticeship from
1982. For ninety years, Hart's Silversmiths have been
making fine work in the tradition of Ashbee's Guild for
domestic, ecclesiastical, and institutional clients.

The partnership of Hart & Huyshe was established
around 1919 as a loose arrangement between George Hart
and Reynell Huyshe, and signboards preserved at the Guild
of Handicraft Trust advertise under their names, 'Metal
Work, Chalices, Tea Sets, Hammered Bowls, Cups,
Tankards, etc.'

Alec Miller arrived at the Guild in 1902 as a young, highly
skilled craftsman, having trained as a carver in his native
Glasgow. His idealism and determination appealed to
Ashbee, who found in him one who was completely
sympathetic with the aims of the Guild. In 1908 Miller
set up in business with Will Hart and gained numerous

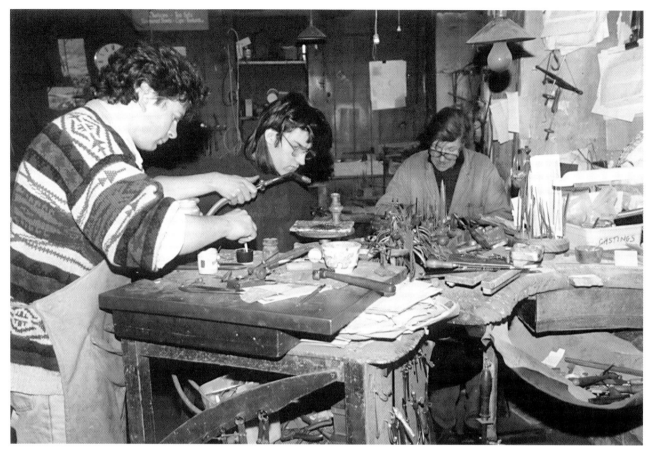

Fig.173 *The workshop of Hart Silversmiths, Chipping Campden, c.1988.*

commissions for architectural carving in Britain and the
United States. From 1910 he also made portrait figures and
freestanding sculptures, and became known for his sensitive
portraits of children. In 1939 Miller moved to California,
where he worked until he was in his eighties.

Sidney Reeve attended the art schools in Kidderminster
and Birmingham and taught for about five years before
joining the Guild of Handicraft in 1902. Janet Ashbee in her
Journal wrote of him enthusiastically as 'another FIND'[3] and
he became an excellent silversmith. After two years with the
Guild, Reeve was appointed to a post at Leicester School of
Art, then under the dynamic headship of Benjamin Fletcher.
Reeve also designed for the Dryad Metal Works, a branch
of the Dryad firm for which Fletcher made designs for cane
chairs. Apart from a short period during the First World
War, Reeve stayed at Leicester until his retirement in 1934.
He returned to Chipping Campden when he retired and in
the Harts' workshop he was able to continue silversmithing.
It was here that he made some of his finest pieces, including
a shield for 'Good Gardening' for Wyggeston School and
a chalice and paten for the Cathedral Church of St Martin,

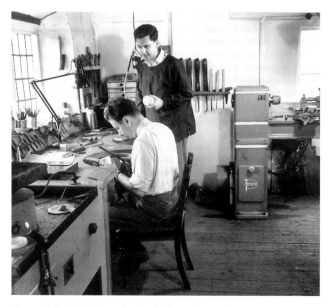

Fig.174 *Robert Welch (standing) and John Limbrey in the workshop at
Chipping Campden, c.1960.*

both in Leicester. Reeve specialised in chasing and produced delicate designs suited to this technique. His son, John, also took up silversmithing and taught classes in the mid-1970s.

Bill Thornton and Charley Downer were Londoners who were elected as Guildsmen in the late 1890s. They worked together for most of their lives until just after the Second World War, making domestic metalwork such as fire irons and gates and also larger architectural work for churches. Small items were supplied to Russell & Sons (Fig.181) and they often showed work at the local exhibitions.

Robert Welch is now better known as a designer than as a maker, but he had a thorough training in art and metalwork at the schools of art in Malvern, Cambridge, Birmingham and, from 1952-5, at the Royal College of Art in London. He set up his studio and workshop in the top floor of the Silk Mill in Chipping Campden in 1955 and three years later was joined by John Limbrey, who has executed much of the silverwork and many prototypes for industrial products designed by Welch. In designing for individuals and for industry, Welch has succeeded in balancing the need for both skilled handwork and for intelligent attention to the demands and capabilities of the machine. Working with a small team, he has been a highly inventive and influential designer for more than forty years, supplying designs to clients all over the world and exhibiting widely. He opened retail shops in Chipping Campden and Warwick in 1969 and 1991, in which the variety of his work can be seen, and also has a thriving mail-order business.

Paul Woodroffe was a book illustrator and stained glass maker who had known Ashbee since at least 1898 when he took part in the Art Workers' Guild pageant, *Beauty's Awakening*. He was never part of the Guild of Handicraft but lived in Chipping Campden from 1904 and had his cottage altered by Ashbee. Here he ran his studio, trained assistants, and undertook a large number of commissions for domestic and ecclesiastical stained glass, including fifteen windows for St Patrick's Cathedral in New York in 1909. Cheltenham Museum has a collection of volumes of watercolours recording his windows (Fig.15).[4] In 1935 Woodroffe moved to Jayne's Court, near Bisley in south Gloucestershire.[5]

The Chipping Campden and District Historical and Archaeological Society has been very enterprising in documenting the activities of this remarkable group of artists and craftworkers in the town and has published a series of small books which provide the most recent information available.[6]

AC

1. Huyshe, W., *Chipping Campden Exhibition of Arts and Crafts*, Stratford-upon-Avon 1924, introduction.
2. *An Exhibition of Cotswold Art and Craftsmanship*, Cheltenham 1935, Cat.84.
3. Ashbee, J., Journal, June 1902, quoted by Slingsby, R.J.F., *Sidney Reeve (1875-1943): silversmith, designer, teacher*. Unpublished undergraduate dissertation, 1992, De Montfort University, Leicester, p.40. Most of the information given here about Reeve is derived from this dissertation and from information from Mr Herald Goddard.
4. CAGM 1988.324-9.
5. See William Morris Gallery, *Paul Woodroffe 1875-1954*, London 1983.
6. Fees, C. (ed), *A Child in Arcadia: The Chipping Campden Boyhood of H.T. Osborn 1902-1907*, n.d. (1985); Jones, T.F.G., *The Various Lives of Wentworth Huyshe*, 1998; Wilgress, J., *Alec Miller: Guildsman and Sculptor in Chipping Campden*, 1987 & 1998; see also Carruthers, A. and Johnson, F., *The Guild of Handicraft 1888-1988*, Cheltenham 1988.

Thomas J. Gill (*fl. c.*1894-1939)

191 Wall panel

Designed and made by Thomas J. Gill in about 1935.

Goscombe stone from Stanway Hill, Gloucestershire.

10×20×2¾ (254×508×7)

Given in 1935 by the maker. 1935.287

Record: An Exhibition of Cotswold Art and Craftsmanship, CAGM, September 1935, Cat.84.

This is almost certainly the piece shown in the 1935 exhibition at Chipping Campden which transferred to the Museum in Cheltenham. The catalogue entry reads: '84. Wall panel in Cotswold stone £2 2s.' and it seems likely that Gill offered it to the collection while it

Fig.175 **Cat.191**

was on display. The piece is recorded in the Museum's accessions register in October 1935 and there is on file a letter of thanks from D. W. Herdman, but no correspondence from Gill.

In Kelly's *Directory of Gloucestershire* for 1935 Gill is listed for 'carving in stone & wood; specialist in Roman lettering'. In earlier volumes he appeared as 'quarryman and assistant overseer'

and it is tempting to assume that he exhibited his work and gave this piece to the Museum in order to establish himself as a letter cutter.

Hart's Silversmiths (1908-)

192* Box and cover

Probably designed and made in 1913 by George Hart, with an enamelled plaque by William Mark.

Hammered silver with painted and gilt enamel.
Hallmarked on one end and inside lid: G of H, sterling, London, 1913.

$1\frac{7}{8} \times 6 \times 3\frac{1}{8}$ (47×154×81)

Given in 1983 by Professor and Mrs Hull Grundy. 1983.196

In 1951 this piece was shown at the *Exhibition of Cotswold Craftsmanship* held at the Montpellier Rotunda in Cheltenham and was attributed in the catalogue to Fleetwood Varley. On grounds of style, however, it seems much more likely to be by William Mark, whose work was more colourful and more figurative than Varley's.

The box is the right size for cigarettes but has no wooden lining.
See Col.Fig.56.

193* Cup and cover

Designed by George Hart and made by Harry Warmington and George Hart in 1935.

Hammered and chased silver with engraved decoration. Under the foot is a pierced plate. Hallmarked on rim: G of H, sterling, London, 1935.

With lid: $15\frac{3}{4} \times 4\frac{5}{8}$ (400×118)

Purchased in 1938 from the maker for £35 with a 50 per cent grant from the V&A Purchase Grant Fund and money from the Leslie Young Bequest. 1939.3

Design: Hart's Silversmiths, Chipping Campden, signed but undated.

The engraving shows the coat of arms of Cheltenham. There is no information in the Museum's files on when this engraving was done. The Curator, D. W. Herdman, and his wife used a photograph of the cup on their Christmas card in 1938 showing the side with the hallmarks, opposite the side with the engraved decoration. The card is

a curious document, from the Herdmans personally but promoting 'An Example of Cotswold Craftsmanship of To-Day in Cheltenham Museum'. If the Cheltenham coat of arms were on it at the time, it would surely have featured? Since Mr Herdman had the Bucknell poker (Cat.77) engraved after it arrived in the museum, it seems likely that this decoration was also added later, but probably in Hart's workshop. The cup was accessioned immediately, so there is no suggestion that it was intended as part of the borough's plate.

Harry Warmington made most of the silverwork from the workshop at this time and did engraving, but George Hart would have done the chasing on this piece.
See Col.Fig.103.

194* Spoon

Designed and made in 1936 in George Hart's workshop.

Hammered silver.
Hallmarked on back of bowl: G of H, 1936, London, sterling.

$5\frac{5}{16} \times 1\frac{7}{16}$ (134×36)

Given in 1990 by Mrs Shelagh Taylor. 1990.858

This and the next spoon were given to Mr and Mrs Taylor as wedding gifts by D. W. Herdman in 1937. Mrs Taylor had come to work at Cheltenham Museum in 1932 and there met her husband, who was the Curator at Gloucester City Museums.

Spoons were not usually designed on paper but were made up in the workshop according to the materials available and the whim of the maker.

The fig-shaped bowl and acorn knop were common in the sixteenth century, when spoons were the main item of cutlery and most people carried their own around with them.
See Col.Fig.105.

195* Spoon

Designed by C. R. Ashbee after sixteenth-century examples and made in 1937 in George Hart's workshop.

Hammered silver.
Hallmarked on stem: G of H, 1937, London, sterling.

$6\frac{1}{16} \times 1\frac{1}{2}$ (154×38)

Given in 1990 by Mrs Shelagh Taylor. 1990.857

The fig-shaped bowl with rat-tail and octagonal knop are derived from seal-top spoons of the sixteenth and seventeenth centuries, the period from which Ashbee often took inspiration. Similar spoons are illustrated in Plate 19 of *Modern English Silverwork* and in Guild of Handicraft catalogues.[1] Such spoons were advertised in Gordon Russell's 'LYGON' catalogues of the 1920s (Fig.181) and are still made today in the workshop since they are good items to keep in stock for the casual visitor. They are often given as wedding or christening presents (see Cat.194 above) and are generally used for jam or honey.
See Col.Fig.105.

1. For example in an undated Guild catalogue of *c*.1902, 'Silver Spoon. Copy of 16th-Century German work. Price 15s.', Silver Studio Collection 2141. Ref.739.23942.

196* Spoon

Designed and made in 1939 by George Hart.

Silver.
Hallmarked on back of handle: G of H, sterling, London, 1939.

$6\frac{5}{8} \times 1\frac{3}{8}$ (161×34)

Given in 1983 by Professor and Mrs Hull Grundy. 1983.189

At the join of the stem and bowl is a flat tail with indented lines echoing the very severe decoration of the knop.
See Col.Fig.105.

197* Beaker

Designed and made in 1988-9 by Derek Elliott (1963-) after C. R. Ashbee. Engraved by David Hart.

Hammered silver with chased and engraved decoration on one side of a stylised pink with an inscription above: THE GUILD OF HANDICRAFT 1888-1988.
Hallmarked under foot: G of H, sterling, London, 1989.

$4\frac{15}{16} \times 3\frac{7}{16}$ (125×86)

Commissioned in 1988 from the maker for £300. 1989.841

To celebrate the centenary of the founding of the Guild of Handicraft the Museum held an exhibition in 1988 which especially focused on the later

history of the Guild and included a range of work from Hart's Silversmiths. The idea of commissioning a commemorative piece came out of that exhibition.

Derek Elliott is particularly skilled as a chaser and liked the idea of using the Guild pink to decorate the piece.[1] The chasing was done on a separate piece of silver and then applied to the side of the beaker and the strip of beading, left over from the early days of the Guild and unavailable commercially in 1988, was also applied.

The form is based on Ashbee designs such as Plate 8 in *Modern English Silverwork* and the engraved inscription is in the style of Plate 71. Some discussion took place as to whether the hammer marks should be as prominent as in early Guild work or more delicate, as used in recent work: '... whether the museum wants a reproduction C.R.A. beaker, or our 1989 interpretation of it.'[2] The decision was for Elliott's interpretation.

See Col.Fig.105.

1. The particular form of the pink is derived from the version used in C.R. Ashbee, *Transactions of the Guild & School of Handicraft*, Vol.1 1890.
2. CAGM History file, letter from D. Elliott to A. Carruthers, 23.3.1989.

Hart & Huyshe (*c*.1919-*c*.1927)

198* Bowl

Probably designed and made in about 1920 by George Hart and Reynell Huyshe.

Beaten copper.
Stamped under base:
HART & HUYSHE
CAMPDEN. GLOS

$1\frac{11}{16} \times 8\frac{1}{8}$ (43×206)

Purchased in 1988 for £15. 1988.332

Very similar items were made for Sydney and Gordon Russell to sell at their shop attached to the Lygon Arms Hotel in Broadway. These were advertised in Cheltenham Museum exhibition catalogues and through small leaflets produced by Russell & Sons (Fig.181).[1]

See Col.Fig.105.

1. CAGM, 'LYGON' catalogue; *Catalogue of a Cotswold Arts and Crafts Exhibition*, Cheltenham 1923, back cover.

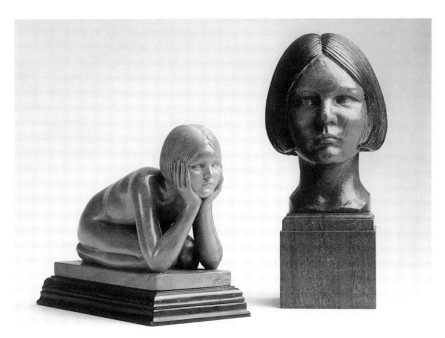

Fig.176 **Cats 199 and 200**

Alec Miller (1879-1961)

199 Sphinx

Designed and carved by Alec Miller in 1927. Limewood on macassar ebony and walnut stand.
Carved on side of base: ALEC MILLER 1927

$7\frac{7}{8} \times 9\frac{7}{16} \times 4\frac{11}{16}$ (200×240×118)

Purchased in 1962 for £120 with another piece by Miller (Cat.200), with grants from Mrs E. Cadbury, Mr A. Mitchell and Major W. T. Hart and from the Friends' Fund. 1962.110a

Record: Royal Academy Exhibition 1929, Cat.1441.

CAGM history file, typed transcript of inscription by Miller on photograph.

Like the following piece, this is a portrait of Miller's daughter, Jane, who was born in 1917. A typed note in the Museum's files gives details of an inscription written by Miller on the back of a photograph of the piece:
'At the RA this was so popular that people stroked down her back till the carving was filthy and I got permission twice to go to the RA early and give her a bath! About 36 people – including E. V. Lucas – who came to Campden to see me about it – but I had given it to my daughter – of whom it is a portrait – now Mrs Wilgress – it is sitting before me as I write this now – California 1945.'

200 Jane

Designed and carved by Alec Miller in about 1927.

Pearwood with mahogany for the hair and base. The glue has discoloured where the two woods are joined at the hairline.
No marks.

$12 \times 5\frac{1}{4} \times 6$ (305×133×152)

Purchased in 1962 for £120 with another piece by Miller (Cat.199), with grants from Mrs E. Cadbury, Mr A. Mitchell and Major W. T. Hart and from the Friends' Fund. 1962.110b

This, like Cat.199 above, is a portrait of Miller's daughter, now Jane Wilgress, whose book on her father's career is the most comprehensive published account.[1]

1. Wilgress, J., *Alec Miller: Guildsman and Sculptor in Chipping Campden*, Chipping Campden 1987, 2nd edition 1998.

J. Sidney Reeve (1875-1943)

201* Fruit bowl

Designed and made by Sidney Reeve in 1935.

Silver, hammered and chased, with eight repoussé panels on the bowl and foot and eight chased and engraved panels around the stem.
Hallmarked: Birmingham, 1935, JSR

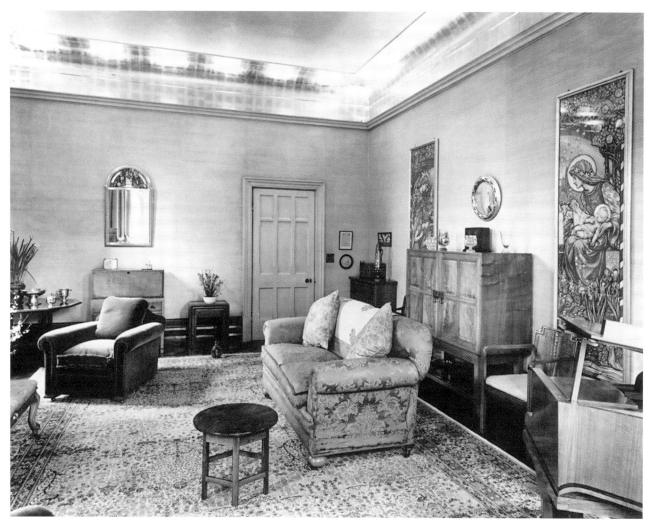

Fig.177 *The drawing room of the Goddard family's house in Leicester c.1950. The silver bowl by Sidney Reeve is on the table on the left (see Cat.201).*

$6\frac{1}{8} \times 10$ (155×253)

Given in 1995 by Mr and Mrs H.M. Goddard. 1997.38

Design: GoHT 1993:1:544: Sketches and notes for decorative panels.

Record: Private Collection: Photograph of the drawing room at the house in Leicester of Mr and Mrs Harold W.Goddard, about 1950 (Fig.177); Illustrated in Harrison, A. How to care for Silver and Plate, Leicester, 1930s.

The bowl was commissioned by Mrs Goddard, who went with her son, Herald, to see Reeve in the silversmithing department at the art college in Leicester. A bowl entitled 'The Seasons' was shown at the exhibition of Cotswold Art and Craftsmanship in Cheltenham in 1935[1] and it is not clear whether this was the same piece, exhibited by Reeve as a fine example of work available for commission, or if it was another. The price shown for the exhibited bowl was £23. Reeve retired from Leicester in 1934 and went to live in Chipping Campden where he continued silversmithing in the Harts' workshop. It is not known if this piece was made in Leicester or Chipping Campden.

The photograph of the drawing room at the Goddard family home, Lyndwood in Stoughton Road, Leicester, shows it on a table by Peter Waals, who made a great deal of very fine furniture and panelling for this house in the 1930s. The bowl was also used often in the dining room, for which Reeve made a set of candlesticks. Goddard's was an old-established Leicester firm making plate powder and liquid polish for silver and it is not surprising that members of the family bought fine examples of silverwork for their own use.

Reeve knew of the Goddards' interest

Fig.178 **Cat.201**

in astrology and the twelve finely chased panels around the stem alternate between images of a man doing seasonal agricultural activities and paired astrological symbols against a cloud or wavelike background. The figures are carrying branches, sawing, scything, and threshing, and each figure panel also contains a symbol. Reeve's annotated

sketches show that he was familiar with some of the possible alternative scenes for the months and he presumably rejected 'killing pig' as unsuitable. As an art worker of his generation and an associate of the Guild of Handicraft he must have known Ruskin's *Stones of Venice*, in which are described sculptures of the months at the entrance to St Mark's and 'a parallel view of the employment of the months from some Northern manuscripts ...'.[2]

See Col.Fig.105.

1. Cat.173.
2. Ruskin, J., *The Stones of Venice*, Vol.II, 1853 Chapter VII Gothic Palaces, LI-LIII. (pp.271-6 in edition by The Kelmscott Society Publishers, New York, n.d.).

Thornton and Downer (c.1908-47)

202 Log rake

Designed after C. R. Ashbee and made by Bill Thornton and Charley Downer in about 1933.

Forged and polished steel with twisted and stamped decoration.
No marks.

$24\frac{1}{4}\times4\frac{1}{4}$ (615×107)

Given in 1933 by Mr S. D. Scott. 1933.93

Record: Exhibition of Cotswold Arts and Craftsmanship, *Chipping Campden 1933.*[1]

S. D. Scott was a friend to the Museum and also gave fine examples of art pottery to the collections (see Cats 170-3). This log rake was donated in September 1933 and it seems likely that he bought it direct from the exhibition which closed on 4 September, possibly at the instigation of Mr Herdman who was good at encouraging known supporters.

1. Cat.129 toasting fork (other iron-work available).

Robert Welch (1929-)

203 Coffee pot

Designed by Robert Welch and made by John Limbrey in 1995.

Hammered and polished silver with fibre insulators in the handle.
Hallmarked on neck: RW, *sterling, London, 1995.*

$9\frac{1}{8}\times7\frac{3}{8}\times4\frac{1}{2}$ (232×187×114)

Fig.179 **Cat.202**

Fig.180 **Cat.203**

Given in 1995 by the designer. 1997.40

Cheltenham Art Gallery and Museum organised a retrospective exhibition on Robert Welch in 1995, which was curated by Margot Coatts. During the planning stages it was proposed that he might design a piece specially for the show. He suggested designing something for the collection and presented the final piece to the Museum.[1]

Welch sometimes names a design after the client and this is called the Cheltenham coffee pot. As with much of his silver, it is a reworking of forms developed earlier, in particular a tea and coffee set made for J. B. Priestley in 1968. The brief then was to design something to harmonise with a Georgian coffee pot but to look modern. On the JB Set the handles were almost circular but the new design is more comfortable to hold. Other pieces have subsequently been made to commission.

It is Robert Welch's wish that the pot should be used in the Museum for coffee, but the occasion has not yet arisen.

1. Coatts, M., *Robert Welch Designer-Silversmith: A retrospective exhibition 1955-1995*, Cheltenham 1995, Cat.SI14.

Paul Woodroffe (1875-1954)

204* 'Taffy was a Welshman'

Designed and made by Paul Woodroffe in about 1930-7.

Panel of painted and stippled glass sections joined with lead. The word TAFFY *appears along the bottom of the panel.*
The edges have been left ready for installation in a window but there is also a twisted wire at the top for hanging, presumably for exhibition purposes.
No marks.

$16\frac{3}{8}\times14\frac{1}{2}$ (415×368)

Given in 1951 by the artist. 1981.1414

Record: An Exhibition of Cotswold Craftsmanship, *Cheltenham 1951, Cat.319.*

There is no correspondence in the Museum's files about the acquisition of this piece but it seems likely that Woodroffe offered it as a gift when the 1951 exhibition closed. In the catalogue it is listed as for sale at £11 11s. It is extremely difficult to date it accurately because Woodroffe made a number of such items over the years. Peter Cormack, in the catalogue of an exhibition held at the William Morris Gallery in 1982, dated it to *c.*1930 and related it to unpublished illustrations for a children's book drawn in 1915.[1] There is also a catalogue entry in the 1937 *Exhibition of Gloucestershire Art and Craftsmanship* for a panel of stained glass entitled *'Taffy was a Welshman'* at £6 6s, and it seems possible that this might be the same one.[2] If so, the fact that Woodroffe eventually gave it to the Museum suggests it was not a popular subject.

Depicted is a shady character with a gun over one shoulder and a basket over one arm containing bacon and leeks. An irate cottager in the background is in hot pursuit.

See Col.Fig.104.

1. *Paul Woodroffe 1875-1954*, London 1982, Cats 80 and 59f.
2. Cat.192.

Gordon Russell (1892-1980) and his firm

Gordon Russell was born in north London but brought up in the Cotswold town of Broadway where his father, the entrepreneur Sydney Russell, had bought and developed the Lygon Arms, a sixteenth-century coaching inn. Through his father, Russell was made aware of the work of both Gimson and the Barnsleys at Sapperton and the Guild of Handicraft at Chipping Campden. He and his brothers went to the Grammar School in Chipping Campden where their classmates included the sons of Guildsmen. Russell subsequently wrote about his youthful admiration for the work of traditional Cotswold craftsmen such as stone masons, tilers, and hedgers.

At the age of sixteen he began working for his father, doing odd jobs at the Lygon and running the family antiques business. He also started going to a life-drawing class in Chipping Campden in the company of such leading figures from the local Arts and Crafts community as Paul Woodroffe, Alec Miller, and George and Will Hart. He attributed his confidence in tackling a variety of design and craft projects to his early familiarity with craftsmen of quality. During his youth he tried his hand at calligraphy, leatherwork, silver and metalworking.

Although furniture dominated his work after the First World War, he continued to take a broad and sometimes experimental approach to design. He produced much of the publicity material for the family firm of Russell & Sons. The firm also sold metalwork made by Hart and Huyshe (see p.151) although it is not clear whether Russell had any input into its design. In 1919 he employed Harry Gardiner who had worked as a gunsmith in Birmingham before joining Gimson's smithy at Sapperton (see above p.110). Earlier that year, Gardiner had applied for a teaching position in Birmingham and had received a glowing reference from Sir William Rothenstein who wrote: 'I look on Mr Gardiner as one of the best metal workers I have come across'.[1] From the early 1920s Russell was producing designs for a wide range of domestic metalwork some of which was derived from Gimson's work. A photograph of the Russell & Sons smithy at Broadway from the 1920s shows five craftsmen at work (Fig.182).

Russell worked with a number of manufacturers, including Stevens & Williams, Brierley Hill, Worcestershire, and James Powell & Sons, Whitefriars, London, to produce designs for domestic glassware. In 1927 Powell's mounted an exhibition in their London showrooms of Russell furniture and experimental cut glass designed by Russell and made by Powell's.[2]

A number of important designers worked for Gordon Russell's firm from the 1920s, including his younger brother, R. D. Russell, Marian Pepler, Eden Minns, David Booth, and W. H. Russell (no relation). Their influence was felt through the range of work produced and bought in for retail by the firm.

Fig.181 'From the Cotswolds', 'Lygon' leaflet, drawn and designed by Gordon Russell for Russell & Sons, 1923.

Marian Pepler produced in the region of two hundred designs for rugs during her career. She also designed textiles, acted as buyer and colour and decoration consultant for Gordon Russell Ltd, and worked closely with Dick Russell, her husband from 1933, on numerous architectural and interior design projects.

She came from a creative background: her father, Sir George Pepler, was an architect and town planner while her uncle, Hilary Pepler, founded the Ditchling Press. She studied at Croydon School of Art and the Architectural Association where she met Dick Russell. On qualifying in 1929 she and her first husband, the designer, Eden Minns, both joined Gordon Russell Ltd. Encouraged by Dick Russell, who was looking for modern geometric textiles to complement his work, she designed her first rug in 1930 and, during the same year, attended classes at the London School of Weaving to understand the techniques of the medium for which she was designing. She made only one of her own designs; otherwise they were produced by a number of commercial manufacturers: the Wilton Royal Carpet Factory, Alexander Morton, Sons & Company, and Tompkinson's Ltd of Kidderminster.

The flat-woven rugs produced by the Carlisle firm of Alexander Morton had been used by Gordon Russell Ltd during the 1920s so it was not surprising that Pepler should

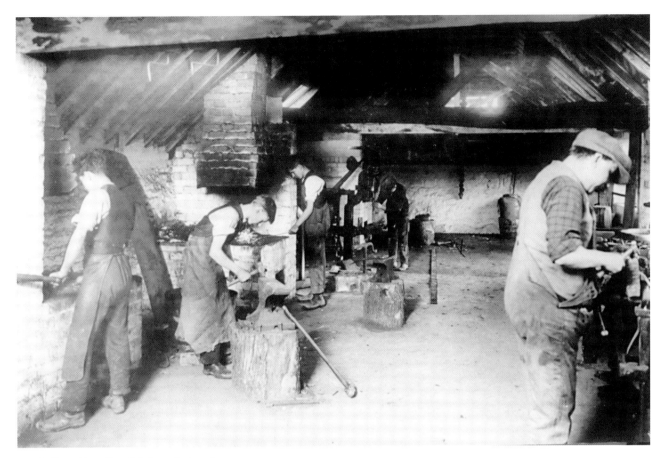

Fig.182 *The smithy at Russell & Sons, about 1928.*

use Morton to produce some of her rug designs. Their associated group, Edinburgh Weavers, also produced some of her curtain designs in the 1930s.

She worked in partnership with Dick Russell on the design of Lobden, a modernist flat-roofed house for Mr and Mrs Albert Hartley at Colwall, near Malvern, Worcestershire, in 1932. Her work was also featured in the exhibition in 1933 on *British Industrial Art in relation to the Home*, at Dorland Hall.

David Booth trained with Dick Russell at the Architectural Association. He joined Gordon Russell Ltd and took charge of the drawing office when Dick Russell moved to London in 1932. He married Elsa Hamburger, an interior designer who successfully built up the fabrics department at the Broadway showroom from about 1928. Booth left in 1933 to set up as an architect in Oxford but continued his connection with the firm.

Russell's retail outlet at Broadway had developed from the family antiques business which profited from wealthy Americans staying at the Lygon Arms. As well as furniture produced by the firm, glass, carpets, fabrics, pottery, metalwork and other household accessories were also bought in, initially by Toni Russell, Gordon Russell's wife; then by Marian Pepler and later by Nikolaus Pevsner. In the 1930s, Gordon Russell Ltd built up a reputation for good

design through the quality of its publicity material and exhibitions in department stores such as Barrow's Stores in Birmingham.

In 1929 Gordon Russell opened a second outlet in Wigmore Street, London, which, despite a very difficult period following the Wall Street stockmarket crash in 1929, expanded to larger premises in the same street six years later. Influenced by Dick and Marian Russell, this new London outlet sold a wider range of goods, displayed for the first time as room sets in a very modern setting. In October 1935, Nikolaus Pevsner (1902-83), a refugee from Nazi Germany, took over from Marian Pepler as buyer for Gordon Russell Ltd. He came to Russell's notice through a talk he gave to the Design and Industries Association on his research for Birmingham University into the design of products for British industry. Although he had no background in retail, he accepted Russell's offer of the post of buyer of factored goods and continued to work for the firm until 1939.
MG

1. CAGM 1991.1098, archive material from the Gardiner family.
2. *The Studio*, Vol.93 1927, p.319.

Fig.183 **Cat.207**

Gordon Russell (1892-1980)

205* *Glasswares*

Designed by Gordon Russell about 1923 and made by Stevens & Williams, Brierley Hill, Worcestershire.

Lead glass blown into a mould and twisted to resemble seventeenth-century wrythen glass. Jug, candlestick, six tumblers and a dessert set comprising two dishes and six plates. The candlestick has a metal socket which may not be original.
The jug has developed a crack, probably due to stresses in the material, and one of the plates has two chips in its rim.

Jug: $9\frac{1}{8} \times 7\frac{1}{2}$ diam. (232×190 diam.)
Candlestick: $8\frac{5}{8} \times 5\frac{1}{2}$ diam. (219×139 diam.)
Tumbler: $4 \times 3\frac{1}{4}$ diam. (102×83 diam.)
Plate: 8 diam. (202 diam.)
Dish: $3\frac{1}{8} \times 8\frac{1}{8}$ diam. (80×206 diam.)

Given in 1986 by Mrs J. Waterson.
1986.1323-26

Record: CAGM 'LYGON' table glass price list and 'LYGON' leaflet produced for Russell and Sons by Gordon Russell about 1923 (Fig.181).

The donor is the daughter of J. H. Simpson who bought these glasses and other Russell items (see Cat.208).
See Col.Fig.106.

206 *Fire irons*

Designed by Gordon Russell and made by Harry Gardiner in about 1924.

Polished steel showing signs of use, the brush is worn.

Stand: $31\frac{1}{2} \times 9\frac{3}{8}$ diam. (800×238 diam.)
Length of tongs: $22\frac{5}{8}$ (569)
Length of brush: $19\frac{3}{4}$ (502)
Length of shovel: 22 (559)

Given in 1984 by the family of Sir Gordon and Lady Russell via the Gordon Russell Trust. 1984.145

Design: GRT, design Nos 143-6.

They were used in the Russells' home, Kingcombe, near Chipping Campden.
This is a reworking of Gimson's designs for fire irons (see for example Cat.76).

207 *Fender*

Designed by Gordon Russell and made by Russell & Sons in 1926.

Polished steel with pierced, chased and stamped decoration.

$3\frac{1}{2} \times 41\frac{3}{4} \times 11$ (90×1060×280)

Given in 1984 by the Gordon Russell Trust. 1984.146

Design: GRT, design No.501.

Used in the Russells' home.
The design is dated 24.6.1926. This piece was available in either rustless steel or gilding metal and priced at 9 guineas.

208* *Reading lamp*

Designed by Gordon Russell and made by Russell & Sons in 1924.

Copper frame with leaded colourless translucent pieces of oyster shell, also known as capiz shell, forming the shade. It was intended for use with an electric light fitting which has not survived. One piece of shell has broken with a section missing, and several are cracked.

$16\frac{1}{2} \times 13\frac{1}{4}$ diam. (420×338 diam.)

Purchased in 1986 for £1000 with a 50 per cent grant from the V&A Purchase Grant Fund. 1986.1322

Design: GRT, design No.166.

Record: Illustrated in the Studio Yearbook, *1926 p.157.*

This lamp was acquired by J. H. Simpson, first headmaster of Rendcomb School, Gloucestershire, for his study at the

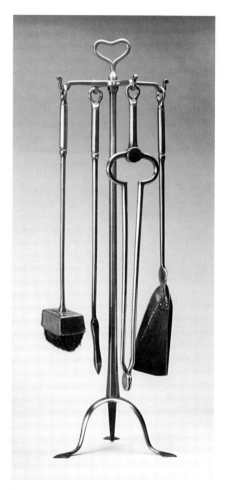

Fig.184 **Cat.206**

school. It remained in the family until it was acquired by Cheltenham.
Rendcomb was founded in 1920 to provide a progressive boarding school education for boys from primary schools in rural Gloucestershire. Like Bedales, the progressive boarding school in Hampshire, it had a strong craft element in the curriculum. Simpson's study at the school was furnished by Russell & Sons; the school also sent pupils to Broadway for training and workshop experience. After leaving Rendcomb in 1930,

Simpson wrote an account of his philosophy and experiences entitled *Sane Schooling*, published by Faber in 1936.

See Col.Fig.109.

209 Rug

Designed by Marian Pepler and made by Alexander Morton, Sons & Company, about 1932.

'Torfyn' quality two-ply woollen pile on flax warp with knotted fringes in pink, natural and raisin brown. Tapestry or kelim weave.
Marked in weave: mp

66×35 (1676×890)

Purchased in 1984 for £500 with a 50 per cent grant from the V&A Purchase Grant Fund. 1984.168

Made for Sir Gordon and Lady Toni Russell for their house, Kingcombe, near Chipping Campden, Gloucestershire. The rug remained in the family until its acquisition by Cheltenham.

210* Rug

Designed by Marian Pepler and made by the Wilton Royal Carpet Factory Ltd, about 1933.

Two-ply woollen pile on flax warp in raisin brown, lime green and natural.
Hand-knotted in 'Wessex' quality, 4×4 knots a square inch.
Mark in weave: pepler

88×54 (2230×808)

Given in 1998 by Daniel Russell, son of the designer. 1998.258

Record: GRT, stock book No.10048, 'Plough' design, retail price: £7 19s 6d.

Made for the home of the designer's in-laws, Mr and Mrs Sydney Russell, at Snowshill, near Broadway, Worcestershire. The rug was used in the dining room over a stone floor.

From 1930 Wilton Royal were able to produce hand-knotted designer rugs at an economic price by using a coarser weave known as 'Wessex' hand-tufting. They worked with a number of prestigious designers including Marion Dorn and E. McKnight Kauffer as well as Pepler. Her designs usually remained her copyright, the rugs were made exclusively for Gordon Russell Ltd and she received a royalty for each sale.

The choice of colours was a crucial

Fig.185 **Cat.209**

element in the design process, and she herself felt it was more than half the design. When interviewed she recalled that Wilton Royal had their own dyeing shed and took a great deal of trouble to match her colours. She remembered visiting the factory and discussing the rug with the girls who were to make it, and how finished carpets were flung out on the lawn in front of the old hand-weaving shed to be admired.[1]

See Col.Fig.108.

1. See Allwood, R. and Laurie, K., *R D Russell Marian Pepler*, London 1983, pp.30-1.

211 Fire irons

Designed by David Booth for Gordon Russell Ltd in 1933.

Chromed steel stand and tools with copper washers; the base is made of oak covered over the top and sides with aluminium.

Stand: 25½×14¾×4⅜ (648×375×111)
Length of shovel: 19¾ (451)
Length of brush: 16¼ (412)
Length of poker: 15½ (393)
Length of tongs: 15⅝ (398)

Given in 1986 by Chris Morley. 1986.1124

Design: GRT, design No.1046.

This was originally designed for Claridges Hotel, London W1. In the first design, the metal cover over the base is not bent down over the sides.

This set can be seen in a contemporary photograph of the living room at Lobden, near Malvern (Fig.186). A modified version with a dark bronze stand appears in Gordon Russell brochures of 1937 retailing at £9 17s 6d.

See Fig.187.

212* Textile remnant

Designed for Gordon Russell Ltd about 1935.

Black, yellow and white slub cotton on a natural linen ground.
Remnant label attached: Ref DB 64302 Chelsea, width 50", 7/- a yard, fadeless, 1¼ yards
GORDON RUSSELL LTD
BROADWAY WORCESTERSHIRE
AND
28 WIGMORE STREET
LONDON W.1
3/-

Fabric width: 47×47¾ (1193×1212)

Given in 1994 by Miss Ann Tilley. 1994.3

The design is GR 238 'Chelsea'.

Miss Tilley's mother bought this remnant and Cats 213 and 214 at a sale in the Broadway showroom of Gordon Russell Ltd in about 1937.

See Col.Fig.107.

213* Textile remnant

Retailed by Gordon Russell Ltd about 1936.

Black, pink and natural silk brocade.
Remnant label attached: Printed: GR 310, W & S, p266/2, 50", 12/-, GORDON RUSSELL LTD/BROADWAY/WORCESTERSHIRE & 40 WIGMORE ST LONDON W.1. *Hand written:* Obsolete 2/6

Fabric width: 22½×49½ (572×1267)

Given in 1994 by Miss Ann Tilley. 1994.2

The design is 'Linfold' by Alec Hunter, first produced by Warner Fabrics in 1934.
See Col.Fig.107.

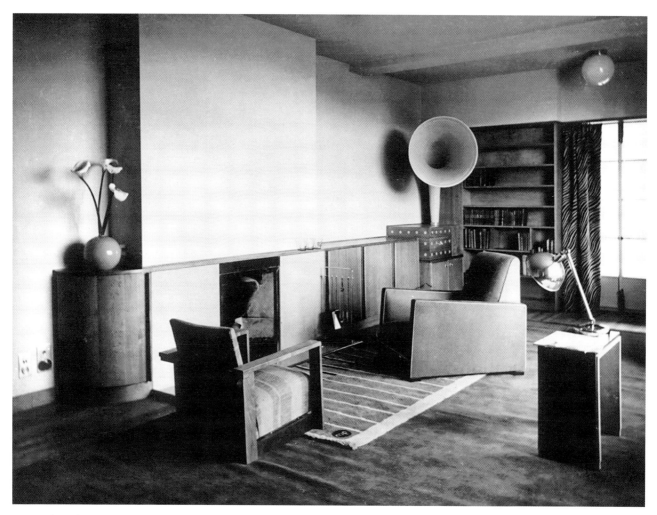

Fig.186 *The modernist drawing room at Lobden, near Malvern, designed by R.D.Russell and Marian Pepler in 1932. By the fireplace is the set of fire irons by David Booth (Cat.211).*

214* Textile remnant

Designed for Gordon Russell Ltd about 1937.

Woven stripes of ivory velvet on a silk ground banded in pink, dark brown and cream.
The fabric width had been cut down.

$112\frac{1}{2} \times 25\frac{1}{4}$ (2857×642)

Given in 1994 by Miss Ann Tilley. 1994.4

Record: Gordon Russell Ltd 'Spring Fabrics' brochure of about 1937 where it is described as fadeless and priced at 11s (55p) a yard. The design is GR 5216 'Corvel Stripe'.
 See Col.Fig.107.

215 Pair of rag rugs

Designer/maker unknown, about 1936. Imported and retailed by Gordon Russell Ltd.

Cotton, woven in alternate stripes of orange, grey and white and horizontal lines of orange, white and beige. One rug is worn and slightly damaged down one side.

$26\frac{3}{4} \times 43\frac{7}{8}$ (680×1115)

Given by Janet Tomalin in 1991 and 1994. 1991.981 and 1994.19

Record: Gordon Russell Ltd 'Spring Fabrics', leaflet 1936.

These rugs were bought from the firm's London showroom in 1938 by the donor who was setting up home in a London flat. They were used on floorboards in a bedroom, one either side of the bed.
 One of Nikolaus Pevsner's innovations

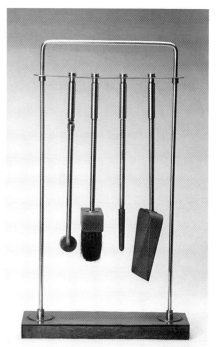

Fig.187 **Cat.211**

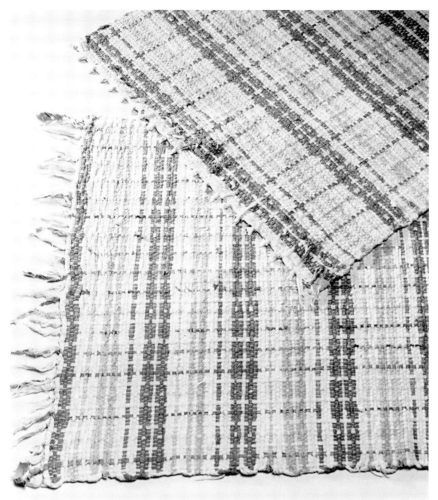

Fig.188 **Cat.215**

as buyer for Gordon Russell Ltd was the introduction of German woven rag rugs to the Wigmore Street showroom. These simple, lightweight pieces, retailing at £1 8s 6d and 17s 6d, sold much better than the more expensive, heavyweight tufted rugs whose bold design elements made them less adaptable.

During the Second World War, the firm found an alternative, British, source for similar rugs which were advertised as 'the first of their kind to be produced in this country' in a Gordon Russell Ltd fabrics brochure of about 1940.[1]

1. CAGM. Gordon Russell archive collection.

216 Carpet sample

Designed by Marian Pepler in 1961.

Two-ply wool/nylon pile on a jute backing. Machine-tufted in 'Wilton' quality.

14×7 (355×178)

Given in 1998 by Daniel Russell, the son of the designer. 1998.259

Produced for the Burghley Room in the Grosvenor House Hotel, Park Lane, London. From 1954-61, R. D. Russell & Partners were employed as interior design consultants for the Grosvenor House Hotel. Pepler's role was to advise on colour and textiles; for the Burghley Room, she chose a dignified and rich colour scheme with walls panelled in American black walnut and brown Thai silk, and a burnt orange ceiling. The early use of nylon pile for the carpet, chosen for its hard-wearing properties, shows how receptive Pepler was to new developments.

Fig.189 **Cat.216**

Eric Sharpe (1888-1966)

Sharpe was brought up in Hampstead where his father, a failed City merchant, spent many of his later years pursuing his passion for wood carving. In 1902, he went to the progressive boarding school, Bedales, in Hampshire where his uncle, Oswald Powell, was second master.

He took up the post of draughtsman in an architectural office in London in 1907; five years later the office was taken over by the architect, Thomas Lawrence Dale who was to become Sharpe's mentor and friend. He was a member of the Art Workers' Guild and soon introduced Sharpe to its ranks. In his twenties, Sharpe travelled in Britain and Europe with his sister, Joan, but some of his most formative travelling came during the First World War. He enlisted in the army in 1914 and spent time in Greece and the Middle East. He was particularly influenced by the low-relief carved work he saw on chairs and other pieces in the Cairo and other Egyptian Museums.

His ambition after the War was for 'something to do with design where I can create something'.[1] He returned to work for Dale who encouraged him to take up woodworking and to enrol for part-time classes at the Central School of Arts and Crafts. He concentrated on figurative and animal carving, and experimental woodwork inspired by the work of Gimson and Sidney Barnsley. It was Dale who introduced Sharpe to another woodworker, Arthur Romney Green, in 1920. Green took him on as a pupil in his workshop in Christchurch; in 1923 Sharpe joined the team of about eight craftsmen producing furniture and woodwork to Green's designs. His strengths were carved and inlaid work and lettering. Green acknowledged Sharpe's particular skill in his pamphlet *Instead of a Catalogue*, writing: 'I am lucky in having on my staff Mr Eric Sharpe who has made his own reputation as a woodcarver. His claw and ball feet, for example, compare favourably with those of the best period'. However, contemporaries from the workshop recall that relations between the two men were often strained.[2]

In 1921 Sharpe married Marian Boyd-Mackay, whom he had met while she was teaching at Bedales in 1920. As he was gradually doing more of his own work while at Christchurch, he decided to set up his own workshop. The Sharpes asked Lawrence Dale to build them a house and workshop at Martyr Worthy, Hampshire, and moved there in 1930. A gilded rip-saw was suspended from the eastern gable as a trade sign.

Fig.190 *Eric Sharpe, c.1920.*

He eked out a precarious existence designing and making furniture and woodwork for private clients and churches. Although he was interested in the possibilities of training and apprenticeship, he only employed one assistant, Norman Terry, until 1939, probably for financial reasons. He was asked to take over from Peter Waals as Technical Adviser at Loughborough Training College after the latter's death in 1937 but declined.
MG

1. Letter from Sharpe to his sister, Joan quoted by Richard Coppin in 'Eric Sharpe and his Furniture', *Decorative Arts Society Journal 17*, 1994, pp.49-58.
2. See Elkin, S., *Life to the Lees: a biography of Arthur Romney Green*, Christchurch 1998, p.67.

217 Carving of St John the Baptist

Designed and made by Eric Sharpe in about 1921-8.

Figure on an octagonal base carved in oak. Screwed on to a square oak stand.

$29\frac{7}{8} \times 8 \times 7\frac{5}{8}$ (759×202×193)

Given in 1995 by Oliver Morel. 1995.576

Sharpe's carved work spans his career, from his marriage bed of 1921 and the Moose Settle of 1925 to the ceremonial chairs of the later years. The links with Dale continued; one of his finest pieces of work was for the church screen designed by Dale and made by Edward Barnsley's workshop in the village of Stratton Audley between 1929 and 1930. For the screen, Sharpe designed and executed a frieze with pierced tracery, carving the intricate work freehand. In contrast, a fall-front writing desk of 1931 for Lady Rachel MacRoberts, the explorer, shows Sharpe in exuberant mood endowing his carved female figures with great strength and vigour.

This carving was made for a font cover but never used. It is a depiction of St John the Baptist as described in *Matthew* chapter 3, wearing clothes of camel's hair and with a leather belt round his waist. The carving was given to Oliver Morel by Eric and Marian Sharpe in August 1966, a few months before Sharpe's death. Oliver Morel is a cabinet-maker in the Art and Crafts tradition.[1] From his workshop at Moreton-in-Marsh, Gloucestershire, from the 1960s until 1984, he ran the Eric Sharpe Memorial Centre which offered research facilities and practical support in terms of loans of tools and advice for wood carvers.

1. See *GCF*, p.154.

Fig.191 **Cat.217**

Studio Pottery

Bernard Leach, Margaret Leach, Katharine Pleydell-Bouverie, William Staite Murray

Bernard Leach is now regarded as the father of studio ceramics in Britain. After studying at the Slade School of Art and training as a bank clerk, he began his career as a potter in Japan. In 1920 he returned to England and set up a pottery at St Ives, Cornwall. It was to become a dominant force in the history of studio pottery in Britain and a training ground for many who were themselves to become significant studio potters. Early students included Katharine Pleydell-Bouverie, Michael Cardew, Norah Braden, and Charlotte Bawden, née Epton. Others followed, including Harry and May Davis in the 1930s and Margaret Leach in the early 1940s.

Production problems in the 1920s and early 1930s led to the design by Bernard Leach and his son, David, of a standard range just before the Second World War. This range was to set a precedent for domestic studio pottery (see below Cat.219).

William Staite Murray was a highly influential potter in the 1920s and 1930s. He became Head of Ceramics at the Royal College of Art in 1926. However he considered himself an artist and exhibited alongside painters and sculptors, for example becoming a member of the 7 & 5 Society in 1927.

Katharine Pleydell-Bouverie trained with Bernard Leach at St Ives and set up Coleshill Pottery on her family's estate at Coleshill, near Highworth, Wiltshire, in 1924. She worked together with the potter Ada (Peter) Mason from 1924-7. Like Pleydell-Bouverie, whom she had joined at St Ives, Mason had studied at the Central School. She left Coleshill after a depressive illness and later emigrated to America. From 1928-36 Pleydell Bouverie worked with Norah Braden. Michael Cardew at Winchcombe Pottery was a close friend and would often stay at Coleshill.

Margaret Leach (no relation to Bernard Leach) trained at art school in Liverpool and worked at the Leach Pottery, St Ives, from 1943-5. The following year, she re-opened Barnhouse Pottery, near Chepstow. The potter Lewis Groves worked with her from 1946-7, as did Dorothy Kemp somewhat later. At the Barnhouse Pottery, Margaret Leach made both earthenware and stoneware. In 1951 she joined Lewis Groves at the Taena Community, a spiritual community involved in pottery and agriculture at Aylburton (later Upton St Leonards) in Gloucestershire. Her slipware of about 1951 at Taena was described by George Wingfield Digby as '… perhaps the most robust and full-flavoured in the traditional manner which is now being made'.[1] She gave up pottery on her marriage in 1956; her married name was Mrs Heron.

The work of the second generation Arts and Crafts Movement designer-makers and the early studio potters probably appealed to the same audience, although whether this was Cardew's 'obscure middle-class people like me'[2] is debatable. They were often sold together; the New Handworkers Gallery in Percy Street, London, for example stocked work by Phyllis Barron, Michael Cardew, Bernard Leach, Romney Green and Ethel Mairet in the late 1920s. Cardew himself wrote that Leach's large slipware dishes should be seen in a small country house of 'Old English character', 'they look their best with white walls or in combination with oak; in fact they are as necessary to the interior of such a house, as the Romney Green furniture and the Mairet textiles'.[3]

HB

1. Wingfield Digby, G., *The Work of the Modern Potter in England*, London 1952, p.83.
2. Cardew, M., *A Pioneer Potter*, London 1988, p.61.
3. Cardew, M., *The Studio*, Vol.91 1925, p.301.

Bernard Leach (1897-1979)

218* Bowl

Designed and made by Bernard Leach at St Ives Pottery, Cornwall, about 1936.

Thrown and turned stoneware with a chun *glaze with fine bubbles and crackles.*
Impressed stamp on side of pot at base: St Ives stamp.
Painted mark on base in black: B L *monogram.*

$2\frac{1}{2} \times 3\frac{5}{8}$ diam. (64×92 diam.)

Purchased in 1936 from The Halcyon, Rye, Sussex, for 7s. 1936.242

See Col.Fig.110

219* Bowl

Designed by Bernard and David Leach and made at St Ives Pottery; decorated by Bernard Leach, about 1947.

Thrown and turned stoneware with painted decoration in cobalt and iron oxides and an oatmeal glaze.
Impressed stamp on base: St Ives.

Painted mark in grey: B L *monogram.*
Paper label on side of bowl: £3 10/-

$4 \times 11\frac{1}{2}$ diam. (102×292 diam.)

Purchased in 1947 from Mrs Playford, Playford Galleries, Clarence Street, Cheltenham, for £3 10s od. 1947.54

The Playford Galleries was a short-lived venture which probably opened in 1947 and had closed by 1955; it advertised itself as 'The Craft Shop, arts and crafts'.[1]

This bowl was part of the standard range made by a team of potters. Three main glazes were used: either *tenmoku*, celadon or the oatmeal glaze used here.

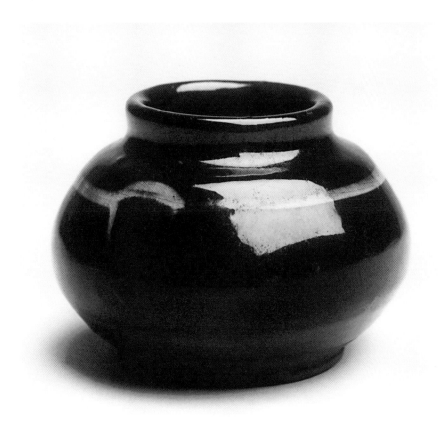

Fig.192 **Cat.221**

Some bowls, individually decorated by Bernard Leach, were offered for sale in the standard-ware catalogue at a special price as 'B. L. decorated'. The Japanese-inspired design recalling a pagoda is typical of Leach's work.
See Col.Fig.110.

1. *Kelly's Directory of Gloucestershire*, 1950, p.40.

Margaret Leach (*fl.*1943-56)

220* Lidded soup bowl

Designed and made by Margaret Leach at the Barnhouse Pottery, near Chepstow, about 1950.

Thrown salt-glazed stoneware with ash glaze inside.
Unmarked

$3\frac{3}{4} \times 6\frac{7}{8} \times 4\frac{1}{4}$ (95×175×112)

Purchased in 1950 from Miss M. E. Leach for 5s. 1950.41
See Col.Fig.110.

221 Small vase

Designed and made by Margaret Leach at the Barnhouse Pottery, near Chepstow, about 1950.

Thrown and turned earthenware with a black slip and trailed white slip decoration.
Unmarked

$2\frac{3}{4} \times 3\frac{3}{4}$ diam. (70×95 diam.)

Purchased in 1950 from Miss M. E. Leach for 6s. 1950.42

Katharine Pleydell-Bouverie (1895-1985)

222* Vase

Designed and made by Katharine Pleydell-Bouverie at Coleshill, Wiltshire, about 1937.

Thrown and turned stoneware with ash and tenmoku glazes.
Scratched mark on base: X D X 1

$4\frac{3}{4} \times 4$ diam. (120×100 diam.)

Purchased in 1937 from Mr T. C. Nixon, Promenade, Cheltenham, for 12s 6d. 1937.212

For information about T. C. Nixon see Cat.22.
 Pleydell-Bouverie was very interested in glazes, specialising in ash glazes made from the different woods gathered on the estate. Her pots are often marked with

letters and numbers, as this example, which refer to a particular glaze or body recipe.
 See Col.Fig.110.

223* Bowl

Designed and made by Katharine Pleydell-Bouverie at Coleshill, Wiltshire, about 1937.

Thrown and turned stoneware with an ash glaze.
Impressed stamp on side of bowl: K P B *monogram*

$3 \times 5\frac{3}{8}$ diam. (76×137 diam.)

Purchased in 1937 from Mr T. C. Nixon, Promenade, Cheltenham for 7s 6d. 1937.213
 See Col.Fig.110.

224* Jar

Probably made by Ada 'Peter' Mason at Coleshill Pottery, Wiltshire, 1924-7.

Thrown and turned stoneware with raised bands. Iron glaze and incised geometric decoration.
Impressed stamps on base EM (*monogram*) COLE

9×9 diam. (229×229 diam.)

Source unknown. 1999.11

Mason adopted a primitive style in her pottery which has led to the attribution of this piece.
 See Col.Fig.110.

William Staite Murray (1881-1962)

225* Vase

Designed and made by William Staite Murray at Rotherhithe, London, in 1922.

Thrown and turned stoneware with an iron glaze with streaks of iron oxide.
Incised inscription on base: W. S. Murray 3/1922 London
Note in pencil on base: 4 / ? / 3 ES

$9\frac{1}{4} \times 6\frac{3}{4}$ diam. (235×170 diam.)

Purchased in 1948 from Mr F. A. Hopkins, East Gate Gallery, 72 High Street, Oxford, for £4 from the Friends' Fund. 1948.55

 See Col.Fig.110.

Michael Cardew (1901-83)
and the Winchcombe Pottery

Michael Cardew, Peter Dick, Ray Finch, Ivan Martin, Sidney Tustin, Winchcombe Pottery.

Michael Cardew shared with Bernard Leach a passion for English slipware. He was interested in country pottery from an early age, admiring the work of Edwin Beer Fishley at Fremington, and earlier slipware. He had lessons in throwing from Fishley's grandson before going to train at St Ives in 1923.

At Leach's he met Katharine Pleydell-Bouverie who was to remain a close friend and supporter, particularly after his move to Winchcombe. She bought a number of Cardew's pots.[1] Her pottery, on her family's estate at Highworth in Wiltshire, about fifty miles away from Winchcombe, provided Cardew with a place of refuge and a source of intellectual stimulus, where he could meet other potters, including Norah Braden (whom he had first met at St Ives), as well as Leach, Shoji Hamada and Soetsu Yanagi (Leach's philosopher friend).

In 1926 he left St Ives to re-open Beckett's country pottery at Winchcombe, Gloucestershire, which he ran until 1936. Cardew was concerned to '… make pots which could be used for the purposes of daily life, and to make them cheap enough for ordinary people … to be able to use them and not to mind too much when they got broken'.[2] He was uncomfortable with the world of one-off gallery pieces, and although he admired William Staite Murray's pots he did not consider his own work to fall into the same category of 'art for art's sake'.[3] He did not feel he belonged to the '… fine art world … but neither did I feel at home in the arts and crafts world. I found its atmosphere curiously suffocating. The original Arts and Crafts Movement inspired by William Morris certainly had a fine Victorian moral fibre and a no doubt necessary if somewhat pedantic insistence on good workmanship. The trouble was that all the products of this good craftsmanship usually looked laboured and mannered'.[4] Cardew felt that what you said was important, more important than the means of expression: '… say it when you feel it must be said and let the craftsmanship take care of itself …'.[5]

Cardew's position and that of many inter-war craftsmen was different from that of their Arts and Crafts predecessors. They were much more concerned to work directly with their chosen material, seeking a direct and spontaneous expression, whereas the Arts and Crafts maker was more often a versatile designer (as for example Morris or Voysey), working with or for many different materials. Cardew and his contemporaries, partly because of their interest in direct expression, were more likely to make an object from start to finish. Arts and Crafts designers with one or two exceptions passed on their designs for others to make.

Ray Finch joined the Winchcombe Pottery in 1936 after

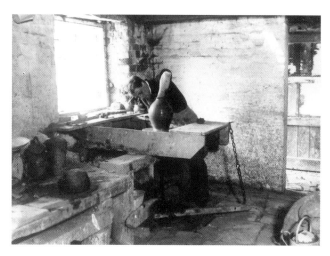

Fig.193 *Michael Cardew at his wheel, c.1930.*

spending a year training with Dora Billington at the Central School of Art. He became manager when Cardew left in 1939 to set up a pottery at Wenford Bridge, Cornwall, and has gone on to reflect more closely Morris's views of an ideal craft practice. Although a disciple of Eric Gill, his working practices come close to Morris's ideal of 'glorious art, made by the people and for the people, as a happiness to the maker and the user',[6] although he would find this description too romantic a view of his craft, which for him is firmly grounded in the practical. He believes that working as a small team '… with each potter personally responsible for the work done promotes both continuity and growth'.[7] He has been anxious to avoid rigid divisions of labour whilst accepting that it was desirable in the production of standard shapes that one person should make the same range. Although the pottery remains hand-made, in recent years Winchcombe has adopted labour saving measures; the clay is now bought in, and clay and glazes are mixed by machine. Ray Finch is pragmatic about the changes, commenting that it is impossible to do everything oneself and compromises have to be made.

Many potters have received practical training and workshop experience at Winchcombe since 1926. Sid Tustin joined the pottery as a boy in 1927 and became an apprentice from 1930-4. He worked at the pottery until his retirement in 1978. In the 1960s and 1970s he made much of the standard range, on his retirement estimating that he had made over a million pots. His pots from the 1950s and earlier often have distinct decoration, particularly of scrolling bands or leaf motifs, or of combed spirals.

Pat Groom joined the pottery as an apprentice in 1947 and left in 1954. Ivan Martin helped with firings at Winchcombe before the Second World War and worked at the pottery from 1947 to 1951. He worked briefly at Prinknash Abbey Pottery before setting up Cricklade Pottery, near Cirencester,

with his wife Kay later in 1951 (see Fig.199). The pottery site, near a river, was chosen because clay could be dug there and the river mud could be used for glazes. They made slipware (often using blue or grey glazes as well as the traditional browns and yellows) and, from the early 1960s, stoneware. Ivan Martin's work is characterised by bold painted decoration or banding in slip and sometimes the use of wax-resist. Kay specialised in press-moulded dishes decorated with slip-trailed or feathered decoration. The Cricklade Pottery closed in 1976.

Peter Dick was at Winchcombe from 1961 to 1964. He made bowls for the standard range and decorated beakers. He also made some pots of his own design, including teapots, jars, plates, bowls and bottles. He set up Coxwold Pottery in Yorkshire after leaving Winchcombe.

Since the early days of the pottery, the main output has been domestic ware with a standard range being introduced in the 1960s. This was used by Cranks Wholefood restaurants from 1961. Mike Finch, Ray Finch's son, has managed the pottery since 1984 and it is currently run with a team of four.

HB

1. Some of her collection is now at the Holburne Museum and Craft Study Centre at Bath.
2. Cardew, M., *A Pioneer Potter*, London 1988, p.61.
3. *Ibid*, p.70.
4. *Ibid*, p.89.
5. *Ibid*, p.89.
6. Morris, W., *The Art of the People*, 1879, in Morris, M. (ed) *The Collected Works of William Morris*, Vol.XXII, London 1914, p.50.
7. May, S., reviewing Ray Finch's pottery in *Ceramic Review*, No.31 Jan/Feb 1975, p.81.

Michael Cardew (1901-83)

226* Dish

Probably designed and made by Michael Cardew at Winchcombe Pottery, 1926-32.

Thrown and turned earthenware with decoration combed through a white slip. Unmarked, price in pencil on side and base: 1/6

2×8 diam. (50×205 diam.)

Given in 1932 by Captain Robert Powley Wild. 1932.40

Captain Wild had a close connection with the Museum. A geologist by training, in 1920 he wrote a catalogue of the collection of rock and mineral specimens. He gave a number of items to the Museum from the 1920s to the 1940s, particularly ethnography but also some decorative art items including a sketchbook by Ernest Gimson. He was Inspector of the Mines Department of the Gold Coast in West Africa and whilst there systematically collected examples of local crafts, including textiles and basketry.

This dish has a coarse earthenware body with bubbles in the slip and imperfections in the glaze, all suggesting it is an early piece. Slip is liquid clay and those used at Winchcombe are described as white or black. The white slip was made with white firing clay, the black from local clay mixed with iron and manganese oxides. This dish has a standard glaze, containing a mixture of red and white clay which, over a white slip, as here, gave a yellow appearance. Other glazes were used: a clear glaze which left the slip a creamy white and a copper glaze which gave green.

See Col.Fig.112.

227* Jug

Designed and made by Michael Cardew at Winchcombe Pottery, about 1930.

Thrown and turned earthenware with a white slip and iron-painted decoration. Impressed stamps on side of jug at base (aligned with handle): MC WP *and incised initials* FRT *or* FAT *scrubbed out.*

$9\frac{5}{8} \times 8\frac{1}{4} \times 7\frac{1}{4}$ (243×210×185)

Given in 1982 by Mrs Constance Tangye. 1982.1077

The incised initials may be FAT, for Allan Tangye, the Arts and Crafts collector whose daughter-in-law gave this jug (see Cat.13).

See Col.Fig.111.

228 Jug

Designed and made by Michael Cardew at Winchcombe Pottery, about 1930.

Thrown and turned earthenware with a white slip and iron-painted decoration. Flaking glaze. Impressed stamps on base: WP MC

$9\frac{5}{8} \times 8\frac{1}{4} \times 7\frac{1}{4}$ (243×210×185)

Given in 1982 by Mrs Constance Tangye. 1982.1078

This jug is almost identical to Cat.227 and is therefore not illustrated.

229* Cider Jar

Designed and made by Michael Cardew at Winchcombe Pottery, about 1930.

Thrown and turned earthenware with a white slip and iron-painted decoration. Impressed stamps on base: WP MC

$11 \times 7\frac{5}{8}$ diam. (280×200 diam.)

Given in 1982 by Mrs Constance Tangye. 1982.1079

Michael Cardew made many cider jars. He wrote of being fascinated by 'the completeness of the shape'. He was unsure whether they would sell: 'I did not then realise what a long and respectable ancestry they had, and thought that they were something I'd invented for myself'.[1]

See Col.Fig.111.

1. Cardew, M., *A Pioneer Potter*, London 1988, p.81.

230* Plate

Probably designed and decorated by Michael Cardew, thrown and ovalled

by Elijah Comfort (1863-1949) at Winchcombe Pottery, about 1930.

Thrown and ovalled earthenware with decoration combed through a white slip. Unmarked.

$1 \times 7\frac{1}{4} \times 7\frac{1}{2}$ (26×186×192)

Given in 1997 by Miss Margaret Robson. 1997.251

This design of a waving line has become known as the Winchcombe pattern. It has been used throughout the history of the pottery in different variations. This deep looping version is particularly found on oval and circular plates. This plate was thrown as a circle and then reshaped by taking out a leaf-shaped piece of clay and pressing the sides together to form an oval dish. Cardew introduced this North Devon technique to the thrower Elijah Comfort. Comfort had been the chief thrower at Beckett's Pottery, which closed in 1914. Cardew persuaded him to return to work in the re-opened pottery. He continued to make country wares, including bread crocks, washing pans and flower pots. When demand for these began to fall in the late 1920s Cardew encouraged him to begin making other things including oval dishes, platters, straight-sided bowls and casseroles. His pots were decorated by Cardew or Sid Comfort. He continued to work at the pottery through the Second World War when it was temporarily closed, but did not continue when it re-opened in 1946.
 See Col.Fig.112.

231* *Jug*

Designed and made by Michael Cardew at Winchcombe Pottery, about 1935.

Thrown and turned earthenware with sgraffito decoration through an iron slip. Impressed stamps on side of jug at base (aligned with handle): WP MC

$8 \times 7\frac{1}{2} \times 6\frac{1}{8}$ (203×190×156)

Purchased in 1935 from the maker at Winchcombe Pottery for 7s 6d from the Friends' Fund. 1935.142

The simple sgraffito plant motif, suggesting a closed bud, was frequently used at Winchcombe by Michael Cardew and Ray Finch and in a slightly different, more open, form by Sid Tustin.
 See Col.Fig.111.

232* *Salt dish*

Designed and made by Michael Cardew at Winchcombe Pottery, about 1935.

Thrown and hand-built earthenware with a white slip and incised decoration. Impressed stamps on base: WP MC

$3\frac{1}{8} \times 5\frac{1}{2} \times 3\frac{1}{2}$ (80×140×88)

Purchased in 1935 from the maker for 4s 6d from the Friends' Fund. 1935.143
 See Col.Fig.112.

233* *Bowl*

Designed and made by Michael Cardew at Winchcombe Pottery, about 1935.

Thrown and turned earthenware with white slip-trailed decoration. Impressed stamp on base: MC WP

$2\frac{7}{8} \times 6\frac{3}{4}$ (73×170)

Purchased in 1935 from the maker at Winchcombe Pottery for an unspecified sum. 1935.146
 See Col.Fig.112.

234 *Large dish*

Designed and made by Michael Cardew at Winchcombe Pottery, about 1935.

Thrown and turned earthenware with black slip-trailed decoration over a white slip. Green glaze. Impressed stamp on base: WP and price 35/-, in pencil.

$3\frac{1}{2} \times 15\frac{3}{4}$ (90×400)

Purchased in 1935 from the maker at Winchcombe Pottery for £1 15s 0d. 1935.198

Fish designs are a common Winchcombe theme, used throughout the history of the pottery.

235* *Bread plate*

Designed and made by Michael Cardew at Winchcombe Pottery, about 1935.

Thrown and turned earthenware with white slip-trailed decoration. Impressed stamp on base: WP MC and price in pencil, 12/6

$1 \times 12\frac{1}{2}$ (25×320)

Purchased in 1935 from the maker at Winchcombe Pottery for 11s 3d. 1935.277

This and a number of other Winchcombe pots from the Museum's collection were

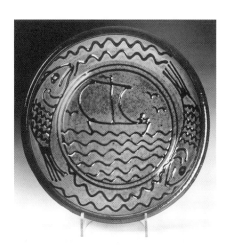

Fig.194 **Cat.234**

exhibited at the 1951 *Exhibition of Cotswold Craftsmanship* held in Cheltenham.
 See Col.Fig.111.

236* *Jug*

Probably designed and made by Michael Cardew at Winchcombe Pottery, about 1935.

Thrown and turned earthenware with the name WINCHCOMBE drawn through a white slip. Impressed stamp on base: WP and price 4/6 in pencil.

$6\frac{1}{4} \times 6\frac{3}{4} \times 6$ (160×170×150)

Purchased in 1935 from the maker at Winchcombe Pottery for 4s 6d. 1935.282

A number of pots are known from the 1920s and early 1930s with the name WINCHCOMBE incised on the body.
 See Col.Fig.112.

237* *Jug*

Designed and made by Michael Cardew at Winchcombe Pottery, 1935-9, or 1942.

Thrown and turned earthenware with an iron glaze and rouletted decoration on the handle. Impressed stamp on base: MC and incised mark 1/1.

$8\frac{3}{4} \times 8\frac{3}{4} \times 7\frac{5}{8}$ (224×224×195)

Purchased in 1942 from Raymond Finch at Winchcombe Pottery for 15s 0d. 1942.63

This may have been old stock made before Michael Cardew left the pottery in 1939 or it may have been made when he returned for a few months in early 1942. Although Winchcombe Pottery is

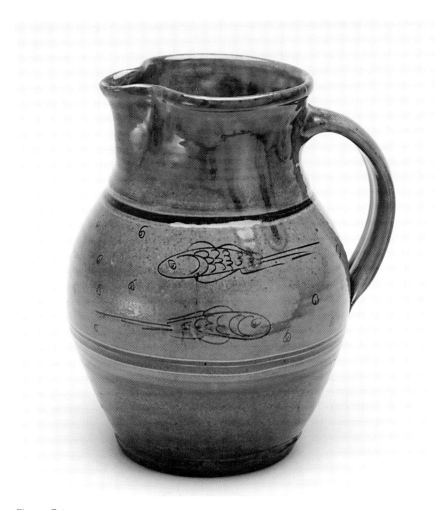

Fig.195 **Cat.240**

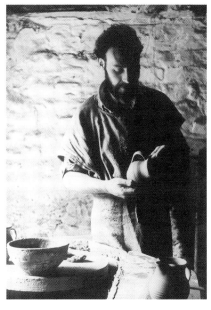

Fig.196 *Ray Finch, c.1940.*

Thrown and turned earthenware, two thirds covered in a white slip with decoration drawn through the slip.
Impressed stamp on base: WP

$9\frac{1}{4} \times 7\frac{5}{8} \times 6\frac{3}{4}$ (235×195×170)

Purchased in 1948 from the maker at Winchcombe Pottery for £1 10s 0d. 1948.98

The jug is a half-gallon size. Both Michael Cardew and Ray Finch liked fish decoration, employing a range of methods including incising, trailing and painting.

241 *Bowl*

Designed and made by Ray Finch at Winchcombe Pottery about 1948.

Thrown and turned earthenware half-covered with a black slip, with white slip-trailed decoration and a reduced iron-green glaze.
Impressed stamp on side at base: WP *and price in pencil 27/6.*

$4 \times 10\frac{1}{8}$ diam. (102×258 diam.)

Purchased in 1948 from the maker at Winchcombe Pottery for £1 7s 6d. 1948.87

Here the standard glaze, which usually gives a yellow appearance, has been reduced in firing by the atmosphere of the kiln to create a greenish glaze. It is unusual in a bottle-kiln firing which normally creates an oxidising atmosphere.

not always marked it is more unusual to have a maker's stamp and no pottery stamp, and this may indicate a 1942 date.
 See Col.Fig.111.

Peter Bruce Dick (1936-)

238* *Storage jar with locking lid*

Designed by Peter Dick and made at Winchcombe Pottery, 1967-9.

Thrown and turned stoneware with an iron glaze.
Impressed stamps on base: WP BD

$5\frac{5}{8} \times 6$ diam. (143×115 diam.)

Given in 1997 by Miss Margaret Robson. 1997.257

BD is the mark of Peter Dick

Jars with a locking lid of this type were developed by Dick from screw-top lids which he had made at Abuja Pottery in Nigeria. The lid proved too complicated for regular production and was not continued after he left the pottery.
 See Col.Fig.114.

Ray Finch (1914-)

239 *Vase*

Designed and made by Ray Finch at Winchcombe Pottery, 1936-8.

Thrown and turned earthenware with white slip-trailed decoration.
Impressed stamps on base: RF WP

$7 \times 5\frac{1}{4}$ diam. (180×135 diam.)

Given in 1938 by the Curator, D. W. Herdman. 1938.118

Finch recalls that his early attempts at slip-trailing produced a fountain-like pattern, like that on this vase, which inspired Michael Cardew to produce his own version. This was later used to decorate the large rose bowls that have become known as 'fountain' bowls.
 See Fig.197.

240 *Jug*

Designed and made by Ray Finch at Winchcombe Pottery about 1948.

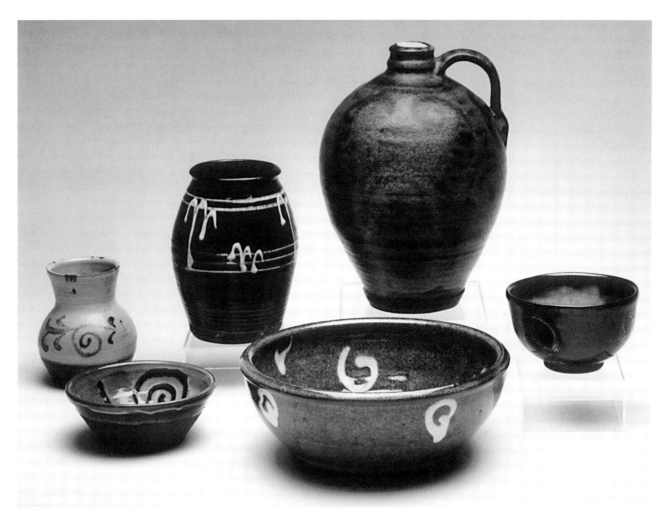

Fig.197 **Cats 243, 249, 239, 241, 247 and 242**

242 Bowl

Probably designed and made by Ray
Finch at Winchcombe Pottery, about
1948.

*Thrown and turned earthenware with a black
slip over a white slip and combed decoration
through a partially reduced iron glaze.
Impressed stamp on base* WP *and price 7/6.*

$3\frac{1}{8}\times5\frac{1}{8}$ diam. (80×130 diam.)

*Purchased in 1948 from the maker at
Winchcombe Pottery for 7s 6d. 1948.100*

The reduced iron glaze creates the green
appearance.

243 Vase

Probably designed and made by Ray
Finch at Winchcombe Pottery, about
1948.

*Thrown and turned earthenware with a white
slip and painted decoration in iron and
cobalt.
Unmarked, price 7/6 in pencil on base.*

$5\times4\frac{1}{8}$ diam. (125×105 diam.)

*Purchased in 1948 from the maker at
Winchcombe Pottery. 1948.101*

244* Jug

Probably designed and made by Ray
Finch at Winchcombe Pottery, 1965-70.

*Thrown and turned stoneware, two-thirds
covered in an iron glaze.
Unmarked.*

$13\frac{1}{2}\times9\frac{1}{2}$ diam. (342×241 diam.)

*Given in 1982 by Mrs Constance Tangye.
1982.1080*

Stoneware production was introduced
in 1959 after some experimental firings
in the early 1950s.
 See Col.Fig.114.

245* Large dish

Designed and made by Ray Finch at
Winchcombe Pottery, about 1967.

*Thrown and turned stoneware with iron
glaze and glaze-trailed decoration.
Impressed stamp* WP *and incised inscription
on base:*
NIKOLAUS PEVSNER, AT
SEVENTIETH BIRTH
DAY GATHERING FROM
GORDON & TONI RUSSELL
KINGCOMBE
FEBRUARY 5 1967

$2\frac{3}{16}\times15\frac{1}{4}$ diam. (56×388 diam.)

*Given in 1984 by the family of Sir Gordon
and Lady Russell via the Gordon Russell
Trust. 1984.156*

The dish came from Gordon Russell's
house at Kingcombe near Chipping
Campden, where it was kept in the
dining room. It had been commissioned
as a birthday gift for Nikolaus Pevsner

(see p.155) but the Russells had made a mistake about his age and it was never given.

This snake-like decoration balancing a central band was particularly used by Ray Finch in the 1960s and 1970s. It relates to the boney-pie decoration he was using around the same period. Boney-pie designs, suggesting the bones of a chicken carcass left after the meat has been eaten, were originally used on nineteenth-century slipware.

See Col.Fig.114.

Pat Groom (1932-)

246* Dish

Designed and made by Pat Groom at Winchcombe Pottery, 1947-53.

Press-moulded earthenware with black slip-trailed decoration over a white slip and a green glaze.
Impressed stamps on base: PG WP *and price in pencil 6/-.*

$2 \times 9\frac{1}{2} \times 8\frac{5}{8}$ (50×240×220)

Given in 1984 by Mrs J. Covey-Crump.
1984.469

The dish was bought by the donor's family about 1951-5. They passed through Cheltenham every year on their holiday and bought pieces at the pottery. It may have been bought as late as 1955 as stock in the shop often took two or three years to sell through.

See Col.Fig.113.

Ivan Martin (1913-79)

247 Cider jar

Designed and made by Ivan Martin at Winchcombe Pottery, 1947-51.

Thrown and turned earthenware with iron-painted decoration over a white slip and a reduced iron-green glaze.
Impressed stamps on side of jar at base (aligned with handle): IM, WP

$10\frac{5}{8} \times 7\frac{7}{8}$ diam. (270×200 diam.)

Given in 1980 by Mrs Kay Martin.
1980.1023

248 Bowl

Designed and made by Ivan Martin at Cricklade Pottery, about 1972.

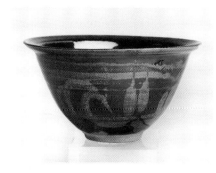

Fig.198 Cat.248

Thrown and turned stoneware with an iron slip and wax-resist decoration with a saturated iron glaze.
Impressed stamp on base: I M

$4\frac{3}{8} \times 8\frac{1}{4}$ diam. (112×210 diam.)

Given in 1980 by Mrs Kay Martin.
1980.1024

Sidney Tustin (1913-)

249 Bowl

Designed and made by Sid Tustin at Winchcombe Pottery, about 1948.

Thrown and turned earthenware with a white slip and black slip-trailed decoration.
Impressed stamps on base: ST WP *and price 3/6 in pencil.*

$2\frac{3}{8} \times 5\frac{3}{4}$ diam. (60×148 diam.)

Purchased in 1948 from Raymond Finch at Winchcombe Pottery for 3s 6d. 1948.99

250* Plate

Designed and made by Sid Tustin at Winchcombe Pottery, 1954-60.

Thrown and turned earthenware with black slip-trailed and combed decoration over a white slip. Green glaze.
Impressed stamp on base: ST

$\frac{7}{8} \times 10$ diam. (23×254 diam.)

Given in 1997 by Miss Margaret Robson.
1997.253

This circular trailed and combed pattern in a black slip with a clear or green glaze is frequently used on dishes of around this date by Sid Tustin, although examples by Ray Finch are also known.

See Col.Fig.113.

251* Plate

Designed and made by Sid Tustin at Winchcombe Pottery, 1954-64.

Thrown and turned earthenware with black slip-trailed decoration over a white slip. Standard glaze.
Impressed stamps on base: WP ST

$\frac{7}{8} \times 10$ diam. (23×254 diam.)

Given in 1990 by Mr Michael Grange.
1990.845
See Col.Fig.113.

252* Beaker

Designed and made by Sid Tustin at Winchcombe Pottery, 1954-64.

Thrown and turned earthenware, half covered in a white slip with combed decoration. Green glaze.
Impressed stamps on base: ST WP

$3\frac{3}{4} \times 3\frac{1}{2}$ diam. (95×88 diam.)

Given in 1997 by Miss Margaret Robson.
1997.254
See Col.Fig.113.

Winchcombe Pottery (1926-)

253* Baking dish

Designed and decorated by Winchcombe Pottery and probably thrown and ovalled by Elijah Comfort, about 1936.

Thrown and ovalled earthenware with white slip-trailed decoration.
Unmarked.

$1\frac{1}{2} \times 6\frac{1}{8} \times 6\frac{3}{4}$ (40×156×170)

Given in 1997 by Miss Margaret Robson.
1997.252

This uses the ovalling technique described in Cat.230.
See Col.Fig.112.

254* Small dish

Designed and made by Winchcombe Pottery, 1954-60.

Press-moulded earthenware with a white slip and black slip-trailed decoration.
Impressed stamp on base: WP

$1 \times 5\frac{1}{2} \times 4$ (26×140×102)

Given in 1997 by Miss Margaret Robson.
1997.255
See Col.Fig.113.

Fig.199 *Ivan and Kay Martin at the Cricklade Pottery, 1960-5.*

255* Small dish

Designed and made by Winchcombe Pottery, about 1955.

Thrown and turned earthenware with combed black slip-trailed bands over a white slip, unglazed rim. Green glaze.
Impressed stamp on base: WP

$1 \times 5\frac{1}{8}$ diam. (25×130 diam.)

Given in 1984 by Mrs J. Covey-Crump.
1984.470

The dish was bought by the donor's family between 1951 and 1955 from the pottery. It probably dates from about 1955 as it has almost certainly been fired in the electric kiln. After a series of disastrous firings the bottle kiln was abandoned around 1953. As the pottery did not have electricity Ray Finch originally used an electric kiln in rented accommodation in Winchcombe itself.

Later he set up electric and gas kilns at the pottery before moving to an oil-fired stoneware kiln in 1959.

See Col.Fig.113.

256* Casserole dish

Designed and made by Winchcombe Pottery, about 1975.

Thrown and turned stoneware with an iron glaze.
Unmarked.

$7 \times 9 \times 9\frac{5}{8}$ ($180 \times 230 \times 245$)

Given in 1997 by Eileen Lewenstein.
1997.258.

Casseroles of this type are part of the standard range produced by the pottery since the early 1960s.

Eileen Lewenstein has worked as a potter since 1946, producing at different times both domestic ware and one-off sculptural pieces. She became joint Editor

of *Ceramic Review* in 1970, retiring in 1997, and has written on Ray Finch and Winchcombe Pottery for the *Review*.

See Col.Fig.114.

257* Baking dish

Designed and made by Winchcombe Pottery, 1975-80.

Thrown and hand-built stoneware with an iron glaze and wax-resist decoration.
Impressed stamp on base: WP

$2 \times 10\frac{1}{2} \times 9\frac{1}{4}$ ($52 \times 267 \times 237$)

Given in 1997 by Eileen Lewenstein.
1997.259

This dish was 'ovalled' using the method the pottery uses now. An oval base is made first. The side wall is thrown separately, cut off the wheel, and as it is flexible is shaped and fixed to the oval base.

See Col.Fig.114.

Recent craft commissions

Alan Evans, Bryant Fedden, Chinks Grylls,
David Kindersley and Lida Lopes Cardozo

Continuing the practice of curators from the 1920s onwards, the Museum has commissioned work from a variety of makers to enhance the fabric of the building and to fulfil specific practical functions. Display cases by Hugh Birkett and Tony McMullen were included in *Good Citizen's Furniture*[1] and this new catalogue provides an opportunity to discuss recently commissioned work in other media. The Museum also collects individual items of contemporary craftwork, focusing primarily but not exclusively on makers from Gloucestershire and the South West, but since this does not continue so directly in the traditions of the Arts and Crafts Movement it is not included here.

All the following pieces were commissioned for the new extension which opened in 1989 or for the improved displays in the original building. The aim was to ask local makers if the relevant crafts were practised locally, and otherwise to look further afield.

Alan Evans was the obvious choice to make forged metalwork for the entrance to the Museum since he works at Whiteway in Gloucestershire and is one of the leading figures in the revival of blacksmithing in Britain since the late 1970s. He trained at Shoreditch College in Surrey and worked at Alan Knight's workshop at Hanbury, Worcestershire, before setting up on his own in 1978. Evans has been an active member of the British Artist Blacksmiths Association which was started in 1978 and he also belongs to local societies such as the Craftsmen of Gloucestershire.

Major commissions undertaken by Evans include gates for the treasury at St Paul's Cathedral in 1981, screens at Broadgate in the City of London 1988-90 and a gateway and handrail for the Public Record Office at Kew in 1995, but he also makes smaller items such as gates and grates for individual clients. In 1993 he was commissioned by the Public Art Panel, Cheltenham Borough Council, to design and make four bicycle stands as part of the pedestrianisation of the High Street.

Bryant Fedden is also a local maker and is a life member of the Gloucestershire Guild of Craftsmen. He is well known for his elegant lettering on glass and other materials and he was approached by the Director to make a plaque commemorating the opening of the Museum extension by the Princess Royal in 1989.

Fedden is a self-taught sculptor and letter cutter. On leaving Cambridge University, where he spent much of his time sculpting in a borrowed garage, he took up letter cutting as a way of making a living at craftwork and has also taught in Pakistan and at Gordonstoun School. He established his own workshop in Winchcombe in 1960. Now based at Littledean in the Forest of Dean, Gloucestershire, Fedden works mainly to commission from architects, institutions and individuals and does much work for churches and cathedrals.

Chinks Vere Grylls, whose stained-glass window provides a bold and colourful attraction in the Arts and Crafts Gallery, has worked in Somerset since 1984. After taking a degree in American Studies in 1972, she attended classes in stained glass at the School of Art in Bideford, North Devon. She set up her own studio in Tiverton, Devon, in 1976 and took a Diploma in Architectural Stained Glass at Swansea in 1981. A move to Cambridge in 1981 was followed by her return to the South West three years later, and then to her present workplace, Smoke Tree Studio, Broomfield Hall, Enmore, Somerset. Chinks Grylls has made windows for churches, houses and business premises and has exhibited widely in Britain, Europe and Japan.

David Kindersley and his wife, Lida Lopes Cardozo, were asked by the Director to make a commemorative plaque because of his admiration for Kindersley's work, in particular the magnificent inscription at the entrance to the Ruskin Gallery in Sheffield. Kindersley trained as a stone carver in London and spent two years with Eric Gill before setting up on his own in 1936. He had a long and distinguished career as a letter cutter and sculptor and was also a major figure in transforming the Arts and Crafts Exhibition Society into the Society of Designer-Craftsmen in the early 1960s. Lida Lopes Cardozo joined the workshop in 1976 after training in The Hague, and she and Kindersley married in 1986. Their work together was a true partnership and they published a series of clear and elegant books under the imprint Cardozo Kindersley Editions as well as making many very beautiful inscriptions. David Kindersley died in 1995; the workshop in Cambridge continues under Lida Lopes Cardozo's leadership.
AC

1. See Cat.107 p.156 and Cat.110 p.160.

Fig.200 and see also back cover, **Cat.258**

Alan Evans (1952-)

258 Grille

Designed and made in 1989-91 by Alan Evans.

Stainless steel, mild steel and aluminium bronze.

$108\frac{1}{4} \times 216\frac{1}{2}$ (2750×5500)

Commissioned in 1988 from the maker for £15,500 with a grant of £1000 from South West Arts for the design. The cost of making the grille was raised by the Friends of Cheltenham Art Gallery and Museums. 1999.18

Design: CAGM.

This grille was designed for the new front entrance of the Art Gallery and Museum, providing a secure yet attractive and dramatic screen to the semi-circular domed entrance.

During the nineteenth century, metalworkers such as William Letheren and Charles Hancock established Cheltenham's reputation for wrought ironwork. The Museum has also collected examples of Arts and Crafts metalwork made in the Cotswolds from the 1930s. Alan Evans was commissioned by the Friends of Cheltenham Art Gallery

and Museums to produce this piece because of his standing as one of Britain's foremost artist-blacksmiths as well as his local connections. The inspiration provided by the Museum's collections in his younger days is acknowledged by the squirrel on the inner face of the grille which relates to the roundels on Gimson's fire dogs (Cat.73). The aluminium bronze nuts that lock the grille together in the shape of acorns provide an additional reference to Gimson's work.

Bryant Fedden (1930-)

259 Commemorative plaque

Designed and made by Bryant Fedden in 1989.

Ash, stained charcoal black and carved through the stain.

106×26 (2693×660)

Commissioned in 1989 from the maker for £780. 1990.833

Design: CAGM.

The plaque commemorates the official opening of the new extension of the Museum by HRH The Princess Royal

Fig.201 *Ernest Gimson's sketch of a marble roundel from the museum at Torcello, Italy, c.1887. This was one of the sources for his design which serves as the logo for Cheltenham Art Gallery and Museum (see Cat.259).*

on 18 September 1989. It hangs in the entrance of the new building, the space for which it was designed.

Bryant Fedden was asked to cut a suitable inscription and after discussion with George Breeze decided to use free lettering in capitals for the names and in upper and lower case for the rest of the work.

Incorporated into the design is the roundel motif from the clergy seat of 1914 by Ernest Gimson and Robert Weir

Fig.202 **Cat.259**

Schultz for Westminster Cathedral.[1] This prototype chair has been in the collection since 1970 and the roundel has served as the Museum's logo since 1982. In the final set of seven chairs in ebony and ivory, the roundel designs differ, but this one is derived from work seen by Gimson in Italy in his student days. Among Gimson's drawings in the collection are rubbings of similar motifs, presumably from stone carvings, and a sketch of a roundel on a page of a sketchbook, labelled 'In Museo di Torcello, in Marble'.[2] Several very similar images appear as illustrations in Ruskin's *Stones of Venice*, Volume Two, and it seems very likely that Gimson's interest in them originated there.[3]

1. See *GCF*, Cat.31 pp.94-5.
2. 1941.225.116.
3. See pls III, inlaid bands of Murano; IV, Sculptures of Murano; V Archivolt in the Duomo of Murano; VII, Byzantine Capitals (Convex Group); XI Byzantine Sculpture).

Chinks Vere Grylls (1948-)

260 *Stained-glass window*

Designed and made by Chinks Grylls in 1989.

Glass and lead. Hand-blown glass from England and Germany with painting in black and silver stain. Some machine-made glass panels have bevelled edges.

Frame: 109¾×108 (2790×2743)

Commissioned in 1988 from the maker for £6798 (plus fixing £172) with a grant of £1000 from South West Arts for the design. The cost of making the window was raised by the Friends of Cheltenham Art Gallery and Museums. 1990.844

Design: CAGM 1990.842-3.

The window was commissioned for the first-floor gallery of the new extension of the Art Gallery and Museum in which the Arts and Crafts collection was to be displayed.

South West Arts agreed to give a grant towards the cost of this and a metalwork grille by Alan Evans (Cat.258), and Christine Ross, the Visual Arts and Crafts Officer at SWA, offered advice on the selection of a stained-glass designer. She and the Director of the Art Gallery and Museums, the Keeper of Museums, and the Project Architect from the Borough Council looked at slides of work by makers from the South West and short-listed two. These were approached in August 1988 with a request that they prepare a preliminary design for discussion (for a nominal fee of £150). After submission of first ideas and a meeting with all involved, the successful designer would then be asked to refine the initial plans for another fee of £700.

The design brief specified that the glass was to be as interesting to people in the street below as to those in the building, that it should reflect the contents of the gallery in which it was to be sited, and that it should focus on the top and side panels of the window, leaving the central panel clear so that visitors could see out. Chinks Grylls was chosen unanimously because her designs showed her interest in and sensitivity to the Arts and Crafts collections, incorporating details from furniture, pottery, and glass which would be displayed nearby.

Drawings given by the artist show how the design developed (Fig.203). Two ideas were proposed, one including quite detailed representation of features such as rush seats, inlay, and painted decoration and the other providing a bolder and more abstract treatment. At the next stage, the boldness was strengthened and the details resolved into the overall design. The colouring was influenced by the only piece of stained glass in the collection, Paul Woodroffe's small panel (Cat.204), and also took into account the planned colours of the carpet of the gallery and of the neon sign for the facade of the building. Chinks Grylls also talked to Alan Evans about his plans for the metalwork grille which was to be installed below her window. There was some discussion about whether the central panel should also be made as leaded glass but it was felt that this would interfere with light for viewing the objects. Pilkington's bronze 'Antisun' Float Glass was specified for this to control light levels on the furniture.

By January 1989 the design and cost had been agreed and work began in the studio. This was completed in April and the window was installed in June, as soon as the timetable of building work allowed.

This was a very rewarding project for all involved at the Museum. The Arts and Crafts displays are approached from the other end of the gallery and the window provides an attraction to draw the visitor along. Its colours and detailing compliment the collections and it continues the spirit of the Arts and Crafts while providing a vigorous design of its

Fig.203 *Designs for a stained-glass window by Chinks Grylls, 1989 (Cat.260).*

own time. It also fulfils the request that it should look good from the outside, and gives a warm focus to the front of the building.

See also back cover.

David Kindersley (1915-95) and Lida Lopes Cardozo (1954-)

261 Inscribed plaque

Designed in 1990 and cut in 1991 from the Cardozo Kindersley Workshop.

Slate.

$22 \times 33\frac{7}{8}$ (560×860)

Commissioned in 1990 from the maker for £2550 with a grant from the R. E. Summerfield Charitable Trust. 1998.264

Design: CAGM.

Fig.204 **Cat.261**

To commemorate the bequest of Ronald Summerfield (Cat.1, see p.86), which enabled the Museum to make great improvements to the displays of social history and the fine and applied arts, the Director wished to mark the galleries with a plaque. He wrote to David Kindersley asking if he would undertake this in his workshop and received an enthusiastic response and a sketch design from Lida Lopes Cardozo. Since the workshop was busy, it was agreed that

work would not start until later in the year and by April 1991 it was almost completed. A letter from Lida Lopes Cardozo, apologising for not having informed George Breeze earlier so that he could visit and see the piece being cut, described how work had proceeded: '… When we started drawing it out we had a lot of fun with getting the flourishes to work. As always my sketch did not solve this problem.

'We left it, changed it left it etc. Then

when it looked just right we were so pleased we started …'.

The plaque was installed in November 1991 above the doorway into the Summerfield Galleries on the second floor of the Museum.

In style the fluid lettering with its extended flourishes shows the influence of eighteenth-century calligraphy.

V Appendix Furniture acquired since 1994

The following items have been added to the collections since the publication of *Good Citizen's Furniture* in 1994.
AC

Charles Robert Ashbee (1863-1942) and the Guild of Handicraft

262* *Semi-grand piano*

Designed by C. R. Ashbee in 1898-9 and made by John Broadwood & Sons, London, in 1900. Metalwork by Guild of Handicraft blacksmiths and painting by Walter Taylor.

Oak with wrought iron strap hinges, the pierced sections laid on vellum. Interior of white holly, painted with transparent colours and gilded highlights. Ivory and ebony keys.

Painted legend inside the back lid:
C. R. ASHBEE DESIGNED AND GAVE THIS PIANO TO HIS WIFE JANET, AS THE WEDDING GIFT, AND WALTER TAYLOR THEIR FRIEND DID THE PAINTING.
Above the keyboard is painted: JOHN BROADWOOD & SONS LONDON.
Marked on frame: Broadwood Action 45542.

$40 \times 59\frac{5}{8} \times 82$ (1017×1515×2083)

Purchased in 1996 from the Trustees of Toynbee Hall, London, via Christie's for £108,000 with grants from the V&A Purchase Grant Fund (42 per cent), the National Heritage Memorial Fund, the National Art Collections Fund and the Friends of Cheltenham Art Gallery and Museums. Conservation work was financially supported by the National Heritage Memorial Fund and Michael Tilson-Thomas. 1996.582

Record: V&A AAD 1/99-1980, Cat.494.

C. R. Ashbee and Janet Forbes (Fig.132) were married in September 1898 and he presumably made the design for the piano around this time. Workshop records at John Broadwood & Sons show that it was not completed until November 1900 and that it cost 180 guineas.[1]

Janet was very musical and the piano held an important place in the Ashbee household. Her daughter Felicity later recalled that 'As very small children we would climb onto Janet's lap where she sat at the piano, and put our hands on top of hers as she played'.[2] Three of the four girls also took part in a 'Drill' devised by Janet, marching up and down the stone-flagged floor of the converted Norman chapel in Broad Campden to folk tunes arranged by their mother and played on the piano.

When they came back from Jerusalem to live at Godden Green, in Kent in 1923, the piano came out of store to go with them, but it was too big when Janet Ashbee moved to Lancashire after her husband's death, and she gave it to Toynbee Hall in East London because the settlement had been so important for her husband's early career. It was there that the Guild of Handicraft first started, growing out of Ruskin reading classes organised by Ashbee.

Prompted by concerns expressed by Felicity Ashbee about the safety of the piano in the unlocked dining room at Toynbee Hall, the Trustees decided to sell, and it was through the intervention of Felicity and the Ashbee family and Alan Crawford, and the help of Nicola Redway at Christie's, that the Museum was able to arrange a private treaty purchase.

This is a superb example of the type of 'Artistic Piano' for which there was a vogue in the late nineteenth century. In 1878 Burne-Jones produced a design for a piano based on an eighteenth-century harpsichord shape and with a rectangular trestle support instead of the bulbous legs of the usual Victorian instrument. This was decorated by Kate Faulkner, who had been involved in Morris & Co from its early days. An example by Arnold Dolmetsch, Herbert Horne and Selwyn Image was shown at the 1899 Arts and Crafts Exhibition, and a fine piano by Robert Lorimer was painted by Phoebe Traquair in 1908. Voysey and Mackintosh are also known to have designed pianos.[3]

Many of these instruments were made by John Broadwood & Sons, who produced an *Album of Artistic Pianofortes* in 1895. Alan Crawford suggests that this was an attempt to find a niche in the market at a time when German pianos had become technically superior and American ones cheaper than the British. Hermann Muthesius makes waspish comments about the piano in the English drawing room in his book *The English House* of 1904-5:

'In view of the fact that the English are probably the most unmusical race in the world the presence of a grand piano in every house is slightly surprising. Dilettantism is in its element in England and even among the educated there is a lack of critical judgement of quality in music that would be impossible in any other country. But despite the absence of discrimination in musical matters, love of music is deep and general among the English.

Pianos of German manufacture, especially those of Blüthner and Bechstein, have now entirely outrivalled those of the old-established English firm of Broadwood. But these instruments are all sold in England in rosewood instead of the black polish that is in general use with us. In England too during the past thirty years there have been all kinds of attempts to give the piano an artistic form. All the artists who design furniture have tried their hands at pianos …'.[4]

Ashbee designed a number of pianos around this time; at least one more semi-grand of this type (and possibly two), and several uprights similar to Baillie Scott's 'Manx' piano of 1896, which also had a great influence on Ashbee's other furniture, especially his cabinets. The front of this instrument opens out in much the same way as a 'Manx', while the unusual rectangular butterfly-hinged double lids provide sounding boards which apparently gave a tone similar to that of a concert grand. This was because of their size and the strength of the frame, of the 'barless steel' type.

Like Ashbee's cabinets, the piano is sober on the outside, in plain oak with restrained decoration provided by the tooled and pierced Ash and Bee motifs on the large strap hinges. It opens up, however, to reveal the light interior, highly decorated with a painted scene and figures, outlined in brown and coloured in mauve and green with gilded details. The colours are now faded and must have been very rich when new. Inside the lid facing the pianist are three women playing instruments within a trellised bower and surrounded by poppies, with a beautiful city and vast sun rays behind and a cloaked male figure asleep before them. There must

be a symbolic purpose in this contrast of light and dullness, in the vision of sun rays appearing as the instrument is opened for playing, as if the music from the piano is warming to the soul as the sun is to the body. The whole scene appears to continue behind the frame of the lid, as if seen through a window.

Above the keyboard and on the inside of the doors appears a series of female figures of vacant expression and doubtful anatomy, as Felicity Ashbee points out, '… though of course, since we had been brought up on Walter Crane illustrations, we were quite used to "willowy ladies" with very long necks'.[5] Each stands in front of a stylised tree holding an instrument and those on the doors have plinths decorated with gilded circles.

Across the framework of doors and lid is a painted poem, *Beethoven in Olympus*, composed by Ashbee himself:

I dreamed that in a garden once I lay
Where three strange women garlanded
 with vine,
Rose and woodbine, and trelliced from the
 sun,
On pipe and lute and viol played to me,
And as they played, the music of all time
Woke in my soul, and great grey poppies
 flung
Their spell about me, and the gates stood
 clear
Of ivory cities such as men pass through
Who seek the infinite, their domes of glass
Translucent, purple, and their gilded vanes
Reflecting light from light. Then at the call
Of one deep chord, the dreaming whole
 awoke.
Voices, and strings, and wind made
 melody
And sound there was of myriad
 instruments
Cunningly fingered, moving to some law
In one triumphant expectation. Till
Unto the measure of all form, the old
Deaf master called, when all once more
 was mute.

Ashbee published the poem in *Echoes from the City of the Sun* in 1905.[6] It expresses his dreams of the ideal city, the 'City of the Sun' derived from seventeenth-century Italian literature,[7] and his feeling for the power of music. He was very keen on Beethoven, especially the Moonlight Sonata, which was his mother's favourite piece.

Inside the back lid are stylised poppies encircled by the details of the making and giving of the piano (see above). Ashbee designed the figures for the painted decoration, which are similar

to drawings for *The Prayer Book of King Edward VII* published by him in 1903. Walter Taylor presumably worked on the separate panels of holly, which were then assembled at Broadwood's. Taylor had been one of the first apprentices at the Guild of Handicraft in 1888 and by 1900 was working for Morris & Co.

Conservation work was carried out on the casework by Charteris Restoration and Conservation to repair recent damage and remove added timber, but it has not been restored to playing condition.

See Col.Figs 117, 118, 119.

1. We are once again indebted to Alan Crawford for much of the information included here. He provided an account of the piano's history and importance when the Museum was preparing applications for grant aid and his text is now in the object file.
2. Extracted from Felicity Ashbee's typescript biography of her mother (pp.2/10-11), also provided for grant purposes and retained in the object file.
3. Wilson, M., 'The Case of the Victorian Piano', *Victoria and Albert Museum Year Book* 3, 1972, pp.133-53; Crawford, A., *C. R. Ashbee: Architect, Designer and Romantic Socialist*, New Haven and London 1985, pp.287-92, 450 (n.24-34); the Lorimer/Traquair piano is in the National Museums of Scotland.
4. Muthesius, H., *Das englische Haus*, Berlin 1904-5, abridged English translation of 2nd edition, London 1979, pp.216-7.
5. Ashbee, F., as above n.2, p.2/11.
6. Essex House Press, Chipping Campden, p.30.
7. See Crawford, A., *Op.cit.*, p.116.

Ernest Gimson (1864-1919)

263 *Bed*

Designed by Ernest Gimson and made at Daneway in about 1902-14.

English walnut with panelled head and footboards and deeply chamfered sides. Metal fittings and casters.

Headboard: 48×38¾ (1219×984)

Given in 1997 by Sir Hugh and Lady Casson. 1997.79

Record: CAGM 1941.222.558, signed 'Ernest Gimson, Daneway House', but undated.

The bed was made for Francis Troup (1859-1941),[1] the uncle of Margaret

Fig.205 **Cat.263**

Casson. Troup was a Scottish architect who entered the Royal Academy Schools in 1884, where he met Robert Weir Schultz and became part of the group of young Arts and Crafts enthusiasts which included Gimson and the Barnsleys. Over the years, Troup had a number of items made at Gimson's workshop, some to his own design or as a collaboration. In 1914-16 he had several pieces made, probably mostly for his rooms at Mandeville Place near Oxford Street, London, where he lived for forty years. This bed is not included in the surviving workshop record of 1914-19, so it seems likely that it was made between 1902 and 1914. The design for it is clearly inscribed, 'For Mr Troup' but is undated. It is also marked in Gimson's hand 'Made by Orton'.

Sir Hugh Casson who grew up in Cheltenham was responsible for the final form of the facade of the Museum's new extension, built in 1989. The family gave the bed to the collection partly because of these personal links.

In design, the bed is typical of Gimson's plainer work, with simple framed and planked head and foot boards and rather dramatic chamfers along the sides. Marks inside the frame suggest that the support for the bed base was altered at some time, and the strips of timber along each side may have been added. They are probably to make it more comfortable getting in and out and suggest that the bed was used in the middle of the room rather than against a wall.

1. For an account of Troup's career see Jackson, N., *F. W. Troup: Architect 1859-1941*, London 1985.

Sidney Barnsley (1865-1926)

264 Part of a chapel screen

Designed and made by Sidney Barnsley in 1922-3.

Oak with chamfered decoration.

90×150×6 (2286×3810×152)

Given in 1997 by the Diocese of Gloucester. 1999.16

Record: CAGM 1973.186:3-4. GRO Gloucester Diocesan Records, F/1 1923/7.

This is part of a more extensive screen dividing the morning chapel from the aisle and choir at Holy Trinity Church, Portland Place, Cheltenham. The faculty

Fig.206 **Cat.264**

was granted in February 1923 for a centenary memorial chapel, this being the anniversary of the church, a gothic revival building by George Allen Underwood.[1] A section became redundant when the interior was rearranged in 1997 and although there were hopes that it could be re-used in another church in the Diocese, this proved impractical so it was given to the Museum.

Sidney Barnsley was an active member of the Gloucester Diocesan Advisory Committee from its inception in 1919 and had been an energetic worker on behalf of the SPAB for many years. He carried out a number of commissions for church woodwork and this is a good example of his sympathetic style.

1. Verey, D., *Gloucestershire 2: The Vale and the Forest of Dean*, Harmondsworth 1970, p.131.

Peter van der Waals (1870-1937)

265 Cabinet/bureau

Designed by Peter Waals and made by George Trevelyan in 1930. Fittings probably made by Alfred Bucknell.

Walnut with inlaid beading of macassar ebony and with ebony handles and lock plate. The top cupboard has two adjustable shelves inlaid with beading, held on wooden supports. Brass door hinges and catch. Inside the bureau are pigeonholes, a lockable central

cupboard with feathered walnut cushioned panel and three drawers with ebony handles, in a frame with ebony and holly chequered inlay. The writing flap is covered with faded plain dark red morocco. Brass hinges and stay hinges with incised and stamped decoration. Cedar drawer linings and cedar back to lower section. The handles are carved, lock-plate chip-carved, and dovetail joints exposed.

Inscribed in ink under the central drawer inside the bureau:
P. Waals. Chalford 1931. *(or 1930?)*
G. L. Trevelyan. Craftsman.

$74\frac{3}{4}×35×17\frac{3}{8}$ (1898×890×442)

Given in 1997 by the family of Sir George Trevelyan. 1997.78

Sir George Trevelyan (1906-96) graduated from Cambridge uncertain as to his future and decided to try the crafts. He joined the workshop of Peter Waals in 1929 as a paying pupil and later wrote vividly about his experience there and what it meant to him.[1] He went into teaching and later became the Warden of Attingham Park, a National Trust house near Shrewsbury, but kept in touch with several of the craftsmen and he had more pieces made for his own home and to his own design.

This piece was the most ambitious made by Trevelyan in his time at the workshop and it was shown at the 1931 Arts and Crafts exhibition at Burlington House in London, which is probably why it is signed and dated. It was used by Sir George and his wife, Helen, in different houses and finally at Hawkesbury, near Badminton, where Sir George's Cotswold furniture and Helen Trevelyan's colourful flower paintings lived happily side by side.

Sir George was an inspiring and energetic man, always pleased to talk about the Arts and Crafts and generous with his knowledge. He was a good friend to the Museum and donated a splendid chair by Eric Sharpe in 1979 and a design by Waals in 1980.[2] It is therefore particularly fitting that this superb piece should act as a permanent memorial to him in the collection.

It is a good example of the fine cabinet-work produced by Waals's workshop, firmly based on the Gimson-Barnsley tradition but lighter in mood. The timber is used in the solid, as in Gimson's work, but the thickness is reduced. Wood for the drawers and doors was clearly chosen for its feathering and carefully matched.

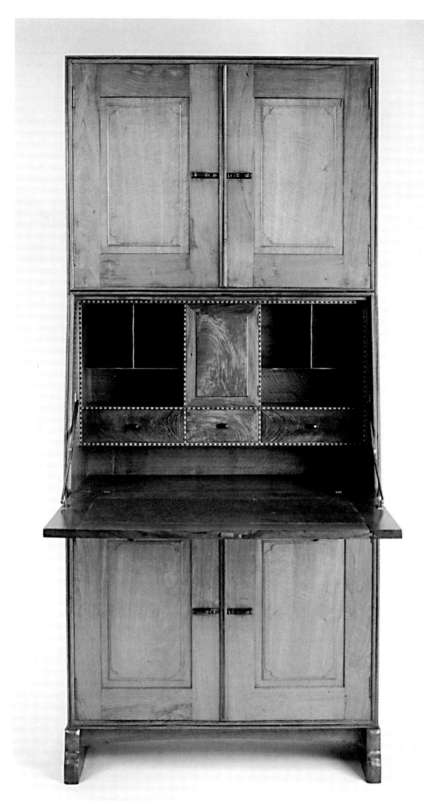

Fig.207 **Cat.265**

1. An account by Sir George was published in the Leicester Museum exhibition catalogue, *Ernest Gimson*, in 1969, pp.43-5, and reprinted in Carruthers, A., *Ernest Gimson and the Cotswold Group of Craftsmen*, Leicester 1978, pp.12-16.
2. See *GCF*, Cat.81, p.134 and p.110, fig.131.

Edward Barnsley (1900-87)

266* Framed set of timber samples

Designed at the Edward Barnsley Educational Trust Workshop, Froxfield, Hampshire, and made by Darren Harvey in 63 hours in 1988.

Oak frame with an inlaid bead of makore and an MDF back, and 66 samples of rare and common timbers.

$22\frac{3}{16} \times 24\frac{5}{8} \times \frac{15}{16}$ (563×624×25)

Purchased in 1994 from the Edward Barnsley Educational Trust for £800 with a 50 per cent grant from the V&A Purchase Grant Fund. 1996.8

Edward Barnsley was very enthusiastic and knowledgeable about cabinet-making timbers and often said that the Museum should have a good set of samples and that he would provide one. This did not happen during his lifetime, but this framed set was shown in the exhibition *Fine Furniture: The Barnsley Tradition Today* at Cheltenham in 1993-4 and the opportunity to purchase it was seized.

Each sample is stamped in the top left corner with a number and the timbers are identified on a separate sheet provided by the workshop:
1 Acacia; 2 Afromosia; 3 Ash; 4 Beech; 5 Black bean; 6 Box; 7 Bubinga; 8 Cedar Atlanticus; 9 Cedar of Lebanon; 10 Cherry; 11 Chestnut; 12 Cocobolo; 13 Danta; 14 Douglas fir; 15 Ebony, Indian; 16 Ebony, Macassar; 17 Elm; 18 Gaboon; 19 Holly; 20 Iroko; 21 Jarrah; 22 Keruing; 23 Kingwood; 24 Laburnum; 25 Laurel, Indian; 26 Lime; 27 Mahogany, African; 28 Mahogany, Brazilian; 29 Mahogany, Cuban; 30 Mahogany, Honduras; 31 Makoré; 32 Maple; 33 Oak, bog; 34 Oak, brown; 35 Oak, burr; 36 Oak, Japanese; 37 Oak, English, flat sawn; 38 Oak, English, quarter sawn; 39 Obeche; 40 Olive; 41 Pau rosa; 42 Pine, Parana; 43 Pine, Scots; 44 Ramin; 45 Padauk, African; 46 Padauk, Andaman; 47 Pear; 48 Plane, London; 49 Rosewood, Indian; 50 Rosewood, Rio; 51 Sapele; 52 Senna; 53 Service tree; 54 Spruce, Norway; 55 Sycamore; 56 Teak; 57 Tree of Heaven; 58 Utile;

59 Walnut, African; 60 Walnut, American; 61 Walnut, English; 62 Walnut, feather grain; 63 Walnut, Queensland; 64 Wellingtonia; 65 Willow; 66 Yew.

The frame has a simple moulding and fine inlaid bead of the type used in the Workshop from the 1950s. Darren Harvey was a second-year apprentice when he made it under the supervision of foreman, Mark Nicholas, spending twenty-four hours on the frame and thirty-nine on the samples. Trainee Hamish Low also worked on this since he was making a box of samples at the time.

See Col.Fig.116.

Hugh Birkett (1919-)

267* Box with lid

Designed and made by Hugh Birkett in 1996.

Framework of Indian laurel, delicately chamfered, with knob and cushion-shaped panels of yew and base of pale timber. Inlaid bead of yew around lid and foot. Leather strips under the foot. Stamped underneath: 19HB96.

$8\frac{1}{2}\times11\frac{7}{8}\times12\frac{7}{16}$ (216×302×317)

Given in 1996 by Mr C. H. Alpe. 1997.81

This box, along with the following three, was chosen by the donor for the Museum from a large collection commissioned by him from Hugh Birkett since the 1940s. All four are good examples of Birkett's interest in making small-scale, delicate pieces (perhaps a legacy of his early engineering training), and they complement the display cabinet by him already in the collections.[1]

See Col.Fig.115.

1. See *GCF*, Cat.107 p.156.

268* Box with hinged lid

Designed and made by Hugh Birkett in 1996. Lock by Martin & Co, Birmingham.

Mahogany. Cedar of Lebanon tray inside with handle of black laurel and green velvet linings to box and tray. Small handle at front of lid and key plate of macassar ebony. Brass hinges and lock and small key. Stamped on base: 19HB96.

$4\frac{1}{2}\times5\frac{13}{16}\times5\frac{3}{4}$ (114×148×146)

Given in 1996 by Mr C. H. Alpe. 1997.82

The decorative dark and light effect down the edges is achieved simply by the jointing of the timber.

See Col.Fig.115.

269* Box with lid

Designed and made by Hugh Birkett in 1996.

Bog oak with sycamore inside and in base. Stamped under base: 19HB96

$4\times6\frac{7}{8}\times6\frac{5}{8}$ (101×174×162)

Given in 1996 by Mr C. H. Alpe. 1997.83
See Col.Fig.115.

270* Box with lid

Designed and made by Hugh Birkett in 1996.

Frame of Cuban mahogany with lining of beech and bottom of maple. The lid has a knob of iroko, inlay around the edge of jarrah, and ten triangular panels of different timbers as follows: oak, peruba rosa, cherry, black walnut, haldu, brown oak, myrtle, sycamore, Indian laurel, Brazilian mahogany. The foot of the box is inlaid with ebony and the sides have thirty square panels in three rows: Top: box, bog oak, lilac, partridge wood, makoré, Rio rosewood, yew, bloodwood, hornbeam, bacoti. Middle: Indian rosewood, olive, blackwood,

Fig.208 **Cat.271**

satinwood, teak, briar, Honduras rosewood, swamp gum, lignum vitae, muhohu. Bottom: holly, laburnum, almond, Rhodesian padauk, mulberry, cocobolo, plum, walnut, old oak, Andaman padauk. Stamped underneath: 19HB96

$7\frac{1}{2}\times6\frac{15}{16}$ (190×177)

Given in 1996 by Mr C. H. Alpe. 1997.84
See Col.Fig.115.

Richard La Trobe-Bateman (1938-)

271 'Triangles' chair

Designed by Richard La Trobe-Bateman in 1992 and made in 1995.

Ash and elm with chromed metal fittings. Stamped under the seat LA TROBE-BATEMAN *and inscribed in ink:* RGSLATRbeBateman Jan 1995 FOR CAS

$35\times21\frac{3}{8}\times20$ (889×543×508)

Given in 1996 by the Contemporary Art Society. 1999.17

The Contemporary Art Society distributes craftwork to subscribing institutions every two years and this chair was the Museum's first choice in 1996. It was bought for the CAS by Peter Dormer and was included in a Crafts Council exhibition, *Furniture Today – Its Design & Craft*, in 1995.[1]

La Trobe-Bateman works in Somerset and now makes bridges and light buildings as well as furniture; his interest, as can be seen in this chair, is in structure as well as function and craft technique. The back and seat are of elm cut across the grain by machine, giving a dramatic texture. In contrast, the smoothly turned legs are made by the traditional method used by Ernest Gimson. Although La Trobe-Bateman's designs are always true to his own day in design, his work reveals a sureness and immediacy similar to the effect of Gimson's own turned chairs, on which the marks of the tools can be seen.[2]

1. See Dormer, P., *Furniture Today – Its Design & Craft*, London 1995, pp.39-41, 72-3.
2. For instance see *GCF*, Cat.20 p.86.

Bibliography

Abdy, J. and Gere, C. *The Souls*, London 1984.

Allwood, R. and Laurie, K. *R. D. Russell Marian Pepler*, London 1983.

Andrews, G. and Comino, M. *William and Eve Simmonds*, Cheltenham 1980.

Anscombe, I. and Gere, C. *Arts and Crafts in Britain and America*, London 1978.

Ashbee, C. R. *Modern English Silverwork*, Broad Campden 1909. New edition with introductory essays by A. Crawford and S. Bury, London 1974.

Aslet, C. *The Last Country Houses*, New Haven & London 1982.

Atterbury, P. and Henson, J. *Ruskin Pottery*, Ilminster 1993.

Backemeyer, S. and Gronberg, T. (eds). *W. R. Lethaby 1857-1931: Architecture, Design and Education*, London 1984.

Batkin, M. *Wedgwood Ceramics 1846-1959*, London 1982.

Batkin, M. *Good Workmanship with Happy Thought: the Work of Alfred and Louise Powell*, Cheltenham 1992.

Baynes, K. and K. *Gordon Russell*, London 1981.

Becker, V. *Antique and 20th Century Jewellery*, London 1980.

Bergesen, V. *Encyclopaedia of British Art Pottery 1870-1920*, London 1991.

Bradford Art Galleries and Museums. *Design Themes in 19th Century Pottery*, Bradford 1981.

Bradford Art Galleries and Museums and Leeds City Museums. *Burmantofts Pottery*, Bradford 1983.

Bradford, E. *English Victorian Jewellery*, London 1959.

Brandon-Jones, J. 'After William Morris', *Artifex: Journal of the Crafts*, Vol.4 1970, pp.52-64.

Brandon-Jones, J. et al. *C. F. A. Voysey: architect and designer 1857-1941*, London 1978.

Breeze, G. and Wild, G. *Arthur and Georgie Gaskin*, Birmingham 1981.

Brighton Museum. *Beauty's Awakening: The Centenary Exhibition of the Art Workers' Guild*, Brighton 1984.

Bury, S. 'An arts and crafts experiment: the silverwork of C. R. Ashbee', *Victoria and Albert Museum Bulletin*, Vol.III, No.1, Jan.1967, pp.18-25.

Bury, S. *Jewellery 1789-1910, Volume II, The International Era*, London 1991.

Callen, A. *Angel in the Studio*, London 1979.

Calloway, S. *Liberty of London: Masters of Style and Decoration*, London 1992.

Cardew, M. *A Pioneer Potter*, London 1988.

Carruthers, A. *Ernest Gimson and the Cotswold Group of Craftsmen*, Leicester 1978.

Carruthers, A. *Gimson and Barnsley: Designs and Drawings in Cheltenham Art Gallery and Museums*, Cheltenham 1984.

Carruthers, A. *Ashbee to Wilson: The Hull Grundy Gift to Cheltenham Art Gallery and Museums, Part 2*, Cheltenham 1986.

Carruthers, A. 'Ashbee Silverwork & Jewellery', *The Antique Collector*, February 1988, pp.23-8.

Carruthers, A. and Greensted, M. *Good Citizen's Furniture: The Arts and Crafts Collections at Cheltenham*, London 1994.

Carruthers, A. and Johnson, F. *The Guild of Handicraft 1888-1988*, Cheltenham 1988.

Cartlidge, B. *20th Century Jewellery*, New York 1985.

Catleugh, J. *William De Morgan Tiles*, London 1983.

Cheltenham Art Gallery and Museums. *Simply Stunning: The Pre-Raphaelite Art of Dressing*, Cheltenham 1996.

Coatts, M. *Robert Welch Designer-Silversmith: A Retrospective Exhibition 1955-1995*, Cheltenham 1995.

Coatts, M. and Lewis, E. (eds). *Heywood Sumner: Artist and Archaeologist 1853-1940*, Winchester 1986.

Comino, M. *Gimson and the Barnsleys: 'Wonderful furniture of a commonplace kind'*, London 1980 (and Stroud 1991 as M. Greensted).

Cooper, J. *Victorian and Edwardian Furniture and Interiors: From the Gothic Revival to Art Nouveau*, London 1987.

Crafts Council. *Katharine Pleydell-Bouverie: A Potter's Life 1895-1985*, London 1986.

Crane, W. *William Morris to Whistler*, London 1911.

Crawford, A. (ed). *By Hammer and Hand: The Arts and Crafts Movement in Birmingham*, Birmingham 1984.

Crawford, A. *C. R. Ashbee: Architect, Designer and Romantic Socialist*, New Haven & London 1985.

Crawford, A., Greensted, M. and MacCarthy, F. *C. R. Ashbee & the Guild of Handicraft*, Cheltenham 1981.

Cross, A. J. *Pilkington's Royal Lancastrian Pottery and Tiles*, London 1980.

Cumming, E. and Kaplan, W. *The Arts and Crafts Movement*, London 1991.

Davey, P. *Arts and Crafts Architecture*, London 1980.

Dawson, A. *Bernard Moore: Master Potter 1850-1935*, London 1982.

Farleigh, J. *Fifteen Craftsmen on their Crafts*, London 1945.

Fine Art Society Ltd. *The Arts and Crafts Movement: Artists, Craftsmen & Designers 1890-1930*, London 1973.

Fischer Fine Art Ltd. *Truth, Beauty and Design: Victorian, Edwardian and Later Decorative Art*, London 1986.

Fitzgerald, P. *Edward Burne-Jones*, London 1975.

Flower, M. *Victorian Jewellery*, London 1951.

Gere, C. and Munn, G.C. *Artists' Jewellery: Pre-Raphaelite to Arts and Crafts*, Woodbridge 1989.

Gere, C. and Whiteway, M. *Nineteenth-Century Design*, London 1993.

Greensted, M. *The Arts and Crafts Movement in the Cotswolds*, Stroud 1993.

Greenwood, M. *The Designs of William De Morgan*, Ilminster 1989.

Haigh, D. *Baillie Scott: The Artistic House*, London 1995

Harvey, C. and Press, J. *William Morris: Design and Enterprise in Victorian Britain*, Manchester 1991.

Haslam, M. *The Martin Brothers Potters*, London 1978.

Haslam, M. *Elton Ware*, Ilminster 1989.

Hinks, P. *Twentieth Century British Jewellery 1900-1980*, London 1983.

Hitchmough, W. *C.F.A.Voysey*, London 1995.

Holme, C. (ed). *Modern Design in Jewellery and Fans*, London 1902.

Howes, J. (ed). *Craft History One: Celebrating the Centenary of the Arts and Crafts Exhibition Society*, Bath 1988.

Jewson, N. *By Chance I Did Rove*, privately published 1951. 2nd edition privately published 1973, 3rd edition Barnsley, Gloucestershire 1986.

Jones, K.C. (ed). *The Silversmiths of Birmingham and their Marks 1750-1980*, London 1981.

Kaplan, W. *et al. Encyclopedia of Arts and Crafts: The International Arts Movement 1850-1920*, London 1989.

Karlin, E.Z. *Jewellery and Metalwork in the Arts and Crafts Tradition*, Atglen, USA 1993.

Kindersley, D. *Mr Eric Gill: Further Thoughts by an Apprentice*, Cambridge 1990.

Kirkham, P. *Harry Peach: Dryad and the DIA*, London 1986.

Kuzmanovic, N.N. *John Paul Cooper: Designer and Craftsman of the Arts and Crafts Movement*, Stroud 1999.

Lambourne, L. *Utopian Craftsmen*, London 1980.

Leicester Museum. *Ernest Gimson*, Leicester 1969.

Lethaby, W.R., Powell, A.H. and Griggs, F.L. *Ernest Gimson His Life and Work*, Stratford-upon-Avon 1924.

MacCarthy, F. *The Simple Life: C.R. Ashbee in the Cotswolds*, London 1981.

Mackmurdo, A.H. (ed). *Plain Handicrafts*, London 1892.

Macready, S. and Thompson, F.H. (eds). *Influences in Victorian Art and Architecture*, London 1985.

Mander, N., Verity, S. and Wynne-Jones, D. *Norman Jewson: Architect 1884-1975*, Bibury 1987.

Mason, S. *Jewellery Making in Birmingham, 1750-1995*, Chichester 1998.

Morris, B. *Liberty Design 1874-1914*, London 1989.

Mulvagh, J. *Costume Jewellery in Vogue*, London 1988.

Myerson, J. *Gordon Russell: Designer of Furniture*, London 1992.

Naylor, G. *The Arts and Crafts Movement*, London 1971.

Naylor, G. (ed). *William Morris by Himself: Designs and Writings*, London 1988.

Newton, S.M. *Health, Art & Reason: Dress Reformers of the 19th Century*, London 1974.

Parry, L. *Textiles of the Arts and Crafts Movement*, London 1990.

Parry, L. (ed). *William Morris*, London 1996.

Poulson, C. (ed). *William Morris on Art and Design*, Sheffield 1996.

Powers, A. *Modern Block-Printed Textiles*, London 1992.

Robinson, S. *A Fertile Field: An Outline History of the Guild of Gloucestershire Craftsmen and the Crafts in Gloucestershire*, Cheltenham 1983.

Rose, M. *Artist Potters in England*, London 1955.

Simpson, D. *C.F.A.Voysey: An Architect of Individuality*, London 1979.

Skinner, D.S. and Evans, J. *Art Pottery: the Legacy of William Morris*, Stoke-on-Trent 1996.

Sloan, H. *May Morris 1862-1938*, London 1989.

Symonds, J. *Catalogue of the Drawings Collection of the Royal Institute of British Architects: C.F.A.Voysey*, London 1976.

Tait, H. (ed). *The Art of the Jeweller: A Catalogue of the Hull Grundy Gift to the British Museum*, London 1984.

Tilbrook, A.J. *The Designs of Archibald Knox for Liberty & Co*, London 1976.

Tilbrook, A.J. and Fischer Fine Art Limited. *Truth, Beauty and Design: Victorian, Edwardian and Later Decorative Art*, London 1986.

Victoria and Albert Museum. *Exhibition of Victorian and Edwardian Decorative Arts*, London 1952.

Victoria and Albert Museum. *Liberty's 1875-1975*, London 1975.

Watson, O. *Studio Pottery*, London 1990.

Wednesbury Museum & Art Gallery. *Ruskin Pottery Centenary Exhibition Catalogue*, West Bromwich 1998.

Welch, R. *Hand and Machine*, Chipping Campden 1986.

Wheeler, R. *Winchcombe Pottery: The Cardew-Finch Tradition*, Oxford 1998.

Whitworth Art Gallery. *William Morris Revisited: Questioning the Legacy*, Manchester 1996.

Wilgress, J. *Alec Miller: Guildsman and Sculptor in Chipping Campden*, Chipping Campden 1987.

Wingfield Digby, G. *The Work of the Modern Potter in England*, London 1952.

Winmill, J. *Charles Canning Winmill: An Architect's Life*, London 1946.

Wright, S.M. (ed). *The Decorative Arts in the Victorian Period*, London 1989.

Index of Designers/Makers and Clients/Owners